Praise for *33 Artists in 3 Acts* by Sarah Thornton

Nominated for the Gordon Burn Prize
Named a Best Art Book of the Year by the *Guardian* and *Huffington Post*
Translated into Eight Languages

"Another art world page-turner." —*Globe and Mail*

"Crystal-clear, fly-on-the-wall perspective. . . . [J]ust when Thornton
has all but disappeared behind exceptionally detailed observations, she
resurfaces to educate, critique, or expand."
 —Annie Buckley, *Los Angeles Review of Books*

"[U]nparalleled access. . . . For readers who are curious about contem-
porary art but know little about it, Thornton has produced a readable,
approachable introduction to the rock stars of that world and their
work." —Kevin O'Kelly, *Christian Science Monitor*

"Her interviews, interwoven to show conjunctions and contrasts, cohere
into a strong three-part whole." —Boris Katchka, *New York Magazine*

"Wonderful portraits of the people that . . . do wonderful portraits.
These characters are no longer creators of icons but icons themselves
and Thornton is in the front pew—but taking notes, not praying at all."
 —*Monocle*

"A compelling account of the rarefied heights of contemporary global
artistic success, skillfully joining the dots to make patterns appear, with
wit and insight and even compassion for her ethnographic subjects. *33
Artists in 3 Acts* is not just a highly enjoyable read but also a book of
enduring value."
 —Craig Clunas, professor of art history, Oxford University

"*33 Artists in 3 Acts* is superb—a work of art in itself—brilliantly and
imaginatively conceived, enormously informative. I will certainly assign
it to my students." —David Halle, professor of sociology,
 University of California at Los Angeles

"A beautiful, enlightening, compulsively readable, and remarkably
subtle book. Its layering of psychology, economics, self myth, popular

culture, craft, and creative discovery is genuinely new, a reading of contemporary art practice that refuses to be over-determined in any one dimension."

—Steven Lavine, president, California Institute of the Arts

"Sarah Thornton's book takes one into the bull's-eye of the contemporary art world. What I especially like is how she tells us when her notably varied subjects disagree with her or would rather she weren't there at all. Most readers will be glad she was."

—Ingrid Sischy, contributing editor, *Vanity Fair*

"It is [Thornton's] attention to detail and illustration of subtleties that bring her interviewees to life. . . . Her flair for creating clear structures offers readers manageable points of access . . . without ever compromising on quality or content, or sounding pretentious—an admirable skill."

—Dea Vanagan, *Canadian Art*

33 Artists in 3 Acts

33 Artists in 3 Acts

SARAH THORNTON

W. W. Norton & Company
Independent Publishers Since 1923
NEW YORK • LONDON

FOR OTTO AND CORA

Since this page cannot legibly accommodate all the copyright notices,
pages 391–97 constitute an extension of the copyright page.

For information about permission to reproduce selections from this book, write to
Permissions, W. W. Norton & Company, Inc., 500 Fifth Avenue, New York, NY 10110

For information about special discounts for bulk purchases, please contact
W. W. Norton Special Sales at specialsales@wwnorton.com or 800-233-4830

Manufacturing by RR Donnelley Westford
Book design by Chris Welch
Production manager: Devon Zahn

Library of Congress Cataloging-in-Publication Data

Thornton, Sarah (Sarah L.)
33 artists in 3 acts / Sarah Thornton. — First American Edition.
pages cm
Includes bibliographical references and index.
ISBN 978-0-393-24097-9 (hardcover)
1. Artists—Social conditions—21st century. 2. Artists—Economic conditions—
21st century. I. Title. II. Title: Thirty-three artists in three acts.
N8351.T49 2014
709.05′1—dc23
2014026823

ISBN 978-0-393-35167-5 pbk.

W. W. Norton & Company, Inc.
500 Fifth Avenue, New York, N.Y. 10110
www.wwnorton.com

W. W. Norton & Company Ltd.
Castle House, 75/76 Wells Street, London W1T 3QT

1 2 3 4 5 6 7 8 9 0

CONTENTS

ACT III: CRAFT

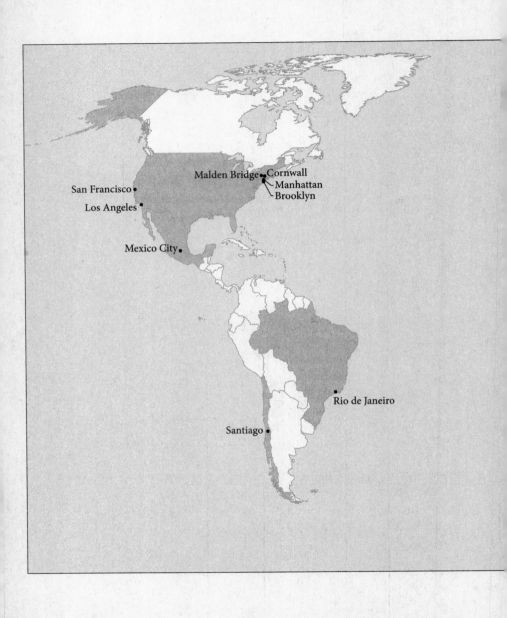

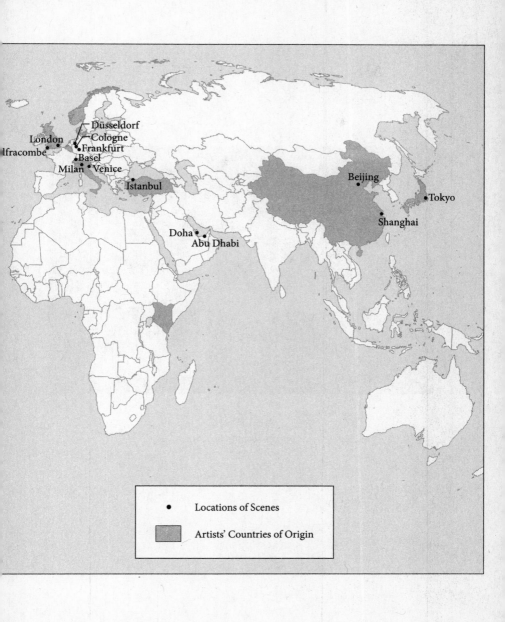

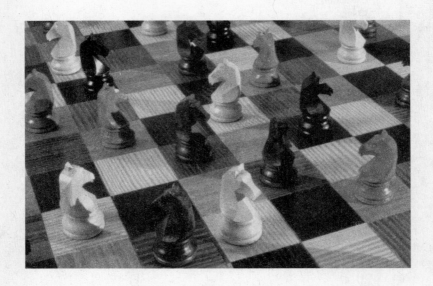

Gabriel Orozco
Horses Running Endlessly
1995

INTRODUCTION

"I don't believe in art. I believe in the artist."—MARCEL DUCHAMP

Artists don't just make art. They create and preserve myths that give their work clout. While nineteenth-century painters faced credibility problems, Marcel Duchamp, the grandfather of contemporary art, made belief a central artistic concern. When he titled an upended urinal *Fountain* (1917), declaring it an artwork, he claimed a godlike power for artists to designate anything they chose as art. Maintaining this kind of authority is not easy, but it is now essential for artists who want to rise through the art world. In a sphere where anything can be art, there is no objective measurement of quality. Ambitious artists must establish their own standards of excellence. Generating such standards requires not only immense self-confidence, but the conviction of significant others, such as dealers, curators, critics, collectors, not to mention fellow artists. Like competing deities, artists need to perform in ways that yield a faithful following.

Ironically, being an artist has become a craft. It is no accident that when Duchamp rejected the handmade in favor of the "readymade," he began crafting identities as well as ideas. He played with his persona in a range of works, presenting himself in drag as a character named Rrose Sélavy and as a confidence man or con artist. Artists often wrestle with the perception that they are charlatans or wannabes. For being an artist

is not just a job; it is a hard-won identity, a reputation that is built up over time, a distinct social status linked to integrity. Having a BA or even an MFA degree in studio art rarely leads people to declare with confidence that they are artists. Institutional endorsements, such as being represented by a dealer, awarded a residency, or exhibited in a museum show, are often prerequisites. But these forms of validation need to be internalized. Like the size and composition of a work, the walk and talk of an artist has to persuade—not just others but the performers themselves. For this reason, I see artists' studios as private stages for the daily rehearsal of self-belief. It's one of the reasons that I chose to divide 33 Artists into three "acts."

This book explores the nature of being a professional artist today. It investigates how artists regard their work and navigate the expectations of art-world gatekeepers. Over the course of four years, I flew thousands of miles and interviewed 130 artists. I tend to over-research so that I understand the big picture and can cherry-pick the most illuminating stories, which means making tough decisions about who to include. My editorial criteria resembled those of both a curator and a casting director. In other words, the artists' work (in the broadest sense) had to be relevant to my themes, but the artists also had to be willing to engage with my questions. I remember asking a highly articulate photographer, who has always insisted on being called an artist, the question that drives the book: "What is an artist?" He replied, "An artist makes art." My heart sank. This is the tedious, tautological answer that aims to close down the conversation. The art world is ostensibly all for "dialogue," except when it threatens to demystify the key player around which its business revolves.

33 Artists in 3 Acts is biased toward artists who are open, articulate, and honest—which is not to say that disingenuousness is completely absent from these pages. On the contrary, I include some suspicious statements for contrast and comic relief. Sometimes I question the utterances; other times I let them slide. I want the reader to be the judge. After reading this book in manuscript form, Gabriel Orozco, the only artist who appears in two separate acts, said, "We are all portrayed in our underwear. At least some of us get to keep our socks on."

The artists in this book hail from fourteen countries on five continents. Most were born in the 1950s and 1960s. Those people who had at least twenty years' experience as artists gave more eye-opening answers to my questions. Also, I was intent on making cross-cultural comparisons, so cutting out very young, "emergent" artists seemed to be the

best way of ensuring that I was not clouding my story with too many variables. In the interest of exploring some of the variation within the expanding field, however, I considered artists who position themselves at diverse points along the following spectrums: entertainer versus academic, materialist versus idealist, narcissist versus altruist, loner versus collaborator. Although many of my subjects have attained high degrees of recognition somewhere in the world, each act contains a scene with an artist who teaches and, like the majority of artists, doesn't make a living through sales of their work.

The themes that govern the book's three acts were a key influence on my choices. Politics, kinship, and craft are rubrics that you might find shaping a classic anthropological tome. They are not typical of art criticism or art history, but I discovered that they demarcate the ideological border that differentiates artists from non-artists, or "real artists" from unconvincing ones—who are variously dismissed as didactic illustrators and activists, unserious hobbyists (a.k.a. "Sunday painters"), or craftspeople and designers. Politics, kinship, and craft also happen to embrace some of the most important things in life: caring about your influence on the world, connecting meaningfully with others, and working hard to create something worthwhile.

"Act I: Politics" explores artists' ethics, and their attitudes to power and responsibility, paying particular attention to human rights and freedom of speech. "Act II: Kinship" investigates artists' relationships with their peers, muses, and supporters, with an eye on competition, collaboration, and ultimately love. "Act III: Craft" is about artists' skills and all aspects of making artworks, from conception through execution to market strategies. Needless to say, an artist's "work" is not the isolated object, but the entire way they play their game.

33 Artists in 3 Acts insists on comparing and contrasting artists. Most of the literature on artists focuses on them individually in discrete monographs, or, when several artists are dealt with in one volume, they are segregated into disconnected profiles. Even when group shows throw artists together in interesting ways, the protocol for catalogue essays is to compare the works, not their makers. Indeed, the art world likes nothing better than to isolate a "genius."

Each act of this book revolves around recurring characters who function as foils for one another. Act I casts Ai Weiwei in opposition to Jeff Koons. The two artists are almost the same age; they are both makers of readymades, heavily influenced by Duchamp, adept at commanding media headlines. However, their attitudes to power couldn't be further

apart. Ai is intent on politicizing everything he touches, while Koons is keen to steer clear of politics. When asked about his relationship to his assistants, Ai talks about running his studio like a student seminar in which he empowers his staff to find their creative selves, whereas Koons's management style is more dictatorial. He likes to set up systems that allow his staff to be, in his words, an extension of his "fingertip" (an almighty image that makes me think of God bestowing life on Adam in the Sistine Chapel). Commenting implicitly and sometimes explicitly on these two iconic figures is a broad range of international artists with divergent attitudes to the place of politics in art.

The antagonists of Act III are Damien Hirst, one of the most prolific artists of our time, and Andrea Fraser, a performance artist who has made very few saleable objects in her career. Hirst, best known for his dead sharks in formaldehyde tanks and Sotheby's auction titled "Beautiful Inside My Head Forever," came up spontaneously in many conversations with artists, mostly as a figure against whom they distanced themselves. Some thought he had abandoned the role of the artist to become an unabashed luxury goods producer, which made him an art-world outcast. Fraser has also occupied the position of a pariah. In her most scandalous work, Fraser solicited a collector (through her dealer) to have sexual intercourse with her in front of surveillance cameras in a hotel room. The piece is an extreme moment in a career characterized by highly intellectual, entertaining, and artful performances that interrogate prevailing myths of the artist. Neither Hirst nor Fraser is a craftsperson in the traditional sense, but they are extremely skilled people with antithetical goals and modus operandi. They are the flags in the sand between which the other artists in this act are arranged.

In Act II, the familial theme of kinship gives rise to clusters rather than pairs. It features a married couple, Laurie Simmons (a photographer) and Carroll Dunham (a painter), who have raised children together but maintained separate careers over a forty-year period of career highs and lows with momentary rivalries running alongside enduring mutual support. Their scenes are juxtaposed with those of Maurizio Cattelan, a Duchampian bachelor, and his brothers-in-crime, curators Francesco Bonami and Massimiliano Gioni. This trio are, in turn, put into perspective by encounters with Cindy Sherman, a creative loner, who once described Simmons as her "artist soul mate." The other artists in this act adopt different styles of teamwork. Some operate studios that feel like family businesses. Others share an artistic identity to the extent that they consider themselves "each half an artist."

While reading 33 *Artists in 3 Acts*, it is important to keep in mind that the chief currency of the art world is not dollars, pounds, Swiss francs, or Chinese yuan. It is an elusive and often contested value: credibility. Globalization is a colossal driver of change in the perception of artistic seriousness. "Local artist" has become synonymous with "unambitious artist." It used to be that national recognition was the first step on the ladder toward international appreciation, but the most significant endorsements are almost as likely to come from abroad. Artists have long congregated in cities like New York, Beijing, and Mexico City. Emigration helps them think outside the conventions of their cultural upbringing and assume identities that they might otherwise feel reticent in adopting. But, increasingly, travel fosters a sophisticated, globalized artist, familiar with a broad range of venues and audiences, networked with curators and dealers in cities on several continents.

One of the many paradoxical attitudes of the art world is that an artist's apparent relationship to the market tends to have more impact on their credibility than their actual financial success. The threat of being dismissed as "commercial" is so intense that many artists underrepresent the volume of their output, refrain from talking about money, and steer clear of any suggestion that they might be pandering to demand. (Damien Hirst did not do this and his reputation has suffered greatly as a result.) Although critics are said to have lost their influence on artists' careers, the media (a sprawling combination of mass, niche, and social) arguably have more impact than ever. Indeed, the power of the market results in part from the fact that high prices command headlines. In today's unregulated art market, however, a record price at auction is just as likely to discredit as to validate an artist (especially a young one) in the minds of all but the most gullible of neophyte collectors.

It is intriguing to note that Giorgio Vasari's *Lives of the Artists* (1550), which coined the term "renaissance" and is considered the first art-historical tome ever written, is littered with references to fame. At a time when museums, not to mention solo retrospectives, did not exist, fame was an unqualified marker of artistic success. Vasari didn't distinguish between celebrity and recognition. Today, art-world insiders disdain celebrity as vapid notoriety but revere recognition, which pays tribute to achievement. In our pluralistic times, however, recognition often comes hand in hand with what feels to artists like misrecognition (being described inaccurately, admired in ways that feel strangely insulting, valued by a social group that is not one's desired target audience). Yet the conviction of others starts with the kind of

stalwart self-belief that not only weathers the stormy factions of the art world, but appeals to them too. Although it is often said that artists must accrue a "consensus of belief" to succeed, unanimity is rare and invariably short-lived. Artists are wise to solicit the tenacious conviction of a faction.

Just as my previous book *Seven Days in the Art World* chronicled the years 2004–07, so *33 Artists in 3 Acts* offers a snapshot of the recent past. All three acts open in summer 2009 and flow chronologically toward the time of writing (2013). The status of artists has changed markedly in the last few decades. No longer typified as impoverished struggling outcasts, artists have become models of unrivalled creativity for a wide range of other professionals, such as fashion designers, chefs, and tech entrepreneurs.

33 Artists in 3 Acts aims to give its readers a vivid and textured understanding of a group of professionals who are increasingly positioned by the wider world as ultimate individuals with enviable freedoms. But the art world, like other social and professional spheres, has its conventions and belief systems. So, while brand-name artists are invariably celebrated for their uniqueness, this book explores the parallels between artists often perceived as unparalleled. Some will find this unromantic reality challenging. Others will welcome it as liberating. I would hope that, like many of the artworks described in its pages, *33 Artists in 3 Acts* is at the very least thought-provoking.

Act I: Politics

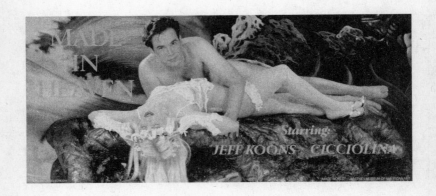

Jeff Koons
Made in Heaven
1989

SCENE 1

Jeff Koons

On a sweltering July evening in 2009, Jeff Koons walks onto the stage of a packed auditorium at the Victoria & Albert Museum in London. The crowd, which is evenly split between art students in ironic T-shirts and retirees in comfortable shoes, gives him a loud round of applause. Clean-shaven with a gentle tan, the artist is wearing a buttoned-up black Gucci suit with a white shirt and dark tie. Twenty years ago, Koons thwarted the expectations of the New York art world by showing up in tailored suits when jeans and leather jackets were the norm. Artists didn't have a uniform but there was one rule: don't look like a businessman.

"It is really an honor to be here," says Koons into a bulbous micro-phone. "Last year, I had an exhibition at Versailles and shows at the Metropolitan Museum in New York, the Neue Nationalgalerie in Berlin, and the Museum of Contemporary Art in Chicago." Artists' talks are often a pitch for recognition; itemizing recent CV highlights is not unusual. "After such a lineup, the Serpentine is the most perfect location. It has been a thrilling experience. I am very grateful," he proclaims like a rock star who has something nice to say about every stop on a concert tour.*

* The Serpentine Gallery is hosting an exhibition of Koons's "Popeye" series but, as the gallery has no auditorium, they are using a lecture hall at the Victoria & Albert Museum.

"I thought I would start by speaking about my history," says Koons as he begins his slideshow. *Dolphin* (2002), a sculpture of what appears to be an inflatable pool toy hanging from yellow chains above a rack of stainless steel pots and pans, appears on the large screen. The sea mammal is a meticulous painted-aluminum replica of the plastic original, but the chains and kitchenware are "readymades"—in other words, store-bought mass-manufactured goods that have been integrated into the work. After mentioning his Pennsylvanian birth in 1955, he gestures toward the rear of the Victorian theater at his mother, Gloria, who attends many of his art events. Moments later, he describes *Dolphin* as a "maternal Venus" whose blow-up valves are like "two little nipples."

Koons has no notes. He tells us that his father, Henry, was an interior decorator who owned a furniture store, so he grew up with "a sense of aesthetics." He understood from a young age that gold and turquoise "made you feel different" than brown and black. His older sister, Karen, was better at everything. One day, Koons made a drawing that his parents thought revealed some talent. "The praise gave me a sense of self," he explains. It's often said that a true artist is good for nothing but making art. Koons's variation on this chestnut is that art was the only domain in which he could compete.

The artist goes on to identify other formative epiphanies. Shortly after arriving at art school, his class went to the Baltimore Museum of Art, where he was unfamiliar with most of the artists on view. "I realized that I knew nothing about art," he says, "but I survived that moment." Koons explains that he likes to make art that requires "no prerequisites." He never wants people to feel small. "I want the viewer to feel that their cultural history is absolutely perfect," he says, smiling blissfully, then invokes "Banality," his seventh series, which he started in 1988. These painted wood and porcelain sculptures of teddy bears, stacked farm animals, the Pink Panther and Michael Jackson took Pop art into the sickly sweet waters of suburban decoration. The kitsch figures were made in editions of three, so they could appear in simultaneous, identical shows in New York, Chicago, and Cologne.

With "Banality," Koons departed from art-world norms in another way. He put himself in advertisements promoting the exhibitions, which

effectively launched his public persona, initiating a subcultural noto-
riety that would eventually turn into widespread fame. Koons devised
four separate ads tailored to the most important art magazines of the
time. For *Artforum*, the most academic of the publications, he depicted
himself as a primary-school teacher with slogans like "Exploit the
masses" and "Banality as savior" on the chalkboard behind him. For
Art in America, he posed as a slightly effete sexual stud, standing next
to two voluptuous bikini-clad girls, while for *ARTnews* he was a tri-
umphant playboy in a bathrobe surrounded by floral wreaths. Finally,
for the European magazine *Flash Art*, he appeared in a self-debasing
closeup with a gargantuan sow and piglet. Koons's foray into advertising
was audacious but not unprecedented. The ads were reminiscent of a
campaign made by General Idea, a gay conceptual art trio, who depicted
themselves as fresh-faced babes in bed together and as black-eyed poo-
dles. Both General Idea and Koons were playing on the expectation that
artists are exemplars of honesty while advertising is a bastion of dodgy
spin. They were questioning the art world's official position that the
work is more important than the artist and flirting with the potential
for blatant self-promotion to kill credibility.

The auditorium is so hot that people are fanning themselves with
newspapers, notebooks, even flip-flops. Koons, who hasn't loosened
his tie and glistens rather than sweats, clicks to another slide, a pic-
ture of himself lying naked with Ilona Staller, a.k.a. La Cicciolina, a
porn actress to whom he was briefly married. Koons made the work
for a show called "Image World: Art and Media Culture" at New York's
Whitney Museum of American Art in 1989. Originally installed as a
billboard on Madison Avenue, the work is an ad for a fictional movie
called *Made in Heaven* starring Jeff Koons and La Cicciolina. It was
the first in a series of the same name, which includes sculptures such
as *Dirty—Jeff on Top* (1991) and paintings like *Ilona's Asshole* (1991).
While artists' mistresses have long appeared as reclining nudes, Koons's
representation of himself on top of his wife was novel. "The easiest way
to become a movie star is to make a porn film," Koons would later tell
me. "It was my idea of how to participate in American popular culture."

As Koons clicks through slides of a number of "Made in Heaven"

works, he doesn't discuss their exhibitionism or speculate about their impact on his career. Instead, he returns to one of his favorite themes—acceptance. "My ex-wife Ilona had a background in pornography but everything about her was absolutely perfect. It was a wonderful platform for transcendence," he says, running his index finger over his lips. "I wanted to try to communicate how important it is to embrace your own sexuality and to remove guilt and shame."

Koons goes on to address the "Popeye" series, on which he has been working since 2002 and whose Serpentine outing is the occasion for this talk. He sees the "Popeye" works as domestic—"something a little more intimate" for the home. They often feature forms that look like blow-up toys. When Koons was a child, his parents gave him a Styrofoam float that enabled him to swim independently. He loved its "liberating effect" and admires inflatables as lifesaving devices that bring "a sense of equilibrium." For Koons, they are also anthropomorphic. "We are inflatables," he says with an evangelical gleam. "We take a breath and it's a symbol of optimism. We exhale and it's a symbol of death." He also suggests an erotic angle on engorgement that makes the audience titter. "There is a huge sexual fetish thing on the Web for pool toys." It is always a bit of a tragedy, he jokes, if they go "soft due to a leak."

For each work in the series, Koons itemizes the things that entertain him. The amusements fall into two main categories: art-historical references to major modern artists and sexual allusions to a variety of private parts and positions. With the modest caveat that he doesn't expect the "viewer to get lost in all my personal references," Koons identifies connections between his works and those of Salvador Dalí, Paul Cézanne, Marcel Duchamp, Francis Picabia, Joan Miró, Alexander Calder, Robert Smithson, Donald Judd, Robert Rauschenberg, Roy Lichtenstein, James Rosenquist, and Andy Warhol. Koons also makes special mention of Jim Nutt and Ed Paschke, with whom he studied at the Art Institute of Chicago. "Ed would take me to tattoo parlors and stripper bars," he says, "exposing me to his source materials."

Running parallel to this chronicle of artistic affiliations is a recital of Freudian interpretations. The artist's favorite adjectives are "feminine" and "masculine," "erect" and "soft," "wet" and "dry." When he makes a

work in two versions, he says it comes in "two positions." The forms of his sculptures and paintings remind him of "vaginal lips," "intercourse," "spread legs," "castration," "a hole," "a womb," and "the pelvic area." Needless to say, a lot of the inflatables are "penetrated." Miraculously, the artist says all this so matter-of-factly and with such a wide-eyed, apple-pie virtuousness that he doesn't seem lewd.

Koons's discourse is so pat that you feel you are in the presence of an actor playing the role of the artist. The artist's lack of spontaneity comes across as synthetic and earnest rather than natural and honest. Andy Warhol was famed for his artifice. He cultivated a vacuous public image, talked in cool sound bites and liked to give the impression that there was no "real" Andy. "I'm sure I'm going to look in the mirror and see nothing," he wrote in *The Philosophy of Andy Warhol*. "People are always calling me a mirror and if a mirror looks into a mirror, what is there to see?" Few artists have mastered the Warholian paradox of persona as convincingly as Koons.

Stabbing his remote control toward the screen, Koons presents his final slides, which include *Sling Hook* (2007–09), an aluminum sculpture of an inflatable dolphin and lobster strung upside down together by a chain—either slaughtered or having some bondage fun. "I always imagine that in that last moment of life, all becomes clear," says Koons in an extremely even-toned, almost soothing voice. "Anxiety is removed and replaced with vision and mission." The artist often invokes performance anxiety. Sometimes he seems to be referring to artistic achievement, other times to sexual function. "Acceptance is what removes anxiety and brings everything into play," says Koons. "My complete understanding of art is about acceptance."

Comfortable with himself
and taboo topics
not afraid of reaction

Ai Weiwei
Dropping a Han Dynasty Urn
1995

SCENE 2

Ai Weiwei

Ai Weiwei refuses to accept the status quo. At the Shanghai Academy of Social Sciences, a few weeks after Koons's talk, Ai demonstrates his contempt for acceptance. Where Koons is polite, Ai is rude. Where the American focuses resolutely on his artwork and steers clear of politics, the Chinese artist consistently diverts attention away from his work toward its ethical context. Born in 1957, Ai is almost the same age as Koons. Although the two artists share a love of Duchamp and a penchant for exploiting mass media, they have disparate responses to power.

Ai is sitting on an elevated platform behind a desk. A pink T-shirt covers his substantial paunch, while a loose-fitting black jacket and blue cotton trousers frame it. His shaggy graying beard gives him the air of a wise man. Beards are not common in China, where they tend to be associated with either Confucius or Fidel Castro.

"Ai Weiwei has made many art works," says Ackbar Abbas, a professor at University of California, Irvine, who is convening this session of a conference titled "Designing China." The audience is about half Chinese. It includes quite a few European academics and a contingent of American graduate students. "Weiwei was a consultant on the Bird's Nest stadium for the Beijing Olympics and has built an artistic compound in Caochangdi, an area near Beijing where he welcomes his friends and sometimes the police," he adds by way of introduction. Ai

takes a few photos of Abbas and the audience assembled before him. "I have no idea what he will talk about today," says the professor. "But we do hope that he will talk about Ai Weiwei."

The artist looks to the man seated by his side, Philip Tinari, a curator who will act as his translator. The Harvard-educated hipster with thick-rimmed glasses has his fingers poised on the keyboard of his MacBook Air, where he will note what the artist says then relay it in English. "Good morning everyone," Ai says in Chinese. "I didn't prepare a speech because when I saw the topic 'Designing China,' I didn't know what it meant. I thought that you could just as easily call it 'Fucking China.'" The audience giggles nervously. Ai is well known for his diatribes against the inhumanity of urban planning in China. When Ai finishes his statement, he leans back and crosses his arms, waiting for his message to be relayed in English. "Every time I come to Shanghai, I remember why I hate it so much," continues the artist who is based in Beijing. The seemingly gratuitous insult hangs in the air. "Shanghai believes itself to be open and international but, in fact, it is still operating with a very feudal mentality."

Ai cites a local human rights violation about which he has written more than seventy blog posts, then mentions his own mistreatment at the hands of the Sichuan police. A week ago, Ai went to Chengdu, the capital of Sichuan province, in an attempt to testify at the trial of activist Tan Zuoren, who was accused of inciting the subversion of state power. At 3 A.M. on the morning of the trial, says Ai, "the cops opened the door to my hotel room. When I asked to see their badges, I was violently attacked." The officers then took the artist into custody and prevented him from giving evidence at the hearing. "We have a totalitarian government that uses monopolistic means to achieve its goals," says Ai. "While China might look bright and shining, it is actually wild and dark."

Ai has a giant welt on the side of his head from the beating, and doesn't yet realize that it has given him a brain hemorrhage that will require surgery. I wonder if the physical discomfort combined with the police brutality has made him more cantankerous than usual. Tinari, who frequently translates for the artist and knows him well, would later explain to me that being in an official Chinese educational institution is

contributing greatly to his foul mood. "The only thing Weiwei dislikes more than officialdom," he says, "is academia."

The artist reads something on his Nokia phone, then raises his head. "If we are talking about designing China," he announces, "I think we need to start with questions of basic fairness, human rights, and freedoms. These are concepts about which China, for all its economic success, still has no basic understanding." Ai stops short, having spoken for a total of ten minutes, and says, "I think it would be best to open it up and take your questions." The artist, who relishes interaction, leans over the desk as if daring the crowd to a showdown. A long, stunned silence follows, then a round of cautious applause.

Ai loves to shock. His best-known self-portrait, which announced his transition from antiques dealer to artist, is titled *Dropping a Han Dynasty Urn* (1995). It consists of three black-and-white photographs in which he holds, releases, and smashes a 2000-year-old antique. For those who value cultural objects, it is impossible not to flinch. While Ai remains blank-faced in the pictures, it would be a mistake to assume, as some have, that the artist disdains the past. On the contrary, Ai has a huge respect for the crafts that were wiped out by the Communist Party during the Cultural Revolution and, in the 1990s, he supported himself by buying and selling antiques. Eventually he established a new category of art that Tinari calls the "ancient readymade." Ai would paint Western trademarks, such as the Coca-Cola logo, on antique vases, and have traditional artisans reassemble old stools and tables into surreal multi-legged sculptures.

The applause dies and Abbas rises to his feet. "Weiwei has put some issues on the table that we have been skirting around. Let's look at these things directly," he advises. A seasoned teacher, Abbas gives the impression that he could run a fruitful seminar in his sleep. "Things here are actually neither lawful nor lawless. Everything is quasi-lawful," he says. Ai drinks some spring water out of a plastic bottle while Tinari explains that the artist is happy to take questions in English. Ai understands English, having lived in New York for twelve years between 1981 and 1993.

Eventually an older American man in the front row asks, "What should Westerners be doing in China?" Ai emits a low growl of a

"hmmm" then says, "I maintain no illusions about Western democracy ... so my advice is: walk around, take some pictures, eat some nice Chinese food, and tell your friends that you had a really great time." Ai loathes pretension and loves joking; he is also a philosophical liberal. In response to the next question, he says, "We have no democracy at the level of voting, no freedom of speech or media. If you ignore these issues, you might as well be farting."

A woman with a faint Germanic accent says, "You have a negative critical attitude, a controversial, shocking fuck-off attitude, but you are an artist. Could you talk about your creative, productive ways?"

Ai winces, then has a quick conversation in Chinese with Tinari. "Criticism and finding trouble is, in the Chinese context, a positive, creative act," declares Tinari for him. "One can risk one's own life in the process." He cites three activists—Chen Guangcheng, Tan Zuoren, and Liu Xiaobo—who have been detained or imprisoned, then adds, "Anyone who thinks that my political interventions are negative or simply 'fuck you' is wrong ... I've done many architectural and museum projects, including one just last month at the Mori Art Museum in Tokyo and one coming up in October at the Haus der Kunst in Munich. I am involved in a massive productive output; it's just not what we are talking about today."

A woman with short hair and glasses follows with an interminable, gushy, jargon-ridden comment that ultimately asks Ai how his "artistic interventions" promote social justice and human rights. The artist has been sitting with his hands in his trouser pockets. He leaves them there. "I am not one to explain my artworks," he says. "If you are interested, you can look at them. Every single work that I make has a basic connection to my most fundamental beliefs and if the work can't express that belief then it's not worth making."

Ai could easily have invoked any number of artworks with democratic or freedom-loving themes in response to her question. In 2007, for example, he created a performance titled *Fairytale* in which 1,001 Chinese people who had never been to Europe went to the small town of Kassel, Germany, during Documenta, an influential art exhibition. One of the dominant definitions of contemporary art is that it makes you look at the world differently. Having spent more than a decade in

the United States, Ai understood that time spent abroad expands the mind. The *Fairytale* performance was accompanied by a compelling installation of 1,001 wooden Qing Dynasty chairs—one for each Chinese traveler. When Documenta was over, the human participants went their own ways and the chairs were dispersed. *Fairytale* was the first work that Ai made with the use of the Internet, recruiting volunteer travelers through his blog. When asked to look back at the stages of his career, Ai says simply that there is the art he made before he discovered the Internet and the work he created afterward.

The audience seems evenly divided between those who find Ai exasperating and those who sit in awe. An Asian American student suggests that contemporary art in China is "an alibi for freedom" and asks Ai to comment on the "dark nature" of the art world. In the past ten years, says the artist, it is more accurate to say that the art market—not art—has prospered in China. "That is what has attracted the Western attention," he affirms. "The art market is like the stock market except that it is smaller, so it can be controlled by an even smaller group of people."

Finally, an Australian who introduces himself as one of the co-organizers of the conference asks the closing question. "I applaud you for your unstinting commitment to principle," he says, then wonders whether Ai is "perversely useful to China?" Over the past year, particularly since Ai has become more belligerently political in his blog, people have been wondering how he can get away with being so outspoken. Theories have abounded. First, people thought he was American. So he posted a copy of his Chinese passport. Then they said that he must have strong family connections that give him the protection of a high-ranking party official. However, the artist claims that if he has a friend at the top, he does not know who it is.

Ai concludes by declaring that, if he were once useful, it appears that he is no longer. A few months ago, Chinese officials closed down his blog. They have since completely erased his existence from the Internet. If you put the three characters that spell the name "Ai Weiwei" into Baidu, the Chinese equivalent of Google, nothing comes up. It's the same for other words, he affirms: "freedom," "human rights," "democracy," and "fuck" are also unsearchable in China.

Jeff Koons
Landscape (Cherry Tree)
2009

Jeff Koons

Most artists in New York City worry less about censorship than reputation management. If you are in the public eye for long enough, laments Jeff Koons, your "inevitable fate" is to be "burned at the stake." Although the analogy between artists and saints, executed for treason or heresy, appears casual, it is one that he makes regularly.

Since 2001, Koons's studio has been located in Chelsea, a few blocks away from Gagosian Gallery, one of the artist's dealers. From the outside, the studio has the air of an art gallery. Its brick exterior is painted white and punctuated by four large grids of frosted glass windows. Inside, one finds a warren of offices for design and administration and workshops for painting and sculpture.

The first stop on a Koons studio visit is a spacious open-plan room full of young people sitting in swivel chairs, staring at large Apple monitors. Gary McCraw, the artist's longtime studio manager, has a station here. A quiet man with long straight hair and a long beard, McCraw manages Koons's growing staff of more than 120 full-time employees. He has the same polite but oddly impervious manner as his master, who he expects will be with us in a minute. While I wait, I catch a glimpse of a new work on one of the screens, a shiny sculpture of a partially naked woman accompanied by a planter of flowers.

Koons appears, wearing an old golf shirt, jeans, and sneakers. "That

Venus—she'll be eight feet high," says the artist, who has noticed the direction of my gaze. "We're putting a lot of care into her. See the way her dress is gathered up in her hands like vagina folds." Wasting no time, Koons ushers me through the office to a painting studio. "I enjoy the sense of community. I don't want to be in a room by myself all day. That's why I created a studio like this," he says, his blue eyes twinkling through wire-rimmed glasses. "I enjoy being able to provide. When I was younger, I was always the guy who paid for the beers."

Koons conducts studio tours for collectors, curators, critics, writers, and TV crews with some frequency, and so he follows a script of sorts. He mentions how he was brought up to be "self-reliant" and tells a story from his childhood about going door to door, selling chocolates and gift wrapping paper. "I enjoyed not knowing who was going to open that door. I never knew what they would look like," he says. "I was always someone who wanted to be engaged. It's the same with being an artist." I've read and seen a lot of interviews with Koons; he rarely gives one without airing this thought about the artist as door-to-door salesman.

We walk into a space that contains six large canvases in different states of completion, hanging on windowless walls. Under the high ceilings and rows of fluorescent lights are many two-tier wooden scaffolds on wheels. It's lunch break, and only one woman persists in painting. She sits cross-legged on the upper deck of a scaffold, listening to her iPod, her nose a few inches from the canvas, a thin paintbrush that leaves no visible strokes in her left hand. Koons composes his paintings on computer, and his assistants execute them through an elaborate system of paint-by-number maps. A single painting is said to take three people sixteen to eighteen months to complete.

The Koons studio is quiet and industrious—nothing like Warhol's "factory," where people acted out wildly on drugs and became stars in his underground films. Koons does not see himself as greatly influenced by Warhol, even though he appreciates that "Andy's work is very much about acceptance." He also admires Warhol's use of repeated images and his large-volume series, which he links to the quaint view that creativity—and fecundity—result from the same life force. "For

a gay man," he says, "Warhol's relationship to reproduction is very interesting."

From the beginning of his career, Koons hasn't just made art; he has made shows. He is adept at creating fully realized bodies of work that are more than the sum of their parts. He is also careful about producing enough work, but never too much. His series are confined to editions of three to five sculptures, a number that renders his work appealingly collectible. One of the most consistently coveted series in Warhol's oeuvre are his 1964 40 × 40-inch portraits of Marilyn Monroe, which come in five distinct colors: red, blue, orange, turquoise, and sage-blue. As it happens, Koons's "Celebration" sculptures, which have commanded his highest auction prices, also come in five "unique" color versions.

Koons doesn't like to talk about his market because he feels that he is misunderstood as "commercial" or motivated by profit. "I don't mind success," he says, "but I'm really interested in desire." When I suggest that commercial motives are attributed almost automatically to artists who command high prices at auction, he replies swiftly, "They don't say it about Lucian Freud or Cy Twombly or Richter." To any question related to money, Koons opts for safe answers. He defines his market, for example, as "a group of people who realize that I am very serious about my work."

The artist's diligent avoidance of market talk is second only to his aversion to discussing politics. In a segment for Japanese television, Roland Hagenberg caught the artist off-guard. "You don't seem to be a man who cares about politics in art?" inquired the documentary filmmaker. "I try to do things that are not harmful to my work," replied Koons. Indeed, overt political content could likely put a damper on his success in stimulating "desire."

While many of the works in progress here spring from older series, three paintings announce the beginning of a new, as yet unnamed body of work. Conceived as a feminine counterpoint to the "high-testosterone" works grouped under the "Hulk Elvis" banner, these paintings are inspired by Gustave Courbet's L'Origine du Monde (1866). Courbet's highly realistic painting of a naked woman, lying on white

sheets with her legs spread, depicted only from her nipples to her upper thighs, is one of the most notorious works of the nineteenth century. On the surface of Koons's new canvases are sketches in silver paint of female labia, which remind me less of Courbet than the plates in Judy Chicago's *Dinner Party* and myriad feminist "central core" images. Under the sexy line drawings are collections of dots in cyan, magenta, yellow, and black. The dot patterns initially appear abstract, but form figurative images when viewed from a distance. Koons pulls me back to the other side of the room, but we are still not far enough away to see the figure, so he brandishes his iPhone and has me look at the works through its camera. A waterfall appears in one painting, a tree in another, a naked couple doing something intimate—I'm not sure what—in a third. Many of his paintings are derivative of his sculptures—sometimes they even look like ads for his three-dimensional pieces—but these *Origine* canvases feel like stand-alone works. I find myself liking them a lot.

"Artistic conquests and sexual conquests. They parallel each other very well," says Koons. The artist has an elaborate personal philosophy that revolves around what he calls "the biological narrative" and includes a lot of pep talk. "The only thing you can do is trust in yourself and follow your interests. That is where you find art," he offers. Sometimes Koons sounds like a life coach or a self-help guru. "My art is not just fun," he says as we walk away from the paintings. "I want my work to help people expand their parameters. Art is a vehicle for connecting to archetypes that help us survive."

Koons takes me through several rooms in which sculptures are respectively mocked up, molded, assembled, and painted. The staff wear white suits, masks, and rubber gloves. With its steel beams and harnesses and all sorts of shiny metal equipment, the studio feels both old-world and high-tech. We end up standing in front of a two-dimensional cardboard model of a sculpture called *Hulk (Friends)*, which depicts a blow-up doll of the green comic-strip character with six small inflatable pool toy animals on his shoulders. The Hulk's facial features somehow resemble the artist's.

For Koons, there is no downside to fame. "You are only over- or underexposed in relation to your ideas. If you can continue to inform

and enlighten..." he trails off. "Any time the platform for your work increases, that's great," he says. Koons divides his working life into "creation" and "platform," or what others might call the production and promotion of their work. "I want to spend time with my ideas so I can make the gesture that I want to make," he says. "At the same time, I want to help my work have a platform so it's not just a gesture alone in the woods."

Back in the mid-eighties, when he was promoting his "Equilibrium" series, best known for its sculptures of basketballs floating in saltwater tanks, Koons said that artists improve their social position through art in the same way that athletes get rich through sports. What is the status of the artist today? I ask.

Koons looks startled, as if my question were a vulgar invasion of his privacy. He turns his head away from me and his body follows. "You asked a question earlier," he says, by way of changing the subject. I let him air some more well-rehearsed patter, then try again but more forcefully. I mention that *The New Yorker* writer Calvin Tomkins once wrote that Koons was either "amazingly naive" or "slyly performative." Tomkins wasn't sure whether he was talking to "the real Jeff Koons or whether there was one." What do you think he means? I probe.

"Who said that?" replies Koons. He goes on to answer a different question. In the early eighties, he learned not to take it personally when people didn't understand his work. "I am ambitious," he adds, going off on another tangent. "I am ambitious for my own potential within this dialogue. I like to feel a connection to Lichtenstein, Picabia, Dalí, Duchamp, Courbet, and Fragonard."

I tell him that I am fascinated by artists' personas. The author of an artwork is part of its meaning, is he not? In the past Koons has admitted that he likes to be anyone people want him to be. Part of me admires the versatility of this saintly door-to-door life coach, while the other part is set on eliciting a confession—or, as Koons might put it, something hard and explicit rather than wet and slippery. I've asked you about your persona twice, I say, and you have evaded the question twice. Come on, I urge with as much sparkle as I can muster.

"My persona?" Koons takes a long pause. "I can't say that I'm not

aware of certain things 'cause I don't want to be naive, but I don't try to create something. I've always tried honestly to make the work and I am always trying to represent the work the way I see it." A kerfuffle in an adjacent room offers a convenient distraction—something heavy is being moved—then the artist's attention returns to me. "I am not naive," he reiterates, and trots out one of his favorite axioms from the late 1980s. "There is a difference between *importance* and *significance*," he says. "Something repeated by the media can be important; we are conscious of it because of repetition. But significance is a higher realm." At first, it's unclear how the distinction relates to my question. Then it occurs to me that maybe Koons thinks his persona is important but not significant.

Ai Weiwei
Sunflower Seeds
2010

SCENE 4

Ai Weiwei

While Koons comes across as canned, Ai feels raw. In China, a country where government propaganda rules the airwaves and independent thinking has been crushed for generations, Ai relishes thinking on his feet and refuses invitations to speak off the record. His belief in freedom of speech means that he is willing to go public with everything that comes out of his mouth as a matter of principle. A performer with an aptitude for improvisation, Ai enjoys taking risks.

London's Turbine Hall is a major test for a living artist. At the heart of Tate Modern, the space is 500 feet long by 75 feet wide and a spectacular five stories high. When the building was a power station, the hall housed the electricity generators that lit up most of central London. Now it is a secular cathedral for commissioned works of contemporary art that aim to enlighten in other ways. Artists need great intelligence and ambition to give meaning to a void this size.

The content of Ai's commission was a closely guarded secret until last night's private view. As I approached the installation, I could hear the crunching footfalls of the half dozen people who had entered the museum ahead of me and who were already treading on the work. I walked out into a rectangular ocean of gray gravel—or was it pebbles? Only when I got to the middle did I reach down to grab a handful of what looked like sunflower seeds. They were so realistic that I had to

touch one to my lips to confirm that it was made of porcelain. Titled *Sunflower Seeds* (2010), the work consists of 100 million exquisitely handmade miniature sculptures. The installation represents the most populous nation—one seed for every thirteen Chinese people—in the material (china) that bears the nation's name.

While the work is worthy of the term "monumental," the artist prefers to refer to it less pretentiously as a "mass production." It took 1,600 people over two and a half years to make. Indeed, Ai saved a pottery-producing village from unemployment, paid his workers above average wages, and made a video about the process. Self-conscious about exploitation, the artist drew attention to the toil, making it an explicit theme in the work.

Ai appears with Danish and American documentary filmmakers in tow; they have been following him for months. We head to the café where he orders English Breakfast tea and the film people take over a neighboring table. The artist seems to be wearing exactly the same baggy black jacket that he wore in Shanghai. After a few effusive remarks about *Sunflower Seeds* and the assertion that I am keen to see him in his Beijing studio, I dive straight into the principal question that drives my research, the one into which I usually coax and cajole my interviewees. What is an artist?

Ai takes a deep breath and then clears his throat. He is a prolific writer and talker. He has posted thousands of blog posts and Twitter messages since 2005. (In Chinese, 140 characters is a novella, he says.) The artist also gives an average of three interviews a day and has probably done at least a dozen Q&A sessions to promote his Turbine Hall show. However, Ai doesn't have a quick answer for this one. "My father was an artist who studied in Paris," he says eventually in English with a heavy Chinese accent. "Then he became a poet in jail." Ai Qing, Weiwei's father, went to Hangzhou art academy, then studied art, literature, and philosophy in France. Upon his return to China, he was imprisoned for three years by Chiang Kai-shek's nationalist government because he openly supported Mao Zedong's Communist revolution. During his incarceration, he didn't have the materials to paint and ended up writing "Da Yan River—My Wet-Nurse," one of his most

famous poems. Then, less than a decade after Mao came into power, he was deemed a "rightist" and sentenced to hard labor. "He was exiled in the same year that I was born," explains Ai. "So I grew up seeing him as an enemy of the state."

Ai's father's "crime" was the loss of his ability to write passionately. "They questioned why he was not embracing the people's revolution," explains the artist. "He wrote poetry about gardens with only one type of flower. He thought that the garden should have variety—all kinds of ideas and expressions—rather than just a single beauty." During the anti-rightist campaign, which was a precursor to the Cultural Revolution, 500,000 intellectuals disappeared. Anyone with an opinion that diverged even slightly from Communist Party policy was punished.

Ai Qing ended up cleaning the public toilets in a village in the remote province of Xinjiang. He gave up writing, and burned his own works as well as his book collection because he feared the Red Guards would come in the middle of the night, find something incriminating, and penalize his family further. "Only in the movies or in the Nazi time could you see things like that. It was very frustrating because this man was not a criminal. But people threw stones at him; the children used sticks to beat him; they poured ink on his head—all kinds of strange things in the name of justice and reeducation," says Ai. "The village people didn't even know what he had done wrong. They just knew he was the enemy."

For a good part of Ai's childhood, the family lived in an earthen pit without electricity or running water. "In political circumstances like those, living underground can provide an incredible feeling of security," Ai once wrote in his blog. "In the winter it was warm, in the summer it was cool. Its walls were linked with America." Ai's father raised the ceilings of this home by burrowing down another foot, and he dug out a shelf that eight-year-old Weiwei considered the apogee of domestic architecture.

Amid these extraordinary circumstances, Ai suffered from malnutrition and ill health. "I understood mortality," explains the artist. "I could feel the wind shake me. I would wake up in the midnight to go to the toilet and see the sky with stars so bright. I felt like I could disappear in

a blink. But, shamelessly, I'm still here, a very fat man, every day eating a lot, talking a lot."

Ai's father was adamant that he did not want his son to be an artist. "He always said forget about literature or art. Be an honest worker." But Ai saw something else in the hardship. "I became an artist because, under such pressure, my father still had somewhere nobody could touch. Even when the whole world was dark, there was something warm in his heart." When his father made a simple pencil drawing or composed a poetic sentence aloud, the young Ai noticed, "He was lifted from reality."

After Mao's death, Ai Qing was rehabilitated and the family returned to Beijing. He became vice chairman of the Chinese Writers Association and eventually one of the nation's literary heroes. Throughout the 1990s, Ai Qing's poetry was on the Chinese junior high school curriculum.

When Ai finishes recounting this story, I return to the question that prompted it. So, is an artist, or at least a significant one, an enemy of the state?

Ai lifts his eyebrows. "The artist is an enemy of . . . ah . . . general sensibilities," he says.

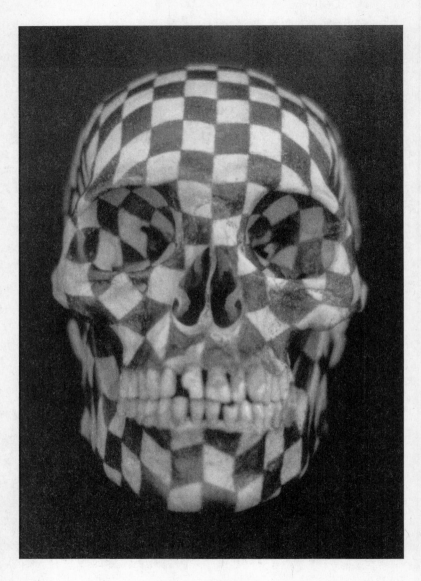

Gabriel Orozco
Black Kites
1997

Gabriel Orozco

A couple of weeks later, in Manhattan, I spy a handful of Ai Weiwei's sunflower seeds cradled in a blue handkerchief on the desk of Gabriel Orozco, one of Mexico's best-known artists. He had been at Tate Modern, to inspect the space of his upcoming retrospective several floors up from Ai's Turbine Hall installation. "I grabbed some to see what they were and decided they were interesting. I didn't know I was not allowed," he says sheepishly. With a beard and dark eyes, Orozco looks like a cross between Karl Marx and Antonio Banderas. I tell him that I too took a handful. I thought that *Sunflower Seeds* might be like one of Félix González-Torres's candy pieces, in which the public is invited to help themselves.

We are on the ground floor of Orozco's Greenwich Village home, a red brick townhouse built in 1845. His desk is stacked with an odd assortment of books. One pile starts with several volumes of Jorge Luis Borges, then rises up through *Marcel Duchamp* by Bernard Marcade to *Snakehead: An Epic Tale of the Chinatown Underworld and the American Dream*. Nearby, a bulging notebook of drawings, photos, and thoughts in three languages—Spanish, French, and English—has the pregnant character of a fetish. Orozco has filled eighteen such notebooks since 1992. At a time when so many artists have gone digital, Orozco prefers analogue tools. "The thinking is in the notebook and

the communication is in the computer," he says with a brawny Hispanic accent. The artist has the puffy look of one who has just woken up, even though it is midafternoon.

In the middle of the desk, next to the sunflower seeds, are the floor plans of the west side of level four of Tate Modern. Scrawled arrows and circles testify to a conversation between artist and curator about the placement of specific works. The artist's solo show started in New York, then went to Basel and Paris, and it will open in London shortly. It will feature "assisted readymades"—in other words, found objects that have been altered by the artist. *Black Kites* (1997), for example, is a human skull that Orozco has covered with a graphite checkerboard grid in order to create an object that fuses the long art history of memento mori with the buzzy visuals of Op art. Another Orozco classic is *Four Bicycles (There is Always One Direction)* (1994), in which four bikes are upended and arranged in an interlocking, acrobatic cluster. (As it happens, Ai Weiwei has made many sculptures using bicycles, although more recently and on a much larger scale, such as *Forever Bicycles* [2012], 1,200 bikes stacked in a spectacular 100-meter-high constellation.) In addition to sculpture, Orozco has made many photographs that find engaging geometric patterns in everyday life and paintings that display winsome abstractions from the imagination. His "Samurai Trees" (2004–06) is a series of egg tempera paintings on oak panels in lustrous shades of gold, red, white, and blue. The artist designed 677 of them on a computer, then delegated the execution of the works to a couple of friends—one in Paris, the other in Mexico City. "I love making things when they require decision-making," explains Orozco. "When it is simply a reproduction process, there is no need for me to do it."

The artist's father, Mario Orozco Rivera, was a muralist in the grand social realist tradition of Diego Rivera, José Clemente Orozco (no relation), and David Alfaro Siqueiros. Gabriel Orozco grew up surrounded by artists and always thought of being one. However, his father didn't care for the idea. "He tried to push me out in a friendly way. For that generation, it was much more difficult to make a living out of art," he explains. Orozco eventually trained in academic painting at the Escuela

Nacional de Artes Plásticas in Mexico City, where he learned, as he puts it, "fresco, tempera, oil, pastel, etching, everything." After a stint helping his father paint murals in order to raise money to buy a car, Orozco decided against the life of a painter—at least initially—and has never embraced the illustrative, message-driven mode of social realism.

Another way in which Orozco differs from his father is that he is not keen on being an "opinionator." Mexico, like France, has a habit of embracing artists as public figures. His father was "an outspoken left-wing artist," whereas Orozco would rather not be a "political professional who opinionates about everything." He has encountered this pigeonhole when traveling to certain countries on the biennial exhibition circuit, where "people expect the artist to be a kind of missionary or doctor that comes to the country armed with good ideas, recipes, solutions, social goodness. You become a kind of *artiste sans frontières*." Orozco leans back, recoiling from the thought. In America, Britain, and other market-driven art worlds, artists are not expected to be politically engaged, and if they are, they are likely to be ignored. "The role of the outspoken activist is occupied by celebrities like Angelina Jolie," says Orozco with a chuckle. "She does the job that in France would be filled by Jacques Derrida or in Mexico by Frida Kahlo."

Orozco's politics are implicit in his art. For example, *Horses Running Endlessly* (1995), a chessboard in which all the pieces are knights, depicts an egalitarian social world where there are no almighty queens or expendable pawns. Although the wooden knights come in four shades of varnish, suggesting teams or tribes, they intermingle on the board as if color doesn't matter. Overall, his chessboard looks less like a battle scene than a dance floor.

Although Orozco declares that "art doesn't have to do with good intentions or morals," he might pass judgment on a fellow artist if he or she takes advantage of others. "There are some ethical aspects in the working that are really important. I'm very sensitive to the idea of cheap labor," he explains. I catch him looking at his anthill of Ai sunflower seeds. "It's not easy," he admits, "for an artist to be in control of all the little problems that the practice generates in terms of politics and exploitation."

I tell Orozco that Ai is also the son of an artist. Orozco counters that his father was jailed a few times in the late sixties and early seventies. "His paintings were censored or kidnapped out of shows. He was never in jail long-term because they couldn't find anything against him. But, basically, yeah, my father was an enemy of the state." Between 1929 and 2000, Mexico was an autocratic state ruled by successive incarnations of the Institutional Revolutionary Party, a rhetorically socialist but generally capitalist organization. Orozco's father was a member of the Communist Party.

The younger Orozco led a nomadic existence for many years, living in Madrid, Berlin, London, Bonn, and San José, the capital of Costa Rica. Even now that he has settled into working in New York (his six-year-old son goes to school here), he spends several months of the year in Mexico and France. On a shelf behind the artist sit a pair of binoculars and a set of bowls that say "bon voyage." "Sometimes I work better on holiday. That's why I take a lot of them," he quips. "New York is noisy. There is too much consciousness."

International travel has been essential to Orozco's experience as an artist. "The outside world is my primary source," he explains. "Mobility becomes part of the work. It's like I need to move out of myself to start." Many Orozco works evoke the joys of free movement. For "Until You Find Another Yellow Schwalbe" (1995), a series of forty color photographs, Orozco drove around East and West Berlin on a moped until he found one just like his, then took a picture of the pair. The resulting images are a witty meditation on reunification and coupledom. By contrast, La DS (1993), which consists of a 1960s' Citroën DS that has been sliced in three lengthwise, suggests the misery of stasis. The middle of the car was removed and the two sides were soldered together, resulting in a gloomy, narrow, engineless vehicle with a central steering wheel for a lone driver. In this work, the streamlined form of the DS, which was once associated with a promising future, becomes a dystopian Frankenstein.

"When I started to do my work, to go out of the studio and out of my country," says Orozco, "one of my aims was to avoid the exoticism of the Mexican artists." Every country has folk traditions, some of which become national clichés. However, Orozco laments the tendency for

people's identities to be "exoticized" or "defined by others, according to prejudiced or preconceived ideas."

Orozco suddenly stands up. "Do you mind if I smoke?" he asks. As we step through some French doors onto a patio that gives way to a well-tended garden, I tell him that when I told a friend this morning that I was going to visit him, she said, "Oh yeah, Gabriel, he's the real thing." Why do people think you are an authentic artist? I ask.

"Well, I think.... um ... very nice question. I do like this question!" says Orozco. A discordant mixture of sounds wafts through the cool, damp air from the music school next door. The artist lights his Camel. "Hmm," he says as he takes a long drag. "I come from a country where a lot of art is labeled surrealist. I grew up with it and I hate that kind of esoteric, dreamlike, evasive, poetic, sexual, easy, cheesy surrealist practice," he declares. "For example, sculpture that blows up some little thing into a big spectacle. I try to avoid this exoticizing of common things." It sounds like you're describing a Koons, I observe. "Exactly, right!" replies Orozco.

I suggest that Koons is not Mr. Authenticity because he works in the Warholian tradition of Pop artifice. Orozco shakes his head. "Warhol was a transvestite. It's not the same as being a fake," he declares with some force. "Warhol was trying to produce cheap work with cheap production systems. Koons is exactly the opposite. It's expensive and very expensive. I would say one is a Pop artist and the other is a capitalist artist."

Orozco's ability to think on his feet is heartening. We move on to a discussion about artists' personas. "Joseph Beuys was the shaman professor," he says. "Richard Serra was the romantic worker, and Jackson Pollock, the pure existential expressive one," he says. "If you generate a genealogy from these models, you can probably find many artists that fit into these types. But I didn't want—and I don't need—to follow these models."

"The real thing?" he says, returning to my original question. "I try—it is not easy and I fail constantly—but I try to be a realist in my work. There is humor, but I'm not flirting with the art world or engaging with the frivolity of the market." Next door, sweeping cinematic strings

emerge victoriously out of the cacophony. "Perhaps I'm real because I am not playing games in terms of manipulation or cynicism," he continues. "Perhaps I'm real because I grow from my work." He pauses, then speaks slowly. "My work is in between the entertainment industry, big market powers, the spectacularization of politics, and everyday life. But it is not a media thing or a rock concert or a political demonstration. It offers, I hope, some moments of intimacy with reality." He laughs, then adds, "Oh man. I hope you like that answer!"

Orozco turns around to go back inside and we walk the perimeter of the room. Despite the fact that he is inclined to call himself a sculptor, Orozco's current preoccupation appears to be painting. Taped to a wall over the fireplace are some red, orange, and pink experiments on paper that evoke boomerangs spinning in the air. Nailed into a wall nearby are many real boomerangs. On two other walls are works on Japanese rice paper that the artist calls "folded drawings that are a little bit like maps." They are covered in hand-drawn shapes, lines, and Spanish words made in acrylic paint, ink, charcoal, and pencil. Orozco knew that he would be very busy with his retrospective tour, so he found a way to make new work on the road, folding the paper so it would fit in his luggage. He fingers through three piles of drawings stacked on a filing cabinet. "This one has been with me for eighteen months," he says with affection. "This one, maybe a year." The concept of folded traveling works reminds me of the "airmail paintings" of Eugenio Dittborn, a Chilean artist. When I mention it, Orozco says, "Ah yes, absolutely!" with genuine surprise.

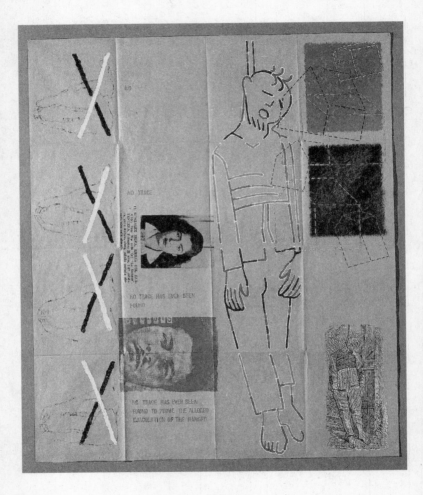

Eugenio Dittborn
To Hang (Airmail Painting No. 05)
1984

Eugenio Dittborn

Eugenio Dittborn has a cult following among South American cognoscenti. After countless hours on two planes, I arrive in the dry, sunny city of Santiago, which sits in a valley beneath the snowcapped Andes. The economy of Chile is on the rise due to a wealth of natural resources and a positive trading relationship with China; the country has seen a concomitant surge of interest in contemporary art.

More than a decade older than Ai Weiwei, Jeff Koons, and Gabriel Orozco, Dittborn is small and wiry with a beaky nose and crow's feet that attest to a good sense of humor. Partial to tweed jackets and corduroys, he looks like a Freudian psychoanalyst. In the 1980s, when the dictator Augusto Pinochet was in power, Dittborn started making collages on long strips of lightweight linen. Each panel was folded up and placed in a specially made envelope emblazoned with the label "AIRMAIL PAINTINGS BY DITTBORN," then posted out of the country to museums for exhibition. The experimental works addressed a range of political and anthropological themes at a time of censorship and cultural conservatism enforced by a police state. "I invented these folded paintings to get out from this place, to be in the world," says the artist unhurriedly, with an amused professorial tone. "They are like messages in a bottle."

Since 1990, through Chile's subsequent democratic governments,

Dittborn has continued to make airmail paintings—over 180 so far—some of which have crisscrossed the hemispheres several times. *La Cuisine et la Guerre* (1994) is a vast work made up of twenty-four panels that display black-on-white images of anonymous faces, open fires, dismembered body parts, and instruments of torture. The panels flew in twenty-four envelopes first to the Reina Sofia in Madrid, then to art institutions in New York, Houston, and Glasgow, and will soon travel to Brazil, where they will enjoy pride of place at the center of the prestigious Mercosul Biennial. "The superstructural meaning is the travel," explains Dittborn. "You can see it in the folds." The work has a double identity; it is a letter when it "sleeps" in its envelope, but it becomes a painting when it is "awake" and pinned on the wall.

In the beginning, Dittborn used regular mail, but now he never strays from private couriers. (He is loyal to FedEx because a rival service lost a panel a few years ago.) When a museum commissions the artist, he makes the painting with the specific destination in mind, then sends it in a number of envelopes. However, institutions occasionally miss the point and return the work after a show in expensive wooden crates.

Santiago has a small art scene in which the vast majority of artists work as teachers. According to Dittborn, there is no artists' community. "It is the contrary of a community," he says in an accent that sounds more French than Spanish. "It's a sort of small and ridiculous battle-field." Consistent in his metaphors, the artist describes his studio as a bunker. Indeed, once in the basement space, you would never know you were in La Reina, a good-looking suburb full of well-kept bungalows and bougainvillea. The L-shaped, windowless room has four cement walls and two gray painted wood ones for pinning up works in progress. Drearily utilitarian, the space is the antithesis of the romantic image of an artist's studio. "When students come here, they are very disappointed," he says with amusement. "I'm a little bit agoraphobic," he adds, as his hands dive into the pockets of his jacket. "I'd like to be in an envelope but I can't fold myself."

Like Warhol, Dittborn works with found images, and like Ai and Koons, he rarely leaves a trace of his own hand, relying on a team of others to do the physical work. One might think that the handwritten

addresses on the envelopes reveal the artist's signature. However, Dittborn employs a man who works at the local gas station—an amateur calligrapher—and asks him to write the destinations in the style of "a nun or a polite, well-educated, Catholic woman," as the artist puts it. What better way for his work to look like an innocent package and evade scrutiny? As it happens, the artist's family history features its fair share of religious persecution. His Huguenot ancestors picked up the name Dittborn while on the run in Germany, and his mother's very Catholic maiden name, which translates as "Holy Cross," was adopted in lieu of a Jewish one during the Spanish Inquisition. "When people escape or exile themselves, they change their identity," says the artist.

At one end of Dittborn's studio is an archive that includes neatly stacked envelopes containing folded works, cylinders holding silkscreens, and gray metal drawers full of fabrics. Everything is carefully numbered and alphabetized. "The order is not compulsive. I'm lost without an assistant," says the artist, who likes to hire people with a "classifying mind" but finds that they are all too often "arty."

Dittborn moves stiffly over to a metal cupboard. He opens it and reveals a row of vintage books, many of which are falling apart. He pulls out picture dictionaries in various languages and secondhand bookstore oddities such as *Manos Arriba*, a true crime compendium depicting murderers and victims. One of the artist's favorite books, from which he has appropriated many images, is Andrew Loomis's *Anyone Can Draw*, a popular how-to book from the 1950s. Dittborn, who is obsessed with rudimentary sketching styles, sees Loomis's very conventional, prescriptive methods as "the last bus stop of Renaissance drawing."

Some of Dittborn's imagery is commissioned rather than appropriated. The artist asked the director of a Chilean psychiatric hospital to invite patients to make drawings of faces and received about 500 in return—all done by one schizophrenic who signed them "Allan 26A." On another occasion, the artist commissioned heroin addicts at a rehab center in Rotterdam to draw their childhood homes as well as the home of their dreams. Dittborn even got his daughter, Margarita, to participate, drawing faces in exchange for pesos when she was seven years old. (She is now an adult and an artist in her own right.)

Dittborn never makes self-portraits. With hands that shake slightly, he pulls out a drawer full of swatches of fabric upon which different drawn and photographed faces have been silkscreened. "You have to be *somebody* to make your self-portrait," he declares disdainfully. However, the artist has created a strong but faceless entity called "Dittborn," about which he writes in the third person. "Dittborn is not me," he explains. "It is a market affair like Buick, Cadillac, Ford . . . Bacon or Picasso. It's a brand in an ironic way, a joke that everybody knows the famous Dittborn." The artist stops and troubles over his English. "Famous or infamous," he wonders aloud. "Is the same thing?" I explain the difference. I'm intrigued by an abstract persona represented by an eight-letter word. Dittborn nods. He relishes what he calls "the self-absence of the artist."

The artist nevertheless admits the influence of his biography. Although he delegates almost every aspect of the physical making of his work—the silkscreening, sewing, folding, envelope-making, and writing—he personally applies the liquid tincture that gives the works their color and their emotional tone. In recent years, Dittborn's airmail paintings have become more multichromatic. The artist had several long bouts of working in black and white, which he attributes to unresolved mourning. He lost many friends during the dictatorship, in particular his psychoanalyst, whose disappearance influenced his work. "I didn't understand it at the time," he explains, "but unconsciously I was trying to find that body."

Death and disappearance are key themes in Dittborn's work. Over the years, the artist has made some twenty-eight paintings in a series titled "The History of the Human Face." Reminiscent of Warhol's "Most Wanted Men" paintings, the works catalogue the faces of assorted social types (such as "criminals," "natives," "madmen") in diverse styles, including medieval woodcuts, police sketches, and childish drawings. "Disappearing is a problem much larger than Pinochet," explains Dittborn as he points to an aboriginal face silkscreened on a scrap of white cotton. "Political disappearance is present throughout Chilean history. The tribes of Tierra del Fuego were almost completely wiped

out. And what about North American natives? And people in psychiatric hospitals. Many of them are 'the disappeared.'"

Dittborn puts the fabric pieces back in the drawer and pushes them out of view. "I don't want to be seen as a hero who resisted oppression, because it was much more complex than that," he says. The seventeen-year Pinochet dictatorship was brutal, but the regime was shorter-lived and less thorough than the Communist "dictatorships of the people." While the Chinese and the Soviets systematically erased generation upon generation of independent thinkers, many of the South American dictatorships overlooked enclaves of artists and writers. "Pinochet took control of theater and music but largely ignored the visual arts because it didn't have a large enough audience," explains Dittborn as he locks the cupboard doors that hide his books. "The most interesting artwork was incomprehensible to the army anyway."

Ai Weiwei
June 1994
1994

SCENE 7

Lu Qing

Ai Weiwei has disappeared. On April 3, 2011, the artist was at Beijing airport en route to Taipei for a meeting. At border control, Chinese officials stopped him and took him away. That was seven weeks ago and he hasn't been heard from since. No one knows where he is.

As I arrive in Beijing, I wonder: in which terminal did his arrest take place? Terminal three, which was designed by the British architect Norman Foster and built for the 2008 Olympics, has a soaring glass dome. It appears to be a national monument to openness and transparency—and to architecture's gift for fiction.

Ai's home/studio is located in the "international art village" of Caochangdi, near the fifth ring road on the outskirts of Beijing, not far from the airport. Until recently, the area was mostly grassland and it still feels a bit like the country. A warm, dry wind whistles through the sapling-lined streets under an overcast sky. Ai's first architectural work was his own studio, which was built out of brick in six months in 1999. People admired its low-cost modernism so much that they commissioned him to design their houses, studios, and art galleries. In an interview with curator Hans Ulrich Obrist, Ai said that building with bricks was "like using words to write something." The village, which is dotted with Ai's buildings, is inflected with the artist's voice.

My cab pulls up alongside a plaque on a brick wall that says "FAKE,"

the name of Ai's design company, which when pronounced in Chinese comes out as something close to "fuck." The double entendre captures Ai's desire to mess with authenticity and authority.

A young Chinese American woman opens a door cut into the turquoise metal gate. She looks both ways down the street, glances up at one of the three surveillance cameras focused on Ai's door, then lets me in along with Emma Cheung, a friend of a friend who will translate for me today. The courtyard is spacious, with a bamboo grove, carved stone antiquities, and some large green and blue ceramic vases.

On the left side of the courtyard is Ai's elegant brick box of a home. On the right side is the office, which I peek into as we walk past. The room is empty of life except for a calico cat sleeping on a chair. Within a few hours of abducting Ai, the police raided the whole compound. They confiscated all the computers and hard drives, accounting books, and financial files related to Fake. In the following week, four members of Ai's retinue went missing: Wen Tao (an ex-journalist involved with Ai's online presence), Hu Mingfen (Fake's accountant), Liu Zhengang (a Fake director), and Zhang Jinsong (a.k.a. "Little Fatty," a relative of Ai's who acts as his driver). The families of these men have no idea where they are, what they have done wrong, or when they will see them again.

Now, a dozen new computers sit on three rows of tables. Lining the right side of the room, like wallpaper, is a list of 5,196 young people killed in the 2008 Sichuan earthquake. Ai's Internet campaign to compile a list of the students who were killed in the disaster, due to the shoddy "tofu" construction of school buildings, appears to be the issue that has most embarrassed the Chinese government. On the back wall is a large photo of the façade of the Haus der Kunst in Munich when it was covered by an Ai installation that commemorated the Sichuan tragedy. Titled *Remembering* (2009), the work featured hundreds of colored school bags that spelled out in Chinese characters a quote from the mother of one of the deceased: "She had been living happily in this world for seven years."

Lu Qing, Ai's wife, meets us at the door of their home in a dress that looks like it was painted with watercolors. I recognize her face from an Ai photograph in which she lifts her dress, revealing white bikini underwear, in front of the Tiananmen Gate. Titled *June 1994*, the work

shows its disrespect for the Chinese government on the fifth anniversary of the Tiananmen protests.

As we are introduced, she warns us that the house is probably bugged. "The police went through the building thoroughly," she says. "They may have planted microphones as small as sesame seeds." The main room is a double-height dining hall-cum-conference room with exposed brick walls and a cement floor that feels a bit like a Soho loft. We sit at a long wooden table surrounded by nineteenth-century chairs made in the Ming Dynasty style, much like the 1,001 chairs that were featured in *Fairytale*. Sitting in the sun on the ledge of a tall window are four large mangoes covered in black marker. Three of them bear Chinese characters; the fourth says "Free Ai Weiwei."

Dignified and elegant in the face of palpable distress, Lu sits at the head of the table with her back to the window. A fluffy, rather dirty white cat struts the length of the table and, when it arrives at our end, rolls into a languorous stretch with its feet in the air. After offering us green tea, she affirms that Ai's detention is illegal even by Chinese standards. The law here dictates that a prisoner's family should be informed within forty days of their whereabouts and the reasons for their incarceration, but neither she nor Ai's mother has been contacted. Lu hates to speculate about why he has been detained. "He's an outspoken artist who has done work about sensitive issues . . . the earthquake is the most sensitive," she admits with both palms up, right hand resting gently in the left.

Lu is an artist herself, but her practice has been subsumed within the larger swirl of her husband's activities. She is the official director of Fake, as the company was set up before Ai had his *hukouben*, or license to live within the city limits of Beijing, a prerequisite to incorporating there. I tell her that I have never met a successful artist who didn't have intelligent support. We discuss a range of Ai's artworks. Lu's current favorites are *Sunflower Seeds* and *Fairytale*. She likes them because they are "very Ai Weiwei," by which I assume she means that they have both emotional intimacy and a sublime sense of the mass. Moreover, they are artworks that reveal an ambition that could move mountains.

The irrepressible dirty white cat head-butts my hand, demanding a

stroke, then lies down on my notebook. "Weiwei is a good example of what a pure artist is," says Lu. "He is very honest. He uses art and media to express himself." Lu believes that the Chinese public's understanding of artists is limited. Indeed, in a country where government propaganda has reigned supreme for so long, very little value is put on the truth and many people have no scruples about bending it. Most young Chinese don't believe Party propaganda and obtain their news from Weibo, the Chinese version of Twitter. However, few are staunch advocates of freedom of speech. In fact, Ai's belief in human rights, not to mention his truth-seeking confrontational style, are perceived as un-Chinese. He is semiregularly accused of watching too many Hollywood movies.

As it happens, Ai's education was effectively foreign. As the artist explained to me in London seven months ago, his French-educated father was his principal tutor. "When I was growing up, my father was forbidden to write but I still can hear the way he used language when he spoke." Also, Ai lived in Manhattan for twelve years. "Before the airplane landed, we circled above New York City for about half hour," he told me. "It was nine o'clock in the evening. The skyline was a miracle to see. The brightness of the city was beyond the imagination. At that moment, everything you know disappears."

In New York, Ai did all sorts of odd jobs—cleaning, gardening, babysitting, house painting—while he absorbed the New York art scene. He read and loved *The Philosophy of Andy Warhol (From A to B and back again)* and became a fan of Marcel Duchamp. "Duchamp saved me," declared Ai. "Through him, I understood that art is a mental activity, an attitude, a lifestyle. He gave me an excuse not to do too much. It was symbolic. I could do something else and still think I'm an artist." Ai remembers admiring Koons's "basketballs in the fish tanks" (his "Equilibrium" series, which was first shown in 1985), but he hasn't followed his work very closely since then. "It's pleasant," Ai said. "It has some contemporary sensibilities. The market itself has become part of the work."

Through the window behind Lu Qing, among the bamboo, I see a marble arm coming out of the ground. It looks like it is giving me the finger. Some people have speculated about the timing of Ai's incarceration. "He couldn't have timed it better, career-wise," one Beijinger told

me. "It's strange that Weiwei's son is exactly the same age as Weiwei was when his father was sentenced," said another. "Ai's legend is empowered by his imprisonment," admitted Philip Tinari (his translator at the Shanghai conference). These comments float through my head as I try to formulate a question that won't add to Lu's distress. If Ai sees *all* of his activities—from making art to blogging and agitating—as art, then can one see Ai's imprisonment as an artistic act?

Lu puts the fist of one hand in the palm of the other, then lowers them both into her lap. She purses her mouth, and bites her lip. I offer that, sometimes, a single incident can bear witness to two opposite tendencies. Ai's incarceration seems both arbitrary and destined to be. "It is hard for me to make any judgment," she says finally, raising her palms gently. "It is not that it is inconvenient for me to say. It is genuinely difficult for me to tell."

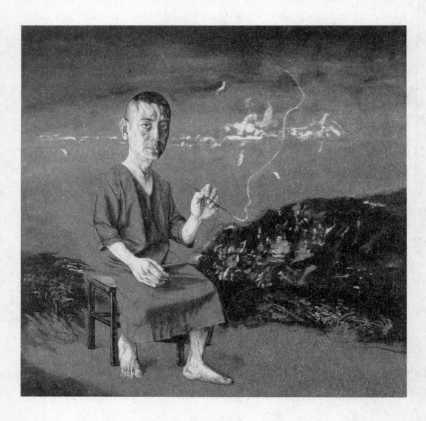

Zeng Fanzhi
Self-Portrait
2009

Zeng Fanzhi

Zeng Fanzhi's studio is only a minute away from Ai Weiwei's, but their artistic lives couldn't be further apart. Zeng confines his endeavors to painting and avoids overt references to politics in his work. Like Koons, he is represented by New York power dealer Larry Gagosian and is one of the world's most expensive living artists.

A few days after my visit with Lu Qing, I am in a cab with Belinda Chen, a PR woman from Christie's, who will translate for me. François Pinault, the owner of Christie's, is about to host an exhibition of Zeng's work in Hong Kong. The Chinese art market has been booming but, despite foreign speculation, it is yet to be well integrated into the global art world, partly because many Chinese artists act as their own dealers. Having recently created alliances with both Gagosian and Pinault, Zeng evidently understands the strategic importance of dealer endorsement when it comes to having a vibrant international career.

Our taxi pulls in behind three glossy black Mercedes parked in the small lot that Zeng's studio shares with his mainland dealer, ShanghART. It's rare to see such an explicit juxtaposition of supply and demand—even Koons's studio is a judicious few blocks away from the Gagosian flagship. A lushly landscaped path leads to a metal gate, which opens onto a courtyard featuring stone lions, bonsai trees, a koi pond. A

turquoise and yellow macaw chained to a metal perch greets or spurns us with a homely squawk.

Once inside, we are ushered past a standing gold Buddha, then through some theatrical curtains into a huge room filled with the Romantic boom of a Mendelssohn symphony. The sound comes from two freestanding chrome speakers, high-tech towers that look like they could communicate with life on another planet. Six skylights puncture the 20-foot-high ceiling. At the near end of the room, leather couches and chairs are arranged on a red Persian carpet around an oversized glass coffee table stacked with books. I'm offered a seat but resist, keen to investigate the scene before me.

Zeng's studio is like a stage set full of objects that display his artistic accomplishments and erudite taste. Intricately carved Chinese antiquities, still lives by Giorgio Morandi, and a painting of a young girl on a couch by the eccentric European modernist Balthus help to frame the mise-en-scène, as does the pairing of a black-and-white photo of Pablo Picasso with a small color pencil drawing that Zeng made of himself when he was seventeen.

These objects endorse the room's main visual argument, which is made by a careful selection of Zeng's paintings and proclaims his high standing as a painter. The lineup kicks off with a 1990 self-portrait as a somber thinker in the style of Max Beckmann, a German expressionist whose work was labeled degenerate when the Nazis came to power. Next to it is an astonishing self-portrait from 2009, in which Zeng portrays himself as a monk with a smoking paintbrush. Then comes a range of landscapes in different sizes, but with the same epic composition: richly layered abstractions with dynamic black diagonal strokes in the extreme foreground and a smoldering fire of red and yellow patches in the middle distance. After this constellation of works come portraits of Uli Sigg (a Swiss collector with an impeccable collection of Chinese art), Lorenz Heibling (the dealer-owner of ShangART), and the artist Francis Bacon. The British painter is depicted in a blue suit with a vertical blur around his head that implies he is plummeting downward like one of his own screaming popes.

On a mezzanine, lording over this all-male pantheon, is a portrait of none other than Karl Marx, in which he peers through a tangle of prickly shrubs with an amorphous white cross glowing behind him. The presence of Mao's ideological inspiration is puzzling. At first, I think that, maybe, Marx remains in the studio because he is not a hot seller, but then I realize that the author of *The Communist Manifesto* must be deliberately on display. Yesterday, Liu Xiaodong, another eminent Beijing painter, told me, "The conceptual artist is a leader. He is like an entrepreneur whose main work is managing his company, whereas a painter is a peasant. He is an artist-craftsman who does it himself." The pre-proletarian peasant is a common analogy for painters here. It signals both a belief in humble, honest work and an anxiety about rising conspicuously above the rest. Artists like Zeng, who was twelve when the Cultural Revolution ended, remember how such individuals were punished. In this context, Marx, a lapsed Jew who declared religion the "opium of the people," may safeguard the artist's studio like a patron saint.

As we take our seats, Zeng lights a seven-inch Cohiba cigar with a lighter in the shape of a handgun. Cohibas were once made under tight security for Castro and other Cuban government officials so that they could enjoy a premium product without fear of assassination.* Nowadays, successful Chinese artists enjoy smoking Cohibas and drinking French red wine. In the back room, Zeng has two climate-controlled fridges stocked with Bordeaux and other imports. "Artists are among the first Chinese to have become rich, so they are models of how to behave like a properly cultured elite," Johnson Chang, a Hong Kong curator and dealer, once remarked to me.

Zeng has a round face with short-cropped graying hair. In embroidered jeans, a dress shirt, and a leather waistcoat, the artist looks like an urban cowboy. When asked about his high prices, Zeng displays his public relations skills. "It is just the beginning. I believe they will

* In the 1960s, an exploding cigar was considered a viable way to remove a Communist from office.

increase further," he says, one hand demarcating levels in the air. "But a good artist shouldn't be overly influenced by the market. He needs an independent creative mentality."

Zeng emphasizes his painting skills over his conceptual acumen. He has a staff of about ten, split between the studio and the office. "None of my assistants are allowed to paint for me, not even a stroke," he says. "My studio is not a boring workshop. I enjoy the creative lifestyle." Given the bohemian tang of his studio, I surmise that he means that, when the Bordeaux starts flowing, it can get a little wild in here.

Expert craftsmanship—not to mention evidence of time-consuming labor—remains a driving force in Chinese art. However, Zeng is careful to position himself as an artist. "Craftsmen don't put their emotions into what they make," he says with a wave in the direction of the photo of Picasso. "Picasso's 'periods' reflect his feelings at different points in his lifetime. Picasso isn't my favorite painter but I admire his changes of style. Bacon . . . I never get tired of Bacon."

One of the strengths of Zeng's oeuvre is that, unlike a lot of Chinese painters, he hasn't become stuck in a single, monotonous, signature style. "I summarize myself into four periods," he says, explaining that these correspond to the production of his "Hospital" paintings (1989–93), "Masks" (1994–2004), "Portraits" (1999–present), and "Landscapes" (2002–present). His mask paintings are his most celebrated and coveted. In these brightly colored works, the masks either hide the characters' emotions or represent truthful feelings that social etiquette and political circumstances prevent them from revealing.

Zeng tells me that he chose to be an artist in order to escape mundane routines imposed by others. His mother was in charge of entertainment at the worker's union; his father he describes as simply a worker. "When you graduate from university, you are usually assigned a job," he explains. "I chose to be an independent artist because I wanted the freedom to paint what I liked without restrictions."

The spontaneous reference to artistic freedom is intriguing, given the Chinese government's policing of so many aspects of culture. What about self-censorship, I ask. "I paint out of enjoyment," he replies. "It

may not be beautiful for the common people." Something has been lost—I suspect intentionally—in translation. I decide to test Zeng, asking him about a taboo subject, the government-ordered massacre of several hundred young pro-democracy campaigners in Tiananmen Square on June 4, 1989. One of his staff immediately interjects with a quick, vehement lecture to him in Chinese. Even so, he is willing to speak to me about it, and does so—but only off the record.

In the past few days, I have spoken to ten or so Chinese artists, all of whom invoked their superlative personal freedoms, which they see as completely different from political liberties. Attitudes toward Ai Weiwei are varied but lean toward the negative. One artist who has known him since they both lived in New York says that he is a "bully with little tolerance for differences of opinion and an egotist with a dictatorial style that mirrors the methods of the Communist Party." Another deplores him as a "politician in the art world and an artist in a political context." By contrast, Zeng is much more circumspect. About Ai Weiwei, he says, "No matter what he did . . . it is not right to put him in jail. It will be very sad if he is not released soon."

Throughout our conversation, my eyes are repeatedly drawn to the extravagant self-portrait in which Zeng wears the vivid red robe of a Buddhist monk with bare feet and extra-large hands. Unlike the earlier self-portrait, in which the artist's eyes are downcast, here he looks directly at the viewer with bluish, rather than brown, eyes. His face is slimmer and paler than in real life. In one hand, he holds a thin paintbrush from which a long wisp of enchanted smoke curves upward into a dark gray sky. This carefully painted character brings verve to a vague, bleak, lifeless landscape. I point at the painting. Your definition of an artist? I half ask, half state. Zeng looks at the canvas for a few seconds. "Yes, an artist is a solitary philosopher," he replies. Although the artist is depicted alone, his stare acknowledges an attentive crowd. And even though his face looks terrifically serious, his charismatic brush is keen to entertain. To my eyes, the portrait suggests the artist has magical powers.

Wangechi Mutu
Me.I
2012

SCENE 9

Wangechi Mutu

In Wangechi Mutu's mother tongue, Kikuyu, there is no word for "artist." The closest term is something like "magician" or "a person who uses objects and imbues them with meaning and power," says the Kenyan-born artist. Mutu has synthetic blue and black braided hair extensions that are rolled into two buns on either side of her head, making her look like an African Princess Leia. The artist, who is almost forty, moved to America when she was twenty years old and has lived here ever since. She still speaks with a light British colonial lilt. Although the Kenyan capital, Nairobi, is a huge, cosmopolitan city—full of "talented folks" who aren't just making "tourist paintings of giraffes," as Mutu puts it—most artists with well-developed careers lead much of their lives outside Kenya. "A *contemporary* artist," she explains, "is engaged with foreign culture."

Mutu and I are in a brownstone in the Bedford-Stuyvesant area of Brooklyn. For some, Bed-Stuy is a black ghetto where white people rarely tread. For Mutu, it's an immigrant neighborhood with a lot of cultural diversity, tension and energy. Unlike the hubs of the Brooklyn artist community (such as Williamsburg or Bushwick), Bed-Stuy appears impervious to young, single, white hipsters. However, the area is increasingly home to professional couples and artists do live nearby, mostly quietly with kids. Mutu makes a good living as she is represented

by high-end dealers such as Barbara Gladstone in New York and Victoria Miro in London. Yet she enjoys the alternative pace here. "When you leave Manhattan," she says, "things calm down and you can think."

Mutu's studio is on the parlor floor of her home. It has exposed red-brick walls, hardwood floors, and nineteenth-century moldings painted white. It is packed with well-organized clusters of magazine clippings, rolls of paper bundled in baskets, and stacks of colored duct tape. Mutu tells me that her assistants did a major cleanup yesterday in anticipation of my arrival, in part to prevent the environment from making me dizzy. In the center of the room is the artist's "operating table," where she pieces together her complex collages. An insomniac with a two-year-old daughter, Mutu relishes the comforts of home. "It isn't the most studio-esque kind of space, but it has great light and it suits my weird habits," she says. "I can walk in here at 4 A.M." (The artist has another studio in an old navy yard where she makes larger-scale works, sculptures, videos, and installations. It has a concrete floor and a freight elevator and is anything but domestic.)

Three sizable works in progress adorn the walls here. They are all collages depicting fantastical women that look like crossbred aliens or futuristic witch doctors covered in body paint. "I am mostly, if not always, obsessed with images of women," says Mutu. "As an African not living in my motherland, I'm also very sensitive to depictions of African people." Two of the collages are in their early stages, and the artist refers to them affectionately as "infants." One of these includes the silhouette of a naked female rock climber. "These strong women are in precarious positions, trying to get themselves up to a higher place," she muses.

The third work, which is closer to completion, features a two-headed figure. The larger head looks out confidently at the viewer with one blue eye and one brown. A little man sits cross-legged under her perfect red lips and a snake coils like an elastic around her tree trunk of a ponytail. The other head could be a cyborg, with sparkly metallic jewelry in lieu of an eye patch. She tilts downward as if in submission, with antennae-like floral protrusions sprouting from the top of her head. Mutu has just decided to call the piece *Me.I.* even though she does not see it as a self-portrait.

Mutu's women are mysterious, *jolie-laide* creatures that address the politics of beauty. "I like exoticism," says the artist. "Anything that is different from the beholder's perception of the norm is exotic. For me, blonde, blue-eyed Aryans are exotic. They are rare where I come from and rare to see on the street where I live now." Her characters are such hybrids that they may be universally exotic. In other words, they are likely to be perceived as foreign by viewers from all over the world.

To say that her collages are multimedia is an understatement. These works in progress feature linoleum, fabric, animal pelts, feathers, sparkles, pearls, powders, paint, and more. "Materials have their own souls—their own chemical properties, gravities, and past lives," she explains as she fingers a scrap of rabbit fur. "I really want them to speak within the work, not in a goofy, ghostlike way but in a practical, sensuous one." The artist also has a broad range of media sources. She cuts out images from *National Geographic*, porn magazines like *Black Tail*, and fashion publications with good-quality paper such as *W*, *V*, and *i-D*. She also draws images from the Internet, "where everything comes from . . . the Eden of all our information."

Immersion in the process of making is essential to Mutu's art. "I am a hands-on intimate worker," she says. "I am too obsessed with the emotions that my work exudes to outsource it." The artist has a studio manager and three assistants whom she describes as "like-minded, empathetic, and rigorous." The assistants work part-time and have their own artistic practices. Mutu does all the cutting, but they help with the gluing, moving, archiving, and administration. Dangling from a silver chain around Mutu's neck is a tiny pair of scissors in the shape of a stork. "I'm a scissor maniac," she says. "I cut everything." In addition to her ardor for slicing and trimming, Mutu loves collage because it is so egalitarian. "Kids make collage, housewives make collage, even if it's just birthday cards," she explains. "It is a democratic art."

Aware of the hierarchies of the art world, Mutu made the strategic decision to do her MFA at Yale. "It was a kind of elite, art-world boot camp," she explains. "It was difficult but necessary in order to segue from making art on the side to making art as a full-time thing." Although Mutu mostly works on flat surfaces, she chose to be in the

sculpture department because she felt painting suffered from more rigid orthodoxies. "Painting is sometimes taught almost like a religion in which you don't question things," she explains. People would tell her that painting was dead. She would ask, "Who killed painting? Why wasn't I allowed to paint before the medium was pronounced dead?" All in all, Mutu didn't feel painting classes were relevant to her experience as "a foreigner with a very different sense of art history."

Still, Mutu appears to be haunted by painting. Among the many images taped to the studio's walls is an old computer printout of a Jean-Michel Basquiat. Painted in his self-consciously primitive style, it depicts a man with a crown of thorns and a schematic set of sausage-and-two-potatoes genitals. His arms are outstretched as if he were crucified. Basquiat was a Brooklyn-born African American who started out as a graffiti artist, then became a neo-expressionist painter. He died of a heroin overdose at the age of twenty-eight in 1988. Celebrated in his day, he is now the only black artist whose work sells for multimillions at auction. "Basquiat just came in and shattered so many barriers," says Mutu. "When I discovered his work, I remember thinking, ah, that's the way to paint, that's the way to attack these pristine problems." Mutu reaches out, trying to straighten the curled corner of the printout. "Tortured messiah boy," she says tenderly. Mutu is grateful that she went to Catholic school even though her family was Protestant because, as she puts it, "Catholicism was great for the visual part of my life."

Mutu likes to be open to other artists' work. She loves Ai Weiwei's *Sunflower Seeds* and even possesses one. "I call them his sperm because I see them everywhere!" she jokes. "He's a sensationalist but I believe in a lot of what he's fighting for." She is less sympathetic to what she calls Koons's "celebrity mania" but she likes some of his work such as *Puppy* (1992), a public sculpture made out of living flowers and other greenery. Mutu suspects that she and Koons come from "completely different ethical families." She is not taken with the idea of art for art's sake. "I've always felt that there are things that could be improved or that are unjust, skewed, covered up," she says. "Successful art can be made by people who don't worry about their responsibility to humanity, but that isn't an option for me."

Mutu's work is not driven by messages or pedagogy but, unlike many in the art world, she does not sneer at didacticism. "Different art plays different roles," she says. "Political art that is precisely geared toward sending an overt, urgent message can be great art." She cites the work of several artists including Martha Rosler, with whom she feels an affinity because they are both "image vandalizers." A collagist, photographer, and video-maker, Rosler is a feminist and antiwar activist whose artworks both campaign and endure.

Before saying goodbye, I urge Mutu to return to the problem of defining her role. "Contemporary artists have the job of being different from the rest," she says with a symmetrical swoosh of both hands, as if she were conducting an orchestra. They are supposed to be "autonomous pioneers" prized for their "individualistic-ness." However, Mutu prefers a less isolated model with a stronger sense of community. "For me, artists are individuals that speak for the group," she declares. "We divulge the secrets about what's going on in the family even if we're not supposed to. We're like a tattletale . . . or an alarm-raiser." Sometimes the secrets are revealed furtively. Other times, intelligence is disguised as innocuous gossip. Whatever the case, persuasion is the goal. "Art allows you to imbue the truth with a sort of magic," says Mutu, "so it can infiltrate the psyches of more people, including those who don't believe the same things as you."

Kutluğ Ataman

JARSE (detail)

2011

SCENE 10

Kutluğ Ataman

With a population of over sixteen million, Istanbul is the biggest city in both Europe and the Middle East. Since it ceased to be the capital of the Holy Roman Empire, the metropolis has been perceived less as a center than a crossroads between East and West, Muslim and Christian, old and new. The Istanbul Biennial, which has been held every second September since 1987, has taken advantage of this hybrid cultural identity, establishing itself as one of the world's most important contemporary art events.

This year, the biennial is taking place in two huge warehouses on the banks of the Bosphorus, the waterway that divides Europe from Asia. Set away from the life of the city, the warehouses are swarming with art-world professionals, including many of the 130 artists from forty-one countries whose work is on view. Some artists arrived well before the official preview to help install their works; they stroll into the 11 A.M. opening, freshly showered, knowing where to go. Others have just landed and show up with carry-on luggage, disoriented.

Art biennials are often incoherent, amounting to something rather less than the sum of their parts. But the curators of this one—Adriano Pedrosa, a Brazilian, and Jens Hoffmann, a Costa Rican—have adopted an unexpectedly effective premise. Rather than using a theory or theme as a unifying rubric, the biennial has a muse: the late artist

Félix González-Torres. Born in Cuba and educated in Puerto Rico and America, González-Torres made conceptual artworks that were politically sophisticated and emotionally engaging. He died of AIDS-related illnesses in 1996.

The biennial is divided into five sections, each inspired by key themes in different González-Torres works. I have arranged to meet Kutluğ Ataman, a Turkish artist, who is in a section of the exhibition that explores gay love and identity named "Untitled (Ross)," after a González-Torres installation of 175 pounds of candies in multicolored shiny wrappers that commemorates Ross Laycock, the artist's longtime lover, who died five years before he did.

Ataman stands in the middle of a large room that contains the work of some twenty different artists. He looks a bit like a pirate, with two platinum loops in his left earlobe. I introduce myself and usher him over to one of his own works, a piece called *Jarse* (2011), which means "lingerie" in Turkish. Ataman is known principally for his videos, but here he displays a copy of his letter of rejection from the military. In it, a psychiatrist affirms that he played with dolls as a child and has been known to wear women's clothes. "The Turkish army is an extremely dangerous place for a gay person," says Ataman, who is now fifty. Mortality is high. "They just say: 'died in action,' 'there was a little accident,' or 'it was suicide,'" he explains. In Turkey, many men try to avoid military service by claiming to be gay, so recruiters are suspicious. "Until recently, they might require evidence of anal sex," he continues. "Even gay men who don't enjoy it would get screwed for the camera. If you were a 'top,' they didn't think that you were gay. You had to prove that you were a 'bottom.'" Although the work is an unaltered document (except for a black line that redacts the artist's national ID number to prevent identity theft), it is part of an ongoing series called "Fiction." For Ataman, everyone's personal history is a creatively edited story. "It is not about a political or tragic situation," he explains. "It is about a character."

Ataman has only recently focused on himself in his work. He is best known for his videos of others. *kutluğ ataman's semiha b unplugged*

(1997) features Semiha Berksoy, a Turkish opera star, speaking and singing about her life from what she claims was her virgin birth to her equally incredible eighty-eighth year. *Women Who Wear Wigs* (1999) consists of monologues by a cancer survivor, a transsexual, a devout Muslim, and a political activist keen to disguise her identity. *Twelve* (2004) presents the stories of six people who believe they were reincarnated, while *Küba* (2005), which won the prestigious Carnegie Prize, is made up of interviews with forty people who live in a Kurdish ghetto of Istanbul. "My subjects are all artists," explains Ataman as he pushes a lock of hair behind his ear. "They are sculpting themselves in front of the camera and creating fictions out of their own lives."

Artists, maybe, but their artistry is a little different from yours, I say. What kind of artist are you? Ataman laughs at the question. "I'm not an interior decorator. I do not make beautiful objects for beautiful people," he declares. "Art is not a job for an artist, just as religion is not a job for a priest." He runs his fingers through his hair again. "Sometimes I see myself as almost like an academic. My artworks are not really products; they are papers that you write when you have finalized a strain of thought."

For Ataman, his credibility as an artist is rooted in his self-assurance. "I never question it in myself but I always question it in others!" he says. "I know what I am doing and know it is genuine. I don't exhibit the work until I am convinced." In this vast room, near his military rejection piece, is another work in his "Fiction" series, a queen-size mattress that is nearly ripped in two titled *Forever* (2011). Ataman stares at the work, puts his hand on his neck, and says, "Unlike those in other professions, artists cut the branch they are sitting on."

Before he became an artist, Ataman studied film at UCLA and both wrote and directed. For him the transition from film festivals to art biennials was fairly smooth. "In today's parlance, an experimental film is an artwork," he says. "The difference relates to market forces. Film investors want a return." Before the arrival of VHS tapes, DVDs, and digitally downloadable films, arthouse and repertory cinemas were packed with people. Nowadays, galleries and museums show filmic

wares, often in multiscreen formats. The benefit of the new environment is that Ataman can, as he puts it, "make works that are impossible to watch." *Küba*, for example, is made up of thirty-two hours of footage displayed on forty screens. The artist doesn't know anyone other than himself who has seen the whole thing.

Ataman's studio, production company, and website are all called "The Institute for the Readjustment of Clocks." Borrowed from a definitive Turkish novel by Ahmet Hamdi Tanpınar about a man who suffers from an inability to adapt to modern times, the name makes light of the fact that contemporary artists seek to be "ahead of their time" and are more often than not in favor of change. Although the avant-garde is dead, vestiges of its mission live on. Conservative artists don't tend to be contemporary. "Art that goes forward can take a long time to be understood, whereas art that moves sideways—that is just elaborating— can be very commercial," explains Ataman. "As an artist, you have to decide which way you want to go."

Nowadays artists also have to conquer territory, crossing borders to accrue international support. Ataman has spent much of his life as an expat, having lived in Los Angeles, Buenos Aires, and London for years and Barcelona, Paris, and Islamabad for months at a time. But most of his artworks have Turkish characters and settings. "I want to translate local points of view into a universal language," says Ataman. "With all due respect to Greenwich Mean Time, Istanbul is degree zero for me." Indeed, Ataman loathes diaspora artists who pander to a foreign audience by making easy "predigested" criticisms of their own culture. He cites a famous Iranian artist who is very popular in America because her work confirms Western prejudices about Iran. "My work functions within my own society," he says. "It is distinguished by that."

Ataman does not see himself as altruistic or even responsible. For example, the artist was at the forefront of creating artworks that looked like documentaries. When he showed *semiha b unplugged* at the Istanbul Biennial in 1997, it was the only work of its kind. Three biennials later, he found that his personal stylistic niche, as he saw it, had been invaded by others. "Everyone was doing documentary-style work . . . but

badly," explains Ataman. So he decided that he would "do something so big that no one would dare imitate it." This is how he came to make *Küba*. "It wasn't because I wanted to give voice to some poor people. That was just a happy outcome," he admits. "I was being a competitive bitch. I was defending my own ground."

Although Ataman describes his politics as "rational, democratic, liberal," the press has variously accused him of being a pro-Kurdish terrorist, a gay propagandist, anti-Turkish, pro-Armenian, and even, remarkably, an Islamic ideologue. Most of these epithets come from the secular press. "I have never got into any trouble with the Islamists," says Ataman. "I am not a good Muslim. But I'm not a nationalist either, so I don't believe in the repression of religion in society—as long as they don't advocate hate."

Ataman stops to air-kiss an old friend, a Turk who lives abroad but who has flown in for the biennial. Out of the corner of my eye, I see Martha Rosler, a senior feminist artist whom I have been trying to interview for some time. Biennial gatherings are important networking opportunities for artists. As artists age, they can become cut off from the wider artist community, increasingly absorbed in their own work. Ataman, however, is a collector as well as an artist, so he keeps track of others. He owns about fifty pieces, including works by González-Torres, Mona Hatoum, and Gabriel Orozco. Although he doesn't own pieces by Jeff Koons or Ai Weiwei, he is quick to pass judgment: Koons's forms are seductive; Ai's are derivative.

Ataman comes from an aristocratic Turkish family who have accepted his homosexuality. "I think it's more of a problem for them that I am an artist," says Ataman. "They would have liked me to get a job in government or to have become a diplomat." Ataman, however, may be fulfilling his parents' aspirations in unexpected ways. Art has become an increasingly significant branch of foreign affairs. For countries without major film, TV, or music exports, a dinner for a visiting artist at an ambassador's residence can be a great opportunity to promote local culture and/or entertain the artist's rich patrons, who may very well be power brokers in the host nation.

Most of Ataman's work can be seen as diplomatic in the sense that it creates a dialogue between social groups that rarely communicate. He resists overt polemics, but one confrontational Ataman work is a sixteen-minute video, *Turkish Delight* (2007). Dressed in a gold sequined bikini with tassels and a long black curly wig, the artist performs an inept belly dance, doing hip bumps, arm waves, butt jiggles, and stomach rolls to the sound of a *darbuka* drum. Ataman gained forty pounds in order to emulate the voluptuousness of a traditional belly dancer, but he didn't shave his stubbly beard or any of his body hair. Even if he weren't staggering around in gold high-heeled sandals and chewing gum, the result would not be pretty. Belly dancing has come to symbolize the exoticism of Turkey itself and some critics see *Turkish Delight* as Ataman's critique of orientalism—the condescending, objectifying way that Westerners have often viewed Eastern cultures. However, the video is also a portrait of the artist as a weary performer forced into representing something he's not. When Ataman was growing up, he claims that he was unaware of homophobia. He never felt his gay identity was a problem until, as he puts it, "I became *the* artist of Turkey abroad."

Many artists dislike the burden of "identity politics." Ataman loathes it when his work is filed under "queer" or "ethnic." The notion of the self in these debates can be flat, inadvertently essentialist and narrowly self-interested. "Identity politics was compelling when it emerged, but it didn't evolve," says Ataman. "If that is the only approach to my work, then it is an incomplete story. I'm not interested in 'identity' as much as how people construct their characters or personas." The artist looks troubled; he's concerned that the term "persona," which he associates with Ingmar Bergman, sounds pretentious. "Persona" may be derived from the Latin word for mask, I explain, but, in the Anglo-American art world, it is often linked to pop culture or more specifically to artists who are skilled at public relations and self-caricature. Whatever the case, Ataman thinks that the art that emerges from identity politics generally suffers from being glib. "All art is political," he declares. "But 'political art' is often facile. Art is not supposed to repeat what you already know. It is supposed to ask questions."

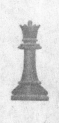

Tammy Rae Carland
I'm Dying Up Here (Strawberry Shortcake)
2010

Tammy Rae Carland

In the Istanbul Biennial, on the wall where Kutluğ Ataman's military rejection hangs, are six large color photographs by Tammy Rae Carland. They depict overhead views of recently vacated double beds. The subtle colors of disheveled sheets and pillows create abstract patterns, so that one photo calls to mind the Abstract Expressionist paintings of Mark Rothko while another summons the Minimalist work of Agnes Martin. As a whole, the series evokes a postwar history of painting. Carland's images of beds also pay homage to a 1991 work by Félix González-Torres, which portrays the cold white sheets and pillows of an empty bed after the death of his boyfriend, Ross. As part of a public art project sponsored by the Museum of Modern Art, González-Torres's image was installed on billboards in twenty-four locations around New York City in May–June 1992. "It was the first work I saw by Félix," says Carland, who has flown in for the biennial from her home on the border between Berkeley and Oakland in Northern California. "I wasn't even sure it was art." Carland's series, titled "Lesbian Beds" (2002), feels both more intimate and more formal than González-Torres's casual, documentary-style shot. For Carland, photography resembles theater as much as painting. "Beds are stages for identity," she says. "They are spaces of 'performativity' that contribute to your sense of self."

While it would have been conspicuous to exclude Ataman, one of

Turkey's best-known living artists, from a biennial with gay love as a theme, the curators have included the work of many less familiar suspects. Carland didn't obtain sustained gallery representation until five years ago, when she was forty-two, and she still doesn't make a living from sales of her art. Like most artists around the world, she has a day job outside her studio. As a professor and chair of photography at the California College of the Arts, however, she is in the fortunate position of being paid to talk about art.

For the Istanbul opening, Carland has abandoned her workaday cardigan and clogs for a batik blouse and high wedges. An assortment of tattoos, including circular texts that say "homesick" and "unbroken," decorate her arms. Carland is impressed with the biennial on a number of levels: it includes a huge number of women, its definition of politics is admirably broad, and it's the first time a major international art biennial has privileged gay and lesbian issues. She also likes the González-Torres premise. "I met Félix the year before he died, when I was enrolled in the Whitney Independent Study Program," explains the artist, as she adjusts the lone clip that tames her frizzy, long hair. "He spent two hours talking to me in my studio. To this day, it's one of best conversations I've ever had about my art." Carland suggests that González-Torres has become a legend not only because his work is really good, but also because "he had the personality to back it up. People were strongly attracted to him as a thinker."

One theme that pervades the art of both Carland and González-Torres is love. "When I was a student, love was not considered appropriate content," explains Carland. "Art was supposed to be anti-beautiful, anti-sentimental, anti-nostalgic. Félix was radical in using all the tropes that were off limits." Carland has taught a graduate seminar on love as it relates to art-making, which explores the psychological dynamics between models, muses, and artist couples. She knows that love is "more elusive, more complicated, much trickier to discuss than sex." I mention that I attended a lecture by Jeff Koons in which he systematically analyzed a body of work with reference to sexual organs and sexual activities. I float the idea that perhaps there is something in the platitude that girls seek love whereas boys want sex. Carland moves her

head a fraction of an inch to one side, then the other. "I'd rather not support that dichotomy," she says.

Although the current art world has all but dismissed the muse as an embarrassing romantic cliché, Carland has had several "creative relationships" that were "energizing." She recommends that we find another term, however. "'Muse' implies that one person is the maker while the other is the subject matter or the inspiration," she declares. Along with her current and previous girlfriends, she cites as a muse the musician Kathleen Hanna, with whom she became friends while studying photography at Evergreen State College in Olympia, Washington. With a third friend, they set up an independent gallery called Reko Muse (a.k.a. "wreck-o-muse"). Every few months, the local band Nirvana, led by Kurt Cobain, would do a gig to help raise the rent money for their space. When Hanna went on to become the lead singer in the preeminent Riot Grrrl band Bikini Kill, Carland provided the artwork for the album covers. The two women were mutual muses or "a sisterhood," as the artist puts it, whose support for each other's "practice" was empowering. In the lyrics to the 1993 Bikini Kill song "For Tammy Rae," the young Hanna expresses how, together, they could cast off critics and gain the self-assurance necessary to be creative:

> We can't hear a word they say
> Let's pretend we own the world today
> I know it's cold outside
> But when we're together I got nothing to hide

Surrogate sisters may be particularly important to Carland, given her family background. While Turkish, Arab, and Persian artists are more likely to come from the secular upper classes, many artists in the West—although still a minority—emerge from the working class. Carland's circumstances were particularly impoverished. She grew up in rural Maine, the daughter of a single mother who worked as a waitress and had five children from three different men. Tammy Rae was the first person in her family to graduate from high school. "I grew up in the kind of welfare-class neighborhood that art students visited to do

their 'street photography' assignments," she says. During a seminar at the local art school, she was embarrassed to see a slide of her mother sullenly sitting at a bus stop on a cold winter day.

Unsurprisingly, Carland was not drawn to the documentary tradition. "I've never been a capturer of the 'decisive moment,'" she says, referring to a phrase associated with Henri Cartier-Bresson, the founding father of photo-reportage. "You can *take* photographs or you can *make* photographs," she says. "I like to stage, to set up, to interrupt reality. I'm a maker." Still, Carland sometimes deploys documentary aesthetic conventions. In "On Becoming: Billy and Katie 1964" (1998), Carland poses as her parents or "becomes" them in black-and-white photographs that mimic the candid, ethnographic style of Depression-era photographers like Dorothea Lange and August Sander. In one picture, *On Becoming Mom #2*, Carland wears curlers and holds a laundry basket in front of a clothesline in an unkempt backyard. She pauses for the camera but can't seem to muster a smile, fulfilling the mission of the genre to depict a hard woman in the midst of a grim life. Although Carland creates fictions, she tends to derive them from careful study of her immediate social world.

Self-portraits often betray or even analyze the expectations that surround artists. Some artists hide in plain sight, much like stand-up comedians. In a color photograph titled *I'm Dying Up Here (Strawberry Shortcake)* (2010), Carland sits on a stool under a harsh spotlight in the middle of a stage with a pink towel over her head. The scene evokes many of the ancillary expectations that befall artists—the pressure to speak, to be seen, to perform, to convince, to entertain. Much like an anxiety dream and more degrading than being naked, the image enacts a kind of ritual humiliation. The pink shroud depicts a kid's cartoon character whose juvenile femininity is at odds with the seriousness of the stark stage; it questions Carland's authority, cuts into her coolness, and acts as a damp rag to her credibility. But it also transforms her head and torso into one big phallic shape and, by these absurd means, somehow thrusts the artist back into the game.

As a teacher, Carland meets many people who aspire to be artists and keeps an eye on the ones who stay the course. She believes that artists

have varying degrees of "repetition compulsion or a drive to repeat a singular impulse over and over again, trying to get it right, or righter." She distinguishes this from some "unstoppable urge to create," because being an artist is mostly about hard work. "It's rooted in discipline more than desire," she says.

For Carland, the worst thing about teaching is having to stop doing her own work when she is "on a roll" and then "get back up to speed" when she resumes. Sometimes the process feels almost "assignment-driven," as she puts it, "given the limited time frames." However, Carland thinks it's healthy to stay engaged with other people's "art practices." "It pulls me away from myself," she explains as she leans back on one of the cement pillars that line the exhibition space.

Carland speaks of her "practice" more often than her work, so I inquire about this instance of art-school jargon. Although the term has a defensive ring, she likes its twofold connotations. On the one hand, "it's like a rehearsal," she says, plunging her hands into the pockets of her white jeans. "You practice until you get it right. It's about what we do rather than a perfect endgame or linear achievement." On the other hand, the term echoes other professional worlds insofar as "doctors practice medicine and lawyers have law practices." If the first nuance "minimizes" the artist's job, the second "legitimizes" it. Either way, Carland advises her students to view their careers as a checkerboard rather than a ladder. "Being an artist is one of the most misunderstood roles," she says. "It is so different from a mainstream career."

Carland's girlfriend, Terry Berlier, an artist who teaches at Stanford, arrives at the biennial. It's late lunchtime. As the day progresses, the warehouses fill with artists, curators, dealers, critics, and collectors from all over the world. On the other side of the room, I see Ingar Dragset, the Norwegian half of the artistic duo Elmgreen & Dragset, standing in front of "Spring Break" (1997), a suite of photographs by Collier Schorr depicting two amorous androgynous girls in white bras. Seeing Schorr's work reminds me of something she said to me a few years ago. When I asked for her thoughts about artists with larger-than-life personas, she suggested that "they usually have larger-than-life bank accounts!"

I put the same question to Carland. "Larger-than-life?" she repeats as she thinks. "Kurt Cobain and I were part of the same punk music community in Olympia. He was the guy next door," says Carland, who followed the success of Nirvana and the suicide of its leader with uneasy interest. "Being famous can really fuck with your identity," she offers. "Everyone feels that they own you."

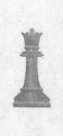

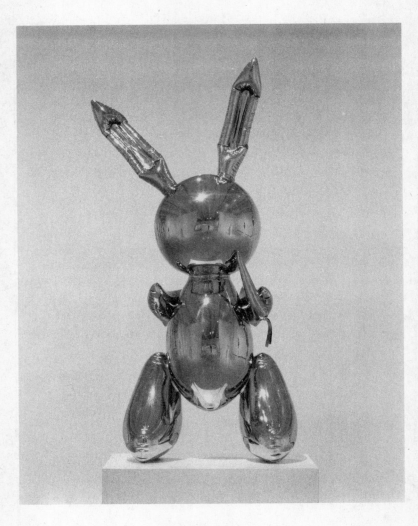

Jeff Koons
Rabbit
1986

SCENE 12

Jeff Koons

In the United Arab Emirates, women wear black *abayas* while men don white, flowing *dishdashas*. This fact darts through my head as I walk on stage in white trousers and a black jacket to chair a panel discussion. Larry Gagosian and Jeff Koons, my interviewees, follow me up the steps. Koons wears yet another impeccable suit with a bright white shirt and dark silk tie. Over the past few years, I've bumped into him in Moscow and Kiev and observed his aptitude for making friends in emerging markets. As he takes his seat, he beams at the multinational audience that has gathered for the Abu Dhabi Art Fair, which takes place on Saadiyat Island near the vast construction sites of the new Louvre and Guggenheim museums. The local Guggenheim's acquisition policy has not been announced, but one insider tells me that it will include "nudes but no Mapplethorpes," referring to the late gay photographer. Gagosian almost never participates in public talks. The dealer is no doubt subjecting himself to this interview in order to ensure that the Guggenheim Abu Dhabi embraces his wares. That said, he doesn't look dressed for business as much as for lunch in Monaco. The middleman slumps in his chair in a beige check jacket, no tie. Some might assume that he was the artist.

The patron of the art fair is His Highness General Sheikh Mohammed bin Zayed Al Nahyan, crown prince of Abu Dhabi and deputy

supreme commander of the United Arab Emirates armed forces. Art and arms might seem like an unusual combination of responsibilities until one remembers the ambassadorial potential of art, which can be used as a bridge to the West and a hedge against religious fundamentalism. Squeezed between Saudi Arabia and Iran, the UAE is often seen as an oasis of *relative* liberalism. Unfortunately, Sheikh Mohammed and his brother Khalifa, President of the UAE and emir of Abu Dhabi, sent Emirati troops into Bahrain to help crush their "Arab Spring" demonstrations earlier this year. The move has not done wonders for the atmosphere at the fair.

On my way into the auditorium, I bumped into two Iranian artists, Ramin Haerizadeh and his brother Rokni, who fled their homeland in spring 2009 and now share a studio in Al Quoz, an industrial area on the outskirts of Dubai a couple of hours' drive from here. The Iranian secret police started looking for Ramin when they discovered partially naked self-portraits from his "Men of Allah" series in a Saatchi Gallery exhibition catalogue. After the intervention of a sympathetic sheikh in Abu Dhabi's Department of Higher Education, the Haerizadehs were granted three-year visas for the UAE. In Iran, the brothers tell me, the general perception of contemporary artists is that they are insane, or atheists, or "insane atheists." Among Islamic fundamentalist regimes, it is considered better to repeat the wisdom of the past than to display originality. As the Haerizadehs explain it, "Creation is for God."

The Koons–Gagosian session is not about the perception of artists in the Middle East. Indeed, I am charged with the task of interviewing the two men about their working relationship. They met in 1981 at a Soho gallery that no longer exists. A decade later, Gagosian "wangled an invitation" to Koons's studio whereupon he bought *Poodle* (1991), one of the few works in the artist's "Made in Heaven" series that is not pornographic.

Do you still own it? I ask.

"I wish," says Gagosian.

The dealer has overseen many lucrative Koons deals. A favorite transaction involved Koons's iconic 1986 *Rabbit*, a small-scale, stainless steel sculpture that was the precursor to his "Celebration" series. Back in the

1980s, Terry Winters, an American artist, bought *Rabbit* for the "modest sum" of $40,000. In the late 1990s, Gagosian sold it to S. I. Newhouse, the owner of Condé Nast, for $1 million, a "startling" price at the time. For Gagosian, it is a "bittersweet story." If he had had "a million dollars sloshing around," he would have kept it.

Koons declares that he has always admired Gagosian's gallery—particularly a memorable show of Warhol's "Most Wanted Men"—and appreciated the dealer's support of his secondary market. It wasn't until 2001, twenty years after their initial encounter, that Koons first gave the dealer work straight out of the studio, a selection of paintings from his "Easyfun Ethereal" series, which were exhibited in Gagosian's Beverly Hills space. What Koons remembers best about this show is a massive truck pulling up to his studio with an image of King Tutankhamun in gold and red on the side. He felt "honored" that Gagosian would ship his work across the country in a climate-controlled vehicle fit for an ancient Egyptian king.

The conversation moves on and Koons reveals that the first time he acquired "anything substantial" for his personal collection, a sculpture by Pop artist Roy Lichtenstein titled *Surrealistic Head #2* (1988), Gagosian was involved. When I ask the artist whether he has bought much from Larry over the years, Gagosian interjects, "Not enough!" Koons chortles and then explains that he mostly collects early-twentieth-century modernists and old masters. When I was in his studio in New York, Koons went on a long digression about his collection, which includes paintings by Gustave Courbet, Edouard Manet, Pablo Picasso, René Magritte and Salvador Dalí. The works that are "most dear" to him are hung salon style, one above the other, in his bedroom. "The rest of my home is boring compared to the bedroom," he told me. "I always feel empowered by an acquisition. It's energy. It's meaning...I don't think about the cost. If you really like a work, you should be prepared to pay even more than it's worth. Things that are really great add value to society." He reiterates some of these thoughts on stage. His language is not as stilted as usual and he is palpably relaxed. Koons appears to feel more at ease speaking as a collector than as an artist.

We show a slide of a work from Koons's new "Antiquity" series, which

will premiere in Frankfurt in seven months' time, then I open up the session to questions from the audience. A Dubai-based Indian woman kicks off what will be a key theme. "Skilled people help with your work. How can you claim to be the exclusive creator of it?" she asks. This issue is a bee in the bonnet of many art-world outsiders, who imagine that "real artists" work alone in their studios. Curious to see how he will respond to this common thought, I turn to Koons.

"I started drawing at three years of age," he says methodically, as if he were speaking to a child. "I started private lessons at seven. When your mind tells your fingers to hold the brush in a certain way, they are just performing the gesture you want to make. It is the same with people. The first time I worked with others was when I was casting at a foundry. I create systems for the people that work with me so I can be responsible for every mark. Everything is performing just like a fingertip, so I am responsible for it all."

It is important not to confuse art with craft, I add. Contemporary artists' identities have shifted. There has been a kind of industrial revolution in art. Artists have become ideas people liberated from manual labor; they can delegate without compromising their authorship.

"It's a question that I get asked a lot as Jeff's dealer," interjects Gagosian. "I don't know any artist who works as hard as Jeff Koons. He is there, every day, hands on. The notion that this is somehow a bogus way of making art is poppycock. You cannot control anything more than Jeff does—from the idea to the computer through the assistants to the fabricator. It is an incredibly focused, demanding process. The backstory that he doesn't 'do it' is just malarkey."

I point out that the romantic notion of the lone artist making art by his own hand obscures the longer history of artists' ateliers crowded with assistants, which goes back to the Renaissance with artists such as Michelangelo and reaches a height in the Baroque period with artists like Peter Paul Rubens.

Even though the lady who voiced the query appears unconvinced, we move on to a series of questions about Koons's *Hanging Heart (Magenta/Gold)* (1994–2006), which sold at Sotheby's in November 2007 for $23.6 million, then the highest price ever paid for a work by a living artist.

The consignor, Adam Lindemann, had bought the work for $1.65 million only a couple of years before flipping it at auction. Several members of the audience appear irate. They think it is immoral to resell a work so quickly for seven times the purchase price. However, both artist and dealer resolutely defend Lindemann's right to sell. "If you are going to have a market, you need liquidity," explains Koons. "You can't take liquidity away." The artist's proficiency with financial jargon reminds me that, for a moment in the 1980s, he worked as a commodities broker. It is also a sign of the times. Nowadays rich artists have portfolios to manage, and those who fraternize with collectors spend time talking shop about markets of all kinds.

Eventually, I announce that we will take one last question. A woman says to Koons, "You have achieved art superstardom. I want to know: is it lonely at the top?" I redirect the question to both artist and dealer. Of course, Koons does not answer her directly. "I always just wanted to participate," he says. "I just wanted to be part of the dialogue." He relays a favorite anecdote about meeting Salvador Dalí when he was seventeen. "I wanted to be part of a continuation of the avant-garde," he says. "In New York, if you want to participate, the ball is thrown to you," he adds implausibly, before turning to face his dealer. "I started by selling posters on the sidewalk," says Gagosian, "and I have never been lonely."

Ai Weiwei
Study of Perspective—The White House
1995

SCENE 13

Ai Weiwei

"If you have never felt lonely, you should become an activist," says Ai Weiwei. "Loneliness is a valuable feeling. Artists need to know how to walk alone." Ai is ensconced in the same Ming Dynasty-style chair at the head of the long wooden table where his wife, Lu Qing, sat when I was here last year. The room is tidier than last time, suggesting that the captain is back and he runs a tight ship. Still, their memorably assertive, sooty-white cat struts the length of the table. Ai pulls his iPhone out of the breast pocket of his thick cotton shirt and takes a couple of photos of my thirteen-year-old daughter, Cora, and me. Ai uploads dozens, sometimes hundreds, of photos every day. Cora, in turn, takes a few shots of the artist and one of the cat, which she will no doubt post on Instagram.

Ai is recovering from his eighty-one-day imprisonment. This morning, he gave himself a buzz cut but left an oblong outcrop of hair on the left side. The powerhouse of a man whom I met in London eighteen months ago is a little out of sorts. According to the terms of his release, he is forbidden to talk about his detention. When he was first set free, he refrained from speaking to the press, but he has slowly become more vocal as he recovers from the ordeal that he tells me was "the highest form of torture . . . two-thirds brainwashing, one-third harassment." The artist is in the process of writing a day-by-day account of

his incarceration, which he thinks could one day become a tragicomic opera or play.

At the airport on the fateful day that he was arrested, Ai was stopped by undercover police who told him that his departure was "a danger to the state." They covered his head with a black hood, put him in a vehicle, then drove for about two hours. When his hood was removed, Ai found himself in a room in a "very standard countryside hotel" with a rug, wallpaper, and covered windows. The artist spent two weeks there before being moved to a less homey location—a high-security military compound. In both places, he was accompanied at all times by two guards, who watched him even as he slept, showered, and shat.

During his detention, he endured some fifty interrogations in which he was handcuffed to a chair. The highly repetitive process often began with the question: what is your occupation? If he replied that he was an artist, his interrogator would pound his fist on the table and yell, "Artist? Anyone can call himself an artist!"

Initially, Ai replied, "Most of us call ourselves artists."

But his interrogator wouldn't have it, declaring, "I think you are at most an art worker!"

"Okay, I can call myself an art worker," replied Ai, who knew this was one battle too farcical to fight.

Ai's captors were keen to eliminate ambiguity from the artist's output. The artwork that most obsessed them was *Study of Perspective—Tiananmen*, a photograph from a 1995 series in which the artist raises his middle finger in front of different landmarks around the world. Again and again, they demanded to know "what does it mean?" says Ai. "So I would talk about the Renaissance, Leonardo da Vinci, and classic examinations of perspective." When his interrogators countered that "everybody in the world" knows that this finger is an insult, Ai would reply that the Italians, among others, use a different gesture. When they asked him about the connotations of Tiananmen, the artist would say, "Feudalism." Indeed, the gate at the north end of the square was not built by the Communists but by a Qing Dynasty emperor. Several times they told Ai that, during the Cultural Revolution, he could have been killed for this photograph alone.

Another artwork that captured the imagination of Ai's inquisitors was *Zodiac Heads/Circle of Animals* (2010), which explores the dynamics between originals and fakes. Ai's piece is a recreation of twelve bronze animal heads originally designed by European Jesuit missionaries for the emperor's summer palace in the 1700s. The palace was looted by French and British troops during the Second Opium War in 1860 and the zodiac heads removed. When two of the originals (the rat and the rabbit) were put up for auction at Christie's Yves Saint Laurent sale in February 2009, it aroused the ire of Chinese nationalists. Ai thought the outcry was misplaced because the heads are not actually Chinese and, in his opinion, have "no artistic value." The controversy inspired him to make his own version in an edition of six.

On what Ai describes as his "most absurd day" of imprisonment, the animal heads were the topic of conversation. First, the police insinuated fraud. "The zodiac you made is not originally designed by you," they said. Then they proposed a conspiracy theory in which they implied that Ai had been recruited by the CIA when he lived in New York and that his art was merely a front through which foreign operatives could pay him for his "anti-China" activities. "They named people, offices, and foreign governmental agencies that I have never heard of," explains Ai. "And they said, Weiwei, we have very solid information on that, so you have to think about it and give us a better answer next time."

Though Ai has not been formally charged with anything, his design company, Fake, has been fined $2.4 million for tax evasion. The Chinese government is well known for obfuscating political matters with other types of accusation. Since his release, Ai has repeatedly asked for a public trial, knowing that he is unlikely to get one. "I am so tired," says the artist, who has to check in with the police for further "reeducation" every Monday morning. "I sit there like a criminal suspect while the police criticize my behavior." What's more, Ai is not allowed to travel beyond the Beijing city limits and has been given no indication of when he will regain possession of his passport. However, unlike Liu Xiaobo, the literary critic who is in the midst of an eleven-year prison sentence, Ai has the run of his home and workplace, perhaps because the artist champions universal moral principles and, unlike Xiaobo,

avoids specific ten-point manifestos that aim to overthrow the one-party state. "The struggle for liberty is the most essential value for the young people for the future," says Ai. "I cannot *not* talk about those things. This is my true condition."

The artist, my daughter, and I walk into a neighboring room that I didn't see on my last visit—a gallery space with a high ceiling punctured by grand skylights. In it are some works in progress for his solo show at the Hirshhorn Museum in Washington DC, which opens in six months. In one corner are several baskets of porcelain river crabs in different shapes and glazes. The Chinese word for "river crab," *hexie*, sounds very similar to the word for "harmony," a government catchphrase often used as an excuse for censorship. Ai picks up a couple of crabs, passing one to me and one to Cora, who is elated to be in an environment full of art and devoid of "do not touch" signs.

In another part of the room is a sculpture created from mangled steel rebar that was exposed when concrete buildings collapsed during the Sichuan earthquake. Some suspect that it was Ai's campaign to name the children killed in collapsed schools that led to his imprisonment. Evidently uneasy about this sculpture, the artist stares at it. "It has no title yet," he announces. "Maybe this political thing leads me nowhere. It is so much frustration. It ruins my family's life. Maybe I have made my point," he says as we walk away from the rusty, minimal metal rods. "Any awkward moment is a creative moment."

Leaning against the far wall is *Study of Perspective—White House* (1995), a photograph in which the artist's middle finger in the foreground is larger than the president's house in the background. I assume that it will be in his exhibition in Washington DC and am surprised to learn that the curators have not requested it. The Hirshhorn show was originally put together by the Mori Art Museum in Tokyo for a Japanese audience in 2009 and titled "According to what . . ." after a Jasper Johns painting. I wonder aloud whether the title makes sense three years later in an American context, especially after all that Ai has gone through. He agrees that the title lacks relevance but fears that it is too late to change it. Our exchange reveals what a handicap it is for an artist to be forbidden to travel. Had Ai been able to spend even a few hours

with the curators in the American capital, they could have thoroughly revamped the concept and content of the exhibition.

Although Ai is committed to staying in Beijing, he is also keen to create a European base in the cellar of the Berlin studio that belongs to his friend Olafur Eliasson, a Danish–Icelandic artist. The building is a brewery that has survived two world wars. His aspiration is that the subterranean space, which reminds him of his excavated childhood home, will be renovated into something that functions as both a studio and an artwork. Thinking of Eugenio Dittborn's studio in Chile, I wonder whether artists who have weathered hostile governments seek safety underground, then note that the cultural sphere that used to be called "the underground" has ceased to exist in the era of the Internet.

Lu Qing enters the room, accompanied by an ancient, overweight cocker spaniel wearing a T-shirt. Lunch is ready. Would we like to join the staff? Ai, Lu, my daughter, and I walk across the courtyard, through the computer-filled office, and into a plain staff room where over a dozen people are helping themselves to chicken, cabbage, and rice. Chinese American college kids and a few pasty Europeans mix with mainland Chinese. We load our bowls, then find seats. "It is very difficult to change, even if you want to," says Ai as he takes his first mouthful. "I lost about thirty pounds when I was in jail. I have gained back every pound. Every day that I criticize the government, I realize, come on, you cannot even lose weight."

The camaraderie around the lunch table is palpable. Ai sees his studio as akin to a class in which he is the instructor. "I tell people to do this and that, but I mostly like to intrigue them to be themselves, find out what to do and make an effort." When Ai outsources the fabrication of artworks to potters, carpenters, stoneworkers, metal casters, cameramen, editors, and the like, the process of delegation can be delicate. The craftspeople know the nature of the material better than he does. "They have their own sensitivities about beauty and you cannot ignore what already exists in their mind," he says. "So my role is to guide, to direct."

Ai appears to have a successful business but it is equally apparent that he is not primarily motivated by it. His income no doubt pales in comparison to Beijing-based painters such as Zeng Fanzhi. About

such artists, Ai is at once understanding and scathing. "China and the Soviet Union had a long time of nonmaterial life because of an ideology that failed," he explains. "The desire for commercial success is a really strong character of today's society. Art activity is human; it is not different from other activities." However, in his opinion, to be a "business artist" requires two qualities: "emptiness and shamelessness." The emptiness reaches beyond mere neutrality to the "high emptiness of Chinese philosophy," he adds, while the "shamelessness makes it very contemporary."

Emptiness and shamelessness are not uncommon in Western art, I say. Some of the most successful artists appear to be nihilists who don't believe in much other than themselves and the luxury goods market. Ai nods. "For them, art has become pure play, lacking any essential truth," he says. "It is a skill of surviving. Deng Xiaoping said it doesn't matter whether the cat is black or white as long as it catches the mouse."

Ai, by contrast, has the kind of self-belief that is deepened and intensified by his cause. Indeed, his belief in the right of people to pursue and speak the truth is so strong that it allows him to weather fifty interrogations. When I wonder aloud what authenticity means to him, he mulls it over. Ai used to trade in Chinese antiques, assessing their genuineness, and, of course, his company is called Fake. It is a complex issue but it boils down to one thing: candor. "It is a habit," he says. "It is a road we are comfortable with." On a related note, Ai tells me that the Chinese language has no term for "credibility." In ancient times, a word related to this kind of reliable integrity existed, but it fell out of use and then was buried by several generations of coercive Communist thought control.

My daughter has been listening intently to Ai. "How do you feel about being famous?" she asks.

"It comes too quick, too much. It is kind of ridiculous but I have good intentions," he says kindly. "Fame needs to have content. If you use it for a purpose, it becomes different. So I am very happy that I have this chance to always speak my mind." Many Western artists squander their freedom of speech through convoluted forms of self-censorship. It is hard to resist Ai's elation that he is not one of them.

Jeff Koons
The New Jeff Koons
1980

SCENE 14

Ai Weiwei and Jeff Koons

Two months later, I am invited to an odd event in the Swiss town of Basel, the day before its art fair opens. Guests will watch the premiere of *Ai Weiwei—Never Sorry*, a documentary film about the artist directed by Alison Klayman, then move on to a champagne reception for Jeff Koons's exhibition at the Fondation Beyeler. While my comparison of the two artists is deliberate, this Basel pairing is no doubt accidental. The Koons show was scheduled long before the Ai premiere and the lack of direct dialogue between the film and the exhibition is marked. For different reasons, neither artist manages to attend the event.

Never Sorry turns out to be a wonderful film. The two scenes that I find most absorbing explore aspects of Ai's life which I haven't seen with my own eyes. In one, Ai eats bite-size chunks of melon as quickly as his two-year-old son, Ai Lao, can deliver them to him. The little game reveals the artist as a playful dad. When the Sichuan earthquake hit, a woman with whom Ai had had an affair was pregnant with his son. The knowledge that Ai was to be a father gave him a strong sense of duty. China's one child policy was instituted in 1979 to curb population growth. In a land of solo children, the loss of one child is the loss of a family.

In the other memorable scene, bulldozers demolish Ai's studio complex in Shanghai. The local government had invited Ai to design the

project as part of an urban regeneration scheme but then did an about-face, saying that the building was illegal. I had heard about this incident but had never seen the jaw-dropping spectacle of its destruction.

The film also contains some explicit statements from Ai. When asked if he is a brand, he affirms, "I'm a brand for liberal thinking and individualism." Ai describes himself as an "eternal optimist" and declares, "If it is not publicized, it's like it never happened." In the last line of the film, he says, "It is the responsibility of any artist to protect freedom of speech."

The Jeff Koons exhibition, which is titled "Jeff Koons," includes three distinct bodies of work: "The New" (1980–87), "Banality" (1988), and "Celebration" (1994–present). The room displaying the earliest series is breathtaking. "The New" comprises dozens of Hoovers (unused vacuum cleaners and carpet shampooers in mint condition), which have been placed in plexiglass cases illuminated from below by rows of blindingly bright fluorescent tubes. I had seen individual pieces from this series at auction previews but never a curated selection of the work. The large room feels like a science fiction department-store showroom, which is glorifying newness and advocating the notion that cleanliness is next to godliness. While Ai has created antique readymades, Koons here focuses on the factory-fresh.

Another thing that intrigues me about "The New" room is that it includes a light box titled *The New Jeff Koons* (1980), in which the artist has taken an old black-and-white photo of himself as a six-year-old boy, backlit it like a street advertisement, and redesignated it as an artwork. With neatly combed hair, the young Koons is carefully posed in front of a coloring book with a crayon in his right hand. He looks at the viewer with his head tilted and a well-mannered smile. It's a portrait of the artist as a boy who understands the power of discretion.

Martha Rosler
Still from *Semiotics of the Kitchen*
1975

Martha Rosler

"You don't have to be a nice person to be an artist," says Martha Rosler. "I've known lots of good artists who are bastards or crazy people that you can't really have a conversation with." Rosler is in her late sixties, with blue eyes and short, blondish hair. The New York artist grew up in the Jewish neighborhood of Crown Heights and now lives in half-gentrified Greenpoint. Although she spent over a decade in California, she retains a Brooklyn accent. "I've never questioned the need to be tough as nails and I'm sure I still come across as hands-on-hips defiant," she explains. When Rosler was beginning her career, women artists were taken more seriously if they behaved just like the men. "We were hard-edged, fast-talking, wisecracking, heavy-drinking young women," she says as she settles into a wicker sofa in her living room.

Rosler is best known for hard-line artworks, including feminist videos in which she is the central performer, and collages with antiwar content. *Semiotics of the Kitchen* (1975) is one of her cult classics. Rosler was a single mother who had only recently obtained her MFA from University of California, San Diego, when she made this black-and-white, six-minute video. In it, she offers a deadpan satire of cooking shows by going through an alphabetized range of kitchen utensils, transforming each one into an instrument of violence. To demonstrate the proper use of a fork, she holds it in her fist and stabs the air. When she "uses"

the ladle, she scoops imaginary soup and then throws the contents out of frame. The work's adoption of a television format and its parody of domesticity (at a time when feminist issues were considered by many to be frivolous) were so outside the artistic conventions of the day that one critic, writing in *Artforum*, suggested it was evidence that Rosler was not a "serious" artist. "That cracked me up," says Rosler with glee. "I learned that there is a minimum ten-year gap between the things that I do and their art-world appreciation." Now dozens of videos on YouTube pay homage to the work, including *Semiotics of the Kitchen Barbie*, in which the blonde Mattel doll tackles life-size eggbeaters and knives in a word-for-word reenactment of the original script.

Another Rosler landmark is *Vital Statistics of a Citizen, Simply Obtained* (1977), a complex thirty-nine-minute video that the artist describes as "a kind of opera in about three acts." The most striking segment reveals two men systematically measuring various parts of Rosler's body as she undresses. At one point, they assess her standing with her arms outstretched, marking her dimensions on a large sheet of white paper pinned to the wall. The resulting sketch suggests an abstract, imperfect version of Leonardo da Vinci's geometrically ideal *Vitruvian Man*. At another point, her bun is undone and her long, wavy, golden hair tumbles down her back, momentarily evoking Botticelli's Venus or a Pre-Raphaelite beauty. The dissimilar histories of the representation of men and women come into play as the two quasi-scientific men humiliate their subject, objectifying her inch by inch. The artist uses a voiceover to make sure that no one misses the work's political implications. "For an institution to be brutal, it doesn't have to be run by Hitler," she announces. "Her mind learns to think of her body as something other than herself," she says later. Overall, the video is a powerful invocation of the routine ways in which people's, particularly women's, human rights are violated. When rewatching the work, I wondered whether Ai Weiwei had ever seen it. I think he'd admire this activist, fighting another system at another time.

Rosler's living room looks like a charity shop hit by a bomb. With my back to a Victorian bay window lined with plants, I look out onto a 55-foot stretch of strewn boxes, stacked books, clunky old television sets,

VCRs, paintings acquired at thrift shops, and women's crafts such as lace doilies, beadwork pieces, handmade dolls, and pottery. Her downstairs workspace looks even more chaotic, with toppled stacks of paper and barricades of unsealed cardboard boxes. Indeed, in order to get to the kitchen, visitors are forced to step over a box which the artist refers to as "last year's taxes." I turn to my host and search for the right words. This space is . . . um . . . rich, I say. You've certainly got a . . . maximal aesthetic. Rosler smiles. "So it seems," she says with a laugh.

Most of the stuff is destined for her *Meta-Monumental Garage Sale*, which will take place in the atrium of New York's Museum of Modern Art. Since 1973, Rosler has been intermittently conducting "participatory installations" that take the form of yard sales in public institutions in which the art is rarely overtly for sale. The events offer museum visitors a chance to haggle over a used teapot or a T-shirt that says "Rock me, sexy Jesus." The sales also comment on the fine line between trash and treasures, the relation between culture and commerce, and the divergent pastimes of different social classes. Curators love these festive critiques of their institutions, but Rosler has mixed feelings because, as she puts it, "nobody knows how much work is involved."

Given the untidy state of Rosler's studio-home, it is amusing to note that one of her most widely reproduced series is titled "House Beautiful: Bringing the War Home." The artist made these collages in two batches, first between 1967 and 1972, protesting the Vietnam War, then again between 2004 and 2008, commenting on the Afghanistan and Iraq wars. In these, Rosler takes images of war, including photos of injured women and children, from magazines and juxtaposes them with advertisements depicting glamorous models and plush households. In *Cleaning the Drapes*, for example, a thin, stylish 1960s' housewife uses a new and no doubt improved vacuum cleaner to dust her gold-flocked curtains. She is oblivious to the American soldiers with rifles who await the next attack outside her window.

The "House Beautiful" works are confrontational, and some critics dismiss them as "didactic"—glib art-world code for work with a political message. "When I was doing the antiwar montages in the late 1960s, I knew people would say 'This is propaganda,'" says Rosler. "I had this

discussion with myself and decided that my position was, 'Fine. It's necessary. It's urgent. Call it what you want.'" A selection of the early collages was shown at the Istanbul Biennial last September. Some forty years on, they have accrued ambiguity. "Looking back, I think they were pretty weak propaganda," says Rosler.

I venture that weak propaganda can sometimes make for powerful art, whereas strong propaganda might lead to lame art.

"No," says Rosler, who doesn't suffer fools. "I am saying that these categories—'art' and 'propaganda'—are ephemeral and have different definitions depending on their era and place." The artist glowers at me, inviting a retort. She taught art at university level full-time for thirty years and wrote many academic essays. She retired in December 2010, so she is perhaps starved for an argument. "The rule for the acceptance of political art is either long ago or far away," she adds. Indeed, art that may have felt specific, instructional, and/or threatening when it was made can appear puzzling, open-ended, and fashionably vintage a couple of decades later.

Rosler mulls over the word "didacticism." "As an artist, I am a teacher. That applies to everything that I do," she says. "My teaching is both in the work and outside it, in my writing and lecturing." She rearranges a couple of embroidered cushions to make herself more comfortable, then reiterates, "I don't have any problem with saying something explicitly political and I don't care whether it's considered art."

It's not important to you that your work is labeled "art"? I ask, a little surprised.

"I'm an avid gardener and I've taken pictures of flowers for many years," replies Rosler. "One of my assistants once dreamed that I showed my nature photos in a gallery. I told him, 'Not in my lifetime or yours!'" Eventually, however, Rosler did exhibit them. "But it came from curatorial insistence, not because I thought Martha would gain credibility by revealing her gardener side!" she says. "They address questions of the environment and growth," she adds and, by these means, makes the photos relevant to her public identity as a political artist.

Rosler doesn't believe that an artwork can be completely apolitical.

"All human utterances have either micro or macro political implications," she explains. "Everyone who lives in a totalitarian system knows that all utterances are supervised for their political content even when they're only analogies." Rosler folds her arms across her chest. "Even 'no politics' has a meta-politics."

Nowadays, many artists attempt to make apolitical art, which Rosler sees as "a market-driven phenomenon." She uses the term "neoliberalism" to describe the laissez-faire economic philosophies that have accompanied financial deregulation and affect people's perception of their personal responsibilities. "Neoliberal art is hard to identify because neoliberalism is not necessarily visible on the surface," explains Rosler. "Neoliberal art is art that appeals to neoliberals. It's art that asserts pure individualism and doesn't try to hide that it's about flash." Rosler considers Andy Warhol to be an important artist, but the "rank and file kids" doing Warholian art today, fifty years after the master, could be considered neoliberal artists.

What about Jeff Koons? I prompt.

"He was a stockbroker. He fits in," she says. "I don't really follow his work. It looks like bling on the biggest scale or décor—shiny, over-the-top, Miami Beach-style decor." Vacuum cleaners are not a common trope in contemporary art, so it is interesting to note how Koons's series "The New" removes and isolates the domestic appliance from its sociopolitical context, whereas Rosler's "House Beautiful" work implicates the lowly Hoover in a military-industrial complex in which "cleaning up" is often an alibi for continued warfare. While Koons depoliticizes his readymades as a matter of course, Rosler infuses hers with references to power relations.

At the beginning of her career, Rosler's artworks were never for sale, but in the 1980s, a dealer convinced her to take on gallery representation by saying, "You see this table. That is the art world. You're not on it!" Rosler realized that if she wanted broader exposure, she needed a gallery to act on her behalf. "Not just because I was sick and tired of duplicating my own slides and sending out copies of my CV," she explains, "but because it was affecting my relevance." Rosler observes that political

artists are increasingly "jumping into the market" because it is "their best opportunity for broadcasting their message."

One aspect of the art market that amuses Rosler is the prevailing attitude toward artists' ages. "When I was studying art, everything made by an artist under forty was considered 'juvenilia.' When was the last time you heard that term?" she exclaims. "Now everyone wants to buy work while it's hot." Indeed, speculators are keen to acquire the coveted "early work" while it is still cheap. "The valuation of art has been inverted by the idea that youth matters, just like in celebrity culture. No one ever used to ask, what's your date of birth?" Rosler considers the question to be pernicious. "What happens, particularly with women, is that they receive attention when they are young, then they disappear when they are middle-aged and, if they survive past that, then all of a sudden they are discovered. Louise Bourgeois! Grandma Moses!" she says, with mock astonishment.*

While art with feminist content once lacked a market, Rosler now sees it as "something of an easier sell than other kinds of politics." The shift came in the 1980s. "It was rather wonderful," she explains. "The most important young artists were three women who had conceptual training and were clearly feminist: Cindy Sherman, Barbara Kruger, and Jenny Holzer."

Rosler once said, "Women cook, but men are chefs.'" Do you still believe this? I inquire.

"It hasn't changed very much," she replies. "Women's art is still 'women's art' while men's art is 'art.'"

What is an artist? I ask abruptly.

"How the *hell* would I know?" she says bluntly, with an exaggerated grimace worthy of a comedian. "Somebody whose sensibility puts a twist on the utterance in such a way that you recognize both its meaning and its composition," she offers up with a shrug. I look at her expectantly, keen to hear more. Even artists as lucid and articulate as Rosler have trouble with this one. Thankfully, she doesn't mind thinking aloud. She points to a table next to the fireplace. "See that sandstone

* Grandma Moses was an American folk artist who was famous in the 1950s.

sculpture. It's by a classic outsider artist named Lonnie Holley, an African American from Alabama." It takes me a moment to pick out the work from the dizzying visual stimulus. About a foot high, it depicts several half-faces carved out of the soft rock. "Some people think that artistic expression should bypass the rational self," she says. "The idea is a hangover from Romanticism and is now associated with the art of mad people and non-white folk artists—so-called outsiders—who are perceived as being untutored, 'natural' artists." I've always liked the sociological transparency of the term "outsider artist"; it brings home the fact that the artists who have received the endorsement of art-world professionals are basically "insider artists."

Our conversation flows into a discussion about "real artists," a phrase often used unself-consciously by artists of all kinds about their peers. "It's a subjective judgment masquerading as objectivity," explains Rosler, who thinks that being a "real artist" is about being "serious," which relates to having "internal standards" in a world where the external benchmarks of quality are almost random. It is also about the ability, as the artist puts it, "to persuade others that there is something in your work that will linger after the initial encounter." Indeed, she has often told her students: "Just convince me."

Rosler warns, however, that the meaning of seriousness "swivels." It used to be that certain subject matters (like women's issues) weren't considered significant enough to inspire artwork, but nowadays heftier themes may be perceived as too grave for art. "Today, art is supposed to be ambiguous or playful," she says, so when a work deals with something like war or homelessness, "it can step outside the bounds of what is considered art." Whatever the case, being serious should not be confused with humorlessness. Rosler often deploys humor to "bypass people's defences when they see criticality coming at them."

Rosler tells me that she has to go into Manhattan for a production meeting about a three-minute video that she is making for the UK's Channel 4 television. It is a condensation of a twenty-minute speech by Prime Minister David Cameron, which excerpts phrases such as "broken society," "twisted moral code," and "communities without control." By abstracting the words from their original context, she shifts the

prime minister's criticism away from the young and the unemployed, letting it linger ambiguously until it starts to attach itself to others, such as bankers and upper-class Etonians like Cameron himself.

I request permission to take her picture as an aide-mémoire. She quickly grabs her midsized digital Canon camera and poses with it. I've seen many photos of her online with a camera in hand. It's an appealing old-school feminist gesture—an assertion that she is an active image-maker, not a passive model, the subject of her own gaze even when she is the object of mine.

As we get up to leave, I return to the problem of defining artists. How do you think the American public perceives artists?

"They are interested in artists as celebrities," she replies, stopping in her front hall to savor the question. "So you have to ask yourself: what are the characteristics that produce a celebrity? Somebody who has some kind of special mojo?" Well-recognized artists are often said to have a special charm or a secret power, an overwhelming confidence. "An artist-celebrity is like a fetish object. You love them and hate them," declares Rosler. "You want to abuse them but you also worship them."

Jeff Koons
Metallic Venus
2010–12

Jeff Koons

Jeff Koons is frowning, with three fingers pressed lightly to his fore-head. The lighting on *Metallic Venus* (2010–12) is distressing. The eight-foot-high, ultra-shiny stainless steel beauty lifts her dress to reveal childbearing hips. It's the sculpture whose prototype I glimpsed on a computer screen when in his studio almost four years ago. Derived from a three-dimensional scan of a nineteenth-century porcelain fig-urine acquired online, the statue includes a planter containing living white petunias. The flowers are an odd touch, suggesting a Pygmalion-esque desire to bring her to life. Venus is the Roman goddess of pros-perity and victory as well as of love. More than any other Koons work, *Metallic Venus* feels like a trophy that will be coveted by members of the global elite who believe in the trinity of sex, art, and money. She is an exceedingly clever distillation of desire.

Weary anxiety marks the faces of the staff of Frankfurt's Liebieghaus Skulpturensammlung, a small, erudite museum containing a concise history of sculpture from ancient Egypt to the Rococo period. It's 5 P.M. on the last day of a two-and-a-half-week installation. Ladders and elec-trical extension cords linger. A conservator with a minuscule paint-brush covers up a scratch on one sculpture, while a workman wearing white gloves dusts another. Vinzenz Brinkmann, the classical scholar who has curated this forty-three-piece Koons sculpture retrospective,

explains to me that the artist has an astonishing appetite for precise modifications. "He is very kind to us but he is strict toward his own vision," he says. "Nothing is neglectable."

Justine Koons is in the next room. Pregnant with her sixth and his eighth child, she walks past *Balloon Venus,* another new sculpture, giving it a cursory glance. Although this work looks like a "Celebration" sculpture, *Balloon Venus* is actually the first work in the artist's new "Antiquity" series. The work is inspired by one of the earliest known representations of a woman, the Venus of Willendorf, a four-inch-high handheld fertility goddess found in Austria in the early twentieth century but dating from around 25,000 BC. Koons's sculpture proposes a new kind of idol—a high-tech grande dame whose cool, untouchable surfaces reflect the viewer. The sight of the artist's expectant spouse between two Venuses evokes one of Koons's more contentious mantras (which is sexy or sexist, depending on your point of view): "The only true narrative is the biological narrative."

I meander through the Liebieghaus, noting how Koons and Brinkmann have created entertaining juxtapositions between Koons's sculptures and the permanent collection. Koons's gold and white porcelain rendition of *Michael Jackson and Bubbles* (1988) sits in front of a row of Egyptian mummies, while a *Total Equilibrium Tank* (1985), containing one basketball, is positioned in the spiritual center of a chapel-like early medieval room. Gary McCraw, Koons's studio manager with the long gray beard, is pouring a saltwater mixture into the tank so that the ball floats exactly in the middle.

In a section of the museum devoted to Asian sculpture, I discover *Hulk (Friends)* (2004–12), which I recognize from a 2-D model that I saw in the studio. The completed work is a six-foot-high painted bronze version of an inflatable toy Hulk with six baby inflatables sitting on his shoulders. The piece looks as light as air and has a finish that resembles plastic. *Hulk (Friends)* took ten years to realize. It "got trapped" in what Koons describes as a spiral of "reverse engineering, endless scanning and redetailing" because the technology was initially not good enough to do what he wanted it to.

In an early Renaissance room full of painted wooden statues of saints, a stainless steel sculpture of *Popeye* makes its debut. Presiding over the space like a latter-day messiah, the cartoon character with bulging muscles holds a silver tin of emerald green spinach. It is intriguing that Koons, a slender artist with an aptitude for management, creates artworks that portray brawny characters with absurd amounts of physical power.

The next morning, I head over to the Schirn Kunsthalle, which is showing forty-five Koons paintings. Together the two exhibitions—titled "The Sculptor" and "The Painter"—form the largest showing of Koons's work to date. Koons is an honorary local. He owns a house in Frankfurt and many of his sculptures are made just out of town at Arnold AG, a top-of-the-line fabricator whose tagline is "Please let us inspire you with our passion for metal!"

The Schirn's vast white hall is a cacophony of Koonses. With the exception of six "Made in Heaven" canvases that have their own "adult" room, paintings from different series are mixed together such that only connoisseurs are likely to catch the conversations between them. My favorite canvases are the ones that I saw in the studio with the dots and the silver sketches meant to evoke Gustave Courbet's erotic *L'Origine du Monde*. I often have a soft spot for works I've seen in progress.

At exactly 9:30 A.M., a PR woman waves me into a nondescript side room for my interview with the artist. As we sit down, Koons gives me a warm smile and says, "Let's do a nice interview." He pours us glasses of water while I tell him as politely as I can that I am familiar with his favorite adages and anecdotes so it would be great if he could resist his penchant for reiterating them and answer my questions as directly as possible.

After a number of questions about the production process and technology behind the new works, I invite the artist to reflect on his verbal strategies. Multiple meanings drive positive judgment of artworks, so it makes sense for an artist to avoid saying anything that might close down debate. The catalogue for this double retrospective contains a conversation between Koons and Isabelle Graw, a Marxist art historian,

which happily departs from the subservient apologetics often found in such books. In it, the artist says, "to keep everything in play is the most stimulating thing you can do." I urge him to elaborate.

Koons tells me that he really enjoys speaking about his work. "The artist is living it, sleeping it ... there is a commitment you have to this dialogue," he says. When I press him about refusing to be pinned down, he replies: "I wish I could have better lighting on the *Metallic Venus*. It is so sexy. I am very pleased about the location of the *Balloon Venus,* next to a beautiful head of Apollo. *Balloon Venus* is a symbol of fertility. It is profound to connect through time and imagine what it felt like to be human in the past. *Balloon Venus* is feminine but, if you look long enough, its breasts become testicles and it can procreate on its own. It is like one person having sex with themselves." Koons wins this round by countering the accusation of vagueness with over-the-top graphic detail.

I move on to a different topic, that of politics. I skip the preamble and plunge in. Are you an aesthetic radical and a political conservative? I ask. Koons proceeds slowly, explaining that he has always been attracted to the concept of the avant-garde and that he likes "the idea that we can create our own reality." Just when I am beginning to conclude that he is like a politician who doesn't want to say anything too specific for fear of losing votes, he offers an uncharacteristically straight answer: "I don't believe I am a conservative. As an artist, I believe in the sense of communal responsibility."

I suggest that his advocacy of cultural acceptance could be seen as an incitement to accept the status quo, a conservative stance. "When I am talking about acceptance," he replies, "it is about the acceptance of everything." Befuddled, I wonder what he means by "everything." Does it include Marxist art historians and Nazi skinheads, Occupy Wall Street protesters and Republican anti-evolutionists? "I know you've heard this story before," says Koons, and then he treats me to a childhood anecdote about self-acceptance, then one about accepting others. I try to interrupt but there is no stopping him. The PR pops her head around the door. My half hour is up.

Outside, in the main exhibition hall, the press pack has swelled to

150 people. A herd of burly photographers charge into position to shoot Koons in front of three different paintings. Dressed in a dapper gray suit, the artist goes through a succession of poses—hands in pockets, finger to chin contemplating the work, a series of squats, and then a position with his arms outstretched as if he were a kid pretending to be an airplane. At the back of the press pack, an American curator tells me, "Koons is one of those artists that whatever he thinks he is doing, it is not what makes him great."

After the photo call and interviews with six TV crews comes the press conference, which is conducted almost entirely in German. Koons and the local culture minister share the middle, flanked by museum directors and curators. This country has more believers in contemporary art than any other. Keen to turn its back on its nationalist past after World War II, Germany embraced international, forward-looking art with fervor. Nowadays, every small town seems to have a Kunstmuseum, Kunsthaus, Kunsthalle, or Kunstverein.

As the conference progresses, the speakers pay increasingly hyperbolic homage to this Künstler. Joachim Pissarro, an art historian and curator who contributed an essay to the catalogue, delivers the final speech and ends up asserting that the "superhuman" precision of Koons's production ties him to "the divine." The practice of isolating geniuses, then bestowing them with saintly status, is as old as art history. Nowadays, the maneuver feels more like a marketing strategy than a credible intellectual position.

As I walk out of the Schirn museum, I think about how Koons has created his "own reality," as he put it in our interview earlier. Curators often argue that artists need to be considered on their own terms. But I don't think it does Koons any harm to be considered on mine.

Ai Weiwei
Hanging Man: Homage to Duchamp
1983

Ai Weiwei

Ai Weiwei cannot attend his solo exhibition at the Smithsonian's Hirshhorn Museum in Washington DC because Chinese officials have not returned his passport. Having referred to himself as a readymade and his ongoing battle with the Chinese government as a kind of performance art, Ai is clear that the opening will be incomplete without him. When asked about his favorite work of art, Ai replies that he doesn't have one, announcing, "I am more interested in the artist than in the work."

A week after the opening of the Hirshhorn show, I am sitting at my desk, waiting to call Ai on Skype. It's 1 A.M. in London, 8 A.M. in Beijing. On the wall behind me is a poster that quotes Ai. In white lettering on a black background, it states, "Say what you need to say plainly and then take responsibility for it." I've adopted it as one of my mottos. In the center of my computer screen is Ai's Skype profile picture, a black-and-white photograph of the artist as a two-year-old boy, perched on a wooden stool with one arm in midair as if he were just about to hail the world's attention. I click on the green "Call" icon and listen to the old-school ring. An assistant answers and fetches the artist who, ten seconds later, looms into frame. He settles into a head-and-shoulders shot with a cropped forehead. His image is pixilated and his voice is occasionally garbled, but Ai seems to be receiving a clear picture and

good sound from me. I wonder if his Big Brothers have degraded the outgoing signal.

After a few pleasantries, I comment that the right to travel is less talked about than the right to free speech. "Limiting an individual's movement through time and space is a crime but, for me, it is also a joke," declares Ai with a half-smile. "The Internet lets me travel. Technology is beautiful in the most impossible conditions. Technology allows freedom." Ai's love of new communication technologies runs deep. Not only does he use Twitter and Instagram throughout the day, he believes they are part of an existential revolution. "The technology allows us to be a new kind of human being," he says. "With the Internet, a person can be an individual for the first time because he can solely construct his knowledge." Certainly, the Internet has allowed for a new type of artist, for whom making art involves social media as much as a brush.

I wonder if an exhibition is the best reflection of Ai's activities. The artist thinks not. "An exhibition is a classic way to show some product," he says. With regard to the Hirshhorn show, he admits that a "better aesthetic" would represent a broader range of his activities. "My art is fragments. Giving interviews is part of my practice. You have to gather a lot of fragments to capture the reality." Ai tells me that he had no direct communication from the museum's staff and that the process was plagued by internal problems, including a shortage of funds. Even if one takes a conservative view of an artwork, the Hirshhorn show could not be called a survey because it excludes many major works.

The reviews of Ai's Hirshhorn exhibition are fascinating because they have tripped over a question that critics usually ignore: what is an artist? Most reviewers got locked into a binary way of thinking: artist or activist? Or as *The New Yorker*'s Peter Schjeldahl finessed it in his opening sentence, "Is Ai Weiwei a political artist or an artful politician?" Adding to the confusion, the *New York Times*'s influential Roberta Smith argued that Ai "doesn't make great art as much as great use of the role of the artist."

Ai experiences "no conscious difference" between being an artist and an activist. "In activism, you can discover art," he says, "but the purpose

of activism goes beyond having a show." He wonders why writers, poets, and academics can be politically active without compromising their primary social identity, whereas artists cannot. "Artists who are human-ists living in inhuman conditions want to reflect their reality," he says. "They use art for other purposes, never just as a witness." Ai takes a deep breath. "For me, being an artist is a total activity. I introduce many things, like political argument and writing, that were not considered art activities." When confronted with the distinction between "great art" and "great use of the role of the artist," Ai rolls his eyes. "Art always has uses," he declares. "It is as if art were supposed to be irresponsible." Indeed, even art that is supposed to be for "art's sake" is invariably deployed for something other than pure aesthetic pleasure.

In addition to attending his Hirshhorn opening, Ai had been sched-uled to speak at Princeton University. When the artist was unable to honor his commitment, his hosts held a panel discussion about his leg-acy instead. A member of the audience asked what kind of public figure in the past or present is comparable to Ai. Thomas Keenan, Associate Professor of Comparative Literature at Bard College, suggested that a martyr was the closest match. "The fact of his martyrdom, his impris-onment, his suffering, is now integrated into the everyday meaning of his name," said Keenan, according to the *Daily Princetonian*. I relay the observation and ask Ai to respond.

"I don't know," he replies, genuinely perplexed. "What are martyrs?"

It's a Christian thing, I explain. The term is associated primarily with saints who died for their faith. Joan of Arc, for example, claimed to have divine guidance; she was considered a heretic and burned at the stake. Twenty-five years after her death, the Roman Catholic Church declared her a martyr. Almost four hundred years after that, it canon-ized her as a saint.

Ai chuckles and grapples for something to say, then points into my office space. One of my three black cats has walked into frame. I'm so used to his impertinence that I hadn't noticed. I shoo him away and take a sip of tea.

Ever since Ai told me about how about his interrogators insisted that he was only an "art worker," I have been wondering if being an artist has

allowed Ai more political leeway than if he were a straightforward activist without any other identity. When I put the thought to Ai, he agrees wholeheartedly. "It has given me a lot of liberty," he says. "As an artist, you can be weird. They say, don't worry about him. He is a crazy artist."

The idea that an artist is some sort of ultimate individual is gaining traction internationally. It may not be prevalent in Iran, but it has made inroads into China. "As an artist, you have to find your own way. In most professions, you don't need to be as much of an individual. For artists, it is most important to be independent," he says. From his position in a Communist country, Ai doesn't see a downside to individualism, except when it generates secret codes that no one understands. "Individualism has to have a relationship to mainstream thinking. If the individual lacks sensitivity, then there is a danger that they will not be understood by the general public. As long as someone can still communicate, individualism is useful."

In an interview some time ago, Ai referred to an artist as a "somebody." The desire to be somebody is a key motivation in a society that values individualism. Indeed, the aspiration may be particularly pronounced in artists. It's my final question, I tell Ai. How do you feel about the whole notion of being "somebody" versus "nobody"?

"Being somebody is being yourself," he replies earnestly. "An artist's success is part of the downside. You can lose yourself. Being yourself is a very difficult game." Ai's fingers disappear into his beard, which looks longer and grayer than it was when I saw him in Beijing. "How can you, at the same time, be yourself and refuse the easy categories that come to you with popularity?" he says. "Most artists struggle to be recognized but fame misrecognizes. The moment you touch success, your sense of being somebody disappears."

Act II: Kinship

Elmgreen & Dragset
Marriage
2004

SCENE 1

Elmgreen & Dragset

Three days before the VIP opening of the Venice Biennale in early June 2009, Michael Elmgreen and Ingar Dragset are standing and smoking in the sun next to a fake real estate sign that says "FOR SALE." Both men are tall and slim. Elmgreen is a fair-haired forty-eight-year-old Dane, while Dragset, a Norwegian with brown hair and a well-trimmed beard, has just turned forty. Having shared a career since 1995, they are, in their own words, "each half an artist" or a "two-headed monster." Their combined nationalities have led to an unprecedented situation wherein "one artist" has been awarded two pavilions at this premier international exhibition.

The hub of the sprawling Venice Biennale is the *giardini*, a park full of pavilions in a broad range of architectural styles. When Elmgreen and Dragset visited the *giardini* out of season, they fancied the location as an upscale neighborhood, then asked themselves: who might live here? They decided to transform the Danish pavilion into the home of a family in the midst of a divorce and the Nordic pavilion (jointly owned by Norway, Sweden, and Finland) into a gay bachelor pad. Then they imagined that both homeowners were avid collectors, which gave them license to fill the pavilions with works by twenty-four artists, including themselves.

"I always thought that if I didn't behave myself as an artist, I'd be reborn as a curator or an interior decorator!" says Elmgreen with a husky laugh in between puffs on a Danish brand of cigarettes called Prince. "As artists, we could be more dictatorial than normal curators, creating an integrated group show that tells a story," he adds. Elmgreen loves confrontation; Dragset prefers diplomacy. "We explained the concept carefully," says Dragset. "We warned the artists that their work might take on other meanings. So far, no one has flipped out." Venice is a notoriously difficult city in which to produce exhibitions. "Everything— *everything*—has to arrive by boat," says Elmgreen with a deep sigh.

The artists are both wearing shirts with fine checks that are the same color as their trainers. Elmgreen's ensemble is red and black, Dragset's is royal blue and white, as if they were twin boys color-coded by a doting mother. When the pair are due to make an important public appearance, they confer on wardrobe to make sure that they don't match. "We don't want to look like Gilbert and George!" says Dragset. Gilbert and George, an older gay artistic duo who always dress in matching tweed suits and use only their first names, declared themselves "living sculptures" in the late 1960s. Before Gilbert and George, artists did performances and cultivated spectacular public images, but few had put themselves forth as art itself. "Gilbert and George were early in doing a sustainable collaboration," says Dragset, admitting the ancestry. "We don't see ourselves as artworks but we do take our humor very seriously," adds Elmgreen.

Elmgreen and Dragset met in a gay bar called After Dark in Copenhagen in 1994, became lovers, and then began collaborating a year later. Neither went to art school, although Dragset had attended university for a couple of years for studies that he describes as "part clown, part Shakespeare." The men were lovers for nine and a half years but are now platonic collaborators. Standing tall with their hands on the back of their hips, their postures mirror each other with uncanny frequency. The name "Elmgreen" would suit a landscape painter, whereas "Dragset" sounds like a cross-dressing performance troupe. The artists think that, together, their names suggest a "boring Scandinavian

law firm," an association they prefer to being perceived as a brand like Bang & Olufsen.

Standing near us in the Danish pavilion is an actor who will play the role of a real estate agent giving guided open-house tours. Rehearsing his lines in a plummy English accent, he says, "The building was designed in 1930 by Carl Brummer in the neoclassical style at the rear. Here we have the modern 1960s' extensions... It has a breezy feel to it, with some gorgeous interiors. Do come in..." Once through the foyer, we enter a living room with a mezzanine whose stairs look like they've been torn apart by an earthquake. Along a corridor is a gothic installation titled *Teenage Bedroom* (2009) by Klara Lidén, a Swedish artist who lives in Berlin. Deeper into the pavilion is a mock kitchen displaying the collection of Weimar porcelain owned by the artists' Milan art dealer, Massimo de Carlo.

The artists linger in a large exhibition space that they have transformed into a grand dining room. On one wall is a work titled *Anything Helps* (2005–09), an arrangement of twenty-two signs used by beggars from all over Europe. Finnish artist Jani Leinonen collected the panhandling signs for roughly $20 each, mounted them in gilt frames and hung them salon style. Beneath these multilingual solicitations is the family's Jack Russell terrier. The taxidermy dog, which sits attentively, evoking the trademark of His Master's Voice, is an untitled artwork by Maurizio Cattelan. "Maurizio was here earlier, checking out the installation," says Dragset. "He is a good team player."

Against another wall stands an Elmgreen & Dragset sculpture titled *Rosa* (2006), a gold-plated statue of a Mexican maid. *Rosa* is the first of a series of faithful portraits, cast from women of different nationalities who work as full-time domestic help. The sculptures wear readymade, black-and-white uniforms over their gilded "skin" and have attentive but inconspicuous postures that are at once dignified and subservient.

In the middle of the room is *Table for Bergman*, a new work by the artistic duo, which consists of a six-meter dining table bisected by a jagged fissure but nevertheless set with crystal glasses, silver cutlery, and a porcelain dinner service. Despite the divorce, etiquette requires that

the imagined couple's social occasion must go on. "It's shinier than a Steinway piano," says Elmgreen of the table that was fabricated in Italy. "We kept having to request another coat of lacquer to achieve the right ambience in the piece."

"Ingmar Bergman is dead cool," offers Elmgreen, referring to the Swedish film director evoked in the title of this work.

"He's definitely dead," remarks Dragset.

"Bergman's project was about people who set out to do something good and become evil in the process," says Elmgreen with some glee. "He was in love with his own neurosis." Elmgreen, though physically fairer, is the psychologically darker of the artistic duo. He has a more menacing demeanor, despite his ample charms.

"Are you in love with your own neurosis?" I tease Elmgreen, then turn to Dragset. "Are you in love with *his* neurosis?"

"It is really hard to be in love with other people's neurosis," says Elmgreen preemptively.

"Michael wouldn't be this amazing person without his neurosis," says Dragset sweetly.

"You are not very neurotic," replies Elmgreen matter-of-factly. Some people look up when they think, others look down, but Elmgreen and Dragset tend to lock into eye contact with each other.

"Have you seen Bergman's *Scenes from a Marriage*?" says Dragset, returning his gaze to me. "Bergman's work is about the struggle of being together. In the cultural landscape of Scandinavia, Bergman is an intellectual father but, in his personal life, he was a terrible father—an egotistical womanizer."

Elmgreen and Dragset have divergent childhood experiences. Dragset's upbringing was happy and he still has a good relationship with his mother and father, who have been married for more than forty years. "What makes a great family are the bad times," says Dragset. "A strong family accepts. It accepts a person's negative traits and it accepts conflict." Elmgreen, by contrast, declares that his parents are "non-existent." He moved away from home when he was sixteen and never saw them again. His father died of natural causes, while his mother

committed suicide. "When I was seven years old, I didn't like who they were," says Elmgreen. "I loved the story of Moses. I fantasized that I had been found in a basket." By contrast, Elmgreen appreciates "the complex family tree" of his former boyfriends. Elmgreen and Dragset have made about a thousand photographs of gay men from all over the world as part of their "Incidental Self" series. "We chose the title 'Incidental Self,'" says Dragset, "because we see the international gay community as a kind of extended family."

Elmgreen, Dragset, and I walk out the back of the Danish pavilion into the leafy *giardini*. It has clouded over and workers are swarming over the neighboring American pavilion, which is showing the work of Bruce Nauman. The Nordic pavilion, by contrast, is completely empty of people. Built in 1962, it is a refined rectangular box with two glass outer walls and a roof with alternating skylights and concrete beams. Three grand old trees grow right through the middle of the building. "It's a very exhibitionistic, transparent space," says Elmgreen.

The art on display in this second home is wide-ranging but rigorously homoerotic. Terence Koh, a Chinese Canadian artist, has created a white plaster tabletop version of Michelangelo's *David* in which the anatomical proportions of the nude original are faithfully rendered in all areas but one, which is significantly enlarged. (I Google the original on my phone and am shocked to see the diminutive scale of the Renaissance ideal.) Other works in the room include Simon Fujiwara's *Desk Job* (2009) and a vitrine of drawings of naked macho beefcakes made by Tom of Finland between 1965 and 1981. Playing on a vintage 1970s' television set in a kind of sunken bed area is a video by William E. Jones titled *The Fall of Communism as Seen in Gay Pornography* (2009).

Elmgreen and Dragset have staged the phallocentric art among vintage sixties' chairs and lamps by a pantheon of acclaimed Scandinavian designers. The sophisticated modernist milieu offers clever ballast to the bawdy artworks, elevating what some might find coarse or distasteful. When the exhibition is officially open, three men who appear to be hustlers will populate the pavilion. "A rent boy in jeans and a white T-shirt will sit there," says Dragset, gesturing towards a red seat in a globe

known as an Aarnio ball chair. "And we'll have a naked guy listening to an iPod in the Wegner ox chair," he says with a wave in the opposite direction. "They'll actually be working as security guards."

In the middle of the Nordic pavilion, around the three live trees, Elmgreen & Dragset have created a "bathroom" with glass walls to display *Marriage* (2004), a sculpture comprising two white porcelain sinks whose stainless steel drain pipes are tied in a knot. It was one of the first sculptures Elmgreen and Dragset made after they broke up. The sinks are the same shape and size, suggesting an egalitarian relationship, but they are tainted by the bondage below. The artists are considering making *Gay Marriage*, which would feature two urinals with entangled pipes.

"There is a lot of love in our work," admits Dragset.

"It's about love not labeled as love," qualifies Elmgreen. "Don't patronize me with your love. Don't show me compassion in a dominating way."

The sinks are one of many works that Elmgreen and Dragset have made that involves domestic doubling. They have also made sculptures of bunk beds (in which the top bunk faces down) and pairs of doors (linked together by a chain lock). "Every time we put something in singular form, it feels a bit funny," says Dragset. "I believe in the idea of soul mates. Relationships need to be mutually inspiring to last."

Maurizio Cattelan
Super Us
1996

SCENE 2

Maurizio Cattelan

On a blisteringly hot day in early August, Maurizio Cattelan is looking out of the open window of a New York City taxi, one arm resting in the wind. The artist is tanned and impeccably fit due to his weekday regimen of 100-length swims. He wears a T-shirt that says "Hung like Einstein, smart as a horse." Cattelan recently decided that designing his own clothes was easier than shopping for them. So far he's made thirty or so unique T-shirts, which feature jokes and slogans that effectively customize his appearance.

I first met Cattelan at a dinner honoring Elmgreen & Dragset in Venice a couple of months ago. Cattelan had allowed one of his artworks to appear on the cover of nine editions of my previous book, *Seven Days in the Art World*. The work featured a taxidermy horse mounted backward, headless, with its rump sticking out of the wall. We'd had email exchanges but never met face to face. When a mutual friend introduced me to him as an ethnographer, he seemed to mishear and exclaimed with great enthusiasm, "You're a pornographer!" That night, he was wearing a T-shirt that said "Make awkward advances to women, not war."

On our way through the gallery district of Chelsea, we pass Jeff Koons's studio on West 29th Street. I identify the building and then

remark that I saw the artist give a talk about his "Popeye" series in London a few weeks ago. Cattelan grimaces and sticks out his tongue. He has never given a public lecture and finds the thought of doing so mortifying. "I speak through images because I can't talk. It's my handicap," he says in a dark baritone with a murky Italian accent. "I forbid myself to appear on radio or television." For many years, the artist hired a friend, the curator Massimiliano Gioni, to give museum talks as "Cattelan." For the first few years, people didn't realize that they were being presented with an impostor. As Cattelan's face became better known through his many self-portraits and as Gioni's curating career took off, they abandoned the ploy.

Our taxi hits the West Side Highway and speeds uptown toward our destination in Harlem, an area with few art galleries. We're going to see an exhibition titled "Maurizio Cattelan is Dead" at a nonprofit space called Triple Candie. Cattelan discovered the show online about a month ago. He hadn't planned to see the exhibition until I goaded him into attending with me.

What is it like to be declared dead? I ask. "It makes your life longer," replies Cattelan. "This is the third time." About ten years ago, an Italian newspaper reported his death. "It was a prank. Someone called the paper." Then there was the documentary about him called *È morto Cattelan!* "I guess it was a gimmick to get attention," he says.

Death is a dominant theme in Cattelan's work. One of his most celebrated pieces consists of a squirrel that has just committed suicide in a miniature 1960s' kitchen. Next to a tiny sink full of dirty dishes, the squirrel slumps with his taxidermy head on a little yellow Formica table and his paw outstretched toward the gun that has fallen by his feet. Made in 1996, the mini-installation is more absurd and vain than tragic. A squirrel who takes things so seriously that he has to take his own life?

Our taxi finally pulls up alongside the gallery on West 148th Street. Triple Candie puts together exhibitions about artists without their permission—a rogue curatorial tactic in an art world that defers to the power of successful living artists, giving them a great deal of control over their solo shows. Upon entering the ground-floor space, we are

confronted with a life-size coffin above which is a sepia tinted photograph of the artist, looking wackily astonished with his eyes bulging and his eyebrows raised. In large lettering on the wall above are the artist's dates: 1960–2009. To the right of the display, a man and a woman sitting at a wooden table glance up from their laptops, noting the arrival of visitors.

Beyond this reception area is a large, oddly shaped room with exposed red-brick walls that are partially covered with white boards; across them at chest height runs a two-inch-thick, black time line, surrounded by wall texts and computer printouts of images of the artist and his artworks. Cattelan places his black-rimmed reading glasses on his extravagant Roman nose and moves in close. The first wall text starts with the statement, "Maurizio Cattelan was a con-artist and a populist philosopher whose art embraced what might be called comic existentialism." The artist emits an amused grumble. The exhibition has been exhaustively researched. The wall texts are better written than those in most museum shows and, with the exception of the posthumous premise, they reveal a meticulous concern for factual accuracy. "I wish there were more mistakes," says Cattelan. "A legend grows through confusion."

Along the wall, past a display of photos, maps, and writings that refer to the artist's strict Catholic childhood in Padua, is a reproduction of an early self-portrait titled *Super Us* (1992). The work features a series of drawings on transparent acetate sheets rendered by a couple of police sketch artists who drew Cattelan's likeness based on the verbal reports of friends and acquaintances. Not only does the piece posit identity as a network of other people's perceptions, it depicts the artist as a criminal suspect. Cattelan may have stolen the idea for this work from the Californian conceptual artist John Baldessari, whose 1971 video, *Police Drawing*, features a police sketch artist making a portrait of Baldessari from students' descriptions. Or, the similarity of the works might stem from the fact that both Baldessari and Cattelan are intellectual descendants of Marcel Duchamp, who championed transgression and sometimes positioned himself as a symbolic outlaw.

A few feet further along the time line, the text declares, "Maurizio was a thief," then goes on to describe an artwork in which Cattelan, "unable to come up with an idea for an exhibition," broke into a gallery and transported its entire contents to a neighboring art space where he was expected to have a show. "Art really did save me from a life of crime," volunteers Cattelan as he points at the text. "I don't know what art does for the people who look at it, but it saves the people who make it."

Around a corner, represented by a photograph of windswept palm trees, is a work that the time line narrative describes as the "greatest hoax of Cattelan's career." *The 6th Caribbean Biennial* (2000) was an event in St. Kitts organized by Cattelan and curator Jens Hoffmann. Promoted with full-page advertisements in art magazines, the event had institutional sponsorship, a director, and a press office. But when a handful of journalists arrived for the opening, they found that there was no exhibition—indeed, no art whatsoever—simply a collection of "name artists," including Pipilotti Rist, Rirkrit Tiravanija, and Gabriel Orozco. The artists did not give seminars or symposia; they simply swam, ate, and took afternoon naps, as they would on any other beach vacation. One critic was irate. "In the absence of art," she scoffed, "the artists themselves became objects of contemplation."

The couple who were sitting in reception when we entered the gallery make their way over to us. She wears paint-splattered shorts and a ponytail that extends down to her butt. His head hasn't seen a haircut in sometime either. "Are you Maurizio?" says the woman, who introduces herself as Shelly Bancroft and her colleague as Peter Nesbett, her husband.

"Why did you kill me?" whines Cattelan in a mock-wounded tone.

"We like a story with resolution," quips Bancroft.

"We did the show because we identify with the act of not seeking consent," says Nesbett, "and doing things on the sly." He gestures toward some tabletop vitrines displaying photocopies of *Permanent Food*, a "cannibal magazine" that refused to observe copyright which Cattelan and his collaborators put together from a wide range of sources.

"As an organization, we feel akin to you," volunteers Bancroft.

"We also relate to the way you think about your sculptures as images that have another life through reproductions," explains Nesbett. "It allows art objects that are owned by the elite to circulate in a broader, more generous way."

Cattelan peers curiously at Bancroft and Nesbett, his reading glasses propped on his forehead. "Are you artists?" he asks.

"We are mostly art historians...who curate," says Nesbett. "We're outside the group thing. We're interested in the ideas behind contemporary art so..."

"Unlike a lot of curators," continues Bancroft, "we don't fetishize art objects and we don't see it as our job to apologize for or glorify artists."

"How do you support yourself?" asks Cattelan.

"We don't," replies Nesbett with a self-conscious grin. "We publish *Art on Paper*. It kind of pays the bills."

"Hmm," says Cattelan. "Dakis should acquire the show." Dakis Joannou is a Greek collector upon whom the artist counts for financial and moral support. Above the fireplace in Joannou's Athens home, in the spot where you would expect to see a dynastic family portrait, hangs an oil painting by George Condo of Joannou as a sailor and Cattelan as a priest.

Out on the street, sirens fill the air as we walk toward Amsterdam Avenue. None of the buildings is over five or six stories high; it is hard to believe we are in Manhattan. Taxis don't venture this far uptown, so we are at the mercy of unlicensed "gypsy" cabs. "I hate to deal with sharks. I hate to negotiate," says Cattelan as he scans the oncoming traffic. An ancient town car slows to a standstill and the driver says, "Wanna ride?"

"Maybe," snaps Cattelan in a weird, high-pitched voice. The driver immediately hits the gas and the car zooms off.

A boxy, battered, black and maroon Lincoln Continental pulls up. Cattelan asks how much to Chelsea and we slide in. A figurine of Jesus is affixed to the dashboard, with his back to the driver, facing the oncoming traffic. "I was raised in the shadow of the Cross," says Cattelan when

I point it out to him. "I lived in constant fear of being punished. My mother slapped me without mercy." Cattelan's mother was an orphan raised by nuns. "She wanted a girl so I used a girl's voice until I was ten just to be loved," he says. Shortly after his birth, his mother contracted cancer. She underwent chemotherapy, only to experience a number of other ailments and eventually cancer again. "My mother assumed that I was the cause of her illness. She died finally when I was twenty-three. I took two photos of her dead but didn't attend the funeral."

Cattelan has made one work titled *Mother*. At the Venice Biennale in 1999, the artist staged a performance in which a Hindu mystic, a fakir, meditated while buried with only his clasped hands visible above ground. The work is best known through a black-and-white photograph in which a man's praying hands emerge from the earth. "It was like my private burial ceremony," admits the artist. "My work pays me back for what I suffered when I was young. It's a conversation in self-esteem that no one wanted me to have."

Representations of women are not common in Cattelan's oeuvre. His best known is a commissioned portrait of Stephanie Seymour, the wife of Peter Brant, a Connecticut-based collector. Nicknamed "Trophy Wife," the sculpture takes the form of a naked bust mounted on the wall in the style of a moose head. Although a Cattelan commission would usually be unique, the artist created this piece in an edition of three so that other men could own *Stephanie* (2003). Cattelan is quick to declare that it is "a terrible work."

Cattelan channels Duchamp in a number of ways, including the dead Dadaist's reputation as a skirt-chaser. A mutual friend at *Artforum* describes Cattelan as "half saint, half yard dog." Needless to say, he is not interested in marriage. "I am not good at relationships. When my space starts to be endangered, I freak out," explains Cattelan. "I have a perfect partner in my work. It's been a twenty-year relationship. We have our ups and downs." Just as Andy Warhol described his tape recorder as his "wife," so Cattelan describes his bicycle as his "girlfriend."

In August, when the galleries are closed, Chelsea is a bit of a ghost town. As we drive through the empty streets to Cattelan's condominium,

I ask the artist how he feels about his life's work in the wake of our excursion to what is effectively, albeit eccentrically, his first retrospective. "We are constantly working on a tightrope," he replies. "The more I go ahead, the higher the tightrope. If you fall from three meters up, you break your legs. But from thirty meters, all your problems are solved at once."

Laurie Simmons
Talking Glove
1988

SCENE 3

Laurie Simmons

As a child, Laurie Simmons's memory for color was so impeccable that she could name lipstick and nail polish shades on demand. To this day, she is still, as she puts it, "curiously conversant in pinks and reds." As Simmons ushers me into the Tribeca loft that is both her home and her studio, I note her auburn hair, burgundy pashmina, and oxblood slippers.

"This is day sixteen of an eighteen-day film shoot," she says, swinging her arm in the direction of the living room. Ladders, spotlights, tripods, and wires of all kinds have invaded a sitting area, rendering it unusable. Simmons's twenty-three-year-old daughter, Lena Dunham, has taken over the loft to make a feature film, titled *Tiny Furniture*, in which Simmons stars.

The living room gives way to a dining area where a large-scale Simmons work, *Talking Glove* (1988), is hung on a white brick wall. In the color photograph, a handcrafted puppet, made from a white glove with black buttons for eyes and red silk tassels for hair, is illuminated against a kid's quilt featuring embroidered horses and houses. The tightly focused spotlight, along with the wide gap between the glove's index finger and thumb, suggests that the puppet is midway through telling a joke. Lena would have been two when Simmons made this picture, a time when Simmons was perhaps struggling with the often antagonistic roles of artist and mother.

At the end of the L-shaped room, we take a left into a kitchen with white cabinets and mint green walls. The artist offers me an organic gluten-free muffin, then, swinging open the stainless steel door of the fridge, she asks, "Are you hungry? What about some homemade chicken soup?" I settle on decaf Darjeeling, one of an enormous selection of teas. Simmons has mixed feelings about the conclusion of Lena's film shoot. She'll be glad to return to her own work without needing to "find somewhere to hide" but she'll miss the experience of performing, which she discovered was "a blast."

Before filming *Tiny Furniture*, giving an artist's talk was the closest Simmons had come to acting. "Some artists invent themselves. That's something I would never do," explains Simmons. "But you're always cancelling certain facts in those talks. You tell people about the hardships and include frank tidbits, but you leave out the self-doubt and the disappointments that still feel excruciating. It's a super well-edited narrative."

In the film, Simmons plays the part of an artist called Siri with two fictional daughters whose roles are performed by her real ones. Aura, like Lena, has just graduated from university, while Nadine, like Lena's younger sister, Grace, is in her last year of high school and applying to colleges. The fictional artist makes photographic still lives of dolls and dolls' houses not unlike Simmons's own. "There is even a fight in the movie where Lena's character asks me, 'Did you ever have a job that wasn't about taking pictures of stupid tiny crap?'" says the artist with a hearty laugh. "Fact is I've never had a real job, apart from a stint as a museum-desk girl."

Siri's personality, however, is not Simmons's. "I'm not an actor, so it was probably easier for me to play a colder, more withdrawn person than a warmer, more engaged one," she explains. "But every time I was too emotive, compassionate, or friendly, Lena, as a director, would slap me down."

Many people assume that artists are self-absorbed, self-centered types, so I float the thought that Lena pulled the character away from its source so that Siri would satisfy popular preconceptions. Simmons frowns and thinks. "I think Siri's character fulfills the expectations of a

single, struggling mother," she says finally. "The absence of a father is so *not* true to our real life." Carroll Dunham, Simmons's husband, who is nicknamed Tip, has always been an active parent. He will not appear in the film and has avoided the mayhem brought on by the shoot by holing up in his studio at their other home in the small town of Cornwall, Connecticut. "Once Lena realized that Tip refused to be in the movie," explains Simmons, "she crafted the persona of Siri accordingly."

We walk back through the living room, past a floor-to-ceiling bookshelf that acts as a room divider, and then down some stairs. "I disappear into my studio the way my father used to disappear into his office," she says. Simmons's father was an orthodontist whose workplace was attached to their suburban house in Great Neck, Long Island. His rooms were off-limits but full of visual stimuli, such as a dental x-ray darkroom and Polaroid cameras for taking closeups of clients' smiles. "I try never to use the word 'practice' about my art-making because my father was a dentist who actually had a 'practice,'" she adds.

Simmons's studio is an oddly shaped room with an open-shelf archive of small props and catalogues on its longest wall. At one end is an area with windows that can be used for shooting set-up photographs; at the other is a conventional office with built-in desks and swivel chairs. "As the shoot has progressed, I've got more and more into understanding this artist-character who is not me," says Simmons as we settle down next to her computer with our mugs of tea. She asks whether I'd like to see a scene, shot two days ago, in which she and her daughter are having a conversation in bed. "This is the thirteenth take," says Simmons, fluttering her crimson nails in the direction of the monitor. "We just kept doing it. I was practically falling asleep. I don't know how Lena will choose which take to use." On the screen, Simmons is lying in bed with her back to her daughter, who is experiencing some youthful existential angst.

"I don't want to be a makeup artist or a massage therapist or a day hostess. I want to be as successful as you are," says Aura, the daughter.

"You will be more successful than I am, believe me," says Siri, the artist-mother.

Simmons pauses the film and turns away from the computer to look

at me. "These lines weren't hard to say at all," she says, then presses "Play" again. The scene continues with the daughter's confession that she has been reading her mother's diaries. Simmons explains that the diaries discussed—and actually read aloud in other parts of the film—are her real diaries from 1974. "There was no stopping Lena ever," she explains. "I thought, let her understand how much of a struggle it was." Simmons had Lena when she was thirty-six, and Grace at forty-two. "Their father and I were adults. We'd worked out a lot of stuff. The only battles that Lena witnessed were the profound disappointments that I suffered at the hands of my own work."

Precociousness seems to be a family trait. Simmons began introducing herself as an artist in kindergarten. She liked to draw but she was also distractible and disorganized. Her mother labeled her "an artist" as a way to explain away her poor grades and messy room. "My mother thought I'd get married and exhibit my work in the local synagogue's art show," explains Simmons. "It never occurred to her that I could really be an artist." Whatever the circumstances, the "artist" label stuck. "I never listened to my mother," says Simmons, "but I've never considered being anything else."

Simmons's "Early Black and White" and "Early Color Interiors" series from the late 1970s feature tiny plastic figures of lone housewives amidst dollhouse furniture. Airless and claustrophobic, these small-scale scenes of women imprisoned in their role seem to represent a mother from the point of view of an alienated daughter. A few years later, Simmons made her "Tourism" photos, which staged plastic dolls with idealized, slim, young-adult body types in clusters of two or three against commercial slides of European tourist sights. These "sisters" may have been liberated from the home but they were nonetheless trapped in the role of appreciators, rather than makers, of culture.

As it happens, Simmons was the middle child of three girls whose parents expected them to be well rounded. Their ideal, explains the artist, was that "we'd play an amazing game of tennis while speaking fluent French then perform show tunes on the piano and sketch someone on a napkin, dazzling them with our ability to render." However,

Simmons feels that "the best artists are lopsided." They do "one thing incredibly well and other things not at all."

Simmons sees herself as "a multitasker in an ADD kind of way." She makes photographs, but she also conceived and directed a forty-minute musical art film titled *The Music of Regret* (2006). She has collaborated with fashion designers and occasionally takes commissions to illustrate articles in the *New York Times*. Now she has acted in her daughter's movie. "I'm self-conscious about doing all these different things because I admire people who focus," says Simmons, who describes her husband as a resolute painter. "I'm a natural collaborator," she says. "My favorite thing is to discover what someone does well and say, 'Do that for me.'"

The phone rings. It's Grace, Simmons's younger daughter, who has recently come out as gay. "Grace is a debating star," says Simmons as she hangs up the phone after a quick chat. "She ran for president at the Princeton Model Congress, but lost to a Republican." On a recent trip to Tokyo, Grace helped Simmons discover the subject of her latest photographic series when she spotted an ad for the lifelike sex dolls that the Japanese call "love dolls" and others call "Dutch wives." Mother and daughter went to the showroom and surveyed the models, many of which were wearing school uniforms.

Simmons rises and takes a few steps toward something draped in a white sheet. She removes the sheet and revolves the swivel chair to reveal what looks like an eighteen-year-old Japanese girl with long black hair in a cheap white slip. The silicone figure comes across as both perfectly innocent and utterly creepy. Her creamy skin is clammy to the touch. "She looks petite but she's really heavy because it is all dead weight. It takes two assistants to move her around," says Simmons. The artist is using their home in Connecticut as a giant doll's house. "A life-size doll required a life-size set," she says. Simmons has been lugging the figure back and forth between Tribeca and Cornwall because she is "still getting to know her."

Simmons tells me that the love doll arrived in a box about six weeks ago with a separately packaged vagina and lubricant. These accessories have been hidden away in the Cornwall house because Simmons feels

the need, as she puts it, "to turn a blind eye to her sexual uses." The doll also came with an engagement ring, which Simmons has used as a prop. "Here's a picture that I took on my first day of shooting," she says, as a black-and-white photograph appears on the screen. The doll seems to be gazing absent-mindedly at the ring on her hand. Shot in a tight closeup, her body is excluded from the frame. The lighting is raked and moody, with a *film noir* feel. Simmons clicks through some photos shot on subsequent days. She is not sure which ones will become works and which will remain outtakes. "What do you think?" she asks.

While there is no avoiding the knowledge that men acquire sex dolls in order to fuck them, Simmons gives her figure another life. I say that the images still feel ineffably sexual in a way that echoes the perverse desires associated with "outsider artists," such as Henry Darger and Morton Bartlett. But Simmons's photographs reposition the "girl" within a protected maternal realm. Simmons nods and tells me that she wrote an article for *Artforum* about Bartlett a few years ago. "We both want to animate the inanimate," she says. "We're alchemists who want to turn common metals into gold."

Carroll Dunham
Study for Bathers
2010

Carroll Dunham

"I've doubled down on solitude," says Carroll Dunham, as he stares at a 9 × 10-foot unstretched canvas on the wooden floor of a huge room with cathedral-like windows. "I was kind of flipped out by being alone when I was young. It took me a long time to get comfortable enough with myself to obtain the momentum to do what I wanted to do." Nine months ago, the artist broke his lease on his workspace in Red Hook, Brooklyn, and moved his studio to northwestern Connecticut, where he and Laurie Simmons have acquired a red brick house and a two-story stucco barn. Dunham makes large paintings in the barn and works on small paintings and drawings in a maze of garrets on the third floor of the house. The buildings were constructed in 1912 for a prominent local family who owned horses, says the artist, but in the 1950s they became part of a school for boys who had "not yet discovered how to make the most of themselves."

Dunham has light brown eyes framed by funky dark-rimmed glasses and an oversized, floppy, black wool hat. He's slim and, even though he is almost sixty, he passes as a Williamsburg hipster. The artist is more isolated than usual because his wife has been in Manhattan, working on Lena's *Tiny Furniture* shoot. Dunham appeared in a few of his daughter's videos but then came *Dealing* (2006), a short movie in which he was supposed to be the artist-father of an art dealer played by his younger

daughter, Grace, who was then fourteen. Initially Dunham refused, so Lena asked Jeff Koons to perform the part. When that fell through due to scheduling problems, Lena "conned" her father into doing it. "When I saw myself in *Dealing*, I was embarrassed," explains Dunham, who looks awkward even when posing for snapshots. "I can't stand evaluating myself in that way. I don't want to be the guy in my kid's movies. I'm not comfortable with having a 'persona.'"

Dunham drags a wooden chair alongside one that already sits at the foot of this vast unfinished work and invites me to stand on it to obtain a sense of the big picture. The painting features the largest vagina I have ever seen. The black oval hole, which is about 18 inches long, lies beneath two mountainous buttocks that are outlined in black and infilled with bubble-gum pink. A blue sea peaks out from behind the figure's monumental left side, while dry land emerges from her right. It's the only work in the room. The rest were shipped out for an exhibition, which is still on view at Gladstone Gallery in Chelsea. As he steps up on a chair, joining me two feet above the floor, Dunham says, "The subject matter is self-explanatory, isn't it? There is a surprising amount of it!"

Dunham started out as an abstract painter who was ideologically resistant to figuration. "I've been drawing these abstract double mounds for years," he says, referring to the shape that forms her bottom. "This is an icon of fecundity, my 'ur' image, my Venus of Willendorf... But I'm still trying to figure out what painting naked women means to me." Unlike pornographic depictions of women, this epic Amazonian is unconquerable. Any attempt to penetrate her would likely result in self-annihilation. In the top right hand corner of the painting, in the artist's left-handed scrawl, are the words "mother black hole," which Dunham dismisses as "just notes to myself" that will "get covered up."

The artist steps down off the chair and walks around to the top left corner of the linen canvas lying on the floor, so that the erect nipple of the figure's one breast seems to point at him. "I've said to students many times, as a criticism, 'This looks like it could have been made any time in the last hundred years.' I am less sure that that is a problem now," he says, as he studies the picture along a diagonal axis.

The painting's treatment of the female body contrasts markedly

with the horizontal odalisques, vertical muses, and Picassoesque man-
gles common to nineteenth-and twentieth-century representations of
women. The scale certainly ups the ante on Courbet's *L'Origine du
Monde*, and the rear view feels very, for lack of a better word, con-
temporary. The nude also happens to have jet-black dreadlocks and a
voluptuous butt. "It is not racially specific for me. I am making formalist
decisions about color and shape." When I look at him skeptically, he
stares back at me then admits, "I find it impossible not to think about
someone else's art without reference to its social implications, but with
my own work, I would err on the side of denial, so as not to lock read-
ings in."

Dunham drifts to the middle of the top of the painting, so that he
is looking at it upside down. "The world is made of stories," he says.
"Do you know Terence McKenna? He was a psychedelic-mushroomist
philosopher. He said that life is much more like a novel than a doc-
umentary film. So, even at my most abstract, I'm still telling myself
stories." Dunham admits the "formalist story" is one of his favorites.
Formalists consider the purely visual aspects of a work of art—its line,
space, color, and texture—to the exclusion of its social, political, and
historical content.

I get down from the chair and take a few steps over to the bottom
right corner of the painting, which hosts a stack of dates: Sept–Nov
2006, June 2008, June 2009. "I have been working on this painting on
and off for over three years," he explains, scratching his head through
his hat. "It's like a jigsaw puzzle. I have to allow a sort of rhythm."
Dunham gesticulates as he talks. His left hand is incredibly expressive;
his right occasionally joins in but never leads. "I have to get the feeling
that the overall drawing structure works. Then I'll start to inhabit it."

On a side table next to a brand new easel, I notice a pamphlet titled
Was Life Created? "It was the weirdest thing," says Dunham, picking
it up and leafing through it. "I was on a walk, thinking about my next
group of paintings, and a cute little lady jumped out of a car and said,
'Sorry to bother you but have you thought about the origin of life on
earth?'" Taken aback, Dunham replied, "As a matter of fact, yes! Why do
you ask?" It turned out that she was a missionary—a Jehovah's Witness

with a philosophical rather than a pushy approach. "The garden of Eden is my real subject," admits Dunham, "minus Adam for the moment."

The barn is chilly and extraordinarily quiet. The twittering of a flock of small birds filters in. I shiver, so Dunham suggests we continue the conversation in his drawing studio. The short walk between the barn and the house offers a view of a frosted green valley and tree-covered hills. We enter via the back door, past a classy dining room with a long vintage table surrounded by armchairs, and walk through a wide hallway adorned with works that the couple have bought or traded with friends. A photograph by Morton Bartlett of a prepubescent girl doll catches my eye. We divert into the kitchen, which, like the one in Tribeca, is stocked with a generous selection of teas.

While we wait for the kettle to boil, I half-exclaim, half-inquire: Lena asked Jeff Koons to play the artist-father in *Dealing*? Dunham nods, while I raise my eyebrows incredulously. He smiles, then cracks into a laugh. "I've known Jeff since the early eighties," he says. "I bought a vacuum cleaner sculpture back then but unfortunately had to sell it a few years later because I needed the money. Jeff's early stuff—everything up through the basketball tanks—was extraordinary. Then, as I say to my kids, we only become more of what we already were."

"Jeff was one of the first from our generation who understood that the avant-garde paradigm was shot," continues Dunham, after some cajoling. "He was crystal clear from the beginning that he wanted to reach an extremely wide audience. That could not be more different from my aspirations. I still see the audience for what I do as vanishingly small—two hundred people." Dunham hands me my mug. "Anyway, I don't want to talk about Jeff. The world has turned him into a topic that doesn't interest me. Money just fucks the whole conversation."

Money? I probe, as we head for the stairs. "The monetization of everything—I mean everything—no one could have imagined the general foulness of it," he replies. "Because of headline prices, art interests people in a way that is not relevant to what it really is." We pause on the second floor, where another wide hallway gives way to four bedrooms. "We live in a cockeyed system," he says more dispassionately. "Basketball players make a hundred times more than teachers. Artists are the

least of it. I suppose we should be happy to live in a world where artists can succeed like that, but it's not what motivates us."

The top floor consists of a labyrinth of attic rooms that have been joined to create an interconnected circuit with multiple doorways. "My sense of composition dictates a lot of my environmental design decisions, which is a nice way of saying that I have a light touch of obsessive-compulsive disorder," jokes Dunham. After wandering through small, well organized rooms with loads of natural light that are devoted respectively to small paintings, watercolors, and reading, we enter an area that looks a bit like an architect's office. It's arranged on two levels and features a large L-shaped counter at which Dunham likes to draw standing up. The counter is covered with clean brown paper and punctuated by three Anglepoise lamps. Dunham makes a hundred or so drawings a year, usually in the afternoon while listening to talk shows on NPR or CBC satellite radio. Although museums have exhibited and collected them, Dunham refers to them as "a sort of personal garbage dump that helps me think."

In a small, windowless space off this room is a white metal cabinet with flat-file drawers, one of several where Dunham archives his works on paper. He rifles through a drawer of recent works, then drops down to one containing older pieces. Lying on top is an 8 × 11-inch graphite drawing dated March 21, 2005. It depicts a man with firm buttocks and skinny legs from the waist to the knees. He has been caught with his trousers down. In his left hand is a gun that is so schematic that it could be a boomerang or a perpendicular ruler. I find it impossible not to empathize with this droll, chastened figure and I wonder if it is a self-portrait. "No," he replies amusedly, closing the drawer. Dunham doesn't make anything he would call a self-portrait but believes in the truism that all artists' work is invariably self-portraiture. "I am never not in the painting," he explains.

Dunham received a degree in studio art from a liberal arts college in Hartford, Connecticut. Nowadays, he teaches one course a year in the MFA program at Yale. He understands how some artists see teaching as anathema to art-making. "A true artist can't formulate rigid concepts about what he or she is doing without freezing the stream," he explains

as we return to the adjacent room. "And teaching requires a certain ability to formulate concepts."

"A *true* artist"? I repeat.

"It's an obnoxious thing to say," he replies. "I'm being facetious."

What does it mean? I probe. People in the art world are always letting comments slip about "real," "true," "authentic," and "genuine" artists.

"The 'true artist'? It means that you are in a loop with your work," says Dunham, looking into his mug, mildly disappointed to note that he has finished his tea. "If I didn't have a significant need to see these things myself, they would never happen. It's me, myself, and I. The three of us need to look at this painting." I counter that, from a sociologist's point of view, artists don't look very autonomous; they are surrounded by social worlds filled with expectations. "Okay, maybe it is disingenuous. It's my version of the avant-garde bullshit," he admits, then deadpans, "Yeah, man, I'm alone with my work. I'm in this wormhole."

Maurizio Cattelan
Bidibidobidiboo
1996

Maurizio Cattelan

The door of apartment 9C opens slowly to reveal Maurizio Cattelan, speaking on the phone in Italian. He wears a T-shirt that says, "Who the fuck is Bruce Springsteen? Not the boss of me." The artist lives and works in a spacious, one-bedroom apartment in a ten-story loft conversion in Chelsea. The entrance hall gives way to an open-plan kitchen and living room with hardwood floors and views of Lower Manhattan. Evidently, Cattelan doesn't do much entertaining, as the sparse furnishings consist of a large gray couch and a miniature table surrounded by four small metal chairs that couldn't comfortably accommodate anyone over the age of eight.

While Cattelan sorts out the fabrication of a public sculpture made of Carrara marble on the phone, I inspect the art objects—some in crates and bubble wrap—that are spread around the room. The only pieces that are properly installed are two minimal polystyrene bas-reliefs by Seth Price, a New York artist in his thirties. Six framed vintage photographs by the late Francesca Woodman lean against one wall, while two colorful psychedelic landscapes by Eugene Von Bruenchenhein, an American outsider artist whose work only became known after his death in 1983, camp nearby. Cattelan takes a keen interest in the surreal outpourings of the untrained and undiscovered. On the windowsill is a menagerie of kitsch from flea markets—a ceramic lion, a couple of

owls, and a black cat with an angrily raised back. The only book in the room is Roald Dahl's *James and the Giant Peach*.

"Darling!" exclaims Cattelan once he is off the phone. He has been talking to Lucio Zotti, an old friend who is "always involved in the conversation." In the late eighties, Cattelan was homeless and ended up living in Zotti's furniture showroom for almost a year. "Every night I had a different couch. Sometimes I slept in the window," says the artist. Since then, Zotti has become Cattelan's most trusted accomplice. He helps oversee the fabrication of the artist's sculptures in Europe, and his sons, Jacopo and Zeno, manage the artist's archive, assist with installation, photograph the works, and lend a hand with other logistics.

Cattelan has two other "important allies," as he calls them, both of whom are Italian curators: Massimiliano Gioni, who is thirteen years the artist's junior and used to give his interviews and lectures, and Francesco Bonami, who is five years his senior and has titled many of the artist's most important works. Cattelan met Bonami on his first trip to New York in 1992, when the curator was in the midst of deciding whom to include in his section of the Venice Biennale. "Francesco is the person everyone wants to meet in their life," says Cattelan. "You need someone to say, 'You are not a genius; this is shit.'"

Returning my attention to the room, I compliment Cattelan on his art collection. His face contorts. "I prefer to call it an accumulation," he declares. "I am just a buyer, not a collector." Cattelan's impulse to acquire other artists' work was initially rooted in competitiveness. "I was jealous of colleagues when I should have been happy for them," he explains. "I decided to save my energy. If you think they are great works, you should buy them." Nowadays he sees collecting as a way of doing "homework." Many successful artists collect art; they invest their income in something they understand.

Competition seems to be on the artist's mind. On the island over by the kitchen is a printout of a small sculpture of a rabbit with stubby ears gazing at a book depicting a rabbit with exceptionally long ears. "It's looking for a title," announces Cattelan. "But I don't think it will have one. It is just a vignette." The problem of sustaining a career weighs

heavily on the artist. He fears being "a great car stuck in neutral." Until recently, he was anxious that he'd be forced to return to a life of odd jobs in Padua. "Now my worst fear is feeling that I've arrived."

Cattelan opens the fridge. Its spotless shelves contain only a couple of takeout boxes of chow mein and a shelf of sparkling water. In confidence, Cattelan tells me that he is preparing a retrospective at the Guggenheim Museum in New York, scheduled for autumn 2011. "I proposed painting the entire outside of the museum pink. It would have been a fantastic communication—a city earthwork—but it was too expensive," he says as he pours me a glass of water. He has another idea, one that will transform the exhibition into a "meta-work," but he is still in discussion with Nancy Spector, the Guggenheim's chief curator, and remains unsure whether they can make it happen.

Cattelan finished high school at night "just for the sake of showing I was able" but never obtained an art school degree. Inventive artists are, by necessity, autodidacts, but it is rare to find artists under sixty with high degrees of museum recognition who haven't taken a single college course. "Making shows has been my school," he says, leaning on the counter, "and eating catalogues."

Where do you sit when you work? I ask. Cattelan looks at me as if I were asking for tiramisu during a ritual fast. He wags his finger at me silently, then takes me into his bedroom. It's a grand corner room with large windows, divided evenly into two areas demarcated by rugs. On a cream-colored shag carpet lies a king-size mattress without pillows that looks like a plinth as much as a bed. On two colorful Chinese rugs from the 1930s stands a round rosewood table, which hosts a large monitor, wireless keyboard, and three piles of paper. Cattelan's bedroom-studio is about communication—phone, email, Skype, and Google. "When the Internet goes down," he says, "I lose my legs. You can have a 2,000-square-meter house but if you are not connected, you are powerless."

I examine the neat piles of paper on Cattelan's desk. Two of them are thicker than the third and seem to be paired. "It's a filtering system," says Cattelan. "I'm processing material that comes from many sources."

I wonder whether it's for an issue of *Permanent Food*. No, he says, it's for a new magazine called *Toilet Paper*. He plants a hand on each pile and says with a smile, "A great artist copies without showing his sources!"

Collectors and dealers often invoke an opposition between originality and derivativeness. Artists see it as a false dichotomy. "Originality doesn't exist by itself. It is an evolution of what is produced," explains Cattelan. "It's like the Darwinian evolution of walking. Nobody did it first." The artist puts these two stacks of paper into crisp cardboard folders, then places them in a closet next to a faux fireplace behind his desk. "Originality is about your capacity to add," he says. "I take a little new step by adding salt and oil. Someone else adds vinegar."

On top of the remaining pile of paper is a picture of a recent Cattelan work: a blank white canvas with many sagging folds that are being propped up by the long handle of a broom. The work makes reference to the *Achrome* paintings of Piero Manzoni, an Italian artist who died at age thirty in 1963. When Cattelan is asked for his autograph, he rarely signs his own name and often writes "Manzoni," a gesture that insinuates kinship. Manzoni is famous for *Merda d'Artista* (1961), an edition of ninety cans of the artist's shit. Weighing 30 grams each, the cans were meant to be sold at the same rate as 18-carat gold, whose fluctuating price was to be determined on the day of sale. "*Merda* was an upgrade of Duchamp's urinal, a kind of *Fountain* 2.0," says Cattelan. The work spoofs the assumption that artists are alchemists and draws attention to the power of artists' personalities in creating value.

Persona is a major theme in Cattelan's oeuvre, which includes a dizzying array of self-portraits. "In the beginning, I was just pointing out the culprit for all the heinous work," says Cattelan. *Super Us* (1992), the salon-style hang of police sketches, certainly suggests an offender, as does *Untitled* (2001), in which a smaller-than-life-size waxwork replica of the artist pokes its head through the floor as if he were breaking into the exhibition via a tunnel. On one occasion, the Cattelan character was installed so that he peered up at a Koons sculpture, an arrangement that suggested the Italian was intent on pocketing some kudos or museum validation.

Procreation and cloning are leitmotifs in Cattelan's self-portraits.

Spermini (1997) is made up of hundreds of little latex masks of the artist hung on the wall in random clusters. *Mini Me* (1999) is an edition of ten small facsimiles of the artist, individuated by different clothing. They sit up on bookshelves and look down at their collector-owners like pets or mascots. Most recently, *We* (2010) puts "Cattelan" in bed with himself. In this double self-portrait, the three-foot-long figures look like identical twin corpses in dark, funereal suits.

Narcissus was clearly unwell when he fell in love with his own reflection but, with artists, I find it hard to distinguish between healthy self-love and morbid egotism. Cattelan's self-portraits are invariably miniaturized, a form of self-deprecation, a literal belittling. When I ask the artist what he thinks about narcissism, he is typically self-critical. "Perhaps my work is a platform for my lowest desires," he ventures with a laugh. "But my works are not me. They are my surrogate family." Indeed, if ever an oeuvre felt like a clan, it is Cattelan's. "When they are conceived, I cuddle them, but the moment the works are released, they become orphans," he admits. "I am happy as long as they don't live near me. Mostly . . . I hate them."

Carroll Dunham
Shoot the Messenger
1998–99

Carroll Dunham and Laurie Simmons

"A long career in the art world is hard on the ego. Laurie deals with it by diversifying, whereas I handle it by drilling deeper," says Carroll Dunham, with a nod at his wife. "When you have made art for so long side by side and raised children," adds Laurie Simmons, "sometimes you just can't believe that you didn't give up." The couple sit next to each other at the long, white, skinny table that bisects their country kitchen. Bowls of bananas, onions, and green tomatoes are scattered on the surface along with a candelabra, a tape measure, three vases containing flowers picked from the garden, and yesterday's *New York Times*, dated July 4, 2010.

"We joke about being soldiers, marching forward regardless of how much flak we're taking," says Dunham, his left fist moving in a midair trudge. "You need strategies to overcome resistance and negativity. You enter troughs where you don't feel motivated. These are battles."

"We also like the artist-as-farmer metaphor," says Simmons, as she sweeps some pale blue delphinium petals off the table into her hand. "We get up early, work hard all day, and grow our stuff."

"The Roman citizen farmer-soldier!" declares Dunham, clearly enjoying the flow of the conversation. "We will fight if needed but generally we'd like to tend our fields."

When artists marry, rarely do husband and wife enjoy equal stature.

Many such couples are governed by an unspoken agreement that one partner's career is more important than the other's. When asked how their respective triumphs affect each other's self-esteem, Dunham asserts forcefully, "A rising tide lifts all boats. End of discussion! If it's good for her, it's good for me. There is no competition!"

Simmons raises her eyebrows. "Can I give a more nuanced answer?" she asks. "We are both very ambitious for our work. Ambitious people feel competition. But even if I feel jealous, I never wish him the worse or want to tear him down. We do feel competitive with each other but we do not begrudge each other's success." Dunham nods in agreement then adds, "I could kill you with nuance."

Dunham and Simmons have both just turned sixty. "We're not blasé about this house. Art did this," she says with relief. "Sixty is a significant number. We are healthy and our children are reasonably sane human beings." Grace, their younger daughter, is in Paris and will be starting at Brown University in September. Lena, their older daughter, is asleep upstairs. She has just signed a contract with HBO to write and star in her own TV series. Her film, *Tiny Furniture*, won best narrative feature at South by Southwest, an annual festival held in Austin, Texas, and is scheduled to have a theatrical release.

"The most fun time to be an artist is when you are young and when you are old," says Dunham between swigs of lemonade. "Getting through the weird middle period with a sense that you've kept growing is a challenge." Mid-career is often characterized by the doldrums. Curators, collectors, and dealers tend to gravitate to "emerging" or "established" artists, ignoring the vast swathe of people working in between. As John Baldessari, a senior L.A. artist, once told me, this results in a lot of "submerging artists."

At first glance, the work of Dunham and Simmons doesn't have much in common. His paintings appear obsessed with formal structures, while her photographs seem driven to explore social codes. When asked why he became a painter, Dunham says, "I'm innately conservative and painting is an ideal place to exercise a progressive conservatism. I operate well within limits. I get a lot of freedom from that." Simmons, by contrast, "latched onto photography" in part to avoid the burdensome

history of painting. "I could never be a painter," she says with tangible dread. "I couldn't get on that train."

Dunham and Simmons relish their differences. "We are a classic extrovert–introvert couple," she says. "The real definition of an extrovert is someone who gains energy from other people. An introvert is someone whose energy is drained by others." Dunham looks at me ruefully. "We don't think the same way," he says. "That's why this whole thing works."

Over the years, however, the two artists have circled around similar subject matter, most recently focusing on sexually charged images of lone women. "When we first got together, Tip was very much an abstract painter," says Simmons. "I always thought that he moved toward figurative imagery because he wanted me to be more interested in him."

"I don't know," he replies. "I see it in a more amorphous way."

"You mean that it wasn't for me?" she says with a mock pout.

"You absorb energy by osmosis from the person you spend time with," explains Dunham. "I never would have expected gender to become so central to what I do. It's about confronting myself as I get older."

When Simmons was young, she daydreamed about being both an artist and a muse. "Being a muse seemed far more viable," she explains. "I barely knew of any women artists and a lot of great paintings were depictions of women. The whole thing was very confusing." Last year, Simmons made a picture about an artist–muse relationship based on two found photographs. On the left side of the work is a black-and-white shot of the Abstract Expressionist painter William Baziotes dabbing a canvas with a thick paintbrush. On the right is a color photo of a woman in a fetishistic black bodice, kneeling spreadeagled on the floor and looking up and out of the frame. The first image came from a gallery invitation; the second was culled from a porn site. Simmons liked the idea that "the abstract painter was engaged in this lofty, reductive practice even though he saw his muse in a world of glowing color."

Dunham was so fond of the work that Simmons gave it to him. He found "something perceptive, hiding within all its disconnects," as he puts it. "The artist in the picture is performing a clichéd act of manly representation. It is how one might imagine that Baziotes went about

his paintings—or how I go about mine—but it bears no resemblance to the way he made his work, or how I make mine."

The phone rings and Simmons steps out of the room to answer it. I ask Dunham how his fecund superwoman is coming along. He tells me that the painting hasn't progressed very much but he has a new idea for it. He recently trimmed about a foot off the bottom so the "black hole is dead center" and has moved the canvas from the floor to the wall. He invites me to the barn to see it before dinner.

"That was Roberta," says Simmons upon her return. "She wanted to know what time we want them for dinner." Roberta Smith, the chief art critic for the *New York Times*, and Jerry Saltz, the main critic for *New York* magazine, rent a house near here during the summer. In addition to being old friends of the artists, they are the godparents of Lena and Grace. Although Smith and Saltz have, on one occasion each and with disclaimers, written about Dunham's and Simmons's work, they have not otherwise reviewed their shows due to the conflict of interest. "Being friends with critics doesn't get you reviews—quite the opposite," says Dunham. "The rewards of our friendship are private and we are happy with the tradeoff."

I ask the artists about the experience of being reviewed. "When you're younger and get a bad review," says Simmons, "you think they hate you."

Dunham shakes his head and says, "I didn't. I thought, they're stupid!"

"Anyway, I don't think it's possible to be impervious to negative reaction," says Simmons with an affectionate eye-roll. "It's the recovery time that changes. You have to know how to pick yourself up, brush yourself off, and get back to work. That's the key to maturity. It's what divides the artists that do what they do from those who are not up to it."

Dunham likes to convert knock-backs into momentum for his work. "Negative commentary makes you feel misunderstood," he explains. "So I often say to myself, 'Apparently, I haven't been clear enough with you people!'" Occasionally, a critic will comprehend the work but detest it. "Someone wrote a review about all the reasons why my work was trivial and I could see, from a certain perspective, what he was talking about.

But I invariably disagree with this critic's taste," he says. "His worldview is skewed away from mine."

"Any work that is really great hovers between terrific and terrible," says Simmons, as she adjusts some orange daisies with conspicuously bulbous centers, a type of flower that appears regularly in her husband's paintings. "When a critic hits you, sometimes it's for something that you've already gone over in your own mind a hundred times."

"Interesting artworks are always hypotheses about what an artwork could be," says Dunham. He rises from his chair and pulls a dark red apple out of the fridge. "Why would anyone think that new art should resemble what art already looks like?" he asks, offering the apple around. No takers; he crunches his teeth into its side.

The caprices of the art world foster all sorts of insecurities, anxieties, and paranoia. "When you are younger, you think about eradicating self-doubt," explains Simmons. "But, as you age, you understand that it is part of the rhythm of being an artist. As I get older, I have developed my ability to examine self-doubt in private, to play around with it, rather than push it away."

Dunham, by contrast, experiences his uncertainty as a strange mixture of self-loathing and megalomania. "Humans set up hierarchies and we are constantly judging," says Dunham. "In the morning, you tell yourself that you're a horrible artist. By the afternoon, you might feel like a god. By dinner, you're a lesser angel."

Confidence is certainly an issue. Many artists, from Marcel Duchamp to Maurizio Cattelan, have presented themselves as con artists. "The general public doesn't understand art so they think that a con has been perpetrated on them," explains Dunham. "That idea goes back to the avant-garde in the nineteenth century. It was always the layperson's reaction to more speculative approaches to painting."

Artists with an appetite for trickery also seem to have a taste for shock. "Shock is just another move in the entertainment complex," says Dunham. "It's bullshit. Who are you supposed to shock? Rich hedge fund managers? All these ideas about transgression—*épater les bourgeois*, as they used to say—are historically specific to the period of the

avant-garde. They were not relevant to artists in the Italian Renaissance and they are not meaningful now." Simmons has placed a half-dozen beefsteak tomatoes next to a chopping board. She seems to tune out while she thinks about dinner. Meanwhile, Dunham suggests a different approach to the question. "Do you find the fact that you're going to die shocking?" he asks. "I do. Art can bracket those human conditions. It can cause you to have a moment of insight."

I suggest that shock is a momentary condition that is easily forgotten, whereas great art offers long-term engagement. The two are neither mutually exclusive nor inclusive. Edouard Manet's *Olympia*, for example, a reclining nude portrait of a French prostitute with her black maid, may have been shocking in 1863, but it endures because of the complexity of the social and sexual relations it depicts and its impeccable execution. Dunham doesn't disagree. "Do you get massages?" he asks. "You know the difference between a soothing back rub and truly deep bodywork. The latter is not pleasant while it's happening but afterward you feel quite changed from it. Shock, awe, whatever. I'm not looking for a back rub from art. I'm looking for something that feels like it matters."

Wondering about what matters, I inquire about political art. "I think it is a bunch of crap," says Dunham, now fully loosened up. The artist quit drinking in 1992, but such are the effects of lemonade in the comfort of one's own home. "Political art is always preaching to the converted." Simmons frowns in obvious disagreement. As a feminist, she takes a broad view of politics. "Speak for yourself," she says, pointing at him playfully with her knife. Dunham enjoys adopting multiple points of view, so he starts arguing the other side. "I think a lot about art's usefulness. Art is valuable to artists in a very different way than it is to bankers, socialites, and politicians. There is no absolute scale of relevance. It's about what you can use. The artists in your book are of use to you. They help you advance your own thinking."

On that note, Dunham stands, says, "Ladies," and excuses himself to bathe before the guests arrive. Simmons returns to the issue of shock and artists as symbolic criminals, a tradition that she sees as a "bad boy" thing. "It's not my romance," she explains. "Maybe male artists

need it more." Women artists face enough challenges to their credibility without adopting the pose of a con artist.

Yet Simmons's large-scale color images of a lifelike sex doll have incipient shock value. The thought prompts me to ask about the love doll's current whereabouts. "You know this house is my open canvas," admits the artist, putting down her knife, wiping her hands, and leading me into the hallway. "When I was convincing Tip to buy it, I told him, what if I shot a photograph in every room. If those photos did well, we could pay for the house." Simmons's hand hesitates on a doorknob as she says, "I can't bring myself to shoot her naked yet." Opening the closet, she reveals what looks like the corpse of a Japanese teenager thrown in an unceremonious heap on a pile of clothes. "People anthropomorphize their dolls and stuffed animals," says Simmons. "But she is a prop. In all my years of working with dolls, they have never become members of my family."

Francis Alÿs
Paradox of the Praxis I (Sometimes Doing Something Leads to Nothing)
1997

Francis Alÿs

"I became an artist here," says Francis Alÿs as he walks me through the Centro Historico of Mexico City toward his studio. "That has a lot to do with my dependence on this place. I don't have a past in the art field in Europe." After some twenty years of expatriate living, the Belgian-born artist has become a Mexican citizen. "The decision was sentimental," says Alÿs, whose tall, pale, skinny physique is a caricature of a gringo. "My son was born here and I have made my whole life project here." Artists often displace themselves, usually to cities like New York and Berlin. Emigration helps them escape the burdens of their cultural heritage and embrace identities that they might otherwise feel inhibited to assume. We turn into Plaza Loreto, an urban square with a church that suffers from subsidence, much like the Leaning Tower of Pisa, and a fountain that hasn't seen water in a while. It is in the border zone between the city's renovated center and a lawless urban sprawl of drugs, prostitution, and pirated goods. Artists are often vanguard gentrifiers but few have studios around here, opting instead for less edgy neighborhoods. Alÿs, however, finds this "epicenter of parallel economies," as he calls it, conducive to making his art.

Many of Alÿs's works start with solo performances that take place in these streets. These "actions," as he calls them, which are recorded in photos and videos, have resulted in a rich succession of portraits of the

artist. In *Turista* (1994), for example, Alÿs stood among the electricians, plumbers, and carpenters touting for work in the Zócalo, the city's premier square. Towering over the real workmen, the artist advertised his services as a tourist with a hand-painted sign, effectively posing as a kind of misfit nonworker, forever on holiday. By contrast, in *Patriotic Tales* (1997), Alÿs's willowy figure leads twenty-five sheep in single file around the main flagpole of the Zócalo. Here the artist is, among other things, a shepherd, a frontrunner, a manager even, with a flock of followers. In *Paradox of Praxis–I* (1997), a work whose subtitle is *Sometimes Making Something Leads to Nothing*, the artist pushes and kicks a block of ice around the Centro Historico for nine hours until it melts. The video distills the Sisyphean chore into an agreeable five minutes, portraying the artist as a tenacious sculptor set on demonstrating the "dematerialization" of the art object in the age of conceptualism.

Along with at least a dozen others, these three self-portraits are also representations of Mexico City. Alÿs's accumulation of actions, photographs, and videos brings some magic to the otherwise forlorn heart of the metropolis in a way that no Mexican artist of his generation has. Perhaps it's no accident that this task fell to a foreigner. A Mexican artist doing the same might have been perceived as making local art. In recent years, Alÿs has shot an increasing number of his videos outside Mexico—in Jerusalem, London, Lima, and Panama City—but he always likes to come back here "to reset the clock and rethink the project from the perspective of this place." Additionally, of late, he has been appearing in fewer videos, opting instead to cast children as stand-ins.

Alÿs's studio is a three-story townhouse built in 1736. Although he once called it the "purgatory" of his artistic production, there is little evidence of agony here. The front door opens into an open-air courtyard where Babouche, a French bulldog, greets guests by sweeping his pink tongue across their toes. On the ground floor are a couple of workshops, one with lathes and other woodworking equipment where Daniel Toxqui, a sculptor and restorer of colonial art, sometimes works. At the back is an old kitchen where Mercedes, the cook, is preparing shrimp taquitos and guacamole. Alÿs stops to discuss the timing of lunch, telling her to expect two extra people.

We walk up the main stairwell, where the walls are green below waist level and turquoise above. The stairs themselves are ocher on the sides, with an orangey-red strip of paint flowing up the center like a faux runner carpet. Although Alÿs trained as an architect, he has done little to the building since he moved in a year ago besides rewiring the electricity and adding skylights. "These colors were here," he tells me. "I have enough visual decisions to make." On the second floor, the bedrooms, which are punctuated by odd bits of vintage furniture from the local street market, are given over to editing suites and painting studios. The warm, calm atmosphere of an eccentric but well-run family business pervades.

One room is exactly the same terracotta color as the backgrounds of a dreamy series of 111 tiny paintings titled "Le Temps du Sommeil" (1996–2010) that I saw at Tate Modern in the artist's retrospective. Alÿs describes the paintings, on which he worked for fourteen years, as fantasies meant to evoke "a god's vision" looking down from the clouds at "little people performing vain acts." Contemporary paintings tend to be large, but Alÿs's works in oil, encaustic, and crayon on wood are often less than five inches high by six inches wide. Miniatures are easily portable, he explains, allowing him to work on them at home or on the road. "In one suitcase, I can pack a whole series." Some of Alÿs's videos, such as his hand-drawn animation loops, are made in editions of four (plus two artist's proofs), then sold to museums and collectors. Most of his videos, however, are free for download from his website, www.francisalys.com. Alÿs finances his videos through the sale of his paintings, which occupy "a therapeutic space" where, ironically, the artist feels that he can step "out of the race of production."

Alÿs stoops next to a large Pampers box that is being used as a makeshift coffee table-cum-desk to pick up a satchel. (Alÿs is divorced and his son is ten years old; he is not sure where the diaper box came from.) The artist extracts two black sketchbooks held together with an elastic band. Inside, a mix of wispy drawings, diagrams, and handwriting cover the grid. He can't use plain paper because it would result in "chaos." Some projects drag on for years; it can be difficult to remember one's original intentions. "Drawings are mood notes," he says. "They help me remember the state of mind I was in when I drew them."

Along the hallway is a room used by Juan Garcia, a commercial painter who often collaborates with Alÿs. The two men met in the early 1990s when Alÿs conceived his *Sign Painting Project*, in which the artist commissioned three commercial painters—Garcia, Emilio Rivera, and Enrique Huerta—to make larger versions of his own paintings, most of which depicted a man in a suit interacting in surreal ways with domestic objects in a monochrome void. The aesthetic qualities of the resulting works underline the distinction between the creating artist and the executing artisan. Indeed, the commissioned copies intensify the aura of Alÿs's originals in the way that postcards of the *Mona Lisa* (1503–17) augment the uniqueness of the Leonardo da Vinci canvas that hangs in the Louvre.

In the adjoining rooms are "the kids," as Alÿs calls them: Julien Devaux, a hirsute video editor in a hoodie, and Félix Blume, a fair-haired sound editor in a T-shirt promoting a Belgian jazz club. Both men appear hypnotized by their computer screens. Devaux helps chronicle Alÿs's actions and has become "crucial to how the stories are told," while Blume is highly skilled at interpreting sound. "I trust his judgment more than my own," says Alÿs, who prefers to collaborate rather than delegate. "The key to good collaboration is that everyone has their own projects on the side," he says. "It's not so much about financial independence as the general health of relationships and the exchange of ideas."

Alÿs sees his studio set up as "a small community, based on belonging." People come together for a project, then go back to their own life. "It's a bit like cousins," he says. "Sometimes you want to be more professional, less personal, less incestuous, but it doesn't happen. These are strong bonds." Beyond the studio, Alÿs says that key individuals at his main gallery, David Zwirner, feel like another community. "It is probably one of the last business fields that is entirely based on trust," says Alÿs. "It's about your word."

Alÿs's phone rings. It's Cuauhtémoc Medina, a curator, art critic, and professor at the Universidad Nacional Autónoma de México. He is at the front door, here to join us for lunch. As we descend the staircase,

Alÿs tells me he has two long-standing colleagues who are "alter egos of sorts." Medina is integral to the "argumentative side" of his work, while Rafael Ortega, an artist and cameraman, has been essential to the "operative side." (Ortega is married to Melanie Smith, an artist who was Alÿs's girlfriend for six years, and Ortega's younger brother, Raul, is Alÿs's assistant.)

After a hug at the front door, Medina, Alÿs, and I settle into the kitchen. Visually, Alÿs and Medina bring to mind the old "Jack Sprat could eat no fat" rhyme. They are both six-foot-four; Alÿs resembles, as far as is humanly possible, an emaciated Giacometti sculpture, whereas Medina looks like a rotund bronze Botero.

The kitchen table is covered with a gray and white checked tablecloth. Running down its center like a spine is a row of bowls containing the taquitos, guacamole, sliced tomatoes, shredded lettuce, large chunks of avocado, fried cactus, grated cheese, sour cream, tomatillo sauce, and a number of other condiments. On a wooden shelf next to the table is a postcard of Kabul International Airport with a blue sky in which the artist has drawn a schematic airplane. "I need to go to Afghanistan again soon," he says. "I won't call it a 'shoot.' It would probably not be the right word for the occasion. But I have an idea for a film that unravels through the city."

One of Alÿs most famous works is *The Green Line* (2004), a video in which the artist strolls through Jerusalem along the 1948 armistice border between Jordan and Israel, dribbling a line of green paint from an open can. I wonder whether the prospective Kabul film will echo the earlier work. Alÿs presses his lips together and thinks for a minute. "The main motor behind many of my projects is a deep incapacity to understand," he says as he walks his long fingers on the table, inadvertently suggesting that traveling on foot is a reliable path to enlightenment. "Religion is a strong, sometimes overwhelming presence in the daily life of both cities," he offers. Alÿs was raised Catholic and doesn't think he could ever be an atheist. "It's too deep in my soul. I don't know how to explain it," says the artist, who is also very interested in Buddhism. Upon reflection though, Alÿs sees *The Green Line* in terms

of a monumental clash of clans rather than religion per se. "Jerusalem represents, in such a universal and atemporal manner, human conflict," he says. "It's a struggle that affects the whole of humanity in one way or another."

Alÿs often draws lines through geopolitical zones, as if his whole body were a pencil or a brush. In *The Loop* (1997), Alÿs travelled from Tijuana to San Diego, towns that are less than twenty miles apart across the Mexican–American border, by circumnavigating the entire Pacific Rim. The artist flew clockwise, starting in Tijuana, stopping fourteen times in places such as Panama City, Santiago, Auckland, Singapore, Shanghai, Anchorage, and Los Angeles, before arriving in San Diego. It's a conceptual piece that pushes the arbitrariness of national borders to an absurd extreme. The work is best known as a black-and-white postcard of a map of the world with the Pacific at its center. I often think of *The Loop* when I sit on long-haul flights for my research.

Alÿs asserts that artists are granted "poetic license," which, once given, can be hard to take away. Medina, who has been listening while he feasts, notes that although artists enjoy an astounding degree of freedom, that doesn't mean that their behavior is ungoverned by norms. "Eccentricity used to be the code," says Medina. "Now, fake normalcy prevails. You're not allowed to be a nutcase like Salvador Dalí anymore." Alÿs looks on with amusement. "Francis's case is slightly odd," adds Medina. "He has been allowed to grow outside the trade."

"For the first time in four centuries," offers Alÿs, "the artist has regained fully integrated social status. It's a liberal profession like it was at the time of Rubens. I'm glad the romantic myth of the starving artist is virtually dead."

Medina folds his arms across his chest and leans back. "Yes," he says, "that has happened in the last twenty years. There is little conflict between most artists and the powers that be. It's back to pleasing the court." However, the curator disagrees with Alÿs's use of the term "liberal profession." "Artists are an internal 'other,'" he says. "They occupy a place in the social order that is essential for the system to be able to look at itself."

Exactly what kind of an artist are you? I ask Alÿs. The question seems

to surprise him. He hums half a tune and claims not to have given it much thought. "A catalyzer," he says finally, as church bells chime over the whir of a freestanding fan. "That's where the artistic component, strictly speaking, comes into play. I'm a *partera*. What do you call a *partera* in English?" he asks vaguely. "Yes, a midwife." The metaphor is a welcome shift from the commonplace that artworks are the artist's own offspring. "I am not an inventor. I'm just the one on the side!" he adds with a laugh.

Medina looks a bit embarrassed by the comment, but he eventually brightens and raises his finger. "It's a Socratic trope," he says with relief. "Socrates saw himself as the midwife of thought because he brought forth the truth through his questions."

Cindy Sherman
Untitled #413
2003

Cindy Sherman

"I don't like to have people around," says Cindy Sherman, shortly after my arrival at the Soho penthouse that is her studio. "It makes me too self-conscious. Only occasionally has an ex-boyfriend or a cleaning lady seen me working." Sherman has been taking photographs of herself by herself for almost thirty-five years. The characters she enacts in her pictures are over-the-top, affected, stagy, crazy, or unwell. They are either performing a role or have just stepped out of one. In a plain gray T-shirt and jeans with a face free of makeup, Sherman is looking every bit the all-natural artist. Only the highlights in her long blond hair, which is tied back in a casual ponytail, hint at artifice.

Sherman's studio is a teenage girl's fantasy. The main room is a large rectangle with ninth-floor views on three sides, featuring mannequin heads wearing wigs, racks of glittery clothes, and an orange plastic cosmetics cabinet crowned with a magnifying mirror. It is dress-up heaven with a professional twist. "I am always really happy in this space," says Sherman, whose face is a charmingly choreographed dance of upward glances, subtle eyebrow lifts, and gentle lip curls. Pinned to the walls are magazine cuttings and computer printouts of women in what the artist calls "preposterous" positions, including a society lady in a ball gown making breakfast and a naked actress with a designer handbag in one hand and an albino parrot on the other. Images of

dowdy businesswomen by a photographer from Boise, Idaho, who is also named Cindy Sherman, are on display nearby.

Sherman keeps her props in a large number of methodically arranged cupboards, which she invites me to open. For an aficionado of her work, doing so offers a gleeful sense of déjà vu, revealing rows of masks, false boobs, prosthetic noses, fake hands, rubber fingers, and plastic babies; multiple color-segregated boxes of wigs, facial hair, clothes, and fabric; and finally, cameras in their cases next to neatly wound cords.

Sherman so loathes delegating that she doesn't even allow her part-time assistant to help her organize her cupboards. Needless to say, she does all her own makeup and lighting. When she takes photographs, she places a freestanding oval mirror next to the camera so she knows exactly what she looks like, then clicks on a remote. Sherman once tried hiring models, but it didn't work.

The youngest of five children (her closest sibling is nine years her senior), Sherman grew up feeling estranged from what she perceived to be an already complete family. She was married for sixteen years to Michel Auder, a video diarist whose first wife, Viva, was a Warhol "superstar." Her list of illustrious ex-boyfriends includes David Byrne, Steve Martin, and artists Robert Longo and Richard Prince. "I've never really had anybody that I talk about my work with," says Sherman. "Whatever my gallery or close friends tell me, I can only really trust myself."

Almost all of Sherman's photographs portray lone characters. The artist broke into the art world at the age of twenty-three with "Untitled Film Stills," a series of sixty-nine black-and-white images taken between 1977 and 1980. Hitting a critical nerve, the work consisted of a fictional archive of photos in which Sherman poses as starlets in movies that might have been made by Alfred Hitchcock or Michelangelo Antonioni. Its satire of female stereotypes took Pop art into a new, subtly feminist realm at a time when the representation of women was a hot topic in the art world. For some senior feminists, Sherman's politics were too discreet. "One told me that I should include text to bring out the irony," says the artist, rolling her eyes.

Ambiguity comes naturally to Sherman because she often feels

genuinely "conflicted." One is never quite sure where she stands in rela-
tion to her characters, and they, in turn, are often difficult to define. The
"Centerfold" series (1981) of twelve color photos, in which the artist shot
herself in a variety of submissive poses, added anxiety to the ambiva-
lence. Although the title conjures up images from *Playboy* magazine,
the works are not obviously sexy. Instead, Sherman presents a range
of reclining muses on their bad days, unready for the camera, lost in
thought, fearful, or depressed, and fully clothed.

I scan the room, overwhelmed by the amount of stuff. "I leave things
out to remind me to think about them," says Sherman, who walks over
to a large Canon video camera, putting her hand on its tripod support.
"I keep moving it around. It's a nagging reminder to myself to please
make a film and start thinking in terms of movement," she explains.
"Another goal is more men," says the artist, who laments that it is hard
to obtain convincing male wigs. "And I want to do more double and
multiple figures," she says, with a wave at some magazine clippings of
twins.

These goals may be delayed by the effort of overseeing her forth-
coming retrospective, which starts at New York's Museum of Modern
Art then travels to San Francisco, Minneapolis, and Dallas. A small-
scale model of eight rooms on the sixth floor of MoMA rests on its own
table near the spot where Sherman would normally shoot pictures of
herself. When she began having museum shows, she was, in her words,
"totally naïve." She would let the curator install and just show up for
the opening. Nowadays, she likes to be more involved because most
museum curators want to arrange the work in discrete series, whereas
the artist is keen to mix it up. Sherman loathes it when similar types
of work—"blondes, brunettes, long hair, short hair, closeups, more dis-
tant shots," as she puts it—are placed too close to one another, because
she is intent on making her characters look as "unrelated" as possible.

On a strip of wall between two windows are images of Brenda
Dickson, a blonde bombshell (and occasional redhead) who played a
villainess on the daytime soap opera *The Young and the Restless* in the
1970s and 1980s. Dickson is notorious for a much-spoofed vanity video
called *Welcome to my Home* in which she gives tips on fashion and

interior décor. Sherman has shots of the actress at many ages, including one where Dickson reclines on a couch under a photograph of herself. Sherman marvels at the "kind of ego," as she puts it, "that needs to put a picture of herself on the wall in her own house."

Back in the 1970s, few would have predicted that Sherman could make so many compelling series through depicting herself. The only specific celebrity Sherman has impersonated is Lucille Ball (a picture taken in a photo booth in 1975 that was blown up and issued as an unlimited edition in 2001). Otherwise, her characters are the kinds of people who seem to be famous for fifteen minutes or loom large in their own lunchtime. The art critic Rosalind Krauss once praised Sherman's early work for being "copies without originals." Almost thirty years later, Sherman's characters position the artist herself as the original.

In the art world, Sherman has become a celebrity brand, not unlike Hollywood actresses who are billed above the movie's title. She has made a few bodies of work from which she is absent, but they do not sell easily or for high prices. Collectors of her photographs want her within the frame. "It's an interesting phenomenon," admits Sherman, then, mimicking a male voice, says, "Is she behind that mask? I only want it if she is in there!" One of Sherman's "Centerfolds" recently sold for $3.9 million, a record for a photograph at auction and particularly remarkable given that the work was made in an edition of ten.

Unlike many of her peers, Sherman has stayed loyal to her dealers: Metro Pictures, the New York gallery that presented her first solo show in 1979, and Sprüth Magers, which has represented her in Europe since 1984. She thinks that artists compromise their reputations when they are obviously motivated by financial gain. "I have grown fond of Larry Gagosian," she says, "but artists damage their credibility when they leave their gallery and go to Larry for more money."

For a woman artist, physical beauty can also disrupt the process of being taken seriously. "I like experimenting with being as ugly as possible," explains Sherman. She goes over to her desk and picks up a stylus, which she moves over a giant track pad while staring at one of two large screens. Here is the hub of her studio, where she spends hours making post-production digital adjustments. She brings up a photograph that

she made for MAC cosmetics of a girly clown in bright makeup, wearing a pink Afro and a blue feather boa. For this picture, MAC used a photo lab that services the fashion industry; later, Sherman used the same lab for a piece from another series and got into a long tussle. "The guy at the lab thought he was fixing it. He got rid of the bags under my eyes and straightened out the mouth even though I had purposely made it crooked," she says. "We kept redoing it and redoing it. It didn't work. It looked boring . . . like a beauty shot."

According to Sherman, being an artist is "a state of mind." She scrolls through the MAC photos, settling on one of a woman in a fake fur coat and purple lipstick—what my mother would call mutton dressed as lamb—and says, "You have to be really focused and constantly make sure that you have faith in yourself." After a show, Sherman usually feels "spent" and wonders, "What else can I do now?" Her most difficult period was in the late 1980s, when she struggled to figure out how to refrain from appearing in her own pictures. These slumps have happened enough that she knows she will get through them. Nowadays, she doesn't feel "bummed out," as she puts it, like she used to.

Sherman is adamant that none of her works is a self-portrait, but I know of at least one photograph that surely represents an artist. Part of her "History Portraits/Old Masters" series, *Untitled #224* (1990) is a careful photographic reenactment of Caravaggio's *Sick Bacchus*, a painting commonly called *Self-Portrait as Bacchus* (c. 1593–94). Curious to understand her thoughts about a female artist pretending to be a male artist who is, in turn, playacting the part of the pagan god of wine, my question starts with the straightforward statement: *Sick Bacchus* is a self-portrait of Caravaggio. Before I can say anything further, Sherman says, "I didn't know that." That's impossible, I think to myself. I explain that I'm reading a biography of Caravaggio by Andrew Graham-Dixon, who argues that Bacchus is a relevant alter ego for an artist because the Greco-Roman god is associated with passion, unruly behavior, and divine inspiration.

"I didn't know that," she repeats.

I opt for another tack. The catalogue that accompanied her four-stop European solo show suggested that Sherman's "Clowns" (2003–04)

were representatives of artists in general and of Sherman in particular. It argued that the clowns' way of transforming themselves mirrored Sherman's own process. Covered in thick makeup and facial prostheses, Sherman's face is at its most painterly and sculptural in these brightly colored, large-scale pictures with psychedelic backgrounds. The "Clowns" are an important body of work, I venture cautiously.

"They are one of my favorite series," admits Sherman warmly. "It was such a multilayered project—learning about the history and system of clown makeup." She was captivated by the idea that clowns wear masks to conceal dark secrets. "Are they hiding pedophilia or alcoholism or a neediness for people to love them? I was fascinated with imagining the personalities underneath the makeup." These sentiments echo those of Sherman's viewers, who often wonder about the real woman behind the characters in her photographs. I suggest that the clown could be seen as a stand-in for the artist.

"I never thought of that," she says matter-of-factly.

Puzzled, I flick through her clown pictures in my head. Two are most memorable. *Untitled #420* is a diptych, portraying a clown couple. The male clown holds a balloon dog with a long phallic tail. The female clown, who has closed eyes and huge wet lips, wears a balloon flower on her dress and several more in her hat. The diptych nods at Jeff Koons. *Untitled #413*, by contrast, portrays a lone clown in tighter closeup. One of the ugliest and saddest in the series, this clown has downturned lips, swollen brown cheeks, and drab, bed-head hair. Most importantly, this clown wears a black satin jacket with the name "Cindy" embroidered in pink on the left breast. If there is a covert self-portrait in your oeuvre, I hazard to say, I assume this "Cindy" clown is it.

"No!" she declares with a twinkle in her eye that acknowledges the in-joke. "Laurie Simmons gave me that jacket years ago. I've always wanted to use it for something."

According to Sherman, she has never depicted an artist in a finished artwork, although she once made images of a couple of artists—one male, one female—for T-shirts for the nonprofit organization Artists Space. "Maybe I have the contact sheet," she says, getting up from the table and going into another room. She returns with two glossy

black-and-white 11 × 14-inch contact sheets that are labeled "1983" in orange grease pencil. The vertical images are closely cropped around Sherman's body. In both cases, she is kneeling in front of a plain paper backdrop. The male artist is a painter who looks at the viewer through his wire-rimmed glasses, brandishing a foot-long paintbrush. The female artist is a photographer with her lips ajar whose eyes are focused on a clear plastic sleeve of slides. "I should do something with the images," says Sherman. "Maybe I'll turn them into an edition."

Sherman has always insisted that her photographs are fictional. "I try to keep everything about myself out of the work," she explains. "I have never been interested in revealing any of my fantasies, personality traits, desires, or disappointments." Indeed, the pictures she edits out of her oeuvre are those she finds "scary" because they resemble her too much. Her favorites, by contrast, tend to be those photographs in which she does not recognize herself at all.

Why are you not interested in revealing yourself? I ask.

"I am sure there are a lot of psychological reasons," she says. "Ah, well, maybe I don't want to be called a narcissist." Strangely enough, when Narcissus became infatuated with his own reflection in the water, he did not realize that he was looking at himself.

Jennifer Dalton
How Do Artists Live? (Will Having Children Hurt My Art Career?)
2006

Jennifer Dalton and William Powhida

"The pictures of the writers have much more gravitas than those portraying the visual artists," says Jennifer Dalton. We're in her studio, a garage attached to her two-bedroom house in the Brooklyn neighborhood of Williamsburg, looking at a work titled *What Does an Artist Look Like?* (*Every Photograph of an Artist to Appear in* The New Yorker, *1999–2001*). Dalton went through three years of *The New Yorker*, cutting out every photo of an artist, musician, designer, author, actor, filmmaker, or architect. Then she laminated and arranged the photographs of each creative type along a continuum of credibility, or what she calls "the spectrum from genius to pin-up." Dalton pulls the thirty images of visual artists out of a gray archival storage box and arranges them in order along the two long tables that line one wall of her garage. The spectrum starts with a somber shot of Alberto Giacometti at work in his studio and ends with one of Tracy Emin wearing black lacy lingerie and sitting with her legs spread apart on a mirrored stool. With few exceptions, the men appear more serious than the women. Many are depicted at mid-range in front of their work, looking directly at the camera without smiling. "Even when the women are not represented as pin-ups, they're not exactly valorized either," says Dalton, pointing to a shot of Pipilotti Rist surrounded by one of her installations. The unwritten rule seems to be: never shoot a woman artist from the waist up if she has great legs.

"My work examines my surroundings, which includes the art world," says Dalton, as she scrapes her white, wrought-iron kitchen chair along the cement floor toward her computer. Dalton is in her mid-forties, married, with a son. She has a BA from UCLA and an MFA from the Pratt Institute of Art. For the past sixteen years, she has had the same day job, inputting appraisal information into the Christie's database. She has stuck with this "low-level" job because she can work from home and save her mental energy for her art.

Dalton clicks on her old Toshiba laptop, which whirs so loudly that it has been nicknamed "the helicopter" by William Powhida, an artist with whom she sometimes collaborates and who will lunch with us today. Up pops one of her works, *How Do Artists Live?* (2006), which is based on responses from 856 artists, collected mostly via the Internet. The piece exists in two forms: first, as a series of twenty-one drawings that are soft chalk pastel on paper but appear to be made on chalkboards, then as a slideshow that presents the drawings in sequence. "I wanted it to look like a handmade PowerPoint presentation," explains Dalton, "so I mimicked the program's compositional tools, putting text in boxes and making statistical charts."

The work takes a subjective spin on sociological data—what Dalton calls "quasi-science." The artist clicks past the title page to a drawing headlined, "How much do artists earn?" It contains a colorful pie chart surrounded by Dalton's handwriting, which reveals that more than half of the artists who responded to the survey earn less than the American median wage. A few slides later, a drawing titled "Artists' #1 Source of Income" reveals that 60 percent of the artists rely primarily on alternative forms of employment while only 10 percent make a living mainly from sales of their art. A sliver of pie suggests that .8 percent derive most of their income through illegal means. "It's mostly not real criminal activity," says Dalton, sweeping her redder-than-red hair off her shoulder. "Most of the money comes from illegal subletting." Another drawing demonstrates that men are twice as likely as women to derive their income through sales of their work.

Toward the end of the presentation, a handwritten title poses the question, "Will having children hurt my art career?" Beneath it, a chart

with four rising bars demonstrates that women with children are much less likely to have gallery representation than women without children. No surprise there. But the graph also shows that men with children are twice as likely to have representation as men without. The bulging bar that represents the artist-fathers is almost phallic. "I think it sticks out like a middle finger," says Dalton.

The chalkboard aesthetic of *How Do Artists Live?* implies the persona of a female school teacher. John Baldessari once told me that he only felt confident declaring himself an artist after he quit teaching high school art. While lecturing at Yale or UCLA can act as an endorsement, being a high school educator usually disrupts credibility, so most artists studiously avoid any evocation of teaching teenagers in their work. I suggest that when artists move into pornographic or drug-addled terrain, they are following a rule rather than breaking one, whereas Dalton has truly transgressed art-world norms. "Yeah, 'bad boy' transgression is very formulaic," says Dalton, who relishes the thought that she could subvert the rules by being "a Goody Two-shoes."

We leave the garage, enter the house through the back door, and walk through the kitchen into the living room, where a twenty-year-old cat called Goose is sleeping beneath a large drawing of a bedroom headboard with the names "Jerry" and "Roberta" handwritten on it in white chalk pastel. Titled *He Said, She Said* (2005), the work likens reviewing to sexual conquest by suggesting that artists are just notches on a critic's bedpost. "The bed in the drawing is the same shape as my headboard," says Dalton with a broad grin, amused by its perversity. According to the notches, one third of Jerry Saltz's reviews were of women's shows, compared to only a quarter of Roberta Smith's. "There's no shortage of women artists, they're just not getting the shows," says Dalton. "When you look at the stats on who's graduating from art school, it's 60 percent female."

We get into Dalton's shiny black Honda Fit and immediately pass an art supply store. Dalton suspects Williamsburg is home to fewer artists than it used to be because it has become too expensive. It still has a vibrant music scene, but the residents have shifted toward "affluent arty types." Artists have been migrating out along the "L train" subway

line for several decades. Williamsburg is just one stop away from Manhattan's East Village, the old hub of the young art scene. "Bushwick is the new place. It's a few stops further out on the L," explains Dalton as we head to the epicenter of the Bushwick art world, to a pizza place called Roberta's.

"The sacrifices of being an artist are enormous and the rewards are often small and fleeting," says Dalton as she drives along Morgan Avenue. "So I ask myself, why do we do this? One answer is community. These are my people. We love talking about art, looking at art, hanging out with other artists." According to Dalton, the people in her small art world are collegial and supportive of one another, even if they are also competitive and status-seeking. "It doesn't usually feel like a zero sum game...except when you look at the list of artists chosen for the Whitney Biennial, then you're just like, *grrr*."

Was that a dog sound? I ask. Could you put that into words?

"*Grrr*...I guess it means, 'Why them?'" As Dalton parks the car, she points out the Bogart, a four-story factory with thousands of small windowpanes that now houses 110 artists' studios and sixteen exhibition spaces. "There are just too many good artists and not enough slots," she eventually says in answer to her own question.

As we walk toward the restaurant, we see Powhida in jeans and a white T-shirt, locking his cruiser bike to a stop sign. He lives around the corner with his wife and teaches half-time at Brooklyn Preparatory High, a school where more than half the students live at or below the poverty line. Truancy vans keep attendance up and, when anyone enters the building, they go through metal detectors and airport-style x-ray machines under the supervision of a branch of the NYPD. Powhida teaches everything from cave painting to street art. "There's no cachet in it," says Powhida, who sometimes experiences culture shock when he goes straight from the school to an event in the white art world. "But it's honest work and it feels like I'm doing some good."

From the outside, Roberta's is hilariously uninviting. The façade consists of a rectangle of cement blocks with rusted metal window grates and a peppering of sloppy aerosol graffiti tags. I assume it satisfies their patrons' desire to be in-the-know. Inside, two cooks with white chef hats

and a wood-burning oven offer reassurance. We sit on benches at one end of a long, communal, wooden table.

While Dalton and Powhida read the menu, I survey the low-key crowd. Dalton is fascinated by the way people "hang out" on Jerry Saltz's and Dan Cameron's Facebook pages. "Jerry sometimes gets over 800 comments on his posts," she says. Powhida has 60,000 followers on Tumblr. He remarks that "the new metrics of success" consist of quickly clicked "likes."

Our waiter eventually ambles over. After he has taken our order, I ask, what percentage of your clientele do you think are artists?

"Seriously?" he replies, as if he has never in his entire life encountered such a nerd. I tell him that I'm a writer so I'm allowed to ask intrusive questions.

"About 30 percent," he says, changing his tone. "I went to art school and 80 percent of the staff have degrees in film studies, art history, or studio art." Clearly, the staff, if not the clientele, are in that awkward no man's land between having studied something and being someone (that you might call an artist).

In spring 2010, Dalton and Powhida organized an exhibition called "#class," which became a gathering place for many artists. The pair transformed Chelsea's Winkleman Gallery into a classroom lined with green chalkboards. Then they held sixty lectures, performances, and discussions (three a day, five days a week, for four weeks) on a number of topics, including "Success," "Failure and Anonymity," "The Ivory Tower," "Bad Curating," and "Painters against the World." Over the course of the month, the chalkboards were repeatedly filled and erased with illustrations from the conversations. Sometimes you could see the bullet points of logical arguments; other times it looked like a bathroom wall of random irreverence.

"A community grew around '#class,'" says Powhida. "It was an instance of 'relational aesthetics.' The social interactions were the art."

"I imagine that it was a bit like the feminist conscious-raising sessions of 1970s," adds Dalton.

"The title of the show was a pun on class," says Powhida as our beers arrive. "An educational group but also 'class' in the economic sense of a

social class." In pursuit of this theme, they decided that the chalkboards should not be a standard green but the elusive color of money. They found a recipe on the Martha Stewart website involving powdered tile grout that allowed them to customize the hue.

One of the most talked about sessions of "#class" was Ben Davis's "9.5 Theses on Art and Class," a riff on Martin Luther's famous "95 Theses" about the failings of the Catholic Church. One of Davis's contentions is that class antagonism manifests itself in critiques of the art market. He sees the visual arts as having an essentially "middle-class character" that is "dominated by ruling-class values" and laments their "weak relations with the working class." Davis is writing a book based on the ten-page document that he circulated at "#class."

Powhida suggests that working collaboratively to create events might be more politically responsible to our times than making objects that display individuality, but he loves "entertaining" himself in the studio by sketching and drawing on his own. Indeed, the artist is best known for his satirical drawings. In a work titled *Post-Boom Odds* (2008), he refers to himself as a "genius trading in specificity and desperation... making fun of shit." His most notorious drawing was published on the cover of the *Brooklyn Rail* in November 2009. Titled *How the New Museum Committed Suicide with Banality*, it featured caricatures of Jeff Koons (described as "the guest curator") and Massimiliano Gioni ("the free agent") who are censured for their part in filling the public space of the New Museum with a private collection, that of Dakis Joannou (labeled "the trustee").

Dalton and Powhida started working together in 2008, when their respective dealers (Edward Winkleman and Schroeder Romero) suggested they collaborate on something. "Our galleries noticed that we both did work that was text-based and obnoxious," says Dalton. "Critical and humorous!" corrects Powhida. So the pair made a set of condolence cards for artists and other art-world insiders to send to one another. On one was written, "I am so sorry for your loss of representation," next to a drawing of a tombstone engraved with the words, "Your career, 2001–2008, R.I.P."

The two artists have never tried to create a unified identity or joint

brand. Yet Powhida admits to being attracted to what he describes as "radical cooperatives" like the Bruce High Quality Foundation. This Brooklyn-based artist collective has shown its work in various exhibitions, including the 2010 Whitney Biennial. It has also raised the funding to run free seminars as part of the Bruce High Quality Foundation University. While Vito Schnabel, son of artist Julian Schnabel and a high school classmate of Lena Dunham, is known to be the collective's agent, the artist-members of the group choose to remain anonymous. Sometimes a spokesperson for the group will suggest that they are resisting the "star-making machinery of the art market." Other times one will admit that anonymity is "a marketing gimmick." Indeed, the Bruce High Quality Foundation has become a celebrated brand. "It's hard to gauge their motivations," says Powhida, "but they can't be all bad."

What are your motivations in sustaining your collaboration? I ask the artists.

"For me it is about letting go of individual authorship," says Powhida.

"I am—the expression 'control freak' comes to mind—but it can be fun to give up full control," says Dalton.

"It's a good way to get out of your comfort zone so you can do something new," says Powhida. "Collaboration is also a form of support. It's harder to dismiss two artists than one."

Maurizio Cattelan
L.O.V.E.
2010

Francesco Bonami

"In the Italian provinces, 'artist' is a synonym for dunce," says Francesco Bonami in his "unauthorized autobiography" of Maurizio Cattelan. The first curator to include Cattelan in the Venice Biennale, Bonami has since exhibited the artist's work seven times, acted as a regular sounding board for his ideas, and titled some of his most important works. The curator has even acted as a ventriloquist for the artist in a faux autobiography that is "full of mistakes that turn out, by chance, to be exactly right."

Bonami and I are looking at a public monument recently erected in the middle of Milan's Piazza Affari or "Business Square." Carved out of gray-white Carrara marble, Cattelan's giant hand has all its fingers cut off except the middle one, the one that has the authority to gesture rudely. The hand, which I heard the artist discussing on the phone when I visited his Chelsea apartment, calls to mind late Roman sculptures such as the Colossus of Constantine. It sits on a high plinth made out of a creamier-colored travertine, the same stone as the Milan stock exchange that looms behind it. The plinth is already covered with graffiti—smiley faces, names with dates, messages to God such as "Ciao Dio!" and a few "Merda" comments that seem to be passing judgment on the work.

In order to obtain a view of the piece, we weave our way through the

Fiats and Clios that are parked around the phallic finger to the edge of the piazza. Rain sprinkles have turned into a steady drizzle, so we take cover under the eaves of one of the many banks that line the square. "Some people think he is giving the finger to the stock exchange. I think the stock exchange is giving the finger to the people," says Bonami with typical jocularity. Bonami has pale blue-green eyes, short-cropped hair, and long gray stubble. He comes across as a mauled teddy bear—one who comes to life and wreaks havoc among the other toys when his owner sleeps.

The sculpture is titled *L.O.V.E.* (2010). It was unveiled in September 2010 to coincide with the opening of a Cattelan show curated by Bonami at the Palazzo Reale. The "retrospective" included only three works: a grand patriarchal Pope (1999), a crucified woman in a crate (2007), and an animatronic figure of a boy with a toy drum (2003). Cattelan saw the selection of hyperreal sculptures as "a family."

While I try to remember what the acronym *L.O.V.E.* stands for, Bonami tells me that it depends on the language and that even though he was "involved in the conversation about the title," he is not sure. "Lies, Liberty, Oligarchs, Violence, Vendettas, Emptiness, Envy?" he surmises. "Elsewhere it might be a stupid piece, but here it works very well." *L.O.V.E.* is the only new public sculpture to grace the streets of Milan for some time. During a dark moment in Italy's rolling economic crisis, Cattelan chose the location, then had friends pull strings to obtain government permission to erect the sculpture there. Initially, it was to be here for only a few weeks, but now, thanks to the mayor's intervention, it will stay for three decades. Most of Cattelan's sculptures are made in editions of three. "I think this one is unique," says Bonami, "but there is always a possibility to do more if someone is asking."

Bonami met Cattelan when he was figuring out which artists to put in his section of the 1993 Venice Biennale. The curator included a few "hot" artists who have since disappeared and many unknown ones, such as Cattelan, Gabriel Orozco, Charles Ray, and Paul McCarthy, who have gone on to achieve high levels of recognition. In 1996, 1997, and 1998, the curator showed Cattelan in group exhibitions in Torino, Santa Fe, and Paris. Then, in 2001, Bonami commissioned a sculpture for the

Museum of Contemporary Art in Chicago. Cattelan delivered *Felix*, a giant cat skeleton. "A terrible work," says Bonami, "the fifth bad work he gave me." In 2003, when Bonami was director of the entire Venice Biennale, he again invited Cattelan to participate. "He sent *Charlie*, a stupid self-portrait on a tricycle," says Bonami. "The only great work Maurizio has made for a show of mine is *All*, which I put in the atrium at Palazzo Grassi as part of my show of Italian art since the sixties." One of the many Cattelan pieces upon which Bonami has bestowed a title, *All* (2007) consists of nine marble sculptures of corpses draped in fabric. Exquisitely carved by masters in a workshop in Carrara (a two-hour drive from here), the restrained sculpture confronts the viewer with the anonymity and odd beauty of death.

Bonami wrote an introduction to his mock Cattelan autobiography in his own voice. "Cattelan is a contemporary Pinocchio," he says, "and I'm like some poor Geppetto forced to listen to endless tall tales and half-truths." Certainly, Cattelan has a reputation for being coy with the truth and often poses for photos in a way that accentuates the unbelievable size of his nose, but the statement also suggests that Bonami created Cattelan. The rain subsides and we perambulate the outer edge of the piazza, moving counterclockwise around the finger. I remind the curator of his analogy, suggesting that Geppetto is the artist and Pinocchio is his masterwork. "Maurizio was already in the piece of wood. I didn't make him but I finished off his legs and got him to walk," says Bonami. "But then I was punished. He kicked me hard in the shins!"

Bonami puffs out his cheeks so he looks like a chipmunk, lets out the air slowly, and then looks at me out of the corner of his eye. "What can I say?" he says. "Maurizio is a very good friend but every time I describe him I come out with something negative."

It sounds like siblings, I remark. You love them but you complain about them.

"Love is a very particular thing," says Bonami. "I wouldn't say I love him and I don't think he loves me. But, yeah, you could say we are like brothers. He has screwed me a few times. It is his way. He can be very annoying. He's always up to something but you don't necessarily know what it is." Bonami's whole face puckers in an emphatic expression of

agony. "Artists are not kind people. They do what they do. That's why they are artists."

Are curators kind? I ask. A *curatore* is a "carer" by definition, yes?

"Curating can be about taking care of the artist. When you do a solo show, you are basically a butler. The artist chooses everything." Bonami has curated retrospectives of Jeff Koons and Rudolf Stingel but, no matter how much he likes the artist, he prefers to work on group shows, which allow him more creative control. "Curator is not even a job," he continues. "It's just something between an artist, a writer, and a butler. We are frustrated people."

Two blondes with complicated handbags and beige Uggs interrupt us, requesting that we take their picture in front of Cattelan's finger. I oblige. Despite the weather, we've seen a steady stream of young people making pilgrimages to the already notorious sculpture.

As we resume our stroll around the finger, Bonami admits that it can be hard to distinguish between "long-lasting artists" and "artists that just have a moment, who are very important but then disappear." However, in a book published in Italian titled *He Thinks He's Picasso*, Bonami puts artists into four hard-and-fast categories according to whether they are real or fake, good or bad. "Bruce Nauman has an urgency to make art. He is very consistent within his rules. He is a good real artist," explains Bonami. "Jasper Johns is a real artist but his work is shit. He is a bad real artist." We pause at the Quentin Tarantinoesque sight of five business-men in long dark coats striding briskly through the square. "Francis Alÿs is a good fake artist," continues Bonami. "Alÿs has a romantic idea of an artist and he plays it very well. He *walks* it well and he has created some great work." Bonami sees Ai Weiwei as the epitome of a bad fake artist. "I would put him back in jail for his art," says the curator cheerfully.

Knowing that Bonami has worked with Orozco, I inquire about him. "Orozco? My old friend," says Bonami, followed by a long pause. "I called him the Michael Corleone of Mexico. We don't talk anymore." Bonami sees Orozco as the kind of skillful political animal who becomes the don of a crime syndicate, just as Al Pacino's character did in *The Godfather*. Orozco is the leader of a group of Mexican artists who used to meet every Friday at his home to discuss their work and are now

represented by kurimanzutto, a gallery he helped found in Mexico City. Bonami extended the analogy in an article in *Tate Etc*, suggesting that Orozco's stalwart supporter, Benjamin Buchloh, a Marxist art historian who teaches at Harvard, was "the Don Vito Corleone of institutional critique." When Bonami curated the Venice Biennale in 2003, he asked Orozco to curate a room in the Arsenale. It turned out to be one of the most praised parts of the show. "Orozco is a very good real artist but he is a fake revolutionary," declares Bonami. "He is a fake revolutionary but a real dictator. But who cares? Art is about aesthetics."

And Cattelan? I ask. "He's a good fake. Sometimes you are such a good fake artist that you redefine the real. Roman sculpture was copied from the Greek but then it became the real thing," says Bonami. Ideas about originality have shifted. "Did the second painter to do a Crucifixion steal the idea from the first one? Until Duchamp, artists were not obsessed with ideas. It was about who could do the best version." Bonami contemplates his watch, which looks like a fancy Jaeger–LeCoultre timepiece to me though he insists, unconvincingly, that it's a cheap, gold-plated knockoff. "Maurizio may be the Duchamp of his time, but he is also the victim of that. His obsession with creating news all around the world has become a problem."

We leave the piazza and talk as we walk to one of Bonami's favorite lunch spots. I was surprised to see Bonami use the word "dunce" in print, even in jest. Art educators will sometimes talk about the high rates of dyslexia, dyscalculia, and attention deficit disorder amongst their artist-students, but it doesn't mean they are not bright. "Most artists are like donkeys. They bray. They make a suffering, complaining sound," explains Bonami sardonically. "Great artists are like horses. A neigh is more heroic. Maurizio kills horses because it is the dream of all donkeys." Cattelan has made several works that allude to struggles for artistic empowerment, featuring these animals. In general, the artist's donkeys (a.k.a. asses) fare better than the noble racehorses, which find themselves stuffed and suspended from the ceiling in harnesses or mounted head first in the wall. As we enter the restaurant, Bonami concludes, "If Maurizio could put a purebred artist on the wall, he would."

Laurie Simmons
Love Doll: Day 27/Day 1 (New in Box)
2010

Grace Dunham

Over the years, Grace Dunham has attended forty or fifty of her parents' exhibition openings. Many of the adults she encountered as a child were artists. They dominated her parents' social circles and even those of her friends' parents because she attended Saint Ann's, a private school in Brooklyn Heights to which so many artists sent their kids that the remedial math class was called "Math for Artists."

Grace has new glasses since she appeared in her sister's film *Tiny Furniture*. This evening at Laurie Simmons's opening in the East End of London, she wears thick round Sol Moscot specs in a style favored by Andy Warhol. Wilkinson Gallery has put on an exhibition of Simmons's earliest and most recent bodies of work. This airy ground-floor room hosts twenty-eight images from her "Early Black and White Interiors" (1976–78), while an even grander room on the floor above displays six large-scale color photos from her "Love Doll" series (2009–11).

"When I was young, these images scared me," says Grace as we inch our way clockwise around the perimeter of the ground-floor space, looking at 8 × 10-inch photographs of doll's house interiors that were made before she was born. We pause in front of a silver gelatin print titled *Woman Lying on Floor (Aerial View)* (1976), in which a plastic housewife doll lies diagonally against a grid of tiles on a kitchen floor. "I used to relate to my mother's series as if they were children's books

like *Magic School Bus*," she explains. "Each series was a different picture book that I could memorize. Nowadays, I think about them in terms of what my mother was going through at the time."

For much of her youth, Grace wanted to be an art dealer—a fact that inspired her sister's first short film, a fake documentary called *Dealing*. "Lena cast me as this ambitious little weirdo in a black turtleneck," she explains. In the middle of this room stands a trio of dealers all dressed in black. Amanda Wilkinson, a platinum blonde in a long black dress with translucent horizontal stripes, is talking to Jeanne Greenberg, Simmons's New York dealer, a pixie-ish brunette in see-through black lace trousers, and Barbara Gladstone, Carroll Dunham's New York dealer, who is meticulously monochrome from her jet-black hair to her shiny Prada platforms. Both New York gallerists attended the preview of the 54th edition of the Venice Biennale last week and will soon head to Switzerland in anticipation of Art Basel.

"I have this horrible memory," admits Grace. "I was in preschool and met a kid who said that her parents were artists. So I asked, what galleries do your parents show at? I was met with a dumb stare. I was probably four or five. I'm embarrassed that I was such a snobby little bitch." From a young age, Grace understood that her parents were among a minority of artists who made a living from their work. "I had a sports trivia relationship to art," she explains. "I could list which artists showed with which dealers and which ones had had major retrospectives." She also had a visceral understanding of the art-world distinction between "serious" and "unserious" artists. "A serious artist is seen to be part of some art-historical progression and is involved in the particular global art world that my parents are, whereas an unserious artist shows at a gallery in Santa Fe," she explains dispassionately. "It is a value judgment that may have more to do with context than the act of making of art."

Grace spent a lot of time making things with her father. "Every night after dinner, we would draw together for two hours. Then, at school, I would draw his characters." Between 2000 and 2007, Dunham rarely depicted women; he focused instead on a snappily dressed male character with a nose shaped like a cartoony cock and balls. Often pictured

with guns, these masculine creatures inhabited an absurd landscape that was closer to hell than paradise. "I too would doodle men with dick noses and top hats," says Grace. "It was like a comic book character to me." About the sexual connotations of her father's work, she says, "I knew but I didn't know. In a lot of ways, I still don't see it." She recently visited her father's studio and saw a painting of a pink woman in an idyllic landscape with an unmistakable vagina. "For me, it is beautiful and celebratory. It upsets me if anyone sees it as profane," she says. "I think my dad is making weird, unique, preposterous paintings about what it means to be a white man. No one ever talks about identity in relation to straight white men's work."

Although Grace is suspicious of people who have "bulletproof answers to big questions," she relishes the query, "What is an artist?" and quickly suggests that we need to distinguish between the public role and the private–creative one. "The artist is just the coolest guy in the room," she says of the former. "The artist is the one that everyone is obsessed with, the figure who inspires and makes people jealous. It's a deeply powerful social position."

Although Grace has never wanted to be an artist, she has always been preoccupied with artistry. "Making things is the organizing principle of my parents' life," she explains. "I was shocked when I heard friends say that their parents didn't love their jobs." This perspective has been reinforced now that Grace is in the "extremely specific bubble" of Brown University, where people, as she sees it, "are into being an artist way more than they are at Princeton, where they want to be bankers."

On our way out of the main room, Grace and I encounter her father, looking dapper in a lightweight wool suit. Carroll Dunham affirms that the exhibition spaces are "striking" and Simmons's work looks "fantastic," then wonders when we can head over to the Bistrotheque restaurant as he has, as he puts it, "hit the limit of my ability to function at an opening." As we climb the stairs to see the "Love Doll" pictures, Grace admits, "I see my parents as well respected with solid, long-lasting careers that have never skyrocketed like those of Cindy Sherman or Jeff Koons. It is weird how well-matched they are in that way. I wonder what would have happened if one of them had their prices triple."

Grace doesn't see examples in art history of artist couples whose relationships resemble that of her parents. Diego Rivera and Frida Kahlo, for instance, she finds particularly inapt and unappealing. "The dynamic of their relationship was so traditional," she explains, wrinkling her nose. "Diego had grandiose ambitions. He made murals with titles like *Man, Controller of the Universe*. Frida made self-reflective, personal paintings about being a victim."

The "Love Doll" photographs, which hang in this elegant room crowned by a pitched roof with giant skylights, simmer with anxiety about the potential of female figures to become prey. *Day 29 (Nude with Dog)* (2011) is particularly uneasy. Simmons eventually managed to get over her inhibitions of photographing the doll naked, settling on a shot in which her mother's poodle has wandered into frame. The presence of a live animal protects the surrogate teen and lessens her vulgarity, distracting us from but not obviating the lewd uses to which her kind are put when undressed.

Simmons is standing, surrounded by well-wishers, in front of *Day 27/ Day 1 (New in Box)* (2010), which depicts a second love doll with long, reddish, curly hair amid the packaging in which she arrived. "It is the only picture that explicitly acknowledges what she is," says Grace, as she checks that her white man's shirt is buttoned up to the top. Simmons acquired one life-size doll, then another—both of which look remarkably like real young women—at around the same time that her two daughters were leaving home. Grace looks startled when I mention the coincidence, asserting that it had never occurred to her. She pulls her long, dark brown hair back into a makeshift ponytail while she thinks. "The second doll looks a lot like my ex-girlfriend," she says. "Their faces are so similar that it's creepy."

Grace and I drift into the center of the room to take in all six "Love Doll" images. I mention Pygmalion, an ancient Greek sculptor who created such a perfect female form out of ivory that she came to life. Pinocchio is a paternalistic variant on the myth. Grace nods. "That's why it was difficult to leave the doll naked," she says. "Dressing her has the effect of humanizing her."

Maurizio Cattelan
ALL
2011

Maurizio Cattelan

Maurizio Cattelan and I are sitting in a frenetic Sichuan restaurant near his Chelsea apartment. With plates clashing and staff yelling in Chinese, it is an abysmal environment for recording an interview. Cattelan's big retrospective opens at the Guggenheim Museum this evening and, while many artists would see the day as an occasion for celebration, Cattelan sticks to his routine. Although he lunches here regularly, he receives no special treatment. His custom-made gray T-shirt says: "My ego follows me."

This morning I went to the press preview of his exhibition. Nancy Spector, its curator, referred to the show as a "mass execution," which treats individual artworks as if they were "salami in a butcher's shop." Survey shows tend to offer a respectful chronological look at the best of an artist's oeuvre, excluding weaker works and giving stronger ones a room to themselves. Selective reverence is a means of inserting the artist into the canon of art history. Few artists resist this elite rite of passage, but Cattelan has refused it and created a landmark show.

Titled "All," the exhibition is an anti-retrospective. It doesn't look back as much as throw everything up in the air—or rather hang it, gallows-style, in the vast spiral-shaped atrium of the museum. Important works are deprived of their majesty while minor works are elevated. "It's unedited and democratic," says Cattelan, once the waitress has

bullied our orders out of us. "I didn't enjoy seeing the works I forgot I had fathered. When you don't like them, you take them out of your mind."

The Guggenheim Museum, designed by Frank Lloyd Wright, exemplifies the age-old competition between architects and artists. It is notoriously inhospitable to art, particularly because its atrium offers a more engaging spectacle than the official exhibition spaces that are arranged along a winding ramp. But Cattelan has effectively upstaged the building by placing all his work in the light-filled center. "My strength has been to use the corner. Artists never want to use the corner but I'm always happy to take it." The Guggenheim rotunda has no corners, so the artist turned his attention to the void. "We're an even match," boasts Cattelan with respect to Lloyd Wright.

"*All* is an experiment, a new work, a meta-work," he explains so morosely that I assume he is bracing himself to be misunderstood. With the exception of a disturbing sculpture portraying three boys with nooses around their necks (*Untitled*, 2004), individual Cattelan works have looked better elsewhere. One piece that is particularly disadvantaged by the hang is *Him* (2001), a spookily realistic portrait of Hitler kneeling in prayer. The work is smaller than life-size and usually installed facing a wall. Viewers approach it from behind, expecting to see a good or, at least, penitent boy. When they are within inches of the work, they realize who "he" is and recoil in horror. Among other things, *Him* poses the question: if the Führer asked for absolution, would God forgive him? But when the figure dangles in the middle of the atrium, its impact is dulled. It even looks like the evil dictator could be ascending. Indeed, Francesco Bonami, whom I saw at the press preview, joked that the works appear to be "souls on Judgment Day, rising to heaven."

The Guggenheim opening has coincided with the announcement of Cattelan's retirement. Artists drift away from making work but rarely make a highly publicized withdrawal. The declaration has led to comparisons with Marcel Duchamp who, in the 1920s, abandoned making art in favor of playing chess. When Cattelan was working on "All," he was, in his words, "not sad but completely detached." He felt like he "couldn't care less" and concluded that he needed a break. Significantly,

the only Cattelan piece to escape being strung up is a small Pinocchio figure, which lies face down in a pool at the base of the rotunda, titled *Daddy Daddy* (2008). The character appears to have drowned or fallen to his death from the ramps above.

"Being an artist is a role game. You can play whatever role you want," says Cattelan between mouthfuls of numbingly spicy chicken. "Retirement opens the game again. It is an opportunity to reinvent yourself."

Cattelan lives in New York less than half the year; he has an apartment in Milan and a "shack," as he calls it, on Filicudi, an Italian island northeast of Sicily. Evidently, he can afford to retire. "I am happy to have escaped my origins but I don't belong to my new class," he says. "My luxury is traveling and being here with you without the stress of making it to the end of the month." He prides himself on the absence of televisions, cars, and cleaning ladies from all of his homes. "My bed is on the floor here, in Milan, everywhere," says Cattelan. "I manage my life like a student with no certain tomorrow."

Retiring from art doesn't mean complete withdrawal from the art world. Cattelan plans to open a nonprofit space called Family Business with curator Massimiliano Gioni. In 2002, Cattelan and Gioni, along with Ali Subotnick, started up a nonprofit space called the Wrong Gallery. Following Cattelan's penchant for miniaturization, it was located in a doorway on West 20th Street, measuring all of three square feet. It mostly showed single works by up-and-coming artists but, once a year, as a result of the group's rental agreement, the gallery would host an exhibition titled "The Landlord's Wife's Show." Occasionally, the exhibitions would spill into the street. Elmgreen & Dragset's *Forgotten Baby* (2005), for example, featured a Mini Cooper containing a lifelike wax baby abandoned in his car seat.

One sideline that is becoming a core Cattelan activity is *Toilet Paper*. Inaugurated in June 2010, the magazine is the latest in the artist's series of collaborative print media projects. *Toilet Paper* contains absurd, surreal, and sometimes sadistic images that Cattelan makes with Pierpaolo Ferrari, a photographer. The first issue had two covers: a black-and-white photograph of a woman looking at a glass eye in a man's mouth, and a color picture of a nun shooting up heroin. With *Toilet Paper*,

Cattelan feels liberated from the expectation of producing great works of art. "I like the idea that it is just a magazine," he says. "It gives me the freedom to do what I couldn't do with my own work, the freedom to make mistakes."

Cattelan started collaborating with Ferrari six years ago on publicity shots in which the artist appeared as a socially awkward prankster with a big nose. "That joker is my front man. I use my face as a device to support my projects," admits Cattelan. The art world—particularly its academic regions—derides the cult of personality. "I need the art world, but it is not the world I want to reach." Then, in summer 2009, Cattelan worked with Ferrari on eleven double-page spreads for *W* magazine, featuring supermodel Linda Evangelista. During the three-day shoot, Cattelan had his first taste of being a "creative director"—a role that he relished. "It was an anomaly, an experiment on the side," says Cattelan, "which may now become my field."

Cattelan has always been interested in what he calls the "media resonance" or "visual persistence" of his work, so his current fascination with more broadly distributed images comes as no surprise. The name *Toilet Paper* may say it all—the desire to be ubiquitous and disposable. "Everybody needs *Toilet Paper*," he quips.

The waitress delivers our bill with two fortune cookies. I crack mine open. It says, "Make it a rule of life never to regret and never to look back." I hand it to Cattelan. On the day of your retrospective, I say, this one is for you. Cattelan reads it, then the slip of paper he's pulled out of his own cookie. "Here's yours," he says with a smile. It says, "There's no such thing as an ordinary cat."

Lena Dunham
Still from *Tiny Furniture*
2010

SCENE 13

Lena Dunham

"I was told that I should go on a date with Maurizio," says Lena Dunham incredulously about the artist who is twenty-six years her senior. The writer–actress–director–producer has just ordered buttered scones and camomile tea in the quiet lobby of a hotel in the West End of London. The front desk knows her only by a pseudonym. She is wearing earrings in the shape of small bats and a slimming black jacket that she describes as a "pleasure to own," and looks much more beautiful than she does on her HBO show *Girls*.

"When I was little, I thought the New York art world was everything," says Lena in her distinctly sweet and scratchy voice. "I can't remember a time when I wasn't aware of the mechanics. You go into your studio, you have studio visits, you have openings." Until the age of eight, she wanted to be an artist. "I thought that was what people's jobs were and I thought it was cool to be the same thing as your parents."

During adolescence, Lena decided that being a visual artist was "old-fashioned" and "small." It felt like "a trap." In her view, the audience for art is "rich people" and "those who wander into the white box." In a world of new communications technologies that have the power to reach millions, "it didn't seem germane." Being an artist felt stifling in other ways too. "My dad is such a verbal, funny person," says Lena, "but he does this job where, for the most part, talking doesn't exist."

When *Girls* first launched, bloggers attacked Lena for benefiting from nepotism, as if Carroll Dunham ran HBO or Laurie Simmons had sway in Hollywood. "People were complaining before they had figured out who my parents were," she explains. Shortly afterward, the Internet was flooded with articles about Lena's "not-so-famous" artist parents. "No one is going to give you a TV show because of your parents," she declares as she slips off her shoes and swings her legs up onto the velvet couch. "It is just not going to happen."

Growing up in an artistic household, however, had positive effects. "I was given the tools, the space, and the support to do whatever I wanted," she explains. "New approaches to old problems were encouraged." Lena thinks about creativity as "an ineffable bug that takes you over but also something that you can learn." The idea that you need to be inspired is unhelpful, if not obstructive. "My parents taught me that you can have a creative approach to thinking that is almost scientific," she explains. "You don't have to be at the mercy of the muse. You need your own internalized thinking process that you can perform again and again."

Although Lena abandoned her desire to be an artist in the strict sense, her definition of an artist could be applied to her current role. "As an artist," she says, "you get the opportunity to write the world—or create the world—that exists in your fantasies. It's a really beautiful thing to do."

From afar, Lena's work in television might look closer to her mother's collaborations than to her father's solitary practice of painting, but Lena doesn't see it that way. "Everything that I do comes out of writing. It's the genesis point," she explains. "You go within yourself, wrestle with your demons, scribble some stuff up and come out with a vision of what the world is like. It is closer to being a painter." By contrast, Lena views being a director as akin to being a photographer because both are "managerial and social." She shines as she admits, "It rescues you from the lonely life of a writer." As an extension of her writing and directing roles, Lena is also a producer. Ironically, in television, the term "producer" is used interchangeably to describe either "the creator" or a person with the financial skills to raise and allocate money. It's hard

to imagine that happening in the art world, where artists who act like dealers are often viewed with suspicion.

When it comes to artists and actors, Lena finds few parallels. "You can't indulge your private creative brain when you are following a script," she says. An actor is more like a musician in an orchestra. "When I am acting, I don't feel like a boss," she explains. "I feel like I am working in service to myself as a director. And I wish every actor was thinking that way too!"

When Lena cast her mother as a dealer in *Girls*, Simmons behaved on set like the artist she is. In an interview broadcast after the program, Lena said, Simmons is "the biggest diva I've worked with in this business. She changed all her lines. She chose her own costumes. She gave direction to other actors as well as the DP." Lena wavers comically between smiling and frowning when I confront her with her words. "I recognized that I was casting someone who can't be complaisant. It's not in her DNA," she explains. "My mom always said to me, 'The talent is allowed to act weird.' She embraces the idea that, as an artist, she can act a little persnickety and say exactly what she wants."

Your mother told me that she uses embarrassment as a tool in her creative process, I say, leafing through the transcript of an old interview with her parents. "If I am starting to feel like I am alone with my pants down in my studio," said Simmons, "I think, okay, let's keep traveling slowly in this direction." *Girls* is full of humiliating situations. Do you use discomfort as a means of gauging the emotional importance of an idea? I ask.

"The kind of shame I deal with in my work is about returning to the scene of the crime with all my senses operating," replies Lena. "I agree with Woody Allen's theory that tragedy plus distance equals comedy." The writer–director–actress describes herself as "insanely close" to her family so it is difficult for her to get perspective on their influence. "My dad is a little more consistent and unwavering in his work process and he's more apt to display it to those around him," she says, "whereas my mom goes away, hands flying, comes back, and something has been made."

Lena sips her tea delicately, with the porcelain cup in one hand and its saucer in the other. She is calmer and more refined than her onscreen persona in the comedy series, whose tagline is "almost getting it kind of together." Indeed, Lena sits a few rungs higher up the class ladder than her Hannah character.

Lena's comfort with her public persona is one area where she and her father, despite their affinities, drastically diverge. When Dunham pere refused to be in *Tiny Furniture*, Lena wrote him out of existence. As he told me, "Father, what father? The kid was created by parthenogenesis or something." Lena is adamant that the film's "complete avoidance" of a father figure was "not in any way a 'fuck you' to him." Rather, she felt that no one else could embody him and has "yet to figure out how to write him."

Despite her intimacy with artists, Lena acknowledges that she has trouble depicting them. Among the quirky, complex male characters on *Girls* is an artist named Booth Jonathan, who is portrayed two-dimensionally as an arrogant egotist. One of the leading female characters compares him to Damien Hirst and then has funny-gruesome bad sex with him. "Artists are hard for me to write," admits Lena. She imagines her "father's disapproval when something doesn't feel real" and she doesn't want to contribute to the comic cliché that contemporary art is a con that dupes through pretension. "Booth Jonathan," she admits, "was based on douche-y college boys more than any of the cool, smart artists I've met through my parents."

Cindy Sherman
Untitled
2010

SCENE 14

Cindy Sherman

Attached to 250 lampposts in San Francisco are banners that declare "CINDY SHERMAN" in letters taller than the Museum of Modern Art's logo. Next to the text is a head shot of Sherman in one of her many guises. Three versions of the artist's face are also being used in an advertisement appearing on the sides of 160 buses. If Sherman is not already a star in the city known for its drag queens and dot-com billionaires, the museum's marketing team will make her one. A retrospective at a major museum is not just an endorsement, but a blast of exposure.

Sherman's retrospective is in the midst of its second installation. On the fourth floor of San Francisco's MoMA is an assortment of deep blue shipping crates from New York's MoMA. Most of the photographs are already hung, but a few rest on white Styrofoam strips on the floor. One man is atop an installation crane or "genie" adjusting the direction of the lights, while another is vacuuming the floor around a hip-high mound of wallpaper that has been ripped off the dramatic curved wall that both introduces and concludes the exhibition. Somehow, the wrong file was printed and Sherman's larger-than-life wallpaper work suffered from unsightly pixilation. The 15-foot-high mural has been reprinted and is scheduled to arrive within the hour.

Sherman is directing a crew of black-gloved installers on the

appropriate height of a 1993 photograph in the third of the ten rooms that make up the exhibition. In *Untitled #276*, a brazen blonde wears a crown and a see-through dress, which reveals her nipples and generous pubic bush. Looking dejected on the floor to the right of this self-appointed queen is the picture of the clown whose jacket is embroidered with the name "Cindy." Indeed, the sad character has just been cut out of the show. The San Francisco version of Sherman's retrospective has fifteen fewer photographs than the New York edition. A productive artist with some five hundred different images to her name, Sherman admits that the edit has not been easy. "If a wall label or the audio guide referred to a piece, it had to stay," she explains. And, as the museum café will be serving a raspberry and vanilla ice cream float inspired by a photo of a clown holding a bottle of pink pop near his groin, *Untitled #415* (2004) can't be cut from the show either.

When I saw Sherman in the studio, she had long, straight, dirty blonde hair. Now she sports a wavy platinum bob. She's also swapped her generic gray T-shirt for a distinctive black jacket, striped shorts, and sparkling blue sandals. Sherman loves fashion. The artist will no doubt blend in well with the collectors who attend her opening wearing Versace and Chanel.

Sherman walks into the next room, and the room after that, eyeing the relationships between the works. She doesn't like it when the installation is "too even." Among the salon-hang of her old master pictures is Sherman's incarnation of Caravaggio's self-portrait as the god of wine. "We had to replace a couple of the frames," says Sherman. When they were installing this series in New York, she noticed that a few had been reframed with plain black wood. "It looks so less interesting," she declares. "I don't know why they did that." When I remark casually that the collector-lenders may have removed the ornate gold frames because they didn't match their slickly contemporary living rooms, Sherman looks aghast.

In the sixth room, we encounter Erin O'Toole, the museum's assistant curator of photography. "We feel pretty good about the show," she says cheerily. "We're almost there. Just need to clean up and do the labels." Sherman is looking over O'Toole's shoulder at *Untitled #155* (1985), a

photograph in which Sherman appears to be a naked corpse lying in the brush and wears a fake bottom with a red crack. The artist walks backward away from the work, leans her torso to the left and then the right. "The butt needs to come down an inch," she says firmly. O'Toole nods at her respectfully, then turns to a couple of installers and half-hollers, "How do you guys feel about moving the butt?"

Sherman is less relaxed here than she was in her studio. The judgment that accompanies museum exhibitions and the social pressures of the opening are taxing for even the most outgoing of artists. Sherman also appears unnerved by her dependence on others. She laments that the installation process has been slow due to union and earthquake regulations. She also seems frustrated that overseeing exhibitions is soaking up so much of her life. "I won't have time to make new work for the next year and a half," she mutters.

We enter the final room of the show, which has been painted teal blue and houses six larger-than-life-size portraits of "society ladies," as Sherman calls them. Here, the artist depicts herself as older women whose multimillionaire husbands, one suspects, have cast them off. Socialites are usually assumed to be superficial, but these lonely female characters convey pain and other intense emotions with a verisimilitude absent from Sherman's early work, which tackles media stereotypes rather than real people. The embattled dignity of these women reveals both the empathy and brutality of the artist's eye. I feel like I know every woman in this room, I exclaim. Sherman laughs, as she often does in response to compliments.

From the fresh-faced characters of the "Centerfolds" to this room of mature women whose erect postures betray the effort it takes to cling to one's youth, the retrospective presents a chronicle of aging. Standing next to the artist amid her work, it is striking how she has aged gracefully in real life but awfully in her fictions. Indeed, the "Society Portraits" evoke Oscar Wilde's classic, *The Picture of Dorian Gray*, in which the vain protagonist sells his soul to ensure that he doesn't grow old while the figure in his portrait becomes decrepit in the attic.

Sherman's work has proved prescient about a culture in which social media fosters obsessive and continuous self-representation. However,

in the very first sentence of the catalogue essay that accompanies the show, Eva Respini declares, "Cindy Sherman's photographs are not self-portraits." This appears to be a nonnegotiable directive in the Sherman universe. "If an actor is on stage with very little makeup," says Sherman, "you wouldn't say that is a self-portrait. They are still playing a role." But what if the actor herself devises all the roles? And insists on total control of the costumes, makeup, art direction, lighting, and camera? Curators of the solo shows of living artists are rarely in a position to insist on these questions; they are generally obliged to fall in line with the artist's own orthodoxies about their work and to make a case for their publicly declared aims. Indeed, curators are vital cocreators of the myths that art historians call "intentionalist fallacies."

Just beyond this room, at the exit and entrance to the show, a professional decorator is finally at work installing the newly reprinted wallpaper. The mural, which was first shown in 2010, features giant jester-like characters that Sherman admits have "a come-worship-me look." These figures tower against black-and-cream sketches of Romantic landscapes appropriated from traditional French toile wallpaper. From her 8 × 10-inch *Untitled Film Stills* to the present, Sherman has moved slowly and methodically toward claiming greater wall space. In the early twenty-first century, when many male artists appear to embrace the motto "If in doubt, make it bigger," Sherman has earned every inch of her scale.

With this mural, Sherman employed digital strategies that she hadn't before. In 2003–04, she made the psychedelic backgrounds of her clown photographs digitally. In 2007, when working on a commission for French *Vogue* featuring Balenciaga clothes, she shot with a digital camera for the first time. Then with this mural, she started manipulating her facial features in Photoshop. Bizarrely, the traits created by these digital alterations seem almost genetic. One character has an extra-long skinny nose; others have eyes that are conspicuously small or close together. They look like inbred demigods bound together in an old-school circus act. "What I like is that they seem related somehow," declares Sherman. "They have certain traits that make it look like they are from the same family."

Rashid Johnson
*Self-Portrait as the Professor of Astronomy, Miscegenation and Critical Theory at
the New Negro Escapist Social and Athletic Club Center for Graduate Studies*
2008

Rashid Johnson

It looks like a bizarre psychoanalytic group therapy session gone wrong. Rashid Johnson and I are standing next to *Untitled (Daybeds 1–4)* (2012), the focal point of the Chicago-born, Brooklyn-based artist's solo show at the South London Gallery. In the center of the grand Victorian space is a row of four chaise longues that evoke Freudian couches, each on its own Persian rug. The four daybeds are upholstered in zebra skin and their wooden frames are "tortured," as Johnson puts it. Three of them are upended, leaving only one patient the opportunity to lie down. "It feels like a triage," says Johnson, as he walks around an open toolbox and a large pot of something black that suggests a witch's cauldron, both remnants of the installation process. "Something terrible has happened and people need help."

When Johnson scoped out the South London Gallery in the wake of the 2011 riots (the most heated of which took place near here), he also visited the Freud Museum in leafy North London. The artist spent a lot of time soaking in the intense atmosphere of Freud's treatment room, which is preserved as it was in 1939. He marveled at its cluttered display of icons and fetishes. "Freud saw African sculptures as therapeutic tools," exclaims Johnson as he tucks a couple of dreadlocks behind his ear. "I grew up in a home with similar figurines but they were employed

in a different way. In our home, they were about identity formation rather than exploring the exotic or the unconscious."

Johnson often jokes about being "abandoned" in Afrocentricism. In the 1980s, his mother, who taught African and American history at Northwestern University, was immersed in the intellectual scene and dashiki-clad lifestyle of the second-wave Afrocentrism spearheaded by activists like Jesse Jackson and Louis Farrakhan in Chicago. The movement had a significant effect on national identity, not least of which was the shift in consciousness from "Black" to "African American." But Johnson's mother and stepfather dropped the Afrocentric lifestyle when the artist was about thirteen. He grins then says, "It was almost as if I had had my bar mitzvah so they no longer had to do all that Jewish stuff."

Johnson leans over and gently rubs his thumb on the underside of one of the tipped-up daybeds that perches on its hind legs. The red oak has been burned to a black crisp by a roofing torch, splattered with black soap (which is made from the ashes of burnt plantain skins and is revered for its healing qualities), then scrawled upon with sticks. Johnson often uses African materials such as black soap and shea butter. "I am really interested in the idea that, through cleansing and conditioning, you can acquire a kind of ritualized Africanness," he explains. Johnson has long been fascinated with the problem of how to be black. "It's not dissimilar to what other people are negotiating. How to be a woman? It's like, 'Okay, how do I make this up?'" he explains, pulling his nerdy beige cardigan down over his white T-shirt. His Margiela sneakers signal his success to people who know their fashion brands.

Amongst the gestural marks on the bottom of the chaise longue, we can see the word "RUN." "A lot of my mark-making represents my neurosis," says Johnson, who has seen a therapist on and off for ten years. "I went into therapy to deal with anxiety. I find it cathartic," he says with a relaxed smile. "Neurosis is associated with intelligence. It's been the privilege of white people, but the black character has all the reason in the world to be neurotic," he adds.

At the far end of the gallery is a black-and-white photograph titled *The New Negro Escapist Social and Athletic Club (Kiss)* (2011), which

is a double exposure of a black man in glasses, wearing a suit and tie. Where the tips of his two noses overlap, his skin has turned white. Johnson has long been interested in the sitter as "a regal person who has the opportunity to be considered" rather than "witnessed or studied or caught on the run." This photograph is one of several images that involve doubling and are, in part, inspired by W. E. B. Du Bois's 1903 sociological text *The Souls of Black Folk*. On his second trip to Africa, when he was twenty-three, Johnson went to the home of Du Bois, who had expatriated himself to Ghana late in life. "Du Bois talks about the idea of double consciousness," explains Johnson. "When you are American and black, you traffic through those two identities."

Johnson has made about twenty photographs of the fictional members of the Negro Escapist Club, many of which depict the sitter in a thick haze of smoke. "I rarely smoke pot now because it makes me paranoid," says Johnson with an embarrassed laugh. "But I smoked every day from the age of fourteen to twenty-five. My teachers would look at me with tilted heads and say 'Mr J-o-h-n-s-o-n' because they knew I was stoned out of my mind." Vast chunks of his schooling no doubt plummeted down a rabbit hole due to his excessive habit, but weed taught him one thing: "to sit down and pay attention." Despite his erudition, Johnson has never been a great student in the strict sense, having started but never finished an MFA at the School of the Art Institute of Chicago. But the incomplete degree hasn't stopped the thirty-five-year-old from being a star artist. He has a survey show initiated by MCA Chicago which is touring museums in three more American cities, and was given a large room at last year's Venice Biennale.

Education looms large on one side of Johnson's family. "My mother comes from the black bourgeoisie, whereas my father is a Johnson from Tennessee," he explains. "Jimmy Johnson—not James. His birth certificate just says 'Jimmy.' It's very plantation." His mother's family, however, has been going to university for generations. Johnson's great-great-great-grandfather was the first black man to graduate from Harvard Medical School. His mother has a PhD and his brother studied law at Harvard. Johnson's parents divorced and remarried when he was young (his mother to a Nigerian, his father to a white Jewish woman). "We

are all very close," says Johnson. "We have barbecues and celebrate the holidays together, but no longer observe the absurd ones like Kwanzaa."

Johnson feels conflicted about the concept of a black brotherhood in part because of his parents' class differences. "Common, the Chicago rapper—we went to college together—has a great line. He says, 'Don't say bitch, that's not something I would call my mother, nor do I call every nigger my brother.'" Johnson pauses and glances over to a mirrored wall sculpture titled *The End of Anger* (2012). "Brotherhood suggests a monolithic black experience," he says. "Intellectually I don't embrace it, but emotionally, I strangely do. The perception of kinship can be exhilarating."

The End of Anger is one of Johnson's many "shelves." These critically acclaimed altarlike pieces present carefully chosen instances of African American intellectual and creative achievement. This work is named after a recently published book by Ellis Cose, which tracks the changing attitudes of black people since the 1960s. Six copies of the hardback are stacked on one of the five ledges that stick out of the backboard, which is covered in an Art Deco–ish pattern of mirrored tiles. On another ledge sits Art Blakey's 1962 jazz album *3 Blind Mice*. Three smaller ledges host pieces of shea butter. The tight geometry of the sculpture is interrupted by splattered outbursts of black soap, making the piece feel like a shrine used for ancestor worship. Johnson admits that his shelves present "a black utopia" that emphasizes victories. "I am more interested in producing a world in which the black character has agency," he explains. "I like to think that we have been formed by history, not handicapped by it."

Johnson complains of the negativity, disguised as "criticality," that is endemic in a lot of art schools. "Students often want to hate everything and just dismiss things," explains Johnson. "When I give college talks, I tell them: you have to fall in love with art or learn to love it." The respect and affection for others' work should run deep. "My interest in jazz or the history of black culture," he says, "it's not something I'm doing to be interesting. It is my story." For Johnson, jazz is "more American than apple pie." It fills him with patriotism. He loves the music when it shuns lyrics, concentrates on pure sound, and grooves its way to invention.

Johnson relishes "that movement, that freedom, that feeling of not being trapped in a classic rhythmic pattern."

Two white guys walk into the room. Johnson's studio manager, an artist called Robert Davis, has a drill in his hand, while Johnson's fabricator, Brian Lewis, is holding a level. The two men are installing a small show of abstract paintings in the upstairs gallery, which was curated by Johnson and includes work by Davis as well as Sam Gilliam, an older Color Field painter, and Angel Otero, a young Puerto Rican artist with a studio around the corner from Johnson's in Bushwick. (Johnson's large studio is a three-minute drive from Roberta's pizza place.) Although Johnson works with a small crew and often populates his art with important cultural figures, the artist still thinks of his artwork as lonely. "When my friends were getting real jobs, I would be in my studio by myself for days on end," he explains. "I couldn't have survived without NPR. I needed to hear human voices. I don't think my work has left that lonely space."

To the right of *The End of Anger* is a large, all-black painting called *National Election* (2012), which looks a bit like the bottom of the daybeds except more "fucked up." It involves several layers of what Johnson calls "abstract expressionist strategies." The base consists of a dynamic pattern of diagonal strips of burnt wooden flooring that is reminiscent of the broad-brush compositions of Franz Kline. A layer of poured soap echoes Jackson Pollock's drip paintings and frenzied clusters of lines evoke early Philip Guston. "It's poetic, a classic 'action,' with a romantic notion of the artist, attacking a surface," says Johnson. Alex Ernst, his assistant, sometimes helps him pour the black soap. "But the gestures are very much mine. I don't think anyone can do it better," he says with a brazen, sheepish grin. "I'm very specific."

Other works in this style tend to go by titles like *Cosmic Slop* (a reference to one of George Clinton's Funkadelic albums) so I inquire about the title *National Election*. Johnson explains that he saw Barack Obama about a month before making the work when his brother, a Harvard acquaintance of the president, was hosting a fundraiser for his reelection campaign. "I met Obama before he became a senator," says Johnson. "MCA Chicago was trying to get young black professionals

to join the junior board and they ended up sitting me next to Barack at dinner. I had heard that he was running for Senate but I didn't believe that someone called Barack *Hussein* Obama had a chance in hell of being elected." Johnson rolls his eyes. "I even told him so."

Around the corner is a wall piece made from wooden flooring that has been burned with a branding iron. Titled *House Arrest* (2012), the work is dominated by an all-over pattern of crosshairs, the kind seen when looking through a riflescope. The symbol, which Johnson associates with the logo of the hip-hop band Public Enemy, appears regularly in the artist's work. Mixed in with the crosshairs are images of palm trees. I suggest that burning images into wood with branding irons refers to how slaves were branded like cattle. "That did not even cross my mind until people mentioned it," says Johnson earnestly, as if he can't quite believe it himself.

"Hip-hop has been important to me since I was a kid," volunteers the artist, who likes the way rappers talk about amplifying their voice with a microphone and insist on their right to be heard. Above all, Johnson loves the hip-hop tradition of bombastic boasting. "It gives you the opportunity to say why you are the most interesting," he says. "That kind of braggadocio is really important to young men and women... and artists."

One of Johnson's early self-portraits is a great example of braggadocio or, at least, balls. Titled *Self-portrait in Homage to Barkley Hendricks* (2005), the photograph mimics a 1977 oil painting in which the aforementioned Hendricks stands naked with nothing on except for a white cap, shoes, and socks. In the painting, called *Brilliantly Endowed*, the senior artist holds his left hand down by his groin for comparative purposes. As it happens, Johnson is better endowed than Hendricks, so Johnson's photo comes across as cocky one-upmanship. "I was a student at the time and Barkley wasn't well known," explains Johnson. "It was a big lesson for me about the difference between painting and photography. I made the work without realizing quite how much I was exposing myself."

Having walked the periphery of the gallery, the artist and I return our gaze to the center of the space. Its high ceiling and giant botanical

garden-style skylight lend splendor to the show's dark materials. Johnson folds his arms across his chest. "I wouldn't change a whole lot," he says. "I usually have trouble in the middle of the room. I'm still learning how my work lives in space. But this feels good."

Since the Barkley Hendricks piece, Johnson has made self-portraits that better reflect the kind of artist he is. *Self Portrait as the Professor of Astronomy, Miscegenation and Critical Theory at the New Negro Escapist Social and Athletic Club Center for Graduate Studies* (2008) comically underlines artists' strange range of knowledges. "When you are taking a photo of yourself, there is no avoiding a conversation with Cindy Sherman," says Johnson, who sees the art world as an "escapist space" where artists' roles are "in flux." The black-and-white photograph features two mirror images of the artist sitting stiffly with a book in his hands, staring soberly through glasses into the distance. A decorative micro-mosaic pattern, like the ones found on Middle Eastern backgammon boards, forms a backdrop. Johnson has said, "the artist functions as a time traveler," but here he seems to position the artist as someone with a double identity—that of a respectable intellectual and a total crackpot.

Carroll Dunham
Late Trees #5
2012

SCENE 16

Carroll Dunham

In late October 2012, eight large, framed paintings by Carroll Dunham were delivered to Barbara Gladstone Gallery on West 24th Street. They were unpacked and placed on foam blocks in the back room of the gallery. Two days later, the tail end of Hurricane Sandy, the largest Atlantic tropical storm on record, hit New York City. A storm surge flooded the gallery district of Chelsea for several hours at high tide. Some galleries took in nine feet of water, others a few inches.

Eight days after the storm, I am sitting with Dunham in his Tribeca kitchen. "I took a good look at the possibility that a year of my working life had been wiped out of existence," he says as he makes tea. "More than ever, I was excited to put these paintings out in the world, so..." He stops to cough heavily. "The thought led to a horrible, unfamiliar, amorphous feeling. Van Morrison said a singer has to sing or they get sick. That's what it felt like... soul sickness."

Where the soul goes, the body follows. The day after the hurricane, Dunham came down with acute bronchitis and, after a visit to the hospital, lay in bed in Connecticut with the heat turned up, watching news of the flooding and blackout, waiting for phone calls from the gallery. His wife, Laurie Simmons, was on holiday in India with their daughter Lena. "I felt like I was a guy in a science fiction story, living alone on a space station, unable to get back to earth because there was no gas,"

says Dunham. Although Gladstone's staff assured him that with one exception the paintings were unharmed, he was still worried. "I always think that I can see things in my paintings that other people don't see," he explains as he treads down the stairs in black socks to his work station, where an open MacBook Air awaits us.

As we take a seat, Dunham explains that, in his delirium, he was deeply disturbed by a coincidence. The "Next Bathers" paintings depict nudes knee-deep in water, while the "Late Trees" feature gnarly trunks topped with lush green leaves caught in extreme winds. "I felt like my paintings caused the storm," says Dunham, clicking through jpegs of the works. "And it gets even freakier." The only painting that remained in the studio portrays a fallen tree whose leaves are caught up in debris from a greenhouse-like glass structure. "The relationship between these paintings and reality is really strange," says the artist, shaking his head slowly in protracted disbelief. "I'm condensing and synthesizing a lot of different things. That's the nature of art. I'm worried about the environment so it must have seeped into the work." Dunham has no doubt that global warming is real and Hurricane Sandy is just an "appetizer." He fears a future in which the earth experiences what he calls "a great winnowing."

This morning, after swinging by the polling station to vote in the presidential election, Dunham went to the art conservation studio of Christian Scheidemann, whom he describes as "a sort of rock-star restorer who has done a lot of work with strange contemporary art materials." Dunham was hugely relieved to find nothing at all wrong with the seven canvases in the workshop. Briny water had touched the bottom few inches of the acrylic paintings, leaving a trace of fine sand but no abrasion. Scheidemann's staff had been able to clean the works with distilled water. Only the frames had to be removed and remade.

Dunham clicks to a jpeg of *Large Bather (Quicksand)* (2006–12), the work that sustained a scratch and doesn't fit into Scheidemann's Chelsea workshop. "You know this one. I've been painting it, on and off, for six years," he says of the "icon of fecundity" that I saw evolving on my trips to Connecticut. Since then, the painting has changed almost beyond recognition. The figure's anus is dead center, as before, but much

smaller. Water still surrounds the left side of her body and land the right, but now the terrain dazzles with dynamic diagonal and vertical arms, legs, and branches. "The scratch is extremely discreet. It's completely contained within that image of the log," says Dunham, pointing to a felled trunk with a stumpy phallic protrusion that directs the viewer's eye drolly toward the woman's ass. The graphic cluster of her buttocks, vagina, and pubes congeals into a rough-and-ready face, perhaps of a bearded stoner rubbing his eyes with thick fists. Many of the objects within the painting evoke more than one thing. "In for a penny, in for a pound," says the artist with a chuckle when I praise the work. "An interesting painting never really settles down in your mind." Dunham's paintings work remarkably well as jpegs—the result of his concern that they should look good from a hundred feet away.

Dunham has decided that Scheidemann, who is often hailed as a surgeon, will deal with the scratch. "It's better for me to just keep my hands off," he declares, as he inadvertently reveals the emotional struggle by sitting on his hands. "My paintings are made of so many layers of transparent paint, with so much overpainting and directionality. It would be very difficult for me, using those techniques, to match it."

Damage with a relevant backstory can add value, I say. In 1964, for example, one of Andy Warhol's crazy entourage brought a gun into the Factory and shot through two works that depict the late Marilyn Munroe. The *Shot Marilyn* paintings, as they are now called, are among the most coveted works in Warhol's oeuvre. So, not only is *Large Bather (Quicksand)* an amazing painting, it has already started to accrue the life of a masterpiece. Dunham seems unsure how to respond. "Far worse things have happened," he says, "to far more valuable paintings."

Dunham's works were not the only ones to make a lucky escape. Francis Alÿs was midway through installing his show at David Zwirner Gallery on 19th Street when the storm struck. His small paintings were laid out evenly on the kind of lightweight tables used by street sellers. "The water went up to five feet in the gallery," Alÿs told me, "but the tables floated. They moved through space, then landed. It was a bit spooky."

Jennifer Dalton's work was not so fortunate. Some drawings from

her "How Do Artists Live?" series were being stored in the basement of Winkleman Gallery on West 27th Street. Although all the artwork had been raised four feet off the ground in preparation for what seemed like the worst possible scenario, the water went up to eight feet. Needless to say, pastel chalk on paper is not water-resistant, and Dalton has decided to remake the works from scratch. A few days ago, I walked along the strip of smaller galleries that are on 27th Street west of Tenth Avenue. The electricity was still out. Dealers were sharing generators to pump the water out of their basements. Museum curators and other friends, wearing white hazmat suits, were hauling works out into the street and quickly ripping off their frames to see if the pieces within could be rescued. The sidewalks were strewn with what looked like wet junk. Mother Nature had thrown everyone together. For a week, Chelsea's art businesses abandoned cutthroat competition in favor of community feeling.

"Barbara Gladstone and I have been working together for ten years," says Dunham. "Republicans keep yammering about 'small business,' but—bastion of radicals or whatever—you'll never find a more small-business, family-values kind of place than the New York art scene. As I've grown into my work, my sense of self, and my role as an artist, I've realized just how much I love art galleries and how intrinsic they are to my ability to do what I do."

Dunham lifts his finger and tells me that he has yet another answer to a question I've asked him several times over the past three years. "Being an artist is a form of radical entrepreneurship," he says. With a self-mocking tone, he adds, "I have a really cool idea for some paintings that I think some people might need to see." Some artists are like entrepreneurs who foster invention, while others are like money-market gamblers who trade in derivatives. Unlike many artists, who self-consciously appropriate or recycle, Dunham puts a high premium on innovation. "The goal of making something that looks and feels original is a little retro," he admits. "I go into a room alone and make things with my hands. I don't call up a lab. It couldn't be more 'ye olde,'" he says. "But a world consisting of nothing but information and transmittable images is not going to honor our physical selves."

The phone rings. It's Lena. He asks her to pick up some Vicks Nyquil cough formula. "Yes, red, the color of vampire blood." He pauses. "No, doll, thanks. I'm all set." He hangs up. Lena returned from India a few days ago. Simmons is still there, sleeping in a tent on the shores of a beautiful lake with wild monkeys. Grace is in Virginia, driving elderly Democrats to polling booths. "There's a lot of research on the way human society affects us as an organism. If I was alone all the time, my immune system would be a fucking mess," he says.

It occurs to me that Dunham is sitting on the swivel chair that was occupied by Simmons's love doll when I was last in this space. Before I can express the thought, he asks, "Do you feel like the kids understand anything about Laurie's and my work?" I'm surprised by the question. Both girls were thoughtful, I say. Grace spoke persuasively about the way you underline rather than universalize a straight white male perspective, while Lena drew my attention to the paradox of a superbly articulate artist who works in a silent medium. "One of the reasons I was so drawn to visual art is because my father was overwhelmingly verbal," explains Dunham. "He was an intermittently failed businessman who had four different careers. He was bright but he talked too much and never delivered the goods." Dunham dreaded a life without direction, so the idea of focusing on something nonverbal felt right. For whatever reason, he has a strong sense of purpose, so he sees himself as "tailor-made" to be an artist.

"Wanna see my 'secret' drawing studio?" says Dunham playfully. The artist takes me back up the stairs past an unusual painting that he made in the late 1990s of a naked, black female character holding a gun, in which both her body and firearm look like puzzle pieces. We exit their loft, wait for the elevator, and then go down a floor. Dunham hasn't bothered to put on shoes for the journey. We walk along the communal hallway to a white door that, once unlocked, gives way to a wacky two-story walk-in closet that is almost impossible to describe. The room was originally two lavatories (on the third and fourth floors) that Simmons used for storage until Dunham took them over to create what he calls a "man cave situation." We go through the room whose walls host three rows of drawings, up a slender staircase to a petite white desk and a

window through which we can see slow-floating snowflakes. The cave feels a bit more like an all-white tree house or a portal to an alternative reality. Having such a small space in the city has its frustrations. "I miss having studio visits from my peers."

Having said that, Dunham is unsure whether he has a peer group. Most of his close painter friends are older or younger than he is. While he is roughly the same age as Richard Prince, Julian Schnabel, Eric Fischl and David Salle, Dunham doesn't think it makes sense to think of them as a group. The artist stares at a drawing of a nude among bulrushes whose nonspecific partial profile means that her identity will forever elude. "It would be nice to think of David as my painting colleague," he explains. "Since my work has focused on the female body, I've come to see his earlier work on that subject—for which he took a lot of shit—in a much more sympathetic light." When artists are young, they often feel the presence of a generational cohort whether they belong to it or not. But, as time passes, the sense of equality essential to the definition of a "peer" falls away. Dunham once assumed this "phenomenon" resulted from artists' desire to be "the only artist in the world or the only patient of their psychiatrist." Now, he thinks, "It's just really hard to find people who are on the same page."

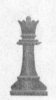

Jason Nocito
Maurizio Cattelan, Massimiliano Gioni and Ali Subotnick
(After General Idea's *Baby Makes 3*, 1984–89)
2006

Massimiliano Gioni

"An extended invisible family...flexible and interchangeable, somewhere between a think tank and a criminal association," wrote Massimiliano Gioni about Maurizio Cattelan's studio in an essay titled "No man is an island." Gioni has, as he puts it, "grown up with Maurizio." Always precocious, the thirty-nine-year-old curator is now the artistic director of the 55th Venice Biennale, the youngest in its 118-year history.

Gioni's first extended encounter with Cattelan was peculiar. "Every time I asked a question, Maurizio would go through a file full of quotes and pick somebody else's words to answer. It was slow and painful," says Gioni, who is sitting in the center of his East Village dining room-cum-office surrounded by shelves full of well-organized books and carefully curated kitsch. "Maurizio was questioning authorship and the self. Until 'The Pope,' the main theme of his work was, 'Who am I?'" "The Pope" is a life-size wax statue of Pope John Paul II knocked down by a meteorite. Officially titled *The Ninth Hour* (1999), the felled father figure is one of Cattelan's most celebrated works. On Gioni's windowsill is a ceramic figurine of a generic pope. Over his praying hands hangs the old key to the Wrong Gallery. Next to it is a battery-operated plastic hand that plays a rinky-dink tune while giving the finger, which might have been

the inspiration for Cattelan's monumental *L.O.V.E.* The objects were gifts from the artist to Gioni and his wife, Cecilia Alemani.

The second time Gioni and Cattelan met, the artist was scheduled to do an interview on Italian public radio. He persuaded Gioni to do it for him. It was the first of many "Cattelan" interviews and museum talks that the curator did between 1998 and 2006. Notoriously, Gioni even spoke as the maker of "The Pope" on Vatican radio. "It was clear I was overstepping the bounds of a critic. You are meant to be objective and maintain a distance from your subject," admits Gioni. "Plus there was an element of corruption because I was getting paid." The ruse is not without precedent. In 1967, Andy Warhol agreed to a cross-country college lecture tour but sent one of his acolytes from the Factory, an actor called Allen Midgette. Given that Gioni is not an actor working from someone else's script but one who has written extensively about Cattelan's work and contributed to the shape of his persona, the curator prefers to think about the scam in terms of a longer art history. He's always been interested in those critics who became the spokesmen for artistic movements, such as Tristan Tzara, who spoke for the Dadaists, André Breton, who wrote manifestos for the surrealists, and Clement Greenberg, who defined the Abstract Expressionist project. "They were the mouthpieces for artists," he explains. "In my case, I was becoming the artist. We took it a step further."

Gioni wasn't impersonating Cattelan so much as lending the artist his own, more articulate way with words. "In the beginning, we thought that Maurizio's voice should feel weird and detached, more Brechtian. We would drop hints, so, if you listened carefully, you knew it was a construction," says Gioni, who chuckles self-consciously when he uses academic jargon. "Then, in about 2001, we decided to go for sincerity, making everything sound heartfelt and confessional, even if it was still completely synthetic." Gioni knows Francesco Bonami well, having worked for him on the 2003 Venice Biennale, and has read his unauthorized autobiography of Cattelan. "I think his 'Cattelan' falls on the sincere side," says Gioni with a big grin. "I told Francesco that it's such a good book that I suspect he was dependent on a ghost writer!"

Gioni zips up his black sweater and glances at his phone. He apologizes that, in the run up to the Biennale, he is so "crazy-busy" that he will have to take a call in twenty minutes. When he resumes focus, Gioni says, "Henri-Pierre Roché said about Duchamp that his greatest masterpiece was his use of time. I have always envied that about Maurizio. He is one of the hardest-working people I know but he has managed to shape his life in a way that allows plenty of free time, or something that resembles free time." With regard to Cattelan's retirement, the curator–critic says it is looking increasingly like "a model" and jokes that he himself should probably retire after Venice. Right now, however, what he really needs is "another me."

When he worked with Cattelan and Ali Subotnick on the Wrong Gallery, and even more so when they curated the Berlin Biennial together in 2006, Gioni came to understand what an artist can bring to the curatorial process. Cattelan basically abandoned his own art for two years to work on the Berlin exhibition and, according to Gioni, did a lot of things that an artist wouldn't normally do, such as sitting in meetings. "Maurizio gave us the legitimacy to try things," he explains. "He gave the whole team an authority and liberty. As Warhol said (who was paraphrasing Marshall McLuhan), art is what you can get away with."

One reason it is difficult to define artists is because there are so many romantic myths about them—some of which steer close to the truth. "I'm just talking about a few friends: Maurizio, Urs Fischer, Tino Sehgal," says Gioni, widening his black-brown eyes. "They are incredibly hardworking professional people but they have a very unusual relationship to authority and rules. They have invented structures to support themselves and, somehow, they are problematizing productivity and efficiency." Gioni leans back in his swivel chair and brightens. "You know how you can recognize an artist?" he says. "An artist is the one who misses planes! How many planes have you missed in your life? I have missed one. The artists I know miss planes all the time. Did they want to avoid the meeting or were they trying to finish a piece? Were they afraid of flying? You never know."

How would you characterize your relationships with artists? I ask.

"I am a polygamist," he says without skipping a beat. "Many curators are loyal to their generation. Francesco Bonami, Germano Gelant, Bonito Oliva—they have been good at that. Maybe my tastes are too diverse or maybe it's just a different time. For whatever reason, I am more of a polygamist than them."

A marriage model, then? I ask.

"It's much more like a divorce," he replies. "Doing a show, you go through a whole relationship in a year—from courting, through the wedding, to trial separation and divorce. But mostly it's about divorce. A lot of the conversations are about money. How can we find more? Could it cost less? Or, oh my God, you didn't tell me you spent that."

Cattelan told me that you haven't put him in your Biennale, I say.

"No? Really?" he replies, a flash of concern crossing his face. "I told him from the beginning he could not be in it. Is he hurt?"

I'm sure he understands, I say, but Venice is Venice and Maurizio is Italian.

"I put very few friends in Venice," he replies. "I made a big effort not to put artists with whom I had worked before."

How would you describe your relationship with Maurizio? I ask.

Gioni looks flummoxed. He covers his mouth with his hand and looks over my shoulder into the distance. "There is a funny story from the sixties," he says finally. "Henry Geldzahler was an early supporter of Andy Warhol, but when he did his comprehensive show of New York painting and sculpture at the Metropolitan Museum, Geldzahler didn't include him. At the opening, someone saw Warhol and stopped him on the stairs. They said, 'Andy, why aren't you in the show?' and Warhol said, 'Because I am Henry's first wife.'"*

* Gioni has slightly misremembered this incident. Geldzahler didn't include Warhol when he curated the American Pavilion in Venice in 1966. Warhol was so hurt that he didn't speak to Geldzahler for several years. In 1969, the curator included the artist's work (notably *Ethel Scull 36 Times*) in his 1969 show at the Met, but Warhol couldn't bring himself to enter the museum. According to Calvin Tomkins, when people asked the artist why he didn't go inside, Warhol said: "I am the first Mrs Geldzahler."

Gioni's phone vibrates. "Sorry, I have to take this. Do you want to wait until I am finished?" he asks. Before I can answer, he says into the phone, "Hello. Yeah. I'm in the middle of something but I'm here and we can do this now." I turn off my digital recorder and put it in my bag. I mouth the words "Thank you" and "See you in Venice," then let myself out.

Laurie Simmons
Still from *MY ART*
in progress

Laurie Simmons

Last night, Lena Dunham won two Golden Globe Awards, one for creating the best comedy series on television and one for performing in it. "Did you hear us screaming in Connecticut?" says Laurie Simmons, shortly after answering my phone call from London. The artist tells me she is sitting in the den, working on her computer. "It's more fun to watch these ceremonies on TV than to attend them," she declares. "The Golden Globes love a newcomer, but the Best Actress award was a real shocker. We think of Lena as a writer." Since the first episode of *Girls*, Lena has appeared on several magazine covers and many television talk shows, but a Golden Globe creates news of a higher order. "We've always been aware of the difference between art-world fame and Hollywood fame," says Simmons. "We joke that, within the art world, you can be as awesome as you think you are. No one is truly famous but everyone is semi-famous."

Simmons recently enjoyed fifteen minutes of semi-fame when Calvin Tomkins profiled her in *The New Yorker*, describing her as an "original and provocative artist" whose work explores "the strange power of human surrogates." Whenever Simmons is discussed in print, Cindy Sherman is invariably mentioned, often at length. "Coming up next to Cindy has its challenges," says Simmons. "It's like being the middle child with two blonde sisters—which I actually am." The two women

have been friends since they met in the late 1970s. Neither was in the influential 1977 exhibition curated by Douglas Crimp at Artists Space that coined the term "Pictures Generation," but both are part of the movement that brought figuration back into vogue among New York's art cognoscenti. In the 1980s and 1990s both showed with Metro Pictures, a gallery in which Sherman became the uncontested star. Having experienced "the loudest roaring mid-career silence," Simmons left Metro in 2000 with the aim of improving her visibility. She now shows with Jeanne Greenberg's Salon 94.

What have you been up to? I ask. Simmons explains that she is obsessed with her new project, a feature film titled *MY ART* about an artist surrounded by others whose careers glimmer more brightly than hers. "The main character is sixty years old, never got married, and hasn't had a show in fifteen years," says Simmons. "She teaches for a living and, at the end of the school year, stays in the country house of a successful artist friend who is always on the road with her travelling solo shows."

Simmons tells me that the successful artist is "someone like Cindy" while the main character is "me without a family, a 'me' in a parallel universe, another 'me' that I know really well." Yet both characters have names that play on Simmons's initials: the star artist is called Lincoln Schneider, the overshadowed one is Ellie Shine. (Ellie is a riff on "L.") Moreover, the film will be shot in Simmons's own Connecticut house, and Shine's artworks can be summed up as "Cindy Sherman meets Maya Deren." Deren, who died in 1961, was an avant-garde filmmaker and dancer who often appeared in her own work, which explored the female unconscious.

"Shine's work recreates scenes from Hollywood movies," explains Simmons of her main character. She dresses up like Marilyn Monroe, Kim Novak, and Audrey Hepburn, and then takes pictures of herself. One day, she accidentally has her digital Canon camera on the video setting and has a "real artistic breakthrough." All Shine wants is an exhibition and a review. "She is a woman of a certain age," says Simmons. "She wants to get on the train, even at the last stop."

The only other time that Simmons has acted in a feature and, indeed,

played the role of an artist, is in *Tiny Furniture*. "Nobody gets an artist right, even the child of two artists. *Tiny Furniture* left me feeling that something was missing," says Simmons. "I will play the lead in *MY ART*, probably against everyone's better judgment, because it will create comparisons to Lena."

However germane the comparisons, Simmons's new film project follows logically from her previous work. Six years ago, Simmons made *The Music of Regret* (2006), a three-act film whose principal theme is intense competition. Act I features two dolls dressed as 1950s' suburban housewives who quarrel until one of their husbands commits suicide. Act II shows ventriloquist dummies competitively courting Meryl Streep, who is a stand-in for Simmons. Finally, Act III draws on Simmons's series "Walking and Lying Objects" (1987–91), in which inanimate things, such as a camera and a doll's house, have sprouted legs. In the film, four objects dance their way through an audition while a pocket watch waits in the wings, failing to get the part because she doesn't have the opportunity to perform.

Although *The Music of Regret* premiered at MoMA New York and then later played at the Whitney, the Met, Tate Modern, Centre Pompidou, and the American Academy in Rome, Simmons feels that it never found its place in the world. "It's forty minutes long—too long for a short and too short for a feature." Simmons admits that she is possessed by regret. "I'm always hyper-conscious of the road not taken."

As it happens, that road was taken by Lena, who had been a keen observer of the production and distribution of *The Music of Regret*. "When I was going through issues with the narrative," says Simmons, "she was in college and I'd send her plot stuff. She helped me a lot." Not long after, Lena started creating her own little videos and wrote a screenplay to fulfill a course requirement. She would make sure that her short films and then her feature fit festival programming categories. "She never wanted to make art films," says Simmons.

Simmons is thrilled that Lena is doing the kind of work she really wants to do and is being widely recognized for it. Nevertheless, having a famous daughter can affect one's sense of self. "It's only been a year that I've been known to the world as Lena Dunham's mother. I have to

figure out how to navigate my life with this new information attached to me ... Tip just casts it off." Indeed, when I last saw Tip Dunham, he told me that he regards celebrity culture as "a fucked-up pile of ridiculous crap" with nominal interest as an "anthropological event." Reflecting on Lena's success, he marveled at the differences between the "platform size" of a television show and a painting, but reaffirmed his interest in making works that "punch harder, go deeper, and do what paintings can do that other things can't." In his mind, he didn't have a choice because "anything else would be undignified."

Simmons, by contrast, embraces indignity. In order to avoid repeating herself, she forces herself out of her comfort zones. It's a means to the end of making fresh works. For Simmons, the agony of embarrassment pales in comparison to the "terror" of feeling invisible. "It is excruciating not to be seen," she explains. Simmons breaks off to talk to Grace, who has just entered the room. She's been in Connecticut for the weekend and is going back to Brown after lunch. "Where were we?" says Simmons when she returns her attention to our call. Your new feature film, Cindy, Lena, embarrassment, invisibility, I say. "Oh yeah," she sighs. "Invisibility taps into something from my childhood. Other artists may have different neuroses, but the feeling of not being seen tips me over the edge."

Maurizio Cattelan
Mother
1999

Francesco Bonami, Maurizio Cattelan, Carroll Dunham, Elmgreen & Dragset, Massimiliano Gioni, Cindy Sherman, and Laurie Simmons

It's the last Tuesday in May 2013, a cool, sunny morning with a forecast of rain. My teenage daughter, Cora, and I are attending the "artists' opening" of the Venice Biennale, which takes place the day before the VIP preview. We walk into the *giardini* just after 10 A.M., swing by the Danish and Nordic pavilions where Elmgreen & Dragset staged their dysfunctional domestic scenes four years ago, past the American pavilion, which already flaunts a queue of people keen to see the work of Sarah Sze, then head for the Palazzo dell'Esposizione. Massimiliano Gioni, the curator of the biennale, is standing on the steps of the white building like the father of the bride outside a church, kissing people on the cheek, shaking hands, and patting backs. Titled "The Encyclopedic Palace," his exhibition is displayed here as well as in the Arsenale, a long, sprawling space that was once a naval shipyard ten minutes' walk away. The double-venue show contains works by 160 people, not all of whom are professional artists. Many are the untrained, insane, or inmate image-makers that go by the label "outsider artists."

Gioni receives us warmly and signs Cora's notebook. She is collect-
ing artists' autographs but makes an exception for him as the show's
curator. He writes a perfect mirror image of his name in capital letters,
an allusion to the artist Alighiero e Boetti. Boetti's alter ego loomed so
large in his life that the artist inserted an "and" (*e* in Italian) between
his first and last names. He wrote forward and backward with his left
and right hands and made many works that involved mirroring. We
leave Gioni as he greets Tino Sehgal, an artist who has contributed a
performance, or "constructed situation" (as he brands it), to the show.

The first room of the exhibition features an illuminated manuscript
of spiritual fantasies by Carl Jung. The psychoanalyst worked on his
Red Book in secret between 1914 and 1930. On a reverential podium
under a glass dome, the book is open to a page where the tongue of
a snake in hell branches out into a slender tree in heaven. As art, it is
conservative—what you might call surreal–medieval—but it has fervor.
The inclusion of Jung complicates the definition of outsiders. Outsider
artists are seen to make art as a form of catharsis or therapy, so they
are invariably positioned as patients—not doctors. Also, outsiders are
usually "illustrious nobodies," as Gioni has put it, rather than famous
intellectuals who make art on the side.

I receive a text message from Maurizio Cattelan telling me that he
has entered the *giardini*, so we head back to the entrance, finding Gioni
where we left him, encircled by two cameramen and a dozen journalists
with notepads. "Our media understanding of an artist as a successful
professional who makes entertaining objects that sell for a lot of money
is very restrictive," he says, his hands waving imploringly. "Artists are
people who do things with images in order to understand the world.
They have a fierce desire to know themselves through..." Gioni stops
mid-sentence. "I have to say hi to a friend," he says. Cattelan walks into
view. The two men hug for a split-second and Gioni mumbles something
in Italian. The artist heads into the show and the curator returns to his
spiel. "All interesting artists are autodidacts," he says. "Even those with
university degrees need to be independent and self-teaching. By includ-
ing outsider artists and non-artists in my show, I am not suggesting that
everyone is a professional, but that everyone is a dilettante."

Cattelan shoots me with his fingers like a kid playing cops and robbers. He wears black skinny jeans and a black suede jacket; a statuesque woman wearing a black dress and carrying a tote bag advertising his magazine *Toilet Paper* accompanies him. "I need to go medium to fast," says Cattelan as we set out. "I am looking for Dakis." The Greek collector often teams up with Cattelan to look at art. He sometimes acquires works at the artist's recommendation and did, in the end, buy Triple Candie's "posthumous" Cattelan retrospective.

Cattelan has shown at the Venice Biennale seven times. The first time, in 1993, was like "committing hara-kiri," he says. "I had this opportunity of my career and I flushed it down the drain. It came naturally." Francesco Bonami had given him a space in the Arsenale, which he, in turn, rented to an advertising company who installed a billboard promoting a perfume. In 1997, he exhibited hundreds of taxidermy pigeons as *I Touristi*. In 1999, he showed *Mother,* the work that featured the buried fakir, and a felled father, "The Pope." But his great coup came in 2001 when he did an off-site project, a Pop earthwork titled *Hollywood*. First, he erected a giant replica of the famous "HOLLYWOOD" sign on top of a centuries-old, mountainous garbage dump overlooking the city of Palermo in Sicily. Then, in a feat of biennial festivalism, he convinced one of his patrons* to charter a plane to take an elite group of collectors and curators (including Harald Szeemann, the director of the biennale that year) from Venice to Palermo, where they were treated to a champagne reception in the dump with waiters in white jackets holding silver trays. Participants say that the stench was overwhelming.

Cattelan finds Joannou without too much effort. He then chats with at least a dozen art-world people and has his photo taken with most of them. "I am already exhausted, without having seen anything," he says, swinging his reading glasses as if they were bikini briefs in a striptease. In highly public situations, Cattelan can't seem to help himself from becoming a clowning mime. Eventually, he manages to look at some art, taking snapshots of the wall labels with his phone. He walks into an installation by Northern Irish artist Cathy Wilkes, an abject sculptural

* Patrizia Sandretto Re Rebaudengo.

family of small figures without arms, wearing tatty cotton clothes, sur-rounded by Victorian pottery shards and old lager bottles. "We showed her in the Berlin Biennial," he says. When I ask for his interpretation of the work, he replies, "Isn't it too early to ask that?"

We eventually enter a dark space containing five dolls made by Mor-ton Bartlett. Each hand-painted, custom-clothed plaster figure is on its own plinth in a plexiglass box, spotlit from above. The girls are all on the cusp of puberty in provocative poses—lips apart, nipples erect, hips cocked. Bartlett was a lifelong bachelor without art training whose pri-vate hobby involved sculpting dolls and taking pictures of them. "This is a real family," says Cattelan matter-of-factly as he inspects the figures. "He made about a dozen puppets. They are all beyond realistic under the skirt." I tell Cattelan that Carroll Dunham and Laurie Simmons own a Bartlett photograph. He admits that he owns two—an intrigu-ing coincidence given that there are only about two hundred prints in existence, all of which were discovered after Bartlett's death in 1992.

How do you define outsider art? I ask as we exit the room. "Cider art? I would like mine in a glass!" he replies.

"Is there an outside?" says Samuel Keller, once the director of Art Basel and now head of the Beyeler Foundation, who overheard my ques-tion. The Palazzo is crowding up with familiar art-world faces. "Every-thing is really inside," adds Keller. "Consider Jean Dubuffet." Dubuffet was a modern French painter who, after reading a 1922 book about the artistry of the mentally ill, coined the phrase *art brut* (the French term for outsider art) and started collecting it. In the early 1950s, Dubuffet said that *art brut* was "more precious than the productions of pro-fessionals" because it was "created from solitude and from pure and authentic creative impulses—where the worries of competition, acclaim, and social promotion do not interfere."

Keller and Cattelan confer about the artist's upcoming exhibition at the Beyeler. Its exact contents are a secret, which has led to speculation that Cattelan is back to making art. However, I know that he has devised a clever way to show something new without coming out of retirement. His *Untitled* (2007) sculpture of a headless taxidermy horse is in an edi-tion of three with two artist's proofs. At the Beyeler, all five horses will

be hung close together on one wall, hindquarters out, like an absurd circus cavalcade. Presenting the individual works as part of a group will shift their meaning substantially. "You can recognize a good work but a masterpiece is difficult," Cattelan told me a few years ago. "The piece has to perform a lot of work to become a masterpiece." Indeed, Cattelan is keen to make his sculptures perform.

We flow through several rooms, then linger in one showing abstract work suggestive of vaginas. Modernist embroideries by Geta Brătescu, a Romanian artist in her late eighties, are hung alongside anonymously authored tantric paintings made between 1968 and 2004. The latter works on paper all feature a central oval shape—often a black hole—surrounded by auras of pulsating color. They remind me that it's time to call Carroll Dunham. He answers on the second ring and says, "We are heading to the Arsenale. Where are you?"

I tell Cattelan that I'd like to introduce him to Simmons and Dunham. He has met Simmons and seen her in *Tiny Furniture*, which he thought was "a blast." He has never met Dunham. He'll come and say hello but needs to see something first. As we leave the leafy *giardini*, I reflect on an artwork by Francis Alÿs, in which he sent a live peacock to the biennale preview to represent himself and hang out with his peers. It was titled *The Ambassador* (2001).

Cora and I pick up awful white-bread sandwiches and sit for a quick lunch with a curator–art historian couple and their teenage daughter. (The British schools are on their half-term break.) The curator confesses that she is not in the slightest bit interested in outsider art. "It always has the same aesthetic, with all that intuitive, repetitive mark-making and those worlds within worlds. It doesn't propose anything new," she says. "You can find kernels of truth in someone's mutterings, but real artists have an intellectual project. It's like the difference between ranting and raving, on the one hand, and philosophizing on the other." Her husband takes a slightly different position, suggesting that curators dislike outsider art almost as much as artists like it. "Artists find it a relief to get away from the over-theorized context of professional art," he says.

We walk over to the other part of Gioni's show and, as we pass through the turnstiles that lead into the Arsenale, we see Simmons in

an off-white trench coat and sunglasses. Since we last spoke, she has shot the first scene of *MY ART*. She hasn't been to the biennale since Dunham was in it in 1988, but she has an old collaborative piece in the Arsenale, in a section curated by Cindy Sherman. How does she feel about the presence of *The Actual Photos* (1985) in the show? "Almost every body of work that I have ever made would fit into this show, so I am a bit befuddled as to why they chose that one," she says, sounding genuinely dazed. Overall, she laments the presence of so many dead outsiders because she knows so many living artists who could use the exposure. "I would have preferred more regional artists than psychics and inmates," she says.

Cattelan comes through the turnstiles and kisses Simmons respectfully on the cheek. After a few pleasantries, he asks, "When did you discover Morton Bartlett?"

"Before you did!" says Simmons. "At an outsider art fair in 1998 or 1999." Cattelan admits that he didn't come across Bartlett's work until 2002 or 2003. I wonder aloud if they collect any other artists in common.

"Maybe your husband?" says Cattelan playfully. "When did I discover your husband?"

"Do you own him?" says Simmons.

"No, but I wish. Do you own him?" asks Cattelan.

Simmons laughs. "Yes, I own him," she replies, wincing at the bad joke.

"You have him by the balls!" says Cattelan teasingly. "I saw the last show at Gladstone and there were only pussies!"

Dunham arrives, as if on cue, greeting Cattelan cordially. I inquire about the health of his *Large Bather (Quicksand)*. "Completely recovered," he says happily. "The repair is invisible—so imperceptible that I wonder whether I hallucinated the scratch." Dunham admits that he had a hard time getting over the show. "It blew me out. I barely did anything all winter," he says.

I take a photo of the three artists together, then Cattelan goes his own way.

In the center of the first large, white, circular room of this part of the exhibition sits an architectural model of a fanciful 136-story building

called *The Encyclopedic Palace* made in the 1950s by Marino Auriti, an Italian American who ran an auto-body shop and a fine art framing business out of his garage. Lining the surrounding walls are forty-four black-and-white images of African women with elaborate, architectural hairstyles by the Nigerian photographer J. D. Okhai Ojeikere. The juxtaposition is droll.

"It's the beautiful round room of an open-minded collector," says Francesco Bonami. "The combination of an Italian American and an African is great for obtaining a grant." The curator is strolling through the show with Vanessa Riding, his girlfriend, and their baby girl. We gossip about Cattelan's show at the Beyeler. Bonami gave it the title "Kaputt," which means "broken" in German and refers to Curzio Malaparte's 1944 novel of the same name. "Four of the horses are castrated. Only François Pinault's horse has balls!" he says, referring to the powerful art collector who owns Christie's. About Cattelan's retirement, Bonami is characteristically flippant. "Maurizio understood that his golden goose was getting old and not laying many eggs," he claims. Nodding at the *Encyclopedic Palace* that looms beside us, I ask for his thoughts about outsider art. He looks at me grimly, as if a dear friend had lost his mind. "It's a dangerous path, a bottomless pit," he says, shaking his head. "Insider artists know how to frame their compulsions. Outsiders cannot stop. It's like the difference between a sommelier and a drunk."

Having lost sight of Simmons and Dunham, we drift swiftly down the cavernous corridor of the Arsenale, eventually finding them in a room that features paintings and photographs made between 1943 and 1961 by Eugene von Bruenchenhein, a Milwaukee baker. Bruenchenhein made small-scale paintings of psychedelic landscapes and skyscapes, as well as photographs of his wife in sexy poses against colorful patterned wallpaper. One of the paintings must be on loan from Cattelan as I remember seeing it in his apartment. "We own a photograph from this shoot," says Simmons, pointing at a picture of a blonde woman sitting in a gold chair with her legs in the air, eyeing the camera coquettishly. "She's wearing the same white underwear in our piece and the lighting is similar."

We've all been thirsty for almost an hour, so Cora and I go in search of water, eventually finding a temporary café where Michael Elmgreen and Ingar Dragset are standing in line. The artistic duo hasn't been to Venice since "their year" four years ago. They are attending now because Gioni is an old friend whose first curatorial endeavor entailed commissioning Elmgreen & Dragset to make a work for the Trussardi Foundation.

"We are here but our minds are in Munich," says Elmgreen. The pair is curating a citywide series of projects that will open in nine days and they still have a lot to do. I repeat one of their lines from our previous encounter: if you don't behave properly as artists, you'll be reincarnated as curators.

"I don't have the taste in my mouth or smell in my nose of being an artist. I'm a cultural producer," says Elmgreen with a semi-flamboyant wave.

Dragset flicks his eyes to the sky, then looks to me for support. "I'm an artist. I wouldn't call myself anything else. Just as I'm gay and wouldn't call myself 'queer,'" he says. "I remember very well making the decision to accept myself as an artist. I had my thirtieth birthday in New York City, where we had a residency. Up until that point I had felt embarrassed, then I thought, fuck it. I can be an artist just as much as anyone else."

"These identity groups are *so* last century. You were a gay artist in the twentieth century," says Elmgreen with a mischievous glint at Dragset. "I would also say that we are far too busy to be artists. We make artworks, do a theatrical performance, publish a book, design a T-shirt, curate a show—so many things." He stares at his creative partner while he thinks, then says, "We are like small mice, avoiding being trapped or cornered. Our work is not about universal truths. All we do is tell small lies."

Cora and I return to the show with four bottles of water, discovering Simmons and Dunham in an intimate room with gray walls in the section designated as Cindy Sherman's. Thirty-two color photographs that Simmons made with Allan McCollum line one wall. They are ultra-extreme closeups of minuscule plastic figures photographed with the

help of an electron microscope. On the opposite side of the room is a vitrine of vintage photo albums owned by Sherman, including several from the 1960s that depict drag queens enacting low-key moments as the "lady of the house."

Dunham is talking to RoseLee Goldberg, the director of Performa, a nonprofit organization that supports performance art, while Simmons is exchanging notes with Sherman herself. We ease our way into the latter conversation. "The curatorial work was fifty-fifty, but Massimiliano is giving me all of the credit. He really shouldn't say that I did all this myself," says Sherman sweetly. These rooms are remarkably in keeping with the Gioni show in the Palazzo dell'Esposizione. Earlier in the day, a freelance curator told me that enlisting Sherman as a curator was "a gimmick, a celebrity endorsement, a licensing job." One of the many pleasures of the biennale is its provision of a seemingly guilt-free occasion to bitch.

Sherman leaves the room with her dealers, Janelle Reiring and Helene Winer, while Simmons, Dunham, Cora, and I trudge on. "Since you started questioning us," says Simmons, as we circumnavigate a Charles Ray sculpture of an eight-foot-tall, blonde businesswoman in a purple suit, "I have been thinking more about the depth and breadth of the construct that we create to transform ourselves into 'believable artists.' It is a much bigger undertaking than just clicking a camera shutter." Dunham chugs his water, then affirms, "There is this reverb. You have to make art to *be* an artist, but you have to *be* an artist to make art. It's about getting your self-representation and your actual activities into alignment. I've gone through moments where I thought 'I hate this, I don't want to do it anymore,' but I always come back to the fact there isn't anything else that would better suit my sense of who I am."

Neither Simmons nor Dunham entertain the idea of retiring. "I haven't ever really gotten what I need," explains Simmons. "It's like being a child. My frustration of not being heard and not being seen drives me." Dunham is even more headstrong. "I am sixty-three and I'm not going to stop. They haven't taken the keys to the car away from me. I know how to do this shit and I have even crazier stuff in my mind. What could be more amusing than powering forward?"

We linger among a compilation of works by Rosemary Trockel, including *Living Means to Appreciate Your Mother Nude* (2001). Another few steps and we encounter *The Hidden Mother* (2006–13), a 30-foot-long vitrine containing 997 photographs of babies taken between 1840 and 1920. Amassed by the Italian artist Linda Fregni Nagler, the images show children posed, propped up, and held still for the camera by women who are covered in blankets, hiding behind chairs or lurking just out of frame.

I am surprised to see Gioni standing by himself on the threshold of the next room. He has just finished giving a tour to a select group of Christie's clients. Knowing that he'll be able to spare no more than a minute or two, I saunter over and cut to the chase: why do so many works in the biennale relate to family? "Art stands in for the people you love," he replies without hesitation, despite his evident fatigue. "Pliny the Elder illustrates the origins of man-made images with the story of the maid of Corinth. The maid's lover is going on a long, hazardous journey so, before he leaves, she traces the outline of his shadow on the wall." He pauses, scanning the crowd who is perusing his show. "That's how painting was born," he adds. "Humans make images to hold onto what they love and what they are about to lose."

Act III: Craft

Damien Hirst
Mother and Child (Divided)
Exhibition Copy 2007 (original 1993)
2007

SCENE 1

Damien Hirst

July 2009. My taxi speeds along country roads toward Damien Hirst's Devonshire farmhouse, then turns into a long driveway, past the artist's herd of grazing cows. The sight reminds me of *Mother and Child (Divided)* (1993), a sculpture comprising a cow and a calf, bisected lengthways, and displayed in four glass tanks filled with formaldehyde. This follow-up to his celebrated shark (a.k.a. *The Physical Impossibility of Death in the Mind of Someone Living*, 1991) consolidated Hirst's reputation for transforming dry conceptual art into witty, emotionally engaging sculpture. Hirst's assistants continue to make these "still lives" (what the French call *natures mortes*), but the artist claims to have ceased production of his spot, spin, and butterfly paintings and closed the studios that make his labor-intensive pill and medicine cabinets. Hirst's own days are now mostly spent alone in a painting studio here on the grounds of his house. In a move that has alarmed the art world, he is applying oil to canvas with his own hand. Hirst has always been cunning; now he is crafty in more ways than one.

As I get out of the taxi, a border collie whose coat is tinted pink from a tussle with wet paint comes to greet me. Jude Tyrrell, the director of Science, Hirst's production company, emerges from the house. She worked with Michael Palin, the Monty Python comedian turned TV presenter, before she took a job with the artist twelve years ago; a press colleague

refers to her as Cerberus, the three-headed dog who guards the gates of hell. A moment later, Hirst appears. His gray shorts and brown hoodie are flecked with multicolored paint and his T-shirt declares, "You'll go to hell for what your dirty mind is thinking." I present him with a copy of the British edition of *Seven Days in the Art World*, which displays Maurizio Cattelan's horse on the cover. "Hmmm . . . the Italian," he says, examining the book with a slight sneer.

I understand Hirst collects Koons so, as we walk through the drizzle toward his painting studio, I tell him that I saw the American artist give a talk last week. Hirst affirms that the Serpentine Gallery's Koons show is "fucking brilliant." When Koons's *Hanging Heart* (1994–2006) sold for $23.6 million in November 2007, he knocked Hirst off the top spot as the world's most expensive living artist. "You can become competitive in your mind with someone like Jeff," admits Hirst. "In your quiet moments, you wonder: what is he doing now? I'm doing this; I hope mine's better. You get competitive but, when you really look at the art, all that goes out the window."

We pass by a newly built indoor pool and gymnasium on which no expense seems to have been spared and, eventually, Hirst's "shed," as he calls it, comes into view. The building was originally a railway signal box to which the artist added a chimney and windows. The wooden façade is covered in drips of turquoise and splashes of black. Humble isn't the right word. Shabby isn't either. It's a nostalgic fantasy of a poor painter's shack.

Inside, the shed is dark and crowded, with exposed rafters and bare lightbulbs. A dozen canvases are stacked against one another; some face out, others stare at the wall. A pathway through the clutter leads us past a large mirror and disheveled bed to three paintings in progress depicting Medusa, which are in a standoff with a taxidermy bear, apparently turned to stone by their angry glares.

Hirst enjoys working in these cramped quarters. "I'm so used to having any space I want. What fucks me up is infinite possibilities." He grabs a canvas that is about seven and a half feet high by five feet wide and skillfully slips it out the front door to lean it against the outside of the building. "I love the fact that I have to plot paths in space," he says as

he moves two more canvases out so we can see the full triptych, which now covers the whole front of the small building. Titled *Amnesia*, the three panels in progress feature a skeletal red figure and red chair in an empty blue room. The middle panel depicts a shark's jawbone containing an eyeball, which, like the eye of Fatima, appears to ward off evil.

"I've always had this romance with painting," says Hirst. "It's like a conceptual idea of a painter. The butterfly paintings were about an imaginary painter who was trying to make monochromes but the butterflies kept landing on the surface and fucking them up. I've always had a make-believe story going on behind the work." These glossy paintings are covered in whole dead butterflies and are distinct from his "Kaleidoscope" paintings, which use only the wings. For the past few years, Hirst has been the largest importer of butterflies into the UK.

Hirst enters a separate prefabricated shed where he dries his work and brings out the three panels of another triptych called *The Crow,* placing them, one by one, on top of *Amnesia*. It's a more minimal composition, with some real black feathers collaged on the surface. "I need to work on twelve paintings at a time, minimum. Otherwise I get frustrated because there's not enough to do," he says. The drizzle turns into a shower. Hirst ignores it; he likes the rain. "I find myself going more toward Rembrandt and away from Bacon. Painting more from life and, through practice, getting better." As Hirst maneuvers the works back inside, he adds, "Painting is really hard. It's about accepting your limitations but reaching for the moon."

Three years ago, when Hirst picked up a brush for the first time since he was sixteen, he was "horrified" to discover that his skills as a painter were exactly where he had left them. "The first paintings were awful, but what I learned was that I had belief," says Hirst. The first and third panels of this *Crow* triptych have white dots in the background. Although they are laid out by eye, they evoke his previous spot paintings, in which multicolored polka dots are arranged in meticulous grids. "The new spots are all about 'the fuck-up,' whereas, before, my paintings were about 'the perfect,'" he explains. He has abandoned a mechanical aesthetic in favor of something he describes as "more personal."

Inside the painting shed, Hirst takes a seat in a grubby, paint-splattered

1930s' leather chair while I settle into a wicker rocker. There isn't an assistant in sight and, frankly, between the stuffed birds, skulls, paintbrushes, and other props, there isn't room for one either. "I always wanted to be the best drawer in the class," he says. "I never was, which helped me. I had to find another way to get ahead. If I had been the best drawer, I would have been disappointed when I got out into the real world." Hirst is known for his entrepreneurial skills—his flair for original ideas, marketing, and management—so many doubt that he is making these works himself. Hirst has someone stretch and prime the canvases but he insists that the paintings are otherwise solo performances. "I don't think people will ever believe that I am painting them. It doesn't matter how much paint I get on my hands." He takes off his large black Prada frames and rubs his eyes. "It's an awkward transition," he confesses. "The idea of me painting troubled me in the beginning. I thought, is it erasing the past? Is it suggesting that I don't agree with it?"

Hirst's shift from a multi-factory operation to a mode that one might associate with an amateur gentleman painter is a career reversal that thwarts prevailing expectations of artistic development and challenges the art world's belief in him. Only a few years ago, Hirst said, "Am I a sculptor who wants to be a painter or a cynical artist who thinks that painting is now reduced to nothing more than a logo?" When confronted with the statement now, he laughs, "I'm both. I'm still cynical. I'm still full of doubt. I'd say I'm a painter *and* a sculptor. I'm an artist *and* a comedian. I'm a hairdresser to the stars!" Hirst is expecting these new paintings to be "slagged off" by critics. "But you know what Warhol said, 'If the critics don't like something, just make more.'"

Hirst is nothing if not prolific. At the moment, he admits to making about a thousand spot paintings. He has a meticulous database from 2001 but there are some blank areas from the drunken 1990s, so he doesn't have an exact total figure. "What you're making dictates how many you make," says Hirst, but then he semi-contradicts himself by implying that demand determines the numbers. "The art market is a lot bigger than anybody realizes," he says, picking up a big brush loaded with gray paint and tossing it in the air like a baton. "If you're interested in the art market side of things then it is to your advantage to make

more," he says, mentioning the name of a figurative painter who makes only a dozen paintings a year. "The market can't really get going because there is not enough of his work in circulation."

Tyrrell signals that it's time for lunch, so we trudge through the rain to Hirst's farmhouse. A huge shorthaired cat called Stanley lounges on a long wooden kitchen table between two Warhols—a gray skull painting and a stunning, small red car crash from 1963 titled *Five Deaths*. "One great thing that came of buying art is that I understand my collectors. Collecting is fucking addictive," says Hirst, steering me into an adjacent TV room. We sit on beanbags under a Bacon self-portrait that Hirst acquired at auction for $33 million. The room has acid yellow walls and blue carpeting. A large-screen television hangs on the wall between another Warhol, an orange *Little Electric Chair*, and an important Bacon from 1943-44. It's thought to be the original right-hand panel of a triptych that hangs in Tate Britain, titled *Three Studies for Figures at the Base of a Crucifixion*. The installation traces Hirst's inspirations from Warhol to Bacon in a room devoted to media.*

What is the difference between you and your myth? I ask.

"Your image is something you wear. It is not something that you are," he says. "I guess I suddenly felt that the person I was wearing wasn't really who I was. I'd undergone some big changes in myself, which hadn't come through in the work. Maybe if I hadn't changed so much, I could have carried on making that work forever." Hirst scratches the back of his head, messing up his short-cropped gray hair. "That's what made me push it to the auction. I was putting something to death as

* This is not the first time I've interviewed Hirst in this house. Back in 2005, after some perfunctory small talk, he took me straight up to his bedroom. The bed was unmade; clothes littered the floor; wet towels were hanging over doorknobs. Afterward, we had lunch with his then girlfriend, Maia Norman, their three sons, and the chauffeur. Hirst hadn't had a drink in several months, but he ordered a bottle of Bâtard Montrachet, then another, then instructed the waiter to prepare a takeaway crate. Five days later, at 1 A.M., I was dragged out of sleep by insistent ringing and met with "Shellllooo Sharah!" In his days as a classic bad boy, the artist was prone to drunk-dialing and, as it happens, mooning. Needless to say, Hirst has long performed for the media with panache.

well as celebrating it." Back in September 2008, Hirst auctioned off over two hundred newly made artworks at Sotheby's for £111 million ($198 million). It was a landmark event in the commoditization of art, which suggested that he had mastered the craft of being what Warhol called a "business artist."

"It's not really the money that I like, it's the language of money," explains Hirst. "People understand money. There are people who might have dismissed my work who can't anymore." The artist often talks about how money and fame can overwhelm art and honesty. "Integrity is about what you're doing," he explains. "Warhol said, 'Look, I'm a starfucker.' If you admit it and you are true to yourself, then it works."

Are you a starfucker? I ask.

"I think we are all starfuckers to varying degrees. The whole celebrity thing comes out of a fear of death, which is what art has always been about. You meet famous people and it makes you feel closer to being immortal in some way." Hirst crosses his arms and looks up at the *Electric Chair*. "Warhol made fame into an art form," he continues. "When I first got involved in art, I was totally aware that you needed to get people listening to you before you could change their minds."

Hirst is distracted by a message on his Blackberry. When he looks up, I say I'm fascinated by artists' personas and his is particularly...

"Repugnant?" he interjects.

Ah, no, I was going to say "complex." His word choice reminds me of a painting in which he depicts himself with an asinine grin, mugging for the camera with Jeff Koons and Victor Pinchuk, a Ukrainian steel oligarch. "It's just a faithful copy of the photograph," Hirst tells me. "I try not to choose photographs that flatter me so they are more believable."

Some art professionals complain that Hirst so persistently breaks art-world etiquette that they wonder whether he has any respect for art. "I've always had trouble with authority. I don't know what respect is," he confesses. "A lot of what I've done has been based on what people said I couldn't do." When he was a student at Goldsmiths College, he organized an exhibition called "Freeze." "Everybody said you can't be an artist *and* a curator. After that, I could never follow any rules." In the early 1990s, a dealer told him that you couldn't sell works by young

artists for over £10,000. "I was like, 'Fuck that.' That was a hell of a lot of money at the time, but I was stubborn and ignored it. That's what the shark came out of. To hell with the £10,000 limit!" Charles Saatchi paid £50,000 for Hirst's first shark in formaldehyde.

Hirst's chef delivers a plate of hot food, which I struggle not to spill on my beanbag; the artist tells her that he will eat later. "I've always thought that art and crime are very closely related," he says, rubbing his hand on his stubbly chin. "Crime is incredibly creative. There's the bank. If I buy that shed next to the bank, I can dig a tunnel, go underneath, break up the floor, take the money out, go back through the tunnel, and no one would know I was there. That is exactly what art is like!" Hirst seems to relish the role of symbolic criminal, an artistic position with more power than an *enfant terrible,* although he is most often described as a showman. "They're all bullshit," he responds, dismissing this list of identities. "At the end of the day, the only interesting people are those who say, 'Fuck off, this is what I think.' It's a very indulgent thing, being an artist."

Andrea Fraser
Official Welcome
2001/2009

Andrea Fraser

Andrea Fraser saunters up to a transparent plexiglass lectern in a black cocktail dress with a plunging V-neck. The artist is a petite but muscular brunette with full lips. Her hair is pulled back in a tight bun, reminiscent of ballerinas, librarians, and other good girls. She unfolds a white piece of paper, then surveys her audience with sparkling eyes. A hundred and fifty people, many of them art students from the local Kunstakademie Düsseldorf, have bought tickets for the nominal fee of five euros. They sit expectantly in the vast white space of the Julia Stoschek Foundation, which is hosting an exhibition about the history of performance art.

"Thank you, Julia," says Fraser upon being introduced. A full-time professor at UCLA, the artist begins with an academic preamble. "Whereas most people who make site-specific art engage with physical spaces and places," she says with a graceful double-armed wave at the room, "my practice focuses on the immaterial aspects of sites—their discourses, rituals, and, above all, their social relations." She makes a series of statements about her artistic strategies and expounds on her belief that the personal is political, then says "Thank you!" She quickly folds the paper, places it on the podium, and takes two delicate steps backward.

With a heavier tread, she stomps forward, turns her head dramatically to the right, and bellows in a male voice, "Thank you Andrea,

for that exemplary presentation." While the crowd laughs, she frowns, standing rigidly upright. Continuing in a baritone, she laments how "the forces of spectacle culture" may have led to the "the demise of radical practice." Then she segues into a lengthy introduction of an artist who is so complex and convincing, so worthy of adulation, that "it is a historic opportunity to have him here this evening."

Fraser looks quickly right and left, then gazes at the ceiling. "Um..." she says wearily. The stiffness of the previous character drains out of her body. "I don't want to sound coquettish...but, as an artist, I'm always disappointed," she says, putting her hand on her hip and half-leaning on the reading stand. "I give something to people, but I don't expect communication. I hope I can make people think, but I don't want to be didactic," she says. "So, why am I an artist? I guess it's because I take a critical position toward the world. It's not about hope. It's about showing my disgust for the dominant discourse."

As if she were shuffling multiple personalities, Fraser mutates into someone else. "How much information can you receive from one artist in a few minutes?" declares this new pundit, before going on to spout absurdly hyperbolic praise for yet another artist. "If masterpieces still can be made, he has managed to make them," intones Fraser gravely. "Exquisitely realized works of power, vision, and extraordinary beauty, works that rise to a level of humanistic allegory significant to us all, even while we may not know exactly what they mean."

The crowd breaks out in quiet chuckles and a few unrestrained guffaws. Some people will have read the script, seen a video version, or even experienced a live iteration of this legendary performance. Titled *Official Welcome*, the piece was first presented in 2001 at the Morse Institute of Conceptual Art (MICA), a private foundation whose physical existence consists solely of a heavy wooden lectern in the Upper West Side living room of Barbara and Howard Morse. According to Fraser, the Morses were her only collectors for over a decade. "Even when I didn't want collectors, when I was against the whole idea that art was bought and sold, they were there, trying to buy." Since then, she has performed the work thirteen times in eight countries.

Official Welcome is a kind of surreal one-woman awards ceremony

in which Fraser plays the parts of nine artists who are being introduced and celebrated by nine effusive art-world insiders. Credited with coining the term "institutional critique," Fraser often explores the institution of the artist in her performance pieces. The script of *Official Welcome* is a carefully researched compilation of art-world voices, based on speeches by and interviews with living artists, critics, dealers, and collectors. Thomas Hirschhorn, Gabriel Orozco, and Benjamin Buchloh (the Harvard professor that Francesco Bonami called the Don Vito Corleone of institutional critique) appear to be the sources of some of the material performed so far. For Fraser, *Official Welcome* is not just about the social roles artists play but about her own psychological responses to them, including her envy of the recognition that other artists have received.

"If I, uh, if I, uh, if I deserve, uh, any of this, uh, I think that can only be because, uh, because I have, uh, finally arrived," says Fraser, clenching the lectern, her eyes glued to the floor. "Arrived at a point where, uh, my work has become, uh, has become, uh universal." Fraser has morphed into an inarticulate painter who ums and ahs his way through a string of clichés about desire, freedom, self-realization, and achievement, then concludes, "That's why I, uh, don't like, uh, to talk about my work." The room bursts into eager applause.

After taking a sip of water, Fraser mutates into a curator who wants to pay homage to an artist of "unshakeable integrity," then an artist who protests, "Oh, stop it! You're embarrassing me," then an acolyte who takes great pleasure in introducing "this modern master, my great friend." For the most part, the alternation between the artists and their supporters feels like one between teenagers and adults, nonchalance and formality, disdain and devotion.

Fraser continues to transmute from artist back into devotee. "We want various things from artists—to be one of us, to be better than us," says a fan. "The fact is . . . she *is* better than us. She's more beautiful than we are. She's more successful . . . with a much more interesting life. She's our fantasy. She lives our fantasies for us."

With a vapid grin, Fraser proceeds to lift her dress over her head. She scrunches the garment and tosses it on the see-through lectern, and then adjusts her black bra and thong. "I am not a person today. I'm an

object in an artwork. It's about emptiness," she says coyly, then moves a few feet stage right and stands motionless with her chin up and her arms by her side for fifteen seconds.

"Isn't she great!" says Fraser in a masculine voice as her character walks back behind the podium, seemingly oblivious to the fact that "he" is wearing only underwear and high heels. "It's fun to sell big artworks, and it's profitable. In the end, a good artist is a rich artist and a rich artist is a good artist." For art-world cognoscenti, Fraser appears to be Larry Gagosian riffing on one of Warhol's adages about how good business is the best art. Her version of Gagosian metamorphoses into a rendering of art critic Jerry Saltz, who takes his turn to gush satirically about another rich artist with an obsession with death. "He's back, and he's bigger and better than ever," says Fraser, channeling Saltz. "He's staggeringly corporate, breathtakingly professional, and eager to entertain. And I hope he'll say a few words to us this evening."

"Yeah, I'll say a few words," responds the artist, who takes a large swig and swishes the liquid around in "his" mouth. "I'd just like to say that the only interesting people are the people who say, 'Fuck off.'" Fraser's character crosses his arms and glares belligerently, then announces, "The True Artist Helps the World by Revealing Mystic Truths." It's the title of a neon light piece by Bruce Nauman that Damien Hirst unfailingly declares as his favorite work of art. "Okay, here are a few more words," says Fraser, continuing to perform Hirst. "How about 'Kiss my fucking ass!' That's a great statement anywhere, right?" Fraser walks to one side of the stage and moons the audience, then to the other side, brandishing her buttocks again. In his days as a heavy drinker, Hirst was known to expose himself this way. Fraser swings around, throws her arms in the air, and declares, "I love you all!"

She pauses with her arms outstretched, then resumes her position behind the lectern and shrinks a tad. "You always do your fucking best," she says in a sweet older lady's voice. "You were our first major purchase ...and we considered it an act of sheer courage."

For Fraser, performing is a craft that is not just about the live event but the whole process of creating the piece: the research, writing, editing, memorization and internalization, rehearsal, and enactment. Although

Fraser never trained as an actor and doesn't work with directors, she is "invested in her skill set," as she puts it, even if it is "kind of naïve or even amateur."

"Attention can be incredibly cruel," says the next artist to emerge from Fraser's string of multiple personalities. This self-confessed bad girl removes her bra, then her high heels, then her G-string. "But if you're really bad you tell the truth and people don't want to hear the truth." Although viewers who come with no prior knowledge of *Official Welcome* often gasp when she disrobes, Fraser sees her nakedness as part of the "grand old tradition of nudie performance art." Indeed, it is such a cliché of transgression that the artist jokes that she is not really naked because she is in quotation marks.

Fraser rests her elbows on the podium, her hands knitted together as if in prayer. Her lean body—pubic hair and all—is visible through the translucent podium, evoking that common anxiety dream of being inadvertently naked in public. "It takes a lot of courage to do what she does," says Fraser, seeming to be self-reflexive. "She's an artist who has uncovered structures so pervasive and profound that no one is innocent in her work—not her characters, not her viewers, not even herself."

After a shift from supporter to artist and back again, Fraser puts on her dress and shoes, then starts crying. "I wanted to be an artist since I was, like, four, because my mother was a painter, a good one, who never had any success," she says, tears running down her face. As it happens, Fraser's mother was a painter who never showed her work professionally and gave up in despair at the mounting rejection. The relief that Fraser feels about her own relatively high level of recognition often makes her weep. She has long felt guilty about the incongruity of criticizing art's institutions while, at the same time, having ambitions to be legitimized by them. "I hope I can convey my sense of gratitude for your attention," she says, wiping her nose with a tissue, "and for being given the opportunity to be heard."

Switching to a chipper voice, Fraser says, "Can I ask everyone to give her a big hand?" She looks toward the wings with her right arm outstretched. "Isn't she terrific?" she says, clapping emphatically. The audience willingly follows the artist's lead. There is applause all round.

Andrea Fraser
Untitled
2003

Jack Bankowsky

"We are interested in how the art market and the publicity machine can become an artist's medium as much as paint on canvas or stainless steel," says Jack Bankowsky. The former editor of *Artforum* is surveying the busy private view of a Tate Modern show that he has curated with Alison Gingeras and Catherine Wood. The exhibition was originally titled "Sold Out" until one of its participating artists objected. It was renamed "Pop Life," a compromise that muddies the curators' thesis. Many of the twenty-one artists included, such as Andrea Fraser, are not exactly what anyone would call Pop. Bankowsky, who is wearing a green polka-dot bow tie, checked shirt, and striped jacket, stands next to a Warhol portrait of Mick Jagger. "Every work an artist makes is part of a complicated performance," he says in his playful drawl. "Our initial subtitle was 'Performing the System, Performing the Self.'"

For Bankowsky, one of the exhibition's highlights is a partial restaging of Jeff Koons's controversial "Made in Heaven" show. In a room separated from the rest of the exhibition, with a parental guidance sign on the door, a range of sculptures and paintings depict Koons and Ilona Staller, his porn star ex-wife, performing graphic sexual acts. *Dirty— Jeff on Top* (1991), a life-size sculpture of the couple in flagrante delicto, is the focal point of the room. Around it are works such as *Exaltation* (1991), a large-scale photorealist closeup of a cum-splattered Staller with

Koons's penis. "'Made in Heaven' is an archetypal instance of an artist pushing things too far and creating outrage," says Bankowsky. "Our show reclaims these moments as definitive."

Bankowsky and I greet Rob Pruitt, a New York artist, then Takashi Murakami, a Japanese artist–curator–collector–gallerist, both of whom have work in the exhibition. I've already been around the show so I am observing artists and revisiting works about which I'm likely to write. On the other side of the room, a paparazzo is snapping a shot of Nicholas Serota, the director of Tate, talking to Grayson Perry, the "transvestite potter," as the tabloids call him, who is working on a show about "Unknown Craftsmen." A few yards to their right is Maurizio Cattelan, standing in front of a black and silver Warhol painting titled *Myths* (1981), which has vertical strips of fictitious characters, each repeated ten times. After Santa Claus, Mickey Mouse, Uncle Sam, Aunt Jemima, Dracula, and the Wicked Witch of the West, Warhol positioned a column of portraits of himself.

Cattelan has a new horse sculpture on display in an adjacent room. This taxidermy beast is lying on the ground, staked with a sign that says "INRI," an acronym of the Latin for "Jesus of Nazareth, King of the Jews." Bankowsky is still not sure what to make of it. "If the dead horse is Maurizio's alter ego," he muses, "then this act of king-making could be outlandish one-upmanship or a way of problematizing the packaging of artists." Bankowsky's verbal style is an idiosyncratic combination of highfalutin and colloquial phrases; he resignedly refers to it as "Valley Girl meets art-speak." When he is drawn into another conversation, I go over to Cattelan to ask about his Christ horse. "Maybe I've been martyred," he says coyly. "Punished for too much pop life!" When I suggest that we go look at the horse together, he reacts with a clownish expression of horror. "I don't like having my picture taken in front of my works. It looks stupid," he says. "Photographers will catch you with the piece if you are not careful."

We meander into a corridor full of Warhol memorabilia, including photographs of the Pop master air-kissing celebrities at openings. Standing below a black-and-white picture of Warhol and Salvador Dalí is Jeff Koons talking to Jeffrey Deitch, a dealer and longstanding Koons

supporter. We greet the two men and exchange niceties. Cattelan turns to Koons, wipes his forehead as if he were overheated, and says, "Phew. People can't stay in your room for too long because they get horny. I should stand just outside so I can catch women as they leave the room." Deitch laughs. Koons stares at Cattelan with a stiff smile, saying nothing.

Later, I find myself on my own in a room devoted to works from Hirst's 2008 "Beautiful Inside My Head Forever" auction. It is an onslaught of glitz: a calf suspended in formaldehyde in a gold-plated tank on a Carrara marble plinth titled *False Idol*; a pair of gold cabinets lined with manufactured diamonds; a large spot painting with a gold background; and a butterfly painting smothered in gold paint called *The Kiss of Midas*. These flashy pieces are continuations of previous bodies of work that have adopted the visual rhetoric of luxury goods. For many years, Hirst repeated the line, "Art is about life and the art world is about money. You've got to keep the two things separate." However, with the "Beautiful" works, money has become a dominant motif, embedded in the gilded paint like his dead butterflies. Hirst likes to pursue "universal triggers," as he calls them.

These art objects, however, are not the main reason for Hirst's inclusion in the exhibition. As the wall text declares, the Sotheby's auction is significant because Hirst "infiltrated the art market" and "turned one of its defining rituals into a work of total theatre." Miuccia Prada, the fashion designer and buyer-loaner of the pickled calf installed here, told me that she thought of the auction as "an incredible conceptual gesture, not a sale." Certainly, "Beautiful Inside My Head Forever" sounds like an ironic-iconic artwork, but artists' opinions are split. Some regard the auction as a daredevil coup and a moment of unprecedented artistic empowerment. Others declare that Hirst has ceased to be an artist. Art is supposed to have goals more profound than profit and the auction was openly mercenary. Hirst, they think, has mutated into a product designer.

Whatever Hirst's identity, the "Beautiful" sale was innovative business. The art market is divided into "primary," which is new work sold through galleries, and "secondary," literally secondhand art, often sold at auction. Usually the only new works sold at auction are donated by artists to raise money for charity, but Hirst's sale was full of primary material straight

out of his studio, some of it not yet dry. Sotheby's delighted in promoting their brand around a celebrity artist rather than the usual jumble of inanimate objects. Never had so much of Hirst's art been seen in one place; various Sotheby's specialists even implied it was a retrospective.

Few people were convinced that the market could absorb 223 lots from one artist in twenty-four hours. Moreover, the first part of the auction took place the very evening in September 2008 that Lehman Brothers declared bankruptcy. The financial crisis was imminent. No one on Wall Street or in the City of London knew whose business might be next. Nevertheless, the sale made £111 (almost $200m) and had a sell-through rate of 97 percent—a feat so incredible that many art-market observers were skeptical that the results were entirely legitimate. The art world's suspicion of the sale was exacerbated by the public relations fiasco that surrounded *For the Love of God* (2007), a platinum skull studded with 8,601 diamonds, which was marketed around an asking price of $100 million. Although Frank Dunphy, Hirst's business manager, announced that "a group composed of a number of interested individuals" were purchasing the skull at its full price in August 2007, *The Art Newspaper* revealed that Hirst and his dealer, Jay Jopling, still owned it six months later. For a time, the confusion cast doubt on Hirst's integrity.

However, Hirst's "Beautiful" auction increasingly appears to have been a genuine financial success. It grew the market; buyers came from twenty-two countries and over a third of them had never bought contemporary art before. Neophyte collectors from the former Soviet Union were among the biggest spenders. Larissa Machkevitch, the wife of a Kazakh mining magnate, for example, bought the golden wall works in this room along with three other lots from the evening sale.

One cloud of doubt that lingers over the sale relates to the fate of—and, some presume, mischief behind—the top lot, *The Golden Calf* (2008), a bull in formaldehyde with 18-carat gold horns and hooves, crowned by a solid gold disc. The title refers to the biblical story about the sin of worshipping idols and adoring wealth. Many saw the garish sculpture as undesirable—the ultimate test of a bull market—but it sold for a record £10.3 million ($18.6m) to an anonymous telephone bidder. The persistent rumor was that it was acquired by the royal family of Qatar. "I don't think that's true," said Hirst when I asked him about it

during my visit in Devon. "I'm sure [the Qataris] did buy things. But it's all hearsay."

Could another artist pull off this volume of trade, selling over two hundred pieces in one fell swoop? Although Hirst is to some extent the son of Koons, the American artist ten years his senior is a conservative market player who issues works in controlled editions of five and concentrates exclusively on the very high end. Nothing could be further away from Hirst's risk-loving modus operandi and his desire to reach out with a broad range of price points. Moreover, Koons is generally cagey about business whereas Hirst is happy to make a spectacle of it.

Bankowsky wanders into the room and we resume our conversation. "The whole issue of Hirst's participation was complicated," admits the critic–curator as he inspects the white hair and dainty golden hooves of *False Idol*. "He was the only artist with whom Alison and I did not have direct contact. He was unavailable and his stance on the show was inscrutable. Although we eventually obtained exactly the works we wanted, all the negotiations were done with the higher-ups at Tate." Bankowsky and his co-curators were surprised that they were not greeted with open arms. "Perhaps he was concerned about the way we would position him, or maybe it was about keeping his luxury label above the rest, just like Louis Vuitton doesn't want to be on the same shelf as a less pricey brand." Bankowsky was keen to have Hirst's work in the show even though it went against his personal taste. "Hirst is perfect for our theme—a pure symptom."

I ask Bankowsky to come with me to look at the work of Andrea Fraser. Fraser is an impressive risk-taker who can also be seen as a kind of anti-Hirst. While Hirst produces goods, Fraser's performances are services. Whereas he often spins his messages, she has an almost self-destructive desire to reveal the truth. We walk through a couple of rooms until we come to the white-walled alcove that hosts *Untitled* (2003). A small, ordinary monitor sitting atop a pedestal displays a video of the artist having sex with a collector in a hotel room.* In a transac-

* Fraser's *Untitled* exists in three versions: a sixty-minute silent video installation (2003), an audio-only installation (2004), and a set of seven photographs and a press release (2006).

tion brokered by Fraser's New York dealer, Friedrich Petzel, the collector prepaid for the production of the video rather than the encounter it represents. Whether it is a metaphor or an extreme literalization, the work is an enactment of the artist as prostitute. As Fraser told the *Brooklyn Rail*, "*Untitled* is about what it means to be an artist and sell your work—sell what may be a very intimate part of yourself, your desire, your fantasies, and to allow others to use you as a screen for their fantasies."

The idea behind Fraser's *Untitled* is sensationalist, but the video is intentionally unspectacular. It consists of one silent, static shot, taken from a high angle, suggestive of surveillance cameras. At this moment, Fraser has her back to the camera, her bare buttocks in full view, but it is unclear what exactly the couple is up to, in part because the scale is so small. Fraser usually plays characters, but this looks like two real people awkwardly having sex for the first time on a white-sheeted king-size bed. *Untitled* has none of the glorified impropriety of Koons's "Made in Heaven" work, nor any of the schmaltzy romanticism of Hirst's "Beautiful Inside My Head Forever." In fact, *Untitled* is such a straightforward document that the Petzel Gallery's visitors' book was full of complaints that the piece was not sexy at all.

"Andrea is really good for the ecology of the show," says Bankowsky. "No one could accuse her of pandering to the market." *Untitled* comes in an edition of five with two artist's proofs. "Lots of creeps wanted to buy it but we refused to sell it to them," Petzel told me. "We recently raised the price to make it even harder to buy. The first video went to the participating collector. A good Belgian collector and the Generali Foundation in Austria took the next two. The remaining videos are for museums but most public institutions are still scared to buy it."

Video art is tricky to sell at the best of times, but Fraser makes it even more difficult by forcing buyers of the work to sign a stringent contract that declares that they are not entitled to show *Untitled* without her consent and that she has the right to review any publicity material they generate about the work. By contrast, Fraser did not have a contract with the collector with whom she had sex. That "exchange" was based on trust. He had bought her work in the past so it felt like "a good

match," as Petzel put it. For Fraser, an artwork is not just the object or performance itself, or even its production and exhibition; it includes its distribution. For this reason, she is keen to control the way her work moves through the world.

"Andrea was really ambivalent about exhibiting the video. It took a lot of coaxing to get her consent," says Bankowsky. He frowns at the monitor as the artist climbs on top of the collector. Rather than exhibiting the sixty-minute video, Fraser often distributes stills of the encounter alongside a shot of the video installation and the original press release. Bankowsky dislikes this strategy. "It willfully neuters the piece and turns it into an archival exercise," he says. Watching *Untitled* is a visceral and emotional experience in a way that looking at the six stills is not. "Andrea's own gesture freaked her out and some of her apologists see *Untitled* as a misstep," says Bankowsky. "But, by the criteria of 'Pop Life,' it is her best work."

While Hirst is fond of launching his art with highly publicized price tags, Fraser chose not to disclose the sum paid by the collector who participated in *Untitled*. She was keen to resist the "pornographic interest in prices." When the video was being shown at Petzel Gallery in 2003, however, the press somehow got a hold of the figure $20,000. Fraser has told me that she found it extremely painful to be publicly identified with a specific monetary value. "I was aware that the artist showing next door was selling paintings for $200,000 each. I was exposed to the art world's steep hierarchy of value and I felt shame at being so cheap within it."

Fraser always names her works, but she opted for the generic *Untitled* in this instance. "'Untitled' is a precious art-world convention," says Bankowsky as we walk out of the alcove. "It suggests that the work is so self-sufficient, so replete, that it doesn't need the supplement of a title." In Fraser's hands, "Untitled" becomes an emphatic label, a witty spoof of all the artworks that go by the name. Somehow, by acting out and controlling a situation in which the moneyman fucks her, she purifies herself of his corrupting influence. If many artists are deemed to be whoring themselves nowadays, perhaps Fraser is one who didn't.

Christian Marclay
Still from *The Clock*
2010

Christian Marclay

Christian Marclay is finishing a masterpiece. He has been cooped up for months in his small studio on the fourth floor of a townhouse in Central London's Clerkenwell neighborhood. He invites me to sit down next to him at his desk and then slumps into his cushioned swivel chair. Yesterday, he missed yoga and was a "zombie" by the time he went home. He has calluses on his fingers from clicking a mouse—or mice, rather, as his twenty-four-hour video *The Clock* is too big to be loaded onto a single computer. Sometimes he bandages a couple of fingers together to stave off carpal tunnel syndrome. Who would have thought that making concept-driven art, crafted on computers, would be so physical?

The Clock is a montage of clips from several thousand films, structured so that the resulting artwork always conveys the correct time, minute by minute, in the time zone in which it is being exhibited. The scenes in movies where viewers see clocks or hear chimes tend to be either transitional ones suggesting the passage of time or suspenseful ones building up to dramatic action. "If I asked you to watch a clock tick, you would get bored quickly," explains the artist. "But there is enough action in this film to keep you entertained, so you forget the time, but then you're constantly reminded of it." Born in California, Marclay was raised in Switzerland speaking French; he still tends to drop the "s" off plural nouns.

Artworks based on appropriation sometimes get ensnarled in copyright issues. "Technically it's illegal," Marclay says of his elaborate remix of cinematic snippets, "but most would consider it fair use." His work ultimately pays homage to these movies, particularly the actors. "When a scene is well acted, you could look at it a hundred times and never get bored. You see the flaws but understand the talent. It's such a vulnerable profession," he says. In *The Clock*, actors crop up at different stages of their careers. "Their fluctuating ages offer an interesting twist on time. The work is a giant memento mori."

While Marclay himself keeps a low profile, many of the faces on screen are world famous. "They're part of this weird extended family and this element of recognition—of familiarity—is appealing," he says. Strangely, Marclay bears more than a passing resemblance to Kiefer Sutherland, the lead actor in *24*, a television series in which each twenty-four-episode season covers twenty-four hours in the life of the main character. Though Marclay acknowledges the importance of fame for Hollywood, he dislikes "the cult of personality" when it comes to art. "I think people get interested in art for the wrong reasons," he says. Certain artists who are central to Marclay's thinking have legendary personas, such as Marcel Duchamp with his transvestite alter ego, Rrose Sélavy. "I try not to admire Duchamp in that way," he says. Aside from a few early pieces, Marclay does not make self-portraits or autobiographical work. "I want people to be interested in the art, not me," he says.

Marclay is also uncomfortable with "the desire to glorify artists" for the sake of their market. "In the eighties, artists were like rock musicians who had to trash a hotel room to be somebody, but that kind of rebellion is out of fashion. Now, when you think of artists, you think of sober entrepreneurs." Like many artists, Marclay feels estranged from the increasing commercialization of art, even if the gallery that shows his work in London is an important hub of the relentless boom. "I'm thankful for the Damien Hirsts that keep my galleries happy and allow me to make this work," he says.

Marclay has been working on *The Clock* for over two years, using Final Cut Pro software. He used to limit his editing to five hours a day, but he has been putting in ten to twelve hours seven days a week for

months. Such are the occupational hazards of making such a lengthy video. "Twenty-four hours is the logical result of the idea. Three hours would be silly," explains the artist, who might spend a whole day fitting together a dozen clips to make just one minute of video. "I get into a zone when editing. I forget about the time. A whole day will go by. A whole week," he says emphatically, aware of the irony.

Six research assistants work from home watching films in search of relevant sequences. For a while they scoured Bollywood films but found little time-marking. "I guess it's a different tradition, with a different concept of time," explains Marclay. By contrast, some American television series are fixated on it. "I have an assistant who is looking at chick flicks. *Sex in the City* is preoccupied with the New York minute." London's "Big Ben" is ubiquitous. "It's the most iconic clock," he says. "Regardless of the provenance of the film, if the action takes place in London, Big Ben appears."

"I have a strange relationship with my researchers because I don't see them," says Marclay. "They drop off their footage at White Cube, then Paul, my main assistant, brings me the catch of the day." Paul Anton Smith works full-time, taking care of the technological and logistical aspects of *The Clock*. London's White Cube and New York's Paula Cooper Gallery have provided the budget. Marclay says he doesn't know the cost of the production. "Ask Jay," he advises, referring to Jay Jopling, owner of White Cube. "It's cheap compared to fabricating a monumental bronze sculpture." The piece will be available as an edition of six with two artist's proofs, for sale to museums and private collectors.*

The Clock will premiere on a big screen with sofa seating on the lower floor of White Cube. Marclay is supposed to fill another floor of

* Six is the magic number for the artificial rationing of photographs and videos that, with digitization, could be reproduced limitlessly without any reduction in image quality. Before this convention was accepted, photographs and videos did not circulate as art. Apologists for the seemingly arbitrary figure point to the history of casting, which restricted the sculptures made from a single mold to eight because of deterioration of the plaster. However, the quota for images made by mechanical means is best explained with reference to the market. Six is the number that balances rarity with ubiquity; it is the amount of works that can be absorbed by a globalized art world.

the gallery with objects, but is still unsure what he will make, because he hasn't had the "mindspace" to think about it. In addition to videos, the artist makes collages, photographs, paintings, sculptures, and performances. Some of his best-known works are assemblages of musical instruments, vinyl album covers, cassettes, reel-to-reel recording tape, and other sound-related materials. When I suggest that music is his signature, he looks worried. "I don't know if it's necessarily identifiable right away as me, especially now that so many artists work with sound imagery," he says. Marclay mulls it over while rubbing his long hands together. "My video editing ability came from years of deejaying," he volunteers.

When Marclay is not working on visual artworks, he is a composer and musician who specializes in making noise. He creates unusual "scores" from found materials and invites other musicians to improvise with them. For Marclay, sight nevertheless prevails over hearing. "An image will leave an imprint that's more powerful than sound, at least for me," says Marclay. When the artist first started working with music professionals, he realized that he did not have the same "acuteness in listening." He has since become more proficient and is absorbed by "how adding an image to sound changes your perception of it, and vice versa."

Marclay has edited most of "the P.M. hours," with the exception of a few holes. "I thought 3 A.M. would be hard but it's pretty tight now; 5 A.M. is the most difficult," he says. "In the movies, people rarely sleep. They are sweating, having nightmares. The phone rings or someone is waking them up." Marclay wants to finish 4 A.M. today, then he'll skip 5 A.M. to work on 6 A.M. He hopes to be done by next week so he can start polishing up the transitions. "Every hour has its own timeline. The transitions are tricky because a lot happens on the hour, but it's fun when you get it right," he says.

Throughout the summer, Marclay has been sending discs loaded with segments of *The Clock* to Quentin Chiappetta, a Brooklyn-based sound engineer with whom he has worked for over twenty years. Chiappetta equalizes the disparately mastered soundtracks of the many film clips. "Sound is the glue that holds the pieces together," explains Marclay, who will also have spent several weeks working on the soundtrack in

Chiappetta's MediaNoise digital audio postproduction studio before the work is completed.

While Marclay enjoys collaborating in a "hands-off" way when it comes to his music compositions, he feels the need to be hands-on with artworks like *The Clock*. "I have people helping me but, in the end, I do the edits," he says. "I sit here every day like a writer in front of a typewriter. It's about routine and process." Previous marathon art films have been lazy by comparison. Andy Warhol's *Empire*, for example, is an eight-hour, silent, static view of the famous Manhattan skyscraper, while Douglas Gordon's *24-hour Psycho* is a slowed-down version of Alfred Hitchcock's 1960 Hollywood thriller. "Great art doesn't necessarily require a lot of work," says Marclay. "Sometimes an easy gesture can be conceptually strong."

After Marclay has shown me a half-dozen finished segments, it strikes me that the sublimity of *The Clock* comes not just from its concept or scale, but its meticulous execution: the intelligent transitions, the filmic jump cuts combined with slow musical decays, the abrupt gongs that take you to completely different places. Marclay honed his editorial eyes and ears on two previous videos. First, he made *Telephones* (1995), a seven-and-a-half-minute compilation of film clips, which progresses from a flurry of dialing, through ringing, to a cacophony of "hellos." Then he created *Video Quartet* (2002), a fifteen-minute montage of musical sequences from films, projected onto four screens that interact with one another in complex ways and so involved sixty minutes of footage. Despite these rehearsals and the progressive refinement of his abilities, Marclay insists, "I don't have any real skills. I'm a dilettante in everything." Really? I wonder if the statement is an instance of his extreme modesty or a knee-jerk way of distancing himself from craftsmen, or both.

The issue of creativity is often difficult for artists to wrap their heads around. "Am I being original this morning? You sense the wonder of discovery when you're doing something that feels new," he says, staring at one of the two large computer screens on his desk. "But, who knows, maybe someone has been there before." Originality is particularly complicated when readymades are involved. "Every image that I use is from

someone else," he declares. "But you can be original in what you steal and how you display your bounty." Marclay fingers the keyboard, evidently yearning to get back to work. "Michel de Montaigne declared that he culled his ideas from everywhere," says the artist, citing the sixteenth-century French essayist. "The ideas were like flowers that he assembled into a garland—only the string holding the flowers together was his."

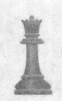

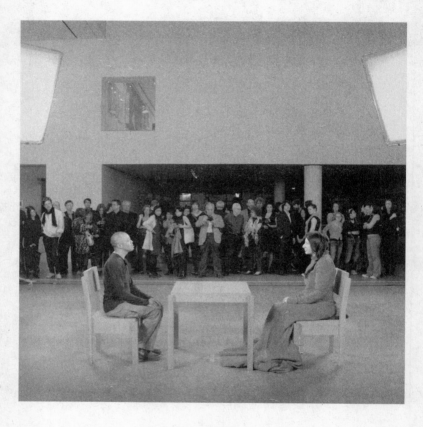

Marina Abramović
The Artist Is Present
2010

Marina Abramović

"Nonverbal interaction is the highest form of communication," declares Marina Abramović, an artist who sees her medium as "immaterial energy." She is in her kitchen in Malden Bridge, upstate New York. The room occupies one prong of a house with a star-shaped floor plan and walls that are full of windows but free of art. The windows yield views of dense woods and a lap pool where, on summer mornings, she swims exactly twenty-one laps. "I have never been influenced by another artist," she maintains in an urgent whisper with a Serbian accent. She finds forests, waterfalls, and volcanoes much more inspiring. "I like to go to the source, to all the places in nature that have a certain energy that you can absorb and translate into your own creativity as an artist." Born in Belgrade, Abramović lived all over the world before settling in the city and countryside of New York.

Abramović's milestone performance *The Artist Is Present* (2010) had her sitting all day, every day, for three months in the atrium of the Museum of Modern Art in New York, engaging in silent one-to-one encounters with members of the public. To preserve her energy, she didn't speak to anyone but museum staff after hours. Now that the speechless blockbuster is over, Abramović delights in mile-a-minute monologues that manage to answer many of the questions I would have asked if I could have got a word in. "Ideas can come anytime,

anywhere, while I am making this gazpacho or going to the bathroom," she says as she chops tomatoes from her garden. "I am only interested in the ideas that become obsessive and make me feel uneasy. The ideas that I'm afraid of."

At the moment, Abramović describes herself as "blank." Indeed, the artist is physically and emotionally exhausted from *The Artist Is Present*. She sat still in a basic wooden chair for over 700 hours, giving "unconditional love to complete strangers," as she puts it. After the first week, she started to experience severe pain. "Your shoulders drop, your legs swell, your ribs sink down into your organs," she explains. Strategic breathing helped. So did out-of-body experiences. "When you have so much pain, you think you will lose consciousness. If you say to yourself, 'So what, lose consciousness,' the pain goes away." During the performance, she claims that she could sometimes smell with the precision of a dog and felt she had "360-degree vision, like a blind man who can see with the body."

Despite her discomfort, Abramović thrived on the energy of the audience, some half a million people over the course of the show. "If it was just for my own self-realization, I would never have had this energy," she explains, "but if I do it for the public, I can bring a higher motivation." Over 1,700 people sat down and stared into Abramović's eyes; many of them were moved to weep. At least seventy-five people repeated the ritual more than a dozen times. Abramović's concurrent retrospective, installed on the fifth floor of MoMA, was the first large-scale historical survey of the work of a performance artist in America. The exhibition of her forty-year oeuvre—much of it in the form of documentation, some of it reenacted by performers—enhanced the aura of the artist's presence on site. Over the course of the show, the cult of Abramović swelled. "This larger-than-life thing is a dangerous state," she observes. "Your ego can become an obstacle to your work. If you start believing in your greatness, it is the death of your creativity." The artist seeks to follow the lessons of Tibetan monks in order to stay humble. Yet it's complicated when the artist herself is the raw material of the work.

Abramović distinguishes between her "high" performing self and her "low" private self. As she pours her "signature gazpacho" into two

white bowls, she trots out her definition of performance art: it is "a construction in which the artist steps from the low self to the high self in front of the public, or from the ordinary self to a different kind of zone and higher state of mind." She concedes that her low self is "full of contradictions" and "things that you are ashamed of," such as beautiful clothes. "I love fashion," she confesses. "In the 1970s, that made you a bad artist." A love of cars or strip bars tended not to have a commensurate effect. Artistic credibility has long been subject to both subtle and flagrant forms of male bias.

For Abramović, the question of how you know you're an artist is much more important than what an artist is. "Humans have to figure out their purpose in life!" she says. "Many people spend so much time doubting. Before you choose a profession, you have to stand still, close your eyes and think: who am I? I was extremely lucky that I found my purpose at a very early stage. Since the day I was born, I didn't want to do anything else. I had my first show when I was twelve." Abramović's conviction is like a hurricane-force wind. "You know you are an artist when you have the urge to create, but this doesn't make you a great artist," she continues. "Great artists result from the sacrifices that you make to your personal life." A woman, she claims, has to be like a man to be an artist. "One of the reasons why there are fewer women artists than men is because women don't want to sacrifice their main function to reproduce, to have a family, and the comforts of everyday life." Abramović, who is sixty-four, chose not to have children. Some time ago, she called herself the "grandmother of performance art." Nowadays, she disassociates herself from the epithet because she dislikes its suggestion that she is ready to retire.

It often appears that Abramović has cast herself in the role of the artist as priestess or shaman. "The public is in need of experiences that are not just voyeuristic. Our society is in a mess of losing its spiritual center," she says. "Artists should be the oxygen of society. The function of the artist in a disturbed society is to give awareness of the universe, to ask the right questions, to open consciousness and elevate the mind." Abramović loathes nihilism and "art that comes out of drugs and the trash holes of being drunk." She is a teetotalling vegetarian, keen on

the clear state of consciousness delivered by fasting. In a way more like aboriginal initiations or Buddhist rituals than conventional Western art-making, Abramović's work aims to be transformative. After the MoMA show, she feels altered. "I still don't have a complete image of what happened to me," she admits, "but I am different in so many ways."

According to Abramović, time is the key to the transformative power of *The Artist Is Present*. "You can pretend for two or three hours, but then pretension stops and the performance becomes life itself," she explains. The only other Abramović performance to last this long was *The Great Wall Walk* (1988), which also extended over ninety days. Although regally self-sufficient now, Abramović was once part of an artistic duo with the German artist Uwe Laysiepen, known as Ulay. They became involved both romantically and artistically in 1976 and made many works together, such as *Imponderabilia* (1977), a performance in which the couple stood completely naked in a doorway through which the public had to pass. By the late eighties, their relationship was faltering and they decided to end it in a ceremonial way on the Great Wall of China. Abramović started at the Yellow Sea while Ulay set out from the Gobi Desert. They each walked 1,500 miles and when they eventually encountered each other, they said goodbye. During *The Artist Is Present*, Ulay came to sit with Abramović. "He was part of my life, not somebody of the audience, which is why it is the only time I broke the rule," she says, explaining why she extended her hands to touch his for a moment before he got up to leave.

Abramović admires those with more willpower than herself, citing Tehching Hsieh, a Taiwanese performance artist based in New York, who did five year-long performances before he quit making art in 2000. His best-known work is *One Year Performance 1980–1981 (Time Clock Piece)*, in which the artist punched a time clock every hour on the hour for 365 days. Each time he punched the clock, he exposed a single frame of film, which led to a short movie. He shaved his head before he started the piece, so his growing hair reflects the passage of time. The video also documents his mounting exhaustion and evident derangement.

When asked about originality in art, Abramović says that it is easy

to spot, but also nonexistent. "We can't invent anything in this world which is not there already. It's about seeing in a different way," she says. "Anything that is revolutionary is in front of your nose and it is never complicated. But you don't see it until you have a safe mind. Performance can help people to get into a state of mind to perceive the simplicity." Abramović suggests that live performance thrives in tough economic times because it takes us back to basics. "It doesn't cost anything and it reminds us of the purity and innocence of art."

Abramović has never sold her performances. For years, she scraped together a living through teaching and commissions. She didn't acquire gallery representation until 1995, when she struck a deal with New York's Sean Kelly Gallery. Nowadays, she also works with Lisson Gallery in London. Her income comes mainly from selling photographs, often in editions of seven, made in collaboration with Marco Anelli, a photographer. These images go beyond mere documentation to attain, in her words, a "static energy and charisma that can really communicate."

The most popular of these works are portraits of her higher self. In the black-and-white photograph that adorns the cover of the MoMA catalogue, *Portrait with Firewood* (2010), for example, Abramović poses heroically in a manner that evokes social realist images of farmworkers. As she sees it, "I wanted an image of the artist as survivor, looking into the future." The artist generally likes her face to be clean of makeup, "so the ideas come through." In a photo titled *Golden Mask* (2009), however, Abramović's face is covered in flaky gold leaf and spotlit against a black background. She seems to be making fun of her objectification as a luxury good.

The question that looms large is: what to do next? "I'm not going to do *Artist Is Present* for the rest of my life even if it was a huge success," she says. "When you repeat, you really lose respect for yourself." Abramović bemoans the snags of success. When artists are celebrated for key works or a "certain language," many of them get stuck. Sometimes the overheads of space and staff force them into a certain groove. "For me, the studio is a trap to overproduce and repeat yourself. It is a habit that leads to art pollution," declares Abramović. "Nothing new

happens. You don't surprise yourself. Artists are here to risk, to find new territory. Risk, especially when you are a known artist, includes failing. It is an essential part of process. Failure is healthy for your ego."

Since *The Artist Is Present,* Abramović has thought a lot about art audiences and her legacy. She has embarked on creating the Marina Abramović Institute, whose mission will be to support performance art (and other forms of performance), particularly works of long duration, and to educate the public in its transformative effect. It will be housed in a 33,000-square-foot space not far from here, in Hudson, New York. Visitors to the institute will undergo "mind and body awareness exercises" that introduce them to Abramović's craft, which may include slow-motion walks and an "eye-gazing chamber."

Performance artists notoriously disdain the theater. Initially, Abramović was no exception. "Performance is about the true reality," she explains, whereas "theater is artificial, the blood is not blood, the knife is not a knife." Nevertheless, she asked several directors to "contact" her life and "remix it," so she could see it anew. Robert Wilson, an avant-garde director, has risen to the challenge with an opera titled *The Life and Death of Marina Abramović,* a project that will no doubt enhance her legend. "The only theater I do is my own," she explains. "My life is the only life that I can play."

The V-Girls
(Andrea Fraser, Jessica Chalmers, Marianne Weems, Erin Cramer, Martha Baer)
Daughters of the ReVolution
1996

SCENE 6

Andrea Fraser

"An artist is a myth," says Andrea Fraser resolutely. "Most artists internalize the myth in the process of their development and then strive to embody and perform it." Fraser is guiding me through the Murphy Sculpture Garden, a collection of modernist works spread over five lush acres of the University of California's Los Angeles campus. She wears a hiking dress that she normally reserves for mountain walks. The hot, hazy morning sees eager high school students enrolled in summer courses rather than the usual college crowd. Fraser has taught at UCLA for the past five years, first as a visiting professor, now as a tenured one. She dropped out of high school at fifteen and has no university degrees. She was hired because of her status as an artist. It didn't hurt that she also happens to have read—and even memorized—significant tracts of art history, sociology, and psychoanalysis.

"They say that there are three kinds of artist: the perverse, the neurotic, and the psychotic," says Fraser, waving her arms expansively. The perverse artist is supposed to have an instinctive, primal relationship to making art. "He is endlessly and easily fecund," she explains with a chuckle. "He prowls brothels and goes on drug trips. He is sensually gratified by his work and merrily transgresses social norms." This model makes sense of the media representations of Picasso and his mistresses, Abstract Expressionists such as Jackson Pollock and Willem

de Kooning, and even Fraser's rendition of a drunken Damien Hirst in her *Official Welcome* performance.

"The neurotic artist is the one that struggles with guilt and shame," she continues, as we take shelter in the shade of a tree. "It's an age-old type that came into its own with the critical, conceptual art of the 1960s. I'm that kind of artist. There's no unproblematic pleasure for me in making work or exhibiting myself!" she explains, sipping green tea from a silver thermos brought from home. "My criticality comes from my family background. Someone said, you don't get your superego from the way your parents raised you, you *actually* inherit *your parents'* superego," she adds with a peal of laughter.

Fraser grew up in the hippie countercultural milieu of Berkeley, California. Her father is a retired Unitarian minister who, when Fraser told him about her scandalous *Untitled* work, confessed that he had once written a sermon in verse about the preacher as prostitute. Her mother came out as a lesbian in the early 1970s and has been a painter, poet, novelist, psychotherapist, and shaman, among other things. When Fraser told her about *Untitled*, she only wondered what her daughter would do next. The artist describes her moral heritage as a strange combination of old-school Western libertarianism, hippie individualism, feminism, and the values of the antiwar and gay pride movements.

What about the psychotic artist? I ask as we cross the grand plaza that leads to the Broad Art Center, which houses UCLA's School of the Arts and Architecture. "I've never focused so much on that," she replies. Although a handful of well-recognized insider artists are clinically schizophrenic, paranoid, or bipolar, psychosis is, rightly or wrongly, associated primarily with outsider artists.

Stationed in front of the art school is one of Richard Serra's giant "Torqued Ellipse" sculptures, *T.E. UCLA* (2006). Made out of 42.5 tons of rusty-looking steel, it is shaped like the bottom of a cone whose top half has been sliced off at an angle. Inside the sculpture, students have chalk-marked its curved walls with peace signs, handprints, footprints, and a crude sketch of what could be a cock and balls or a first-year sculpture assignment. It's like a blank canvas beckoning aspiring artists to make

their mark. Apparently, the university has to clean it weekly. "I'm not sure Serra really fits into any of those psychopathological categories," says Fraser when I ask about the macho monument-maker. "I think that a lot of minimalism is obsessional," she adds, "which could put him in the neurotic camp." Although most artists don't fit neatly into these mythic types, it is still useful to ruminate on them.

The Broad Art Center spans two buildings renovated with a $23 million donation from Edythe and Eli Broad: an eight-story concrete, stainless steel, and teak structure called the Tower and a two-story, predominantly red brick building nicknamed the Little Broad. We enter the latter. "The art department is one of the top-rated programs in the entire university," says Fraser proudly, as we walk down a white hallway lined with gray lockers. Before Fraser came to UCLA, her finances were precarious, with little income and a lot of debt. "I had been more or less homeless for over a decade because of the nature of my site-specific work, but also because I couldn't afford to live in New York, so I would sublet my apartment and travel as much as I could," she explains. Fraser clears her throat and takes a deep breath to shake off her welling emotion. The artist cries at the drop of a hat; she has even written about it. "My current position could not be more distant from that kind of life. I have a kind of job security that is almost bizarre at this point in time."

Fraser fumbles with some keys, then swings a door open. The white-walled, windowless cube is full of lights on tripods, some of which have umbrella diffusers. A cement brick sits on a stool in front of a silvery gray roll-down backdrop. "This is the room where I shot *Projection*," she says. Based on edited transcripts of her own psychotherapy sessions, *Projection* (2008) is a two-screen video installation in which the artist plays the roles of both psychotherapist and patient.

"I've seriously considered leaving the art world—and ceasing to be an artist—a number of times," says Fraser. "Most recently, I was dealing with a lot of emotional conflicts: my discomfort with the market, my trauma about exposure, my need to control things." Fraser thought about embarking on a PhD in anthropology or training to be a psychoanalyst. Realizing that she would be subject to strictures that weren't

of her own making, she decided against both. "For me, being an artist is about having a relatively free space where I can engage, reflect, and investigate things that I'm really concerned about."

We skip up the stairs to "New Genres," Fraser's department. Created in the 1970s by Chris Burden, a performance artist and sculptor, New Genres seeks to expand the definition of art and experiment with different "mediums" (art-world parlance for "media" of communication such as canvas, bronze, and readymade urinals). At UCLA, however, the departmental divisions between artistic forms are loose. For example, Hirsch Perlman, an artist known principally for his photographs, teaches in the sculpture department. And Mary Kelly, whose materials have included her son's dirty diapers and the lint that accumulates in dryers, heads up the scholastic stream called "Interdisciplinary Studio."

"Are you sure you really want to see my office?" asks Fraser. "I have never had a space that represents me. When I first got calls from art dealers who wanted to do a studio visit, I'd say, 'I don't have a studio,' and that would be the end of the conversation!" Fraser unlocks the nondescript door to reveal a small room jammed with cardboard boxes, crates, wrapped-up framed things, and gray metal filing cabinets. Fraser describes the contents of the brown packages. "These are editions that I got in exchange for..." She puts her hand on her forehead. "I'm not sure what," she says. "These are Brazilian carnival costumes. These boxes have art in them, mostly by other people." Fraser opens up the metal cabinet. "These are my videos. This is my dossier that I had to put together for advancement." Behind the boxes is a table stacked with dozens of books and some disassembled bookshelves. "It's just storage," she says finally.

Down the hall is a lecture room with about seventy seats, a wood veneer lectern and a range of projection equipment for PowerPoint presentations and the like. "This is the classroom where I teach a course called 'The Field of Art,'" says Fraser, for whom the term "field" refers specifically to the work of Pierre Bourdieu, a French sociologist, who saw the art world as a kind of socioeconomic battlefield. "When I was young, I thought that being an artist was an *anti-institutional* role, then I read Bourdieu and he made it impossible to imagine that artists

could be outside of, or against, society." Fraser walks up to the podium and looks out over the empty classroom. Many of her performances take the form of talks, and the artist occasionally performs parts of her works when she is teaching. She feels that lecturing is one of her most important activities and she values the impact she's having on how people think.

When Fraser asks her undergraduates why they want to be artists, the main answer is "So we can do what we want!" To which she responds, "Okay, so what do you want? What matters to you? You have this extraordinary privilege. Don't waste it." Not long after that, she breaks the news: "When you graduate, loaded up with thousands of dollars of debt, you may not have much freedom!"

Every artist I've ever interviewed has valued their extra liberties—even if it is simply the choice to work all night and sleep all day. Fraser is particularly interested in freedom from the myriad restrictions of what Bourdieu calls "social aging"—a process by which people resign themselves to their position in a highly stratified society. "Artists don't have to settle on a station or status, a clear class position or national identity," says Fraser as she drops her large black handbag on a chair. "We can be children forever." Indeed, artists are often seen to indulge in perpetual play, avoiding the world of "real" work and adult commitments. No wonder art-school admission offices are overwhelmed with applications.

"Another fantasy of being an artist is omnipotence," says Fraser. "Freud talks about the artist as being able to create his own world, and Winnicott believed that infants initially experience the world as their own creation." The British psychoanalyst D. W. Winnicott is most famous for his theory of transitional objects, which argues that things like security blankets and teddy bears act as a bridge between a child's imagination and the real world. Heavily invested with meaning, these transitional objects are prototypical art objects or, as Fraser puts it, the "original readymades." (Fraser has two poodles, one of which is named after the psychoanalyst.) "Winnicott even wrote about this phase of development where babies experience this tremendous narcissistic insult when they are stripped of their fantasy of complete omnipotence,"

she adds. The implication is that artists hang onto the empowering fantasy and act out their supremacy in the universe of their work.

So, do you dream of being a god? I ask. Fraser hmms and leans lightly on one of four empty white pedestals that are scattered around the room. "Maybe the way babies do when they are worshiped by their parents," she says amusedly. "One of the core fantasies of artists is unconditional *love* and the associated unconditional value attributed to anything that we produce. It is not, first of all, about money. It's about love, attention, recognition, regard . . . and freedom from shame."

Grayson Perry
The Rosetta Vase
2011

Grayson Perry

Grayson Perry has long wanted to create an exhibition of a fictional civilization in which his childhood teddy bear is worshipped as a god. A few years ago, the artist pitched the idea to the British Museum—a "multi-faith cathedral," as Perry puts it, to which five million people make pilgrimage every year.* The result of his request is "The Tomb of the Unknown Craftsman," an exhibition in which Perry displays thirty of his own works alongside 170 artifacts from the museum's collection.

Perry is celebrated as a "potter," but he makes conceptually sophisticated art in a range of media associated with the crafts, such as ceramics, tapestries, prints, etchings, and clothing. His teddy is a mangled bear with a heart-shaped head called Alan Measles. The "transitional object" helped the artist survive a harrowing upbringing and, as such, is a relic that Perry imbues with almost mystical clout. "When I was a child, I parked my power—my male qualities of leadership and rebellion—onto Alan Measles for safekeeping because I lived in a threatened environment." Alan Measles has adorned the glazed surfaces of Perry's ceramic vases for many years, but, in this show, he stars in a range of media as

* The British Museum is an encyclopedic museum of mankind with some eight million pieces in its collection, including many important ancient objects, but few modern or contemporary artworks.

a pope, warrior-missionary, wandering holy man, spiritual apparition in the pupil of a giant eye, and Japanese "dogu" goddess.

Does the show reflect displaced fantasies of omnipotence? I ask. Perry looks at me like I've just delivered shocking news. "The show is about the veneration of the transitional object," he replies after some pondering. "All gods are like cuddly toys insofar as people project their ideas onto them. It's a form of survival, a way of dealing with fear." Perry cites his experience of psychotherapy as a huge influence and suggests that it has been essential to his success in three ways: it has helped him with his emotional health, given him methods to access difficult truths, and led him to some of his most important subject matter. We slip under a cordon to enter the exhibition, which is still in the midst of installation. Surrounding Perry's distinctive vases are ethnographic oddities such as tabletop temples (an Egyptian "soul house" and a Tibetan shrine) and "power figures" including a Malian one that resembles a bison and a Congolese character suggestive of a witch doctor.

One work that Perry made especially for the show is *The Rosetta Vase* (2011), a two-and-a-half-foot-high pot depicting a landscape-cum-map drawn in blue glaze with a fine brush on glossy yellow and white backgrounds. It stands chest-height on a pedestal under a heavy-duty vitrine typical of anthropology museums. Alan Measles appears on the pot in several places, at one point riding a crusading horse as part of a heraldic sign that says, "ICONIC BRAND." Perry peers at the pot with me. He has a blonde bob, a ruddy complexion, and British teeth. "From mud to masterpiece, the pots are totally me," he says. "My assistant doesn't even order the clay; she just does email." Perry enjoys the slow, physical process of making pots and relishes the thinking time afforded by the "boring bits," such as drawing the many small lines that form the ocean at the base of the pot. He is "slightly suspicious" of artists who never get dirty.

The Rosetta Vase is displayed against the wall but, from the side, one can see a painting of a baby labeled "THE ARTIST." The infant has oversized Buddha-like ears and his body parts are covered with phrases like "interior quest," "risk-taking," "unconscious enactment," "class mobility," and "power," which appear to list Perry's artistic drivers.

According to Perry, craft can be taught whereas art is about self-realization. "I can teach someone to make my last artwork but not my next one," he explains. Mutual antagonism tends to characterize the two domains. "A lot of artists are really bad craftsmen and most craftsmen are really bad artists," he explains. The craftsmen grumble that the artists "can't even draw," while the artists criticize the craftsmen's work as conventional and kitsch. "I try to have the best of both worlds," he says, "making things as well as I can and developing ideas that are chunky."

Perry has long been fascinated by Duchamp's urinal, not least because it is made of porcelain. "Duchamp didn't choose a ceramic knick-knack off his auntie's mantelpiece but hardware from a plumbing supply shop," says Perry. "Conceptually the readymade gesture would have been the same, but the cultural connotations were different." Perry notes that the 1964 edition of Duchamp's *Fountain*, the one found in most museums today, is not a readymade at all but a sculptural replica, handmade by an Italian potter to look like a 1917 mass-manufactured urinal.

We wander past the shrines into an area full of talismans and fetishes. Among them is a Perry work titled *Coffin Containing Artist's Ponytail* (1985), a small, crudely made ceramic coffin with a glaze drawing of a body at rest with a three-dimensional sculptural head. I point at the face and look puzzled. "Charles I," deadpans Perry. The small bust used as a mold came free in a box of cornflakes. "I grew my hair for about five years then cut it off as a means of trying to kill off my feminine side. His long hair reminded me of mine," says Perry, his Essex accent weighing in more heavily when he speaks of the past. Charles I, who believed in the divine right of kings, was beheaded in a proto-democratic coup in 1649, which temporarily abolished the British monarchy. Losing your hair was a kind of decapitation or castration? I ask. "Maybe," says Perry noncommittally.

Perry is wearing trousers and a baggy beige jacket this morning, but his shaved eyebrows and the small blob of makeup in the corner of his eye betray the fact that he wore a dress last night. The artist no longer attempts to suppress his feminine side. Ever since 2003, when Perry accepted the Turner Prize on national television in a baby-doll dress covered in embroidered bunnies, his alter ego, Claire, has become a

public personality. She appears in several works here: *La Tour de Claire* (1983), a tower of flint and found objects; *Shrine to Alan and Claire* (2011), a ceramic sculpture that resembles an Orthodox Christian road-side memorial; and *Map of Truths and Beliefs* (2011), a 23-foot-long tap-estry that Perry calls "a vastly professional piece of outsider art." At the opening next week, he is planning to wear a pink satin blouse with red lederhosen, made by a master costumer who has done work for movies such as *Batman*. Do such sartorial transgressions make it easier to break the rules of art? "The emotional loading of cross-dressing is so powerful that other sorts of taboo-breaking don't faze me," he says.

Despite Claire's noteworthy presence, Perry is adamant that she is not a work of art. She emerged out of his sexual obsessions rather than his artistic concerns. Perry pivots to look at his grand tapestry, focusing on Claire, who is wearing a long necklace from which his teddy bear dangles in lieu of a crucifix. Eventually, he admits that his refusal to elevate Claire is a means of disassociating himself from performance art. At college, Perry "wallowed" in performance art and decided that it was painfully pious. "When it's entertaining, it becomes theater; when it's not, it is earnest and boring," he says. Perry has never experienced a work by Marina Abramović but he did see Andrea Fraser's *Untitled* when it was shown in "Pop Life" at Tate Modern. "I remember thinking that it was one of those ideas that needed to be done. It's a boundary marker around the edge of art," admits Perry, excluding Fraser from his sweeping dismissal of her medium. "The show was slammed but I really enjoyed it. Damien's gold stuff was seductive and irksome. Like wine, his work needs laying down. It will look brilliant when it comes back in twenty-five years."

We continue to examine Perry's detailed *Map of Truths and Beliefs*, which charts the incongruous places to which people make pilgrimages, from Mecca to Davos, Nashville to Auschwitz, Venice to Stratford-upon-Avon. This tapestry, like his others, was drawn by hand then scanned into a computer, where the artist refined the colors. It was then woven on a massive computerized loom. "I don't fetishize the handmade. I pro-gram it in now!" declares Perry. He believes that digital technology will save craftsmanship because it separates the creative process from the

drudgery of production and offers easy customization. "A computer is more blank than any blank canvas. It's not like a box of crayons that can only do one thing well," he explains. "We shouldn't be nostalgic about our analogue skills because new skills are coming along all the time."

Although he has adopted conceptual and digital modes, Perry still loves beautiful objects. "It is a noble thing to be decorative," he says as we enter a section of the exhibition devoted to sexuality, which includes some "drag kings," nineteenth-century coins that were painstakingly reengraved by anonymous craftsmen to change the sex of Queen Victoria. "Objects are the unique selling point of art," he continues. "All those alternatives to the art object are precisely that—alternatives. They need the gravitational pull of the object in the museum to maintain their relevance." The artist notes that alternatives such as performance art are usually financed directly or indirectly by the sale of art, so the "high-minded" stance of many of these artists against commodities strikes him as old-fashioned and two-faced.

Perry wouldn't want to be seen as a cheerleader for the art market; he laments its excesses and distortions. "Big is not best," he says by way of example. "Artists' big work is rarely their best, but big work often sells for higher prices. Every artist has their ideal scale—a kind of bell curve of quality—but nowadays they aggrandize their work into incompetence to promote themselves in the art world." One exception that proves the rule is Christian Marclay's *The Clock*, which Perry describes as the "Sistine Chapel of video art." Not only is it "hypnotic and conceptually tight," it achieves the "permanence of an object" because, as a twenty-four-hour piece, it doesn't go away.

We wind our way deeper into the installation, whose walls darken as we go, changing from pearl to charcoal gray. A workman in white overalls emerges through the back door, beyond which lies the gift shop. "Oh, hello, sorry . . . I'm the guy whose show it is," says Perry. The man nods in a way that suggests that he already knows the famous artist. At the center of *The Tomb of the Unknown Craftsman* is a sculpture with the same name—a coffin in the shape of a ship that is supposed to be sailing into the afterlife. Perry made the work in rusted cast iron. "Maybe my rust is a reaction against that glossy conceptualism. I had

to resist my lust for shininess," says the artist, whose ceramics often glisten with glaze. On top of all the metal is a prehistoric flint hand axe—"the original tool that begot all tools, the lodestone of craftsmanship," says Perry.

A miniaturized death mask with a crooked nose and full lips represents the unknown craftsman. Who's that? I ask. "Oliver Cromwell," replies Perry flatly. Cromwell, the reformer who had Charles I beheaded? That is hilarious. *Coffin Containing Artist's Ponytail* implies that the artist is an autocratic king, while this tomb proposes that the craftsman is merely a man from the middle gentry, though a potentially lethal one. "I've never noticed that," says Perry deliberately, mulling it over. "You can read into it what you will. I like the theory. I think I'll use it!"

For Perry, the split between art and craft has long involved class. "Whereas a craftsman is a worker, a painter is often just an incredible craftsman in a suit jacket." In fact, he believes that, despite its high status, most painting today is just craft. "Painting is locked into a tradition," he explains. "It is very difficult to be original unless you can find a micro-niche, and then it's difficult to step out of your niche because the territory on either side is already inhabited by another artist with his own micro-niche."

Perry also believes that the distinction between artists and craftsmen relates to the acknowledgment of authorship. "Everything in the Tate has a name attached, which gives the objects their significance, whereas almost everything in my show—and in the British Museum—is anonymous," he says. "Historically, craftsmen have subsumed themselves in communities. Only since about 1400 have artists developed egos that seek the plaudits of genius." The development of artists, as we know them, is linked to the rise of humanism and individualism during the Renaissance. Indeed, Giorgio Vasari's *Lives of the Most Excellent Italian Painters, Sculptors, and Architects, from Cimabue to Our Times* (1550), which culminates with the assertion of Michelangelo's genius, is considered the first written installment of art history.

"Being an artist is a narcissistic business," admits Perry, "which is made worse by fame." When people hang on your every word and when your signature alone is worth money, the world seems to revolve on a

different axis. "If you weren't a narcissist before, then you become one," he adds. "It is most potent when you are unaware of it. If you're aware, then it starts to dilute."

For Perry, self-consciousness is both an obstacle and the main route to change. "The big burden for artists working in the art world is self-consciousness. We've lost our innocence. We're constantly looking at ourselves making art," he explains. "It's one of the many appeals of outsider artists; they don't give a damn about what other people think." However, the more self-aware you are, the more chance you have to improve your life and work. "The first tool of intellectual growth is awareness. They say that consciousness is a candle in a warehouse, so there is an awful lot you cannot see. I'm keen to move the candle about." Perry believes that, although the link between art and madness is over-romanticized, it can't be dismissed either. "You need to be quite obsessed to get art made." Personally, however, he prefers "high-end sanity." As it happens, his wife, Philippa, is a psychotherapist who is writing a book titled *How to Stay Sane*.

Is there a craft to being an artist? "I don't think you can discount the fact that who you are and how you comport yourself is part of the deal," he replies. "Even if you become a hermit and don't utter a word, it's part of the deal." Perry brainstorms on the craft of being a conceptual artist, suggesting that probing habits of thought and spotting things you really care about are essential. "Don't wait around for a thunderbolt because a flicker is what it might be," he advises. "Don't discount silly ideas, because coolness is the enemy of creativity. Do pay attention to the things that hipsters haven't noticed yet."

We retrace our steps, stopping near the entrance to the show next to a pot called *The Frivolous Now* (2011). The duck-egg blue vase with an ancient Greek shape is covered in graphically rendered expressions such as "LOL," "tagging," "improvised explosive device," "phone hacking," "privileged elite," "stunning 3-D," and "cute YouTube clips" (the latter is next to a childlike drawing of a cat). "Ceramics are very much my signature dish, but I only make pots about half the time," he says. In addition to making tapestries and sculptures, Perry writes and presents television programs. He's currently working on a three-part series

for Channel 4 on taste, a theme that is also inspiring his next series of artworks. "I'm only going to have shows with TV tie-ins now!" he says, with the cackle of a pantomime witch.

Perry is mindful that such moves could undermine his credibility among art-world insiders, but he sees their version of "seriousness" as an unappealing set of conventional behaviors, sprinkled with jargon and somber tones. In any case, the "inherent ridiculousness" of his transvestism, as he puts it, excludes him from that club. A journalist once asked Perry, "Are you a lovable character or a serious artist?" The artist has since been fascinated by the dichotomy. "Apparently, serious artists are rude, difficult to understand, and unconcerned with popularity," he says with incredulity. "The very opposite of lovable."

Yayoi Kusama
Obliteration of My Life
2011

Yayoi Kusama

Yayoi Kusama is gazing at an image of herself. Glenn Scott Wright, director of Victoria Miro Gallery, has just handed her a copy of Sotheby's quarterly magazine. On the cover is a photo of the artist wearing a shiny red wig and a red polka-dot dress. Today, she is wearing the same synthetic bob and similar garb. While the Kusama on the magazine poses in front of a pulsating red-and-black spot painting, the artist here sits at a table on the third floor of her Tokyo studio, with bookshelves on one side and a glass-brick wall on the other. Takako Matsumoto, a documentary filmmaker who has been shadowing the artist for the past eleven years, logs the self-reflexive moment.

Kusama was famous in New York in the 1960s, but she was almost forgotten as an artist after she moved back to Japan in 1973 and checked into the psychiatric hospital where she still lives. Since childhood, Kusama has made art to help her deal with her psychological problems. These include terrifying hallucinations in which she experiences the sudden melting of the boundary between herself and the universe. But if there is one thing that Kusama has never feared, it's the limelight. The artist often starts her working day by reviewing her press. Media presence would appear to be an instant, if short-term panacea for fears of annihilation.

"I'm very excited to show you my new paintings," says Kusama. She

understands English but doesn't speak it well, so one of her assistants translates. Scott Wright needs to select thirty or so works to show at Victoria Miro in the spring, when the artist's retrospective is on display at Tate Modern. Kusama refocuses on the magazine. "This is fantastic. Is it Morandi?" she exclaims, pointing at a beige still life by the Italian modernist. "And Richard Serra?" she says, regarding a large metal sculpture by the American artist on a subsequent page.

Kusama has always been highly aware of art history. In the late 1950s, shortly after moving to New York, she made abstract paintings in which white loops of hand-painted mesh float over black backgrounds. With prolonged viewing, these "Infinity Nets," as she called them, become undulating oceans of dots. The "Nets" deliberately one-upped Abstract Expressionist works, such as Jackson Pollock's "drip" paintings; the compositions were more radically all over the canvas and the process of producing them was more intense. They also coincided with the arrival of the next notable art movement, Minimalism. Perhaps most importantly, these paintings acted as psychological safety nets, protecting the artist from her fear of melting into the void. In 1961, she created an "Infinity Net" that measured thirty-three feet, an unusually large abstract work for the period, which betrayed the scale of both her obsession and her ambition. Kusama has never stopped making "Net" paintings; they are an "endless" series.

Kusama peers up at Isao Takakura, her studio director, who wears a white-collared, short-sleeved shirt and polka-dot shorts. "Brother," she says, "where's the two-page article about our exhibition at the Reina Sofía?" The retrospective was initated by the chief curator of Tate Modern, but it has opened first at the Reina Sofía Museum in Madrid. The show will go to Centre Pompidou in Paris before London and then finish up at the Whitney Museum in New York.

Takakura returns with a double-page spread from *Asahi*, a high-circulation Japanese daily. Kusama shows it to Scott Wright, promising to have a translation sent to him soon, and again becomes captivated by her press. She turns the page and examines an article about Francis Bacon, whose work has made a high price at auction. "He died a few years ago, didn't he?" she comments. Twenty years ago, in fact. An

assistant emerges with two copies of a new catalogue raisonné of her prints, which are gifts for Scott Wright and me. Kusama autographs them for us, but looks inquiringly at an assistant when it comes to writing the date. "Two zero one one," says the young woman patiently.

Although Kusama clearly has difficulty keeping track of time, she has demonstrated near genius when it comes to her sense of space. In 1963, she created one of the first fully realized instances of installation art. *Aggregation: One Thousand Boats Show* features a rowing boat filled with phallic sculptures installed in a room papered with 999 black-and-white photographic reproductions of the very same work. Three years later, Andy Warhol imitated her treatment of walls with his *Cow Wall-paper* (1966). About Warhol, Kusama has said wryly, "We were like . . . enemies in the same boat."

Kusama went on to make masterful "Infinity Mirror" rooms. When I first experienced one of these works, titled *Fireflies over the Water* (2002), almost a decade ago, I found myself moved to tears by its godlike view of a sublime universe. These dark rooms contain hundreds of tiny lights that are reflected by mirrored walls and ceilings, and a black pool of water that covers the floor. With such spellbinding spaces, Kusama translates her existential terrors into works that inspire feelings of awe, elation, and plenitude.

Another assistant—apparently there are eight of them—suggests they show Scott Wright "the products." I am told that they are "very, very secret" and I promise not to write about them until after their release. She leaves and returns with three Louis Vuitton handbags over each arm. "Aren't there more? Please bring them all," says Kusama. She sips water from a yellow-polka-dot glass while a few more bags are loaded onto the table.

Your average polka dot tends to be identical to its mates, lined up mindlessly in equidistant rows. A Yayoi Kusama spot, however, is a living, breathing thing that throbs with a sense of purpose. Louis Vuitton has superimposed a couple of Kusama patterns over the brown LV monogram on their handbags: a psychedelic galaxy of small, medium, and large spots and an arrangement that the artist calls "nerves," which assembles multisized dots into snakelike forms.

Kusama has long been interested in clothes. In the 1960s, she made unwearable sculptures in the form of gold shorts covered in macaroni and white stilettos stuffed with phallic lumps. At that time, she also had a fashion company that made outfits for the sexual revolution, including pieces with strategically placed holes, dresses for two people and orgy robes. "All my creative selves live together harmoniously within me, no matter whether it is art or fashion," she explains.

"Brother, shall we go downstairs and look at art now?" says Kusama to Takakura, who looks like he could be her son or grandson. We pile into a small elevator with Kusama, who sits in a polka-dot wheelchair, while others, including Matsumoto with her camera, descend the stairs. Kusama tells me that she has trouble with her legs because, for years, she painted on her knees. She can't bear it when anything gets in the way of making art because it alone stops her from obsessing on suicide. I ask how often she thinks about dying. "Almost every night," she says. "Particularly these days because I am an insomniac."

The second floor of this three-story building houses a painting studio with racks for storage at one end and a large sink surrounded by an array of paints and brushes at the other. In the center is the low table where Kusama paints. It is currently empty, but marked with multicolored straight lines that are the phantom edges of many canvases. As two assistants pull paintings out on rolling tracks, Scott Wright tells me that the announcement of the retrospective somehow "flicked a switch in her" and Kusama has made over 140 paintings in eighteen months. "Death is just around the corner and I am not yet sure I am a great artist," she explains. "That is why I am absorbed in painting."

Kusama's new canvases synthesize the history of her art—her preoccupation with infinity and omniscience along with motifs such as dots, nets, snaky "nerves," and eyes. Painted on the table from all four sides, the series bears witness to a fantastic variety of compositions using a limited range of unmixed colors. Some of the pictures have strong optical effects; others look like primitive topographical maps.

"I've been working very hard, devoting all my energies to them. I did it alone without any assistance. It's all Kusama," says the artist, as her assistants continue to shuffle paintings in and out of view.

"Yes, I can see that," says Scott Wright. "They're great. Very vibrant. Very beautiful. I love their aura. They have tremendous energy."

"Thank you," replies Kusama. "Now, we will show you some much better ones." The artist tells us that many of these paintings made their debut on TV in Matsumoto's most recently broadcast documentary film. "It's quite difficult to get airtime and the program was three hours," she observes.

Women artists often wait a long time for their accolades. The advantage of late recognition is that it can spur them to new heights. Louise Bourgeois did some of her best work in her eighties. At eighty-two, Kusama clearly aspires to do the same. What are your tips for staying creative for so long? I ask.

"My life has always been thoroughly devoted to art. And I'm mesmerized by encounters with remarkable people like Glenn," she says of the dealer by her side. Kusama is a celibate who has written about her aversion to sex, but she seems to have a schoolgirl crush on Scott Wright, a handsome British Asian gay man.

Why is Glenn so important? I ask.

"I like his willingness to understand my art. He'll never know how much I've been longing to see him," she says. Scott Wright's previously scheduled visit was cancelled because the Tōhoku earthquake closed the airport. "In art history, we find many great artists who always had a sponsor or a dealer," she adds. More than just showing and selling the work, a gallery puts an artist on the map, makes her relevant, gives her a reason to be.

We descend to the ground floor, which is principally a storeroom with rolling racks, full of larger paintings. A table has been set with a Kusama-patterned cloth, cold bottled green tea and individually wrapped cookies. Frances Morris, the curator of Kusama's retrospective, and a dozen or so people, most of whom are members of the Tate's Asia-Pacific Acquisitions Committee, will be arriving any minute. Stacked in a corner of the room are some recent yellow-and-black dotted pumpkin paintings, which I assume were made with stencils, given the firm, fine detailing, which is not characteristic of Kusama's hand nowadays. In her youth, Kusama experienced hallucinations in which

pumpkins spoke to her in a "generous unpretentious" way, and pumpkins were the subject of her first exhibition of paintings, for which she won an award in 1948.

Members of the Tate committee file into the room, wiping their feet on the mat, as the streets are still wet from a typhoon that hit Tokyo last night. After the artist shakes everyone's hand, her assistants unveil some of the new paintings that are stored on the ground floor. Morris gives a running commentary, itemizing their "iconographic" and "decorative" elements. She doesn't ask any questions directly to Kusama, but glances respectfully in her direction with almost every statement. The artist zones out, overwhelmed by the interaction and Morris's quick, clipped British speech.

The group is ushered upstairs to the painting studio, where a canvas with a base coat of shimmering silver now lies on Kusama's table. An assistant helps her into a red swivel chair, hands her a paint-splattered smock and then brings her a bowl of acrylic paint that is exactly the same shade of fluorescent vermilion as her wig. With her left palm firmly planted on the canvas, she draws an arc confidently with her right. She then gives it triangular prongs, so it looks like the spine of an iguana. She paints a large spot beside it, then a border of triangles or waves along the edge of the painting. Her audience watches in silence. "It's almost like automatic drawing. There is no hesitation," whispers Morris, as if she were a sports commentator describing a tense moment on the eighteenth hole. In the sixties, Kusama made a foray into performance art with "happenings." Today, the artist delivers a more intimate bit of theater—an oddly moving demonstration of her power over an aesthetic domain.

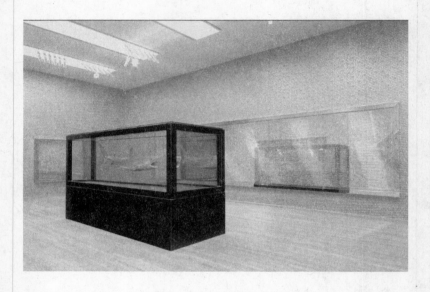

Damien Hirst
The Kingdom (2008) and *Judgement Day* (2009)
installed at Tate Modern, 2012

Damien Hirst

"The last time I saw paintings as deluded as Damien Hirst's latest works, the artist's name was Saif al-Islam Gaddafi," writes Jonathan Jones in the *Guardian* about the third Hirst show to hit London this year. "The son of Libya's then still very much alive dictator showed sentimental paintings of desert scenes in an exhibition sponsored by fawning business allies."

When I saw these handmade Hirsts, depicting shark jaws, parrots, lemons, and fetuses, at White Cube, the gallery's owner was waxing lyrical about them to Victor Pinchuk, the Ukrainian collector, who Hirst told me was initially "the only buyer, really" of this body of work. Since visiting the artist's shed in Devon three years ago, I've seen Hirst's do-it-yourself painting several times. It is hard not to agree with Jones when he recommends that the artist should beware of becoming "an absolute ruler . . . utterly surrounded by yes-people" who enable "trivial and pompous slabs" to go public. Indeed, when artists' fantasies of freedom, omnipotence, and unconditional love go unchecked, they often yield work of uncertain skill.

The year began with a couple of installations of the artist's spot paintings—part of an imperial spectacle organized by Gagosian Gallery to display 326 paintings in eleven venues in eight cities around the world. Painters working for Hirst have made some 1,400 paintings with

multicolored polka dots laid out on mechanical grids. For almost a decade, the artist has promised to quit making the works, but demand for them was such that the artist decided to make them an "endless" series. I spoke to Carroll Dunham shortly after Hirst's eleven-venue show was announced. "Dot paintings all over the world may be of sociological interest," he declared, "but the idea that they are meaningful as painting is absurd. These aren't paintings as much as placeholders for something else." Indeed, full-time painters were generally appalled. David Hockney, a senior British Pop artist, got into a media spat with Hirst, declaring in an interview with the *Radio Times* that the younger artist's dependence on assistants was "insulting to craftsmen."

When I saw the sixty spot paintings that were hung in Gagosian's Britannia Street gallery, the flood of painters' invective was hard to ignore. Hirst may be an innovative sculptor, but he is an opportunistic painter. The decorative canvases, named after pharmaceutical drugs, absorb meaning by association. Writing for *The Art Newspaper*, Cristina Ruiz traveled the world to view all eleven shows and found that the works "make much more sense in rich cities like Geneva and Beverly Hills." By contrast, when she saw the paintings in Athens, she felt that the ailing Greek economy would likely lead even high-net-worth individuals to "balk at the frippery."

Shortly after the spot painting shows closed, Tate Modern unveiled Hirst's first major retrospective. Seventy-three works made over a twenty-four-year period are arranged in a chronological circuit. The general trajectory is from gritty to glitzy, from punk assemblages, such as cabinets filled with medicine boxes and cigarette butts, to art that looks like bespoke luxury goods.

Funnily enough, even *The Physical Impossibility of Death in the Mind of Someone Living* (1991), the first of Hirst's landmark sharks in formaldehyde, has also been upgraded. Some art historians have interpreted this sculpture as a portrait of Charles Saatchi, the collector who commissioned it. However, Saatchi sold the work in 2004 to Steven Cohen, a Connecticut-based hedge fund manager. When the younger, richer Cohen discovered that the original cold-blooded carnivore was shriveling up, he commissioned Hirst to remake the work with a fresh shark.

The survey show has met mostly with praise and is enjoying high visitor numbers. Like all retrospectives, it tells a convincing story partly through judicious exclusions (i.e., no figurative paintings). It also omits *The Golden Calf*, the bull in a gold-plated tank that was the poster child of Hirst's 2008 Sotheby's sale, and keeps *For the Love of God*, Hirst's notorious diamond skull, at arm's length, displaying it downstairs in the Turbine Hall. In contrast to Tate's usual aesthetic, the skull is spotlit in a dark room, much like jewelry at an auction preview. Hirst would seem to be marketing the unsold piece, but the museum insists that the installation is simply commenting on the "belief system" of capitalism.

Many collectors are hoping that the Tate show will pull the artist's secondary market out of the doldrums. In 2011, Hirst's highest price at auction was a tenth of what it was at its peak in 2008. And the total turnover in Hirst works was less than $30 million, putting the artist well behind Gerhard Richter, Zeng Fanzhi, Zhang Xiaogang, Jeff Koons, and Richard Prince. With other artists, this market decline might be irrelevant to their reputations, but Hirst's financial acumen is an integral part of his artistic persona. He has made money a main theme of his art and auctions part of his oeuvre. Such are the hazards of being a "business artist."

Cady Noland*

Cady Noland loved Damien Hirst's Sotheby's sale. She wishes that more artists had such power over the circulation of their work. Noland had her last solo show of newly made work in 1996, when she was forty years old. Since then, she has become a cult figure whose work is hugely admired by younger artists and a growing coterie of collectors. Last November, one of her sculptures, *Oozewald* (1989), was consigned to Christie's. The six-foot-high silkscreen depicts Lee Harvey Oswald at the moment he is being shot by a vigilante avenging the death of John F. Kennedy. It is displayed on a cutout, made of aluminum rather than cardboard, that nevertheless gestures toward the format used for film stars in cinema lobbies. A golf ball-sized "bullet" hole near his mouth is stuffed with an American flag. The violent piece, which many would see as quintessentially uncommercial, sold for $6.6 million, making Noland the world's most expensive living woman artist.

Wearing a black hat and sunglasses, Noland looks like a movie star who is keen to stay incognito. She is petite with long blonde hair and red lipstick. We are sitting at a table for two at a Pain Quotidien café on Seventh Avenue in New York. It's a quiet summer afternoon and the place is nearly empty.

* Ms. Noland would like it to be known that she has not approved this chapter.

Noland is the daughter of the late Color Field painter Kenneth Noland. At first, the two artists seem to have little in common. While he had a long, lucrative career, making abstract paintings in the shape of bull's eyes, she enjoyed a fifteen-year stint, creating sculptures and installations using silkscreens and very precise arrangements of found objects such as handcuffs, chain-link fences, barbecues, and Budweiser beer cans. Whereas he was integrated into high society through several wives and appeared to live the American dream, she has studied its seamy underside. "He had his own problems with the auctions," she says, suggesting their kindred dislike of that part of the art world. Exposure to his life as an artist no doubt oriented her own. "Dealers were already demystified for me," she adds.

Noland has long been fascinated with conspiracy theories, criminality, and psychopaths. In an article titled "Paranoia Americana," the late artist Steven Parrino argued that Noland's subjects are "not social anthropology, but clues to herself." Noland made several works using the image of Patty Hearst, the granddaughter of newspaper magnate Randolph Hearst, who was kidnapped by the Symbionese Liberation Army and then joined their cause. According to Parrino, the Hearst story played into Noland's deep-seated fears.

As Noland sees it, psychopaths are just an extreme example of Americans' tendency to treat each other like objects. In a manifesto titled *Towards a Metalanguage of Evil* (1987), she expresses the belief that the psychopath has a lot in common with "the entrepreneurial male." While she was once preoccupied with characters like Charles Manson, she is now obsessed with the people that move the art market, whose lack of regulation attracts insider traders, manipulators, tax evaders, and money launderers. "The art market is a maze and it's intentional," she says. "Every situation that comes up is its own Rubik's Cube."

Noland laments the way auction houses "throw artworks together pell-mell." Lately, her work from the 1980s and 1990s has been appearing regularly at auction. "I have had to plead with them to present it correctly," she says, tugging at a red plastic teddy bear pendant, one of several necklaces that are part of a carefully curated ensemble. "It's

terrible when the element of chance is introduced," she explains. "An auction is like throwing the dice. It's like cutting up a writer's words and throwing them up in the air. If I had known that everything would be flipping at auction, I would have made works that were impervious. I know it sounds paranoid and crazy, but..." She stops talking when a woman in dark glasses sits down at a neighboring table. Noland's vibe is so intense that the woman gets up and moves to a table further away.

Last week,* the artist was in court, being sued for her "tortious interference" in Sotheby's sale of *Cowboys Milking* (1990), which depicts two men forcibly milking a cow. The corners of the silkscreen-on-aluminum work were "bent and slightly deformed," according to contemporary art conservator Christian Scheidemann, and Noland felt obliged to renounce her authorship of the work. The Visual Artists Rights Act of 1990 grants artists the right to prevent the use of their name in association with "distorted, mutilated, or modified" work that could prejudice their "honor or reputation." When Noland disowned the work, Sotheby's withdrew it from the sale, despite having previously given it an estimate of $200,000 to $300,000. The Swiss dealer who consigned the work was enraged and decided to litigate. Noland brings up the case, but tells me that her lawyers have advised her not to talk about it. She has even refrained from speaking about it with friends because she is certain her phone is tapped. She recommends that I read Eamon Javers's *Broker, Trader, Lawyer, Spy: The Secret World of Corporate Espionage.*†

Like many artists, Noland finds it distressing when her sculptures are incorrectly installed and combined with works that engender the wrong kind of dialogue. Many of her works, she claims, are missing parts. This tends to happen when dealers, keen for the commission on a resale, "yank the works out of happy homes," as she puts it. We discuss *Oozewald*, which was bought at auction by Philippe Ségalot, an art consultant who many assume was bidding on behalf of the Qatari

* Today's date is August 20, 2012.

† On May 3, 2013, the Supreme Court of New York County granted Noland's motion to dismiss the complaint against her, a decision that was not appealed.

royal family. She thinks it will be impossible for them to install the work properly and worries that they will combine the "cutouts" with other works. "Only certain works look good together," she declares.

Few curators have any hope of being as meticulous as Noland. When she was installing her last brand-new work to be included in a public exhibition in 2001, she spent many hours shifting the objects by millimeters and their angles by single degrees. When the show was over, she instructed the staff of Team Gallery to take it apart and dispose of the pieces in separate trash bins around the city. In the past, she has admitted to a "pathological tendency" in her own work—a type of "throwaway inventiveness" that she likens to the behavior found in horror films such as *The Texas Chainsaw Massacre*.

Many galleries have tried to host Noland solo shows. Not so long ago, Gagosian Gallery hired Francesco Bonami to put together an exhibition. When Bonami, a longtime Noland fan, contacted the artist, she told the curator that she did not want to be "saved from obscurity" and would shoot Larry Gagosian if he dared to do a show of her work. In her opinion, "Artists go to Gagosian to die. It's like an elephant graveyard."

Only Triple Candie, the Harlem gallery that held Maurizio Cattelan's "posthumous" retrospective, has managed to host a "survey" of Noland's work. In 2006, with the help of three artist friends, the owners recreated some of Noland's most celebrated installations as best they could, given limited finances and sketchy information about exact scales and materials. Titled "Cady Noland Approximately," the show outraged many New York critics. Jerry Saltz, who sees Noland as a fierce poet, called it "an aesthetic act of karaoke, identity theft, [and] body snatching."

A curator at the Museum of Modern Art told me that they were interested in the possibility of doing a Noland retrospective. The artist shakes her head. "Maybe in ten years," she says. She cannot do it now because "it would pull me into the nightmare" of worrying where all the works are coming from and going to, not to mention how they are being displayed and cared for. "I'd like to get a studio and start making work," she admits, but tracking the old work is a "full-time thing."

Gabriel Orozco
River Stones in progress at the artist's home in Mexico City
2013

SCENE 11

Gabriel Orozco

"You can take refuge here. It is like a country inside a country," says Gabriel Orozco as we enter a cloistered courtyard, which dates from the 1600s when his Mexican home was a convent. The house lies behind a stone wall crowned with bougainvillea in San Ángel, the "barrio" of Mexico City where he grew up. Although the artist has owned the house for only eight months, he feels like he has lived in it forever. "I guess I'm going to die here," he says, his hoarse voice counterpointed by birdsong. The artist, who is wearing a kaftan and flip-flops, drank more than a few shots of mescal last night, celebrating the victory of his football team, Cruz Azul. He will give me a tour while his housekeeper makes his favorite hangover cure, *huevos con salsa,* while Mónica Manzutto, the co-owner of the city's kurimanzutto gallery, who has escorted me here, catches up on phone calls in the morning sun.

Orozco points out a door crowned by a 1930s' mural depicting a man holding a rifle sitting on a white horse, painted by Juan O'Gorman, an important architect and painter. O'Gorman designed the studios of Frida Kahlo and Diego Rivera, which are two minutes away, as well as the landmark façade of the library of the National Autonomous University of Mexico. This fresco was not a commission: O'Gorman grew up in this house and painted it while he lived here.

We walk to the other side of the courtyard, past a few of the artist's

new, beautiful, green and gold "piña nona" paintings, then enter a wood-paneled library with a majestic fireplace and a compendium of curios-ities. The largest artwork in the room is a 1970s' portrait of Orozco's father, confidently drafted in black acrylic on plywood by David Alfaro Siqueiros, one of Mexico's three great muralists. On a wooden pedestal backlit by a window is a human skull, which I wish was adorned with a graphite grid like Orozco's celebrated *Black Kites* (1997). I assume Orozco's memento mori influenced Hirst's diamond skull. It was sin-gled out for critical acclaim when it was shown in London in 2004, and Hirst collects Orozco's work. For his part, Orozco sees Hirst as "an impresario who gets in trouble because it is hard to believe in his numbers." He thinks that artists lose credibility when they "bluff."

Off the library is a chapel that was converted into a studio by O'Gorman's father, then into a sixteen-seat cinema by Manuel Bar-bachano Ponce, the Mexican film producer who owned the house after him. Ponce's wife was a fervent Catholic who commissioned paintings of morose saints. Orozco came to parties here as a teenager, when the house was full of virgins and crucifixes. Raised as a Communist, the artist still considers himself a "community-ist" and, as such, is intoler-ant of religion. He is particularly hostile to artists who he feels act like "Catholic missionaries in third world countries."

Beyond the holy doors is a capacious living room with a wall decked out with graceful anatomical sketches of muscular arms drawn by Orozco's father—a poignant reminder of his time spent honing the vanishing craft of drawing from life. At the other end of this vast room, a Steinway grand piano sits next to a big white canvas. "In case I have a great idea," says Orozco with a throwaway gesture that implies they are a dime a dozen. "You have a hypothesis. You feel the energy. Your nerves are working. It's a bit like sport."

By luck as well as design, Orozco's prolific output has met with hearty demand. He has been able to sell his art since graduating from univer-sity. "I don't care so much about being rich, so I don't feel the pressure of the market. On the contrary, I feel support." The artist puts an unlit cigarette in his mouth, leaves it there for the temporal equivalent of a puff, then removes it with two straight forefingers. "The artist is not in

his bubble of a studio, rejecting all the forces of the market in a capitalist society. That is a romantic view. It's just not realistic," he explains. Indeed, handling one's market—making decisions about how much art to make and where to show it—is part of the craft of being an artist.

We pass through some heavy wooden doors made by an "important carpenter," as he puts it, "a man with a name." Then we admire some "serious" pre-modernist chairs, made in Mexico from tropical wood. In an octagonal room with a hidden spiral staircase is a pastel portrait of a youthful beauty, Orozco's mother circa 1960, by Ramón Alva de la Canal. Orozco's parents were divorced in 1974 whereupon the family dispersed, leaving San Ángel. "I have come back to the place where my family was together and reunited my parents with the portraits," he says. "But not in the same room. I could never do that to my mother!"

The artist's breakfast is ready, so we settle into some vintage Shoemaker "sling" chairs in the shade of the arcade surrounding the courtyard. Dizzy from the visual stimulation of this almighty house, it takes me a moment to notice that we are surrounded by dozens of stones. They are partially carved and marked up with black geometric lines and indications like "←3mm→." They sit on old wooden stools, in makeshift sandboxes, and between potted plants on the floor. Stencils, protractors, wax pencils, and black Sharpies lie nearby. "You are in the studio!" says Orozco in response to my gaze, as he bends over the coffee table to eat his eggs and black beans.

Orozco has been celebrated for his "post-studio practice," particularly in New York, where he first made a name for himself with *Yogurt Caps* (1994), an installation of nothing but four blue-rimmed transparent plastic lids from Dannon yogurt containers. For many years, it was important to him "not to have a studio, not to have a permanent assistant, not to have secretaries." But now that he makes more artworks from scratch (as many artists of his generation who started out in readymades do), he has spawned de facto studios in all six of his homes. (When I visited him at his New York townhouse a couple of years ago he avoided the loaded term "studio," preferring to call his workspace an "operational center.")

For the past six months, Orozco has been collecting stones, made

smooth by centuries of erosion in Mexican rivers, and drawing patterns on them, then handing them over to a stonemason who carves and polishes them according to his instructions. "They are tumbling stones," he says. "They have traveled so much they are soft. They are not monumental. They are about circulation, rotation, change." Once Orozco has chosen his stone, he spends a lot of time looking at it, touching it, deciding how to engage with it. "It's a kind of spiritual process. You get into a mineral mood. It is about imagining the stone's past rather than tattooing or stamping it," he explains. "The type of craft and the mentality of the making are very Mexican."

A few of the rocks are engraved with designs that hark back to pre-Hispanic and Aztec art, but most have an extraterrestrial quality, as if an alien civilization had taken up the art of Zen stone gardening with a laser cutter. At the same time, they are almost all recognizable as Orozcos. The circle has been a formal fetish since the artist learned to spell his name, while checkerboard patterns and wonky all-over grids are persistent inclinations. Indeed, a half-finished oval stone, which is the size of a bread loaf, bears a scalloped fish-scale pattern that reiterates an art-school drawing from 1982 that hangs in the library. "If I thought in a straight line, I'd get to a dead end," explains the artist. "I need to think in circles and keep coming back around."

Manzutto, slim in a little black dress and running shoes, leaves her fountain-side "office" to inform us that it is time to head over to the gallery. Among other things, Orozco needs to meet the stonemason and fine-tune the locations of the forty-four works in the show. While the artist goes upstairs to change, Manzutto explains that the artist has, until now, had only one show at kurimanzutto, despite having spurred the gallery's foundation.

Orozco is highly influential—the leader, even, of an informal school of art. Between 1987 and 1991, a group of artists came over to his house once a week for a workshop that started at 10 A.M. and ended at around 10 P.M. after several rounds of beer. The participants included José Kuri (Manzutto's husband and business partner) as well as the artists Damián Ortega, Abraham Cruzvillegas, Dr Lakra, and Gabriel Kuri (José's brother), all of whom are now represented by kurimanzutto.

Gabriel Kuri recently told me that he had learned a lot from Orozco's "precision and lightness of touch" and his ability to combine good ideas with strong formal structures. Kuri admitted that he had to strive to find his own voice because Orozco was such a powerful character. "He can own circles," he joked, "as long as I get to own crushed cans."

Upon reappearing in an untucked white shirt and baggy trousers, Orozco climbs into the passenger seat of a navy Volvo next to his driver while Manzutto and I take the back. Kurimanzutto officially opened on August 21, 1999, the very day that Leo Castelli, a legendary New York dealer, died. "I did not have any representation in Mexico, so I decided to form a team," says Orozco about kurimanzutto. The artist has "ended up organizing people" since he was a kid, but he is forever ambivalent about it. "It's part of my personality but I don't like the burden. I have to be careful that they don't make me a dictator or a godfather," he says with appealing camaraderie.

Orozco coined the name kurimanzutto, which he loved because it sounded Japanese, and set up an internship for Manzutto (until then a grad student) at Marian Goodman Gallery while José Kuri finished a masters degree in international affairs at Columbia University. "Gabriel [Orozco] created all the founding aspects of the gallery," says Manzutto. "We would help artists realize projects. We would be mobile and versatile, working with a stable of artists that were good and without representation, not the hot international names." For the first two years, kurimanzutto organized group shows in makeshift spaces that were virtually nonprofit. The gallery was both a business and a prolonged artist's project—albeit one with a very different ethos to Hirst's "Beautiful Inside My Head Forever" auction. After several years supporting solo shows and art fair booths, Kuri and Manzutto realized that they needed a permanent space. "The art industry had become a monster. We had to adapt to the new circumstances," explains Orozco.

The car pulls into a predominantly residential street in San Miguel Chapultepec. Kurimanzutto is three stories high, with the ground floor demarcated by vertical wood panels. We enter through a wide tunnel of a room into an open-air patio featuring a perilous staircase without railings, which would never pass inspection in the USA or Europe. Once

through this courtyard, we go back inside, past a reception area and into a grand exhibition space that was once a timber yard with a high A-frame wood ceiling. Four large plinths of different heights in different shades of muddy gray display a range of Orozco rocks.

José Kuri, the other half of kurimanzutto, comes down from his office to greet us. "*Hola, chavo*," says Orozco to him affectionately. They converse in Spanish, then the artist wanders off to inspect the installation. He takes up a number of static positions with his arms crossed, looking hypercritical. For a number of years, sales of Orozco's work paid kurimanzutto's bills, but Ortega, Cruzvillegas, and José's brother Gabriel now bring in substantial sums too. When I ask Kuri how he would describe his relationship with their artists, he says, "Complicity is the best word. We have a complicity in everything they do—in relation to their work, ideas, travel, and politics."

"The space is not easy," says Orozco upon his return. "There is a weird wall, we call it *el muro del diablo*, the diabolic wall, because it is so hard to resolve." The artist points to the right side of the room, where a built-in bench offers seating and displays a few stones. "My solution was to kill the wall with the bench—to make it disappear." Orozco tells me that the other problem for his show was the base. The stones looked great resting casually on the stools in his patio, but that would be "too romantic, too country, too charming" for the display here. "And individual pedestals would look horrible, conventional." So Orozco decided on four platforms with a bench on one wall and a chest-high shelf on the other. "The base of a tri-dimensional object is like a frame on a painting," he explains. "You don't want it to interfere or feel mechanical. It needs to be functional and neutral in a way that allows you to concentrate on the object."

Juan Fraga, a stonemason who usually works with a generation of artists now in their seventies, arrives with two assistants. The three muscular men in T-shirts set up a table covered in gray carpet, then carry in ten stones one by one. Orozco picks up a stone, studies its underside, and rubs it with his thumb. "*Muy bien*," he says, followed by some quick-fire Spanish in which he refers to Fraga as "*maestro*." The artist points to a black mark on one stone. One of Fraga's assistants, apparently his

son, pulls some white gauze and liquid industrial cleaner out of a duffel bag. Orozco marks up a couple of the stones, which will have to go back to the shop for further carving and polishing. Otherwise, these late arrivals are ready to be added to the show.

Someone hands a red pen and a list of works to Orozco. Each sculpture is represented by a thumbnail shot and a description, which includes a mineralogist's assessment of the material, such as "granite cobblestone." The gallery's registrar is currently on her knees with a clipboard and a measuring tape, calculating the size of the works. Orozco needs to commit to titles. "A title helps to round off the piece," says the artist as he walks to the shelf on the left wall that bears about five works. He flips through the paper, finding the right picture, then writes *"Brain Stone"* in capital letters, holding his pen in the upside down way that left-handed people use to avoid smudging ink. He moves efficiently from one rock to the next, occasionally savoring the stone with his hands. He writes *"Fish/bird," "Turbo Bone,"* then *"Infinite Carv . . . "* which he crosses out and replaces with *"Cyclical Drop."*

Manzutto joins us with my girlfriend, Jessica Silverman, who owns a gallery in San Francisco, to head out to lunch. "Did you ask him your favorite question?" says Jessica to me. I look at her blankly. I have absolutely no idea what that question might be. She turns to Orozco and inquires, "What is an artist?" Orozco looks at me affectionately, but in a way that also makes clear that I'm a pain in the ass. "I don't give the answers. I am the one asking the questions!" he says jocularly. Orozco contemplates a work that he has just titled *Soccer Boulder*. It looks like a deflated ball—a humble talisman of a heroic past. "The border between art and craft is blurry. The decorative arts can be innovative and fine art can get into a system of repetitive production," he explains. "There are moments when artists are artists and then they are not anymore. When they are not thinking, they become craftsmen of their own art."

Beatriz Milhazes
Flowers and Trees
2012–13

Beatriz Milhazes

"Human beings want something beautiful to live with. That is not a shallow desire. It affects our well-being," says Beatriz Milhazes. She is driving past a colonnade of palm trees that lines the Jardim Botânico, which gives this Rio de Janeiro neighborhood its name. Milhazes is taking me to her studio. She has worked in the area since she attended Parque Lage, a stunning art school housed in an elegant Beaux-Arts building on the edge of the rainforest.

Milhazes parallel parks on a quiet street with nineteenth-century row houses on one side and a mid-twentieth-century community center on the other. "We have the feeling that the world doesn't need artists because art doesn't meet our basic needs to survive. But that's not true," she says, her hands still on the wheel. "Even the most primitive cultures have decorative art. They always needed to ..." She takes off her gold-rimmed aviator shades and looks at me with her big black eyes, struggling to find the right words. "Aestheticize and exteriorize their thoughts and feelings."

We pass five men playing cards at a table positioned between a couple of large trees that grow out of the sidewalk, then pause in front of a two-story house with shuttered arched windows. Milhazes rummages for her keys in a sizeable snakeskin handbag. She creaks open the right side of the French door to reveal a long room with a cement floor, an exposed

brick back wall, and high ceilings. The side walls display three colorful, unstretched paintings, which are abstract but suggestive of flowers. The first has a central daisy shape bounded by circles and stripes. The second is more tulip-like, with a throbbing, swollen center surrounded by geometric leaves. The third is a hybrid of the other two, disrupted by swirling arabesques. Milhazes makes her works upstairs, then hangs them down here until she is ready to let them go. If these pass muster, they will be shown at Fortes Vilaça in São Paulo later this year.

"I don't want easy beauty," she says, studying the works. "I want conflict. I want intensity, strong dialoguing, challenging eye movement." Milhazes's work is both riotously baroque and rigorously structured. One's eye bounces around her paintings like a pinball kept in continuous motion by an accomplished player. "Collectors find that my paintings are hard to hang in their homes. When they install one, they realize they have to take everything else out of the room!" she says with a fragment of a giggle, adding that her works are also a challenge for curators hanging group shows. As Milhazes sees it, her paintings have the splendor of "an elephant rather than a nice lady."

Pinned on a bulletin board full of gallery invitations is a flyer for a show by Bridget Riley, a senior British painter, featuring a vertiginous arrangement of curvy black-and-white stripes. "Riley is a great painter," says Milhazes. "I am interested in optical reactions and possibilities, so Riley, and Op art in general, is important to me." Marcel Duchamp asserted that conceptual art was superior to what he called "retinal art." Milhazes is familiar with the argument and shrugs it off. "Duchamp abandoned painting... and painting *is* my subject," she says in her warm, raspy voice. "I think all art is abstract. Sometimes my paintings refer to figurative things, but even my flowers are not so representational. They open the door for an eye experience." Milhazes absent-mindedly checks the clasps of her gold hoop earrings, which are framed by a mane of frizzy ringlets. "I always wanted to work with painting because it's a flat space that belongs to me—a space where I can develop my own private world."

On a table below the bulletin board are some Havaiana flip-flops that display a detail from a painting by Tarsila do Amaral, a surrealist

whose work often addressed the tropical exuberance of Brazil. Milhazes considers her an important influence even though she cannot see a visual connection. "The freedom of carnival is strong in me," she says. "I sometimes see my work as 'conceptual carnivalesque.'"

Many of the artists from whom Milhazes derives motivation happen to be female, like Riley and Tarsila (as she is called), but also Sonia Delaunay, Georgia O'Keeffe, and Elizabeth Murray. The daughter of an art history teacher, she also feels empowered by the canon of modernist Brazilian art history, which celebrates a handful of women artists such as Lygia Clark, Anita Malfatti, Lygia Pape, and Ione Saldanha.

Brazil is the only country in the world where the most expensive living artist is female. "I cannot afford to buy back my early work!" says Milhazes, whose paintings have commanded the highest prices for several years.* Elsewhere, women don't even crack into the top twenty. I observe that the Mexican art scene appears to be a boy's club and wonder what makes Brazil different. "Brazil is very Latin-macho," says Milhazes, "but the big mix of cultures and nationalities means that sometimes things can happen in a more open way. Maybe the roles—or the rules—are more fluid."

Milhazes picks up the left flip-flop, which depicts a naked figure sitting in the sun. She has nothing against estates that license the work of dead artists to keep their oeuvre alive, but she can't bear the idea of becoming involved in this kind of marketing herself. "It is not my thing," she says. "I want my work to be shown in places where the audience can see it a hundred percent. With mass-produced stuff, the quality goes down. I don't want to do things that will make me feel sad."

Avoiding mass-market projects is one way that Milhazes maintains her focus. "You cannot lose your relationship to the work. You need to be happy in the studio because if you lose that, you lose everything," she explains as we climb a modern staircase with wooden slat steps and metal rails. The artist's main workspace is a bright room where open

* The consigner of an artwork, usually a collector, reaps the reward of a high auction price. However, an artist with a strong resale market will often see an increase in the prices of their newly made work.

windows offer an angled view of *Christ, the Redeemer* (1931), the giant Art Deco statue that presides over Rio. Air conditioning would interfere with the way Milhazes likes her paint to dry, so stand-up fans dot the dark hardwood floor. Shelves and tables host thousands of tubes of acrylic paint, hundreds of brushes, thumbtacks, tweezers, a paint-splattered hammer, and a hair dryer.

Five works in progress hang in this room. Four of them are smaller pieces in their early stages. The largest, a six-foot-high by eight-foot-wide canvas, is almost finished. A strip of flimsy plastic sheeting covered in leaf shapes, adorned with royal blue and acid yellow wavy patterns, hangs down over a section of the canvas. Milhazes uses a collage technique in which she draws on transparent plastic, applies acrylic paint to the drawing, glues the dry paint to canvas and then peels away the plastic. I might be looking at the final layer of the painting; Milhazes is not sure. "This one is dangerous because if I glue it, it's impossible to change. It's over," she explains. Milhazes developed this mode of making her work in the late 1980s while researching various printing processes, including monotyping. Under the window, in a series of piles that merge into one another, are the pieces of plastic upon which Milhazes paints. If she likes a drawing, she will paint it over and over again, using it on multiple paintings. "Some pieces of plastic have been with me for ten or twelve years," she says. "They have their own memory of the process."

Milhazes has long loathed the visible presence of expressive brushstrokes. "My work is very rational," she explains. "I like a filter between my hand and the work. I like this shiny, bright, smooth surface." The fact that Milhazes's paintings borrow their texture from plastic is part of what makes them feel appropriate to our times. But often the transfer of paint onto the canvas is imperfect, leaving ghostly apparitions of the layer underneath. Although Milhazes describes herself as a "control person," she is happily resigned to the fact that her method contains these elements of chance.

I sit down on the only comfortable chair in the room at Milhazes's insistence, while the artist takes a hard stool. She lifts weights, so sits with effortless good posture. From about eight feet away, we examine

the canvas further. It uses a huge range of colors—pinks, blues, oranges, browns—with a more restrained assortment of shapes—circles, squares, semicircles created by the interaction of the two, along with straight and curvy stripes. The remarkably complex composition somehow maintains a dignified equilibrium. "I like very much this moment here. I don't want to destroy it," says Milhazes, pointing to twenty or so yellow concentric circles that are intermingling with a looser arrangement of multicolored rings. "And this is kind of special," she says about a group of shapes that evoke globes floating in a sea of turquoise.

"I've been looking at this layer for almost a week and I cannot say yes or no," says Milhazes. She stands and walks over to the painting and removes the plastic sheet that holds the blue and yellow leaflike forms. Now that it's gone, I can see why it was there. Its pulsating pattern somehow brings the painting to life. I find it strangely distressing to look at the canvas without it. "Yes, maybe that is the solution," she says.

Milhazes started making this painting over six months ago. "My process is slow because I need to think," she explains. "Time is the key to everything." Milhazes made eight paintings last year but didn't finish them all because she was distracted by her retrospective shows in Rio and Buenos Aires, as well as various book, print, and collage projects. "Of course, I think about my paintings when I'm out of the studio, but I can't make any serious, precise decisions," she says, her right hand flowing from her forehead toward the canvas, demonstrating not so much her sightline as the direction of her mind's eye. "If I am not concentrated, I will never arrive anywhere. I need to be here."

Although she once felt the pressure to be more prolific, Milhazes now refuses to rush or be diverted from "what the work needs," as she puts it. In the early 1990s, when she first started selling paintings, her dealer in São Paulo, the late Marcantonio Vilaça, requested works for art fairs, group shows, and specific collectors. Vilaça was, by all accounts, charismatic and persuasive. "I tried at first but then just stopped. I told him that I could *not* move this way," she asserts. "I understood very fast that the pace of the market was not for me." So resolute is Milhazes's focus on the priorities of her work that she can't imagine anyone would compromise their art for the market. With regard to Damien Hirst, she

says, "I don't think he's seduced by money. He's playing with how to sell things, questioning what the values are, and testing how far he can go with that conceptual project."

From her earliest days, Milhazes has had a disciplined work life. After leaving art school, she rented a studio building with nine other artists. "We were all in our early twenties. They used the studio to play music and meet friends. I never did," she says, correcting her posture to sit upright on the brutal little stool. Milhazes is admirably grounded, a characteristic that seems to derive from her clear-minded subordination of her ego to her work. Nevertheless, I am unprepared for the prosaic modesty of her response when I ask, what kind of artist are you? "I tell my friends that I'm like a bank worker," she says with a calm grin. "I come to the studio five days a week and do my job. I pay attention to detail and try not to make mistakes."

Andrea Fraser
Art Must Hang
2001

Andrea Fraser

Looming like a demigod over the entrance to the prestigious Museum Ludwig in Cologne is Andrea Fraser, depicted on a two-story billboard. She has been honored with the Wolfgang Hahn Prize, which is accompanied by a retrospective show and $100,000 for acquisition of a work or works by the artist. Fraser once imagined that such accolades were "narcissistically stabilizing," but experiencing them brings home the fact that status is always relative and conditional. At the awards ceremony, Fraser quoted aptly from a number of her works—not just from the careful arrangement of acceptance speeches that she performs in *Official Welcome*. Self-fulfilling prophecies are Fraser's stock-in-trade. Indeed, she once declared, "Art-making is a profession of social fantasy ... overvaluing and overestimating possibilities, investing in futures that do not really exist are occupational requirements."

The Museum Ludwig has one of the best collections of modern art in Europe, with particularly strong groupings of Picasso, Warhol, and Lichtenstein. Built in 1986, the awkward building has a jagged roofline with hundreds of skylights that shed a glorious amount of natural light. A grandiose processional staircase leads down to Fraser's show, which is in a subterranean area often used for exhibitions dominated by video.

An eight-foot-high pile of spectacular readymade costumes, a work by Fraser titled *A Monument to Discarded Fantasies* (2003), sits in the large foyer at the bottom of the stairs. During carnival in Rio de Janeiro, thousands of people parade in extravagant *fantasias* (which means both "costumes" and "fantasies" in Portuguese) that are sometimes discarded in the street when the festivities are over. The symbolism of the custom caught Fraser's imagination. After repeated visits to Rio and São Paulo—which led the artist to take up samba dancing and, for a time, weightlifting—Fraser's body came to play a central role in her work. The artist credits Brazil with helping her "make peace" with her exhibitionism.

Fraser finds performing to be "less terrifying" than standing around while people look at her work. She also prefers to internalize and embody ideas than to externalize and distill them into objects. "As artists, we exhibit parts of ourselves, whether it's our bodies, or things we make, or our inner lives in the course of interviews. We expose ourselves," Fraser told me when I saw her at UCLA. While a desire to communicate is a key artistic motivator, a fear of being too direct or didactic also prevails. Fraser refers again to her favorite British psychoanalyst, D. W. Winnicott, who wrote an article titled "Communicating and Not Communicating," which considered the case of artists. It analyzed the inherent dilemma between the desire to express oneself and the anxiety that it provokes, between an urgent yearning to be known and a more urgent need to keep parts of oneself hidden. "That conflict," explained Fraser, "is central to a lot of what artists do."

The museum is packed with a professional throng of collectors, curators, and dealers who have come from all over Germany to Cologne for its annual art fair and attendant events. While few people focus on *Discarded Fantasies*, a substantial crowd watches *Art Must Hang* (2001), a video installation in which Fraser impersonates Martin Kippenberger, a cult German artist, delivering a drunken after-dinner speech. Kippenberger died in 1997 at age forty-three of alcohol-related liver cancer. The prolific painter may have doubted the future viability of painting but he had complete conviction in his larger-than-life persona. To this day, the most

sought-after Kippenberger works are self-portraits, particularly a series in which he wears white underwear and flaunts his pot belly.

"Can we have some quiet here, so one can say a few words?" hollers Fraser in German in a masculine voice. "Would one of our top art dealers and teachers, for example, be so kind as to take a seat?" Fraser appears as a ghostly life-size projection on the wall between real canvases; her virtual feet seem to touch the gallery's wooden floor. Her rendition of Kippenberger is a word-for-word reenactment of a speech that he delivered after the opening of a show by his friend Michel Würthle, an artist better known as the owner of the Paris Bar, an art-world hangout in Berlin. "So today, let's drink to the artist ... But let's not forget what mean, petty bourgeois assholes we are, who can't even look at this dumb-ass exhibition," says Fraser gruffly with a slight sway. Kippenberger's notorious speeches were abusive rituals punctuated with bad jokes about Nazis with speech impediments, "foreigners," "faggots," and "squeaky little bunnies" who should "throw their tampons out the window."

On one of her many trips to Germany, Fraser had heard Kippenberger give such an impromptu monologue. She decided she wanted to perform one of his speeches, eventually discovered a single recording, which she treated as a readymade, transcribing and memorizing it. "Kippenberger was performing 'the asshole' in a way that was both self-conscious and self-loathing," Fraser told me. "He performed his ambivalence towards his peers and patrons with sadomasochistic zeal. I respected that about him."

The show has become so packed with people that it is hard to move. After several rooms featuring video installations comes a large open space, which includes documentation in vitrines, books central to Fraser's intellectual formation, and monitors with earphones playing performances such as the mock conference panels that Fraser created with the V-Girls, a feminist troupe, between 1986 and 1996. After that, I enter a room featuring a single round small speaker installed in the middle of a white wall, which is playing an audio-only version of *Untitled*, Fraser's sexual "exchange" with the collector. In this ambient piece, the

artist includes all her own sounds and edits out his. It feels unnervingly intimate and adds a whole other dimension to the silent video version of the work.

In the final space of the retrospective are two texts including "L'1%, C'est Moi" (2011), which Fraser wrote as a means of tackling her discomfort with the booming art market's reliance on the gap between the rich and the poor.* Fraser started out by investigating the involvement of museum trustees in the financial crisis. When *Artforum* declined to publish the unsolicited piece, the artist then wrote a slightly different article for the German quarterly *Texte der Kunst*, in which she used an alphabetical listing of the top 200 collectors published by *ARTnews*. For example, "A" includes Bernard Arnault, whose $41 billion make him the fourth richest man in the world. The mega-collector is the owner of Louis Vuitton Moët Hennessy, which, "despite the debt crisis, reported sales growth of 13 percent." "B" is for Eli Broad, the principal benefactor of UCLA's art school. He is a major shareholder of AIG, the recipient of the largest government bailout in American corporate history. And so the list goes on. Few artists focus on the sources of the art market's liquidity, let alone point out that "what has been good for the art world," as she puts it, "has been disastrous for the rest of the world." Fraser adopted the 1 percent nomenclature after reading an article in *Vanity Fair* by Joseph E. Stiglitz, which described how the top 1 percent control 40 percent of America's wealth. When the Occupy movement hit the news, Fraser's article went viral.

On its own wooden lectern opposite "L'1%, C'est Moi" is the catalogue of the Whitney Biennial 2012, in which Fraser published "There's no place like home," an essay that addresses similar themes. Fraser was initially invited to contribute to the biennial's catalogue, but did so on the condition that she was a participating artist. In assuming the double

* In January 2012, Fraser left her New York dealer, Friedrich Petzel, because she did not want to be involved in the "commercial art economy of sales to ultra-high-net-worth private collectors." She continues to be represented by Galerie Nagel Draxler in Cologne, which sells her work only to museums.

role, Fraser moved from being a servile scribe to featured talent and her text was put on display on a pedestal in the exhibition. Although essays are an important part of Fraser's output, she doesn't call them "works." In her opinion, the category of an artwork is a "ghetto or prison" and she is keen to resist the "avant-garde impulse to pull more things into the prison."

Isaac Julien
Still from *PLAYTIME*
2013

Isaac Julien

"Stand by," bellows the first AD or assistant director. Like the other twenty crew on set, he is dressed entirely in black and wears shoes that don't squeak so he can move around quietly. They are working on the empty thirtieth floor of Heron Tower in the heart of the City of London. Advertised as an "advanced business life environment," the new skyscraper has floor-to-ceiling windows that offer commanding views of the metropolis. Landmarks such as the "Gherkin" and the "Shard," the tallest building in the European Union, which is co-owned by the Qatari ruling family, stand out against a cloudy, windswept sky. Changing light conditions have been one of the day's biggest battles for the DOP (director of photography), her gaffer (chief lighting technician), and his three sparks (electricians).

"Quiet on the set," hollers the first AD with firm affability. He acts as an extension of the director's will, a proxy who whips everyone into position so the director can focus on the big picture. "Cameras running!" he shouts. A young man wearing a T-shirt sporting a picture of a stack of old VHS tapes swings an iPad in front of the lens of the state-of-the-art high-definition Steadicam. It says that we are on the set of *PLAYTIME* directed by Isaac Julien, and tells the exact time down to the hundredth of a second. The iPad or "smart slate" has replaced the old-fashioned chalkboard clapperboard once used to identify the take.

"Okay, ready and ... action!" Colin Salmon, a dashing black English actor best known for his appearances in James Bond films, walks into frame; Craig Daniel Adams, a young white Scottish actor, is sitting on a leather swivel chair. Dressed head to toe in Prada, they are playing hedge fund managers who are considering the office space for the headquarters of a company called G.E.T. Capital. Adams's character tells an anecdote in which he describes how he defined hedge funds at a party. "You see that guy over there, the one in that group with the short dark hair who keeps looking at me?" says Adams's gay character to Salmon's straight one. "Well, let's say I'm convinced he's wearing briefs, not boxers. I'm so sure of that one sartorial fact that I bet $20 million on it. The trouble is that if I'm wrong, I'm wiped out. So I also bet he is wearing boxers. Let's say, I put $19 million on that possibility. That's the hedge! Now, if I'm right, I make a million, but if I'm wrong, I'm only going to lose a million, because I'm almost fully hedged." The cameraman steps soundlessly around them with a boom operator hugging his side. "And what if he's commando?" asks Salmon. "You'd need to take out another option." The actors and their shadows come to a standstill. "He wasn't," retorts Adams coyly.

"Okay, cameras cut!" says Isaac Julien from behind a black draped enclosure where two monitors relay the live feeds—the area the film industry calls a "video assist" or "video village." It reminds me of *The Wizard of Oz* when the mysterious, supreme wizard is revealed as just a man behind a curtain. "Thanks, guys! That's good. That's exxxxcellllent!" says Julien as he emerges. The artist, the eldest of five children, took care of his siblings while his parents worked nights; his warm, patient tone suggests that mothering was his introduction to management. "I thought it was quite nice when Colin [Salmon] happened to walk out of frame and back," says Julien to Nina Kellgren, the DOP with whom he has worked for over twenty years. Among other films, Kellgren shot *Looking for Langston* (1989), Julien's celebrated meditation on gay desire, which is considered one of the founding pictures of "queer cinema."

Today, Julien and Kellgren are working from a script but no storyboard, developing ideas as they shoot. If they were making a film for

the cinema, they would likely have had to lock down their goals for financial reasons. But they are producing a seven-screen work for the art world—a limited edition of six (and one artist's proof) for viewing in galleries, museums, and private foundations. Julien entered the art world in the mid-nineties when he was invited to make a work for the Johannesburg Biennial and Victoria Miro Gallery started to represent him. After losing some editorial control over *Young Soul Rebels* (1991), a film that won the Critics' Prize at Cannes, Julien was keen to obtain greater artistic autonomy. Moreover, funding for independent film projects was drying up, so the shift to arts patronage was not just liberating, but lucrative. With the help of his galleries, Julien has raised a budget of £1 million ($1.6 million) for this film.

PLAYTIME is an exploration of the power of money, and more specifically, the huge sums that go by the name of financial capital. Following the eminent geographer David Harvey, who likens capital to gravity, Julien is fascinated by the ways that this abstract, invisible force affects people's lives. The hedge fund managers segment, which is one of five scenes, tackles the concept of capital most directly. The other scenes, which include segments shot in Dubai and Reykjavik, concentrate on its effects. Julien did not travel during the first twenty years of his life (with the exception of a single day trip to Calais), so exotic locations have become staples in his films. He has been working on *PLAYTIME* for the past three years; this is the final day of shooting.

A good part of the script for this hedge funders segment derives from interviews with Diane Henry Lepart, a handsome woman of Jamaican descent, who is having her makeup done next to a wall of windows overlooking North London. She is wearing a black Prada coat with huge fox-fur cuffs and some diamond-like bling around her neck. "I'm somebody we call a portfolio player," she tells me. "I like to do lots of different things: hedge funds, private equity, asset management. But acting is a different thing. I'm out of my comfort zone. I'm on the board of a theater—the Donmar—so I've seen lots of plays, but this..."

"Now, Diane," interrupts Julien, taking her hands in his. "We want you in this scene so it's got a documentary element. It's like life and fiction mixed—a real hedge fund manager with the thespians." He walks

her over to the part of the vast room in which they are shooting, while I venture into the video village.

Ensconced behind the curtain are a researcher, a script supervisor, a sound engineer hunched over a keyboard attached to a black box, and Adam Finch, the project's editor. Finch met Julien at Saint Martin's School of Art in the 1980s and has edited all his multiscreen works, from *Trussed* (1996), a two-screen work, to *Ten Thousand Waves* (2010), which involves nine large-scale screens arranged in a spiral shape. "We worked for a long time on three-screen installations. It's a nice format with a history in the religious triptych. We developed a lexicon and a syntax for that kind of parallel montage," says Finch. "When we moved to four screens with *Fantôme Afrique* [2005] for Centre Pompidou, things got complicated. The viewer could no longer see all the screens at the same time. We wanted people to move around in space. My job was to choreograph that." Finch tells me that *PLAYTIME* will be viewed on seven screens arranged in a figure-eight formation.

"Right, we need to go! We're losing light! First positions everyone!" roars the first AD. Julien and Kellgren zip in front of the monitors and put on headphones. The gaffer, stylist, and makeup artist pile in behind them. The cramped quarters of the village give me an opportunity to snoop in Finch's notebook, which lists the framing, timing, and director's opinion on each take. Finch is concerned that this footage is a little wordy. "You know what editors say," he whispers. "You have to murder your babies. If they don't work, cut 'em out."

"Cameras running? Quiet on the set. Action!" says the first AD. Behind the curtain without earphones, I can only hear snippets of dialogue.

"Wow, nice view," says Lepart.

"Yeah, we were talking about transparency . . ." says Adams.

"Twenty years ago, the heart of the market was a trading floor where we did deals with each other face to face," says Salmon. "Now the heart of markets is an air-conditioned warehouse full of computers . . . It feels like we're hardly responsible anymore . . ."

Adams says something about the Occupy protests, but I can't make it out. I flip through the script trying to find the lines, but am diverted

by others. "The more PhDs you have working for you, the higher the intellectual capital of the brand," says Salmon's character. "These new guys...have an almost occult ability to make money. They're my golden eggs."

"Cut. Okay. Lovely," says Julien unpersuasively. Coughing erupts and chatter resumes. Julien strides over to Lepart and the actors. Upon his return he tells me, "There's a big difference between actors and non-actors. The actors drive you mad, but they have a magic. Non-actors also have a power, but it's much harder to get it out of them." I comment that the variety of skilled labor on set, from actors to gaffers, is dazzling. "I am reliant on a lot of people's aesthetic knowledge and technical expertise," he replies. "Everybody does their thing. They are all artists in their own right." He estimates that about 150 people will have been involved in the making of *PLAYTIME* by the time they've done all the special effects and postproduction work. "The arrival of high-definition computer technologies means that filmmaking is more labor-intensive than ever," he adds.

Julien enjoys working with the latest technologies in his pursuit of ever more rarefied visual pleasure. He grew up on a rough council estate in East London surrounded by "ugly poverty." He thinks the art world's conflicted relationship to beauty results from upper-class guilt. In his opinion, ugly realities can be depicted in beautiful ways; he cites Billie Holiday's exquisite "Strange Fruit," whose lyrics are about the lynching of African Americans in the Deep South. He also refers to French Creole, the language his Saint Lucian parents spoke at home. Creole arose from slavery but displays a creativity that transcends its abject roots. Julien sees Creole as a model for his art's hybrid forms, which combine Hollywood-style narrative grandeur with experimental ruptures.

The first AD has called for another take. On his way back to the video monitors, Julien stops to fix the tie of Mark Nash, his husband, who is an extra in the next scene. The artist abhors what he calls "laissez-faire attitudes" to appearances. Nash is a curator and academic who collaborated with Julien on the fictional biopic *Frantz Fanon: Black Skin White Mask* (1995) and has had cameos in two other films. As a key confidant and co-owner of JN films, Julien's production company, he

has an associate producer credit. At the command of "Action," we stand in silence. When Julien yells "Cut," Nash and I start a conversation in which he tells me, "Artists are able to open themselves up into different media, whereas some of us like to hide. They are also able to tolerate a lot of anxiety about whether their work is good and whether people will like it or not. With the right supporters, they can make it through."

Glenn Scott Wright of Victoria Miro Gallery, Julien's dealer, whom I haven't seen since he took me to Yayoi Kusama's studio in Tokyo, arrives to play his part as an extra. He tells me the names of the patrons of *PLAYTIME* (the Kramlichs, the Loves, the Linda Pace Foundation) and mentions that Bernard Arnault acquired *Ten Thousand Waves* for his Fondation Louis Vuitton.

After a few more takes, I find myself next to Kellgren, the DOP, while other members of the crew set up the shot of the extras around a corporate boardroom table. When I mention the craft of filmmaking, she exclaims, "Cinematographers are not just craftspeople! From script to screen, the process is intensely creative and interpretative. Yes, we are working on someone else's idea, but there are many shades of gray." Kellgren fingers an old-school monocle called a director's viewfinder that hangs on a black cord around her neck. "A film crew is complex and interdependent and very hierarchical," she adds. Finch, the editor, is still in his spot against the wall in the video village. "There is a clear divide between the people who are creatively involved and those who are technically involved," he explains matter-of-factly. "The creatives are the director, DOP, editor, composer, costume designer, and set designer. The technicians are the camera operators, sound recording guys, gaffers, and sparks. It's on a sliding scale. The first AD looks like he could be important, but he's really just a gofer."

Once the boardroom shot is wrapped, Salmon has time to spare while everyone works on a moving closeup of Lepart's high-heeled feet walking. The actor has worked with Julien before and appreciates his precision. "Isaac often asks you to do things that don't feel natural but when you see the installation, you go, ah!" he explains. Salmon worked with Woody Allen on *Match Point* (2005), so I ask him how Julien and Allen differ. "Wow!" he replies. "Hmm... Woody's got a spirit around

him. He's very enigmatic but very clear that he's allowing it to happen. He gives you the head—the lines, the melody—and he lets you improvise. 'Now just tawk, *just tawk*,'" says Salmon, imitating Allen's accent. "Whereas this," says Salmon as he looks around the office floor, "is a bit more deconstructed. The head is more complex, more Cecil Taylor." Salmon reaches down to a black case that I hadn't noticed, unclips it, and, to my amazement, pulls out a gleaming trumpet. "Woody plays more traditional jazz. Isaac is more avant-garde," he concludes. "I have to play some music in the next scene."

"Nice and quiet, please," says the first AD. "No talking! Okay, settle! Quiet guys, please. And...action!" Lepart walks slowly, the clatter of her high heels echoing through the unoccupied space. "Cut. That was great, darling!" says Julien.

"Excuse me while I warm up my trumpet," says Salmon, who starts playing a relaxed jazz number. Julien sees rhythm as central to his structures and often likens his art to songs, so I can see why he and Salmon enjoy working together.

The first AD approaches Julien and says, "Tell me what we're doing."

"I'm imagining the Steadicam just following Colin while he plays the trumpet through the whole space," says Julien about the final shot of the day.

"So I clear everything back into the corner? We're worried about the reflections of the Steadicam," says the first AD. The sun has dropped below the horizon. The city lights are stunning but veiled by the reflections of the inside of the room.

"I don't really know what it's going to look like, cause I haven't been here at night," says Julien. "I quite like the idea of deconstructionist motifs. It's going to be almost impossible not to have reflections of the camera anyway."

"I was thinking it would be nice—kind of haunting—to have the space lit with the available ceiling lights," chimes in Kellgren. "Let's clear all my lights out. I think it will be fine."

How are you feeling about today? I ask Julien.

"It's exciting when the actors and everybody else bring an idea to life," he replies. We could have done with two days here, though." He

adjusts his thin black tie. He's wearing a white collared shirt, the only person behind the scenes to contravene the dark dress code. "This is a very technical shoot with a lot of dialogue," he adds. "I don't want it to look visually pedestrian."

I press Julien about his comment earlier that the members of his crew are all "artists in their own right." He replies with a look of concern, then says, "I want to credit everybody. And some people, like Adam [Finch, the editor], I couldn't begin to tell you. I need his mastery of the apparatus."

Julien is adamant that he is not expressing his "solitary self" but "listening to things" around him. "Mark and I went to the opera recently," he says. "And all evening, I watched the conductor and kept thinking, that's what I do. An artist is the person that holds things together. He may have original ideas, but he also needs the wherewithal to realize them."

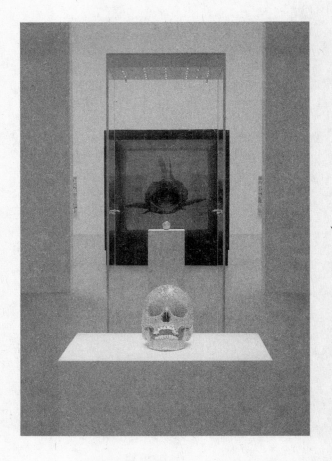

Damien Hirst
For the Love of God (2007), *For Heaven's Sake* (2008), and *Leviathan* (2006–13)
installed in Doha, 2013

Damien Hirst

Doha is so hot and dusty that my throat hurts. In front of a building completely covered in Damien Hirst's multicolored spots, guest workers are preparing sand dunes to be turfed. Only a few date palms and Hirst's *Hymn* (1999–2005), a 20-foot-high bronze sculpture painted to look like a plastic anatomical model, cast a hint of shade. The statue's cyborg face, whose bug-eyed right side reminds me of *Star Wars*'s C-3PO, suits this inhuman environment.

Hirst's largest retrospective, titled "Relics," opens today. Unfortunately, I don't seem to be welcome here. A public relations officer, acting on behalf of Hirst, called my editor at the *Economist* a few weeks ago to say that the artist would not talk to me, implying that the magazine would be wise to send someone else. I assume Hirst is still offended by an article I wrote three years ago (the year after I visited him at his home in Devon) titled "Hands Up for Hirst: How the bad boy of Brit-Art grew rich at the expense of his investors." Remarkably for an arts piece, it set a record for the highest number of hits on the *Economist* website upon its publication in September 2010. The article didn't pass judgment on his art but gave a detailed factual account of the steep downturn in its market.

The press pack is as thin as I've ever seen it. The only journalist from a major daily newspaper is Carol Vogel from the *New York Times,* who

has just written a story about Hirst's *The Miraculous Journey*, a sequence of fourteen gargantuan bronzes that charts the growth of an embryo from conception to birth. The first sculpture depicts a sperm penetrating an egg; the final portrays a 46-foot-tall baby endowed with what is the first penis on public display in the Gulf region. Sited outside a hospital, the work exploits a loophole in Muslim law; it is halal to represent the body if it is for scientific and educational purposes. Sheikha Mayassa al-Thani, the director of the Qatar Museums Authority, told Vogel that she thought the giant baby boy was a self-portrait.* Ironically, although the baby's facial features resemble those of the artist, the sculpture—which is so generic as to be voiceless—doesn't look like an artwork by Hirst at all.

While the other journalists start a guided tour with Francesco Bonami, the retrospective's curator, I follow the photographers to the photo call. Wearing a white T-shirt, black jacket, and gold and silver chains, Hirst stands with his arms crossed in front of a colorful round spin painting, titled *Beautiful, childish, expressive, tasteless, not art, over simplistic, throw away, kids' stuff, lacking in integrity, rotating, nothing but visual candy, celebrating, sensational, inarguably beautiful painting (for over the sofa)* (1996). He frowns at each photographer individually, giving each lens its moment of eye contact. After a minute or two, he notices me brandishing my iPhone at the back, raises his hand high above his head, and hollers "Hi!" in a strangely mocking teenage girl's voice.

Hirst disappears and I join the journalists who are loitering around *For the Love of God* (2007). For the first time, the diamond skull is presented as an artwork in dialogue with other pieces, rather than like crown jewels spotlit in a dark room. It is in a face-off with a shark

* The Qatari ruling family, whose cultural spending is spearheaded by Sheikha Mayassa, the thirty-three-year-old sister of the emir, has been the world's biggest art buyer in recent years. They bought Paul Cézanne's *Card Players* for $250 million and have also acquired record-priced Hirsts, including *Lullaby Spring* (2002) for $17 million. Rumor has it that they will eventually build a museum of modern art but, for the moment, most of their collection is thought to sit in Zurich in a confidential, tax-free storage facility known as a freeport.

in a formaldehyde tank called *The Immortal* (1997–2005). Behind it, a smaller skull—that of an infant, covered in pink diamonds—is staring into the mouth of Hirst's largest shark work to date, a 22-foot black basking shark in a 34-foot-long tank titled *Leviathan* (2006–13). "That little one scares the shit out of me," says Robert Bound, culture editor of *Monocle,* about the baby head. The skulls are in a grand rotunda at the center of the show. "Ninety-nine percent of the visitors to this show will be coming to see the diamond skull," says Arsalan Mohammad, editor of *Harper's Bazaar Art Arabia.* "It's pure Gulf."

A few feet away, Myrna Ayad, editor of *Canvas* magazine, peers at a wall label, noting that the title *For the Love of God* has not been translated into Arabic. "When you use the word 'Allah,'" she explains, "you run a huge risk." A self-declared atheist, Hirst's regular references to religion take on different shades of meaning in the midst of zealous believers. A PR person comes over to escort Ayad to her group interview with Hirst. She offers to share her notes with me when she discovers that I haven't been given a slot. Ask him about "Relics," the title of the show, I say as she leaves the room. Is the artist positioning himself as a saint?

I wander past Bonami, who is holding forth in front of a handful of local journalists in the next room, referring to the new shark as a "killer work." The curator gave me a tour a few days ago. Installers wearing turquoise rubber gloves were placing medical instruments in stainless steel cabinets to the sound of Paul Simon's *Graceland,* and men in hazmat suits were dumping boxes full of British fly larvae, flown business class by Qatar Airlines, into Hirst's installation *A Thousand Years* (1990). Bonami met Hirst in the mid-nineties, included his work in the 2003 Venice Biennale, and oversaw the presentation of the diamond skull in Florence in 2010. He believes wholeheartedly in the sinister and still unsold piece. "Even if we forget who made it," he told me, "the diamond skull will always be an object of interest."

Despite the diamonds—and the lavish wealth needed to host this show—the theme of money in Hirst's work is downplayed. The exhibition is not strictly chronological, so Hirst's general trajectory from cheap materials to luxurious ones is not obvious. Also, unlike Tate Modern's retrospective, this one does not group together works from

the artist's lucrative Sotheby's sale. Instead, it spreads four of these pieces over three rooms, which lends them different interpretations. For example, *The Kingdom* (2008), a small shark in a black tank (which the Qataris are assumed to own), is surrounded by eight spot paintings with black backgrounds. In this context, the lone shark takes on a psychedelic quality, as if it were enjoying an altered state. "They wanted a serious show," said Bonami, who evidently finds it hard to crack jokes in this milieu. He is a loyal Hirst fan but, when pressed, he admitted that the artist is like a "rock star with an entourage—unable to walk alone."

I find myself standing in front of *With Dead Head* (1991), a black-and-white photograph of the artist (before he was one) next to a cadaver's head in a morgue. My phone rings. "Meet me in the lobby," says Jean-Paul Engelen, the sweet, long-suffering director of public projects for the Qatar Museums Authority. As he ushers me along a narrow corridor, Engelen tells me that there has been a change of plans and I can now join a group interview and even ask a few questions. I run into Ayad on the way. "I asked your question about relics and saints," she says, pulling out her notebook. "He said, 'I have problems thinking about God. I think he's an artist.'" She widens her eyes with amusement. God is an artist? I repeat incredulously. Is he saying that God is made in his image? She nods, shakes her head, and shrugs sequentially, promising to send me the full transcript.

Hirst is sitting with his back to the door in a windowless room with three journalists and four communications handlers, including one whose company advises individuals on "reputation management." The session is already underway. Jude Tyrrell, Hirst's right-hand woman, waves me to the far end of the boardroom table, which is dotted with clusters of Coke, Red Bull, and Perrier.

"I have a lot of opposing views. All my shows feel like group shows. Lots of artists live in my head," says Hirst to Bound, who is recording a podcast for *Monocle*'s website. They're in the midst of a comfortable fireside-style chat. Hirst readjusts his rings—three of which are in the shape of a letter H.

Bound concludes his interview and Silke Hohmann, an editor at

Monopol, a German art magazine, takes over. She asks a series of questions about exhibiting in the Gulf. "When the culture is not your own, it is hard to be provocative in the right way," explains Hirst. "The objective is to get people to listen to you even if you want them to change their minds a little bit."

Next up is Mohammad from *Harper's Bazaar Art Arabia,* who concentrates on Hirst's fourteen-piece sculpture depicting life in the womb. "It's probably the least radical of my works," concedes Hirst. Then he admits, as if by way of explanation, "There are not a lot of clients out there." When Mohammad finishes, Hohmann pipes up with another question: "What is your favorite artwork?" Hirst gives the same answer he has given for twenty years. "Bruce Nauman's neon," he says, taking a moment to remember the title, "The True Artist Helps the World by Revealing Mystic Truths." He also declares a fondness for Piero Manzoni's *Artist's Breath* (1960), a balloon that is literally full of artistic hot air.

"Sarah, do you want to ask any questions *about the show*?" asks Tyrrell, who is chairing the session. "Just go for it! Express yourself!" says Hirst in that puzzling "gay" voice, which attempts to be friendly but betrays residual hostility. Given the peculiar response that Hirst gave to Myrna Ayad's question about the title "Relics," I decide to ask it again. Jeff Koons talks about how artists are "burned at the stake"; I wonder if Hirst somehow feels martyred by the art world. In calling your show "Relics," are you positioning yourself as a saint? At least that is what I mean to ask, but instead I also ramble about titling strategies and art-historical hagiography.

"That's your five questions!" exclaims Hirst with a guffaw. Happy to have the upper hand, he adds, "After years of giving your works these long titles, you realize that people just call it 'The Shark' or 'The Skull.'" Hirst uncrosses his arms and leans forward. "And I thought it was ironic to refer to contemporary art as relics. I don't think you can say that artists are saints. Do we believe that relics are real anymore? Aren't there five thousand ribs of Jesus Christ?" This response diverges greatly from the one he gave Ayad. "A relic is a venerated object from a

time gone by," continues Hirst. "There is no denying that art has power. It is difficult to know what gives it that power. I like the idea that one plus one equals three in art whereas, in life, you get just two."

One thing I've always enjoyed about Hirst is his willingness to talk numbers and business. Back in 2005, when I interviewed the artist in his bedroom, he had just come back from his company's annual general meeting in Seville and told me how he was against "line management" because he preferred a "homely" cottage industry. "I go for loyalty rather than efficiency anyway," he explained. He also recounted a story about the labor that went into making one of his meticulously crafted pill cabinets. "It was like they were down the pill mines," he said. "I found it very uncomfortable. You can't be selling these things for a lot of money when you have people slaving away like they were in a sweatshop." In those days, Hirst had fifty employees.

How many staff do you have at the moment? I ask. "A hundred and thirty?" says Hirst, turning his head to Tyrrell. "A hundred and fifty," she says, correcting him.

And how many staff did you have at the height of your productivity? "At the height, it was two hundred and fifty." I wonder aloud if that bulge in numbers was in 2007–08, when Hirst was making 223 lots for the Sotheby's sale. "Probably a bit before that, when I was doing the butterfly show for Gagosian," he says. Hirst manages his empire through an array of companies, including Science, Murderme, Other Criteria, Damien Hirst and Sons Ltd, D Hirst Ltd, and The Goose Wot Laid the Golden Egg. His businesses are registered in both Britain and Jersey, an English-speaking tax haven off the coast of France.

Would you tell me about your relationship with Francesco Bonami? I ask. "He's been an absolute joy to work with," replies Hirst. "We're old friends. When I lived in New York in '95, we used to hang out and drink. We go back a long way—even if he does slag me off in his books."

A tad irritated with Hirst and his team, and knowing we're in a non-democracy, I ask, what are your thoughts about freedom of speech? Tyrrell looks sternly at me for flouting her rules. "Wow," says Hirst. "I am completely against it. It should be made illegal." Hirst leans back and crosses his arms. "If it were simple, it would be great, but it's a gray area."

"Artistic freedom?" says Tyrrell, trying to redirect him into safer terrain.

"I love freedom," says Hirst. "I think we should have as much as possible but I'm not sure how much is possible. I prefer art, where you can say something and deny it at the same time."

Visibly relieved to adjourn the session, Tyrrell says, "Thank you, Sarah!"

An hour and a half later, the press pack has been whisked away for lunch on a boat and VIPs start to fill the lobby, which is covered in butterfly wallpaper and features a café made to look like an upmarket pharmacy. Among the auction house people and dealers is a large coterie of Italian collectors (supporters of Bonami as much as Hirst) and a number of Arab collectors who have flown in from the United Arab Emirates and Kuwait. A delegation from Saudi Arabia hovers around a prince who is the grandson of King Abdullah and son of the heir apparent. No one seems to know his name but a gold and black robe makes his status clear. Also present is Sheikh Hassan (a cousin of the emir and an artist), Miuccia Prada (the owner of the giant *Leviathan* shark), Franca Sozzani (the editor-in-chief of *Vogue Italia*), Nicholas Serota (director of Tate), and Naomi Campbell (who is in the region for a fashion show in Dubai). Francesco Vezzoli, an Italian artist in town for his own exhibition, titled "Museum of Crying Women," stands with me, sipping fruit juice (no alcohol allowed). "Many people use Hirst as a target or symbol for all things bad," says Vezzoli. "They think he has done too much, been overexposed. But I find the moralists, who talk like monks but lead the lives of supermodels, to be much more offensive." In response, I explain the British concept of "champagne socialists."

When the lobby seems filled to capacity, Sheikha Mayassa arrives with her attendants, causing weird mayhem. Her bodyguards randomly part the crowd, unsure of who should be in or out of her entourage. Mayassa wears a black abaya, showing a good inch of her pulled-back hair, a brown handbag slung like a satchel across her body, and flat Pradas with thick soles. I join the crowd wafting into the show behind her and see it for the third time.

Halfway through the exhibition, I find myself contemplating a large

stainless steel cabinet whose shelves are lined with cigarette butts. Titled *The Abyss* (2008), it was sold at Sotheby's "Beautiful" sale, then shown in the Tate retrospective. A few weeks ago, I heard that the person who acquired *The Abyss* also bought *The Golden Calf* (2008), the controversial bull with the gold-plated horns, which was the top lot of the sale and hasn't been seen since. The wall label here says that the work is on loan from the Fondation Louis Vuitton, which suggests that Bernard Arnault owns both works. If I'd discovered this information a few years ago, it would have been a nice scoop, but now I'm not sure who cares.

In a room featuring *Saint Bartholomew, Exquisite Pain* (2008), a gold-plated statue with a detachable fig leaf, I notice Hirst deep in conversation with Jeff Koons. They have both shown with Gagosian Gallery and share a lot of the same collectors. Koons's wife, Justine, and Hirst's new girlfriend, Roxie Nafousi, stand by their sides, their paparazzi-ready smiles looking jetlagged. Koons is fastidiously trim and crisp. Although Hirst has changed into a black collared shirt, he is a mess by comparison. When the men finally part, Hirst strolls over to me and says, "Who was that artist I was talking to?"

Andrea Fraser
Projection
2008

Andrea Fraser

Andrea Fraser is sobbing. "I've always been ambivalent about my field. I made a career out of that ambivalence, to some extent, but in the last couple of years, it's gotten extremely difficult. I just don't think that I can do it anymore," she whimpers. The artist is wearing green leggings and sitting in an orangey-yellow Arne Jacobsen "egg chair." She is projected life-size in high definition on one wall of a dark room in Tate Modern. "I feel like I'm producing this for you," she says. "I am trying to figure out what you want."

Fraser fades from the right wall, then reappears on the left. She's wearing the same clothes but her demeanor is completely different. "So, here's a situation where you're not being represented," says this new character with cool confidence in a lower voice. "There's no one looking out for you to make sure you have a seat." Titled *Projection* (2008), the two-channel video installation is based on transcripts from Fraser's real psychotherapy sessions. Specific nouns have been replaced with indefinite terms like "here," "this," "you," "me," which create fruitful ambiguity. Sometimes the members of the audience, for whom there are stools in the middle of the room, feel like they are being addressed directly; other times, they feel like interlopers, privy to the artist's personal traumas. The work progresses by way of twelve short monologues,

a bit like an ultra-slow-motion tennis match in which artist and shrink slog it out in convoluted volleys.

"Sculpting yourself into a kind of heroic figure, hoping someday to be recognized," says Fraser-as-therapist.

"Like a lot of artists, I live in a very, very privileged world that I'm a kind of guest in," says Fraser-as-patient, slipping off a shoe, pulling her leg up on the chair, and appearing to withdraw.

Suddenly, the volume dips to inaudibility, then rises dramatically. I peer out of the darkened space to find Valentina Ravaglia, a new member of Tate's curatorial displays team, next to a "time-based-media technician" who has his head in the equipment cupboard. They are fine-tuning the installation in advance of Fraser's imminent arrival. Ravaglia sees installing the show of "that pillar of institutional critique, Andrea Fraser" as a "professional rite of passage." We chat about her job and this area of the permanent collection that the staff calls the "surrealist hub." Then I tell her about my research and ask: what, for you, is an artist? She looks pained, so I tell her to take her time, mull it over. She shakes her head. "No, please," she replies. "The more you think about it, the worse it gets!"

I go back into the darkened room to sit in the crossfire of projections. "The conflict *here* is between different sides of yourself," says the therapist with a slightly dismissive flick of her hand. "Sometimes it is useful to hear your own arguments so you can discern your own bullshit." She leans forward as if to coax her patient into trusting her. "I think this is a form of ritual suffering," she says. "That's how it comes across."

"This is a kind of surgery," replies the artist-patient eventually. "It's not about stirring my soul. It's about rearranging my mind."

I see a silhouette in one of the doorways. Fraser's hair is shorter than it was when she shot *Projection*, but otherwise it's as if a third Fraser character has joined the installation. The living artist turns to Ravaglia, who has also entered the space, and says, "The distance between the two screens is not optimal. I'm used to seeing it with a different sense of scale. Here I look larger than life." The curator makes an affirmative noise. "The colors are too contrasty and the images are flattened,"

continues Fraser. "The two images are in such different light conditions. Are you sure they are in the same relationship to floor?"

"They are within a centimeter," replies Ravaglia.

"The distance between the screens should be twenty-five feet," says Fraser.

"This is twenty-two feet," says Ravaglia. I follow the women out of the space while the curator explains that they can improve the lighting conditions and contrast. They stop next to the wall text about the work to discuss a few corrections. Ravaglia is taking it in her stride. She is wearing a vinyl necklace representing an anatomically correct heart. Fraser never wears jewelry. When they have concluded their negotiations, Ravaglia says, "You didn't bite my head off, so that is a victory!" Fraser smiles affectionately at the young curator. "I'm a perfectionist and control freak," she says. "But I don't want to be *that* kind of an artist—even if I have it in me."

This part of the permanent collection is a little quieter now. When I arrived, forty or so French high school students were stationed in front of a work that I can now see is Pablo Picasso's *Weeping Woman* (1937). The painting depicts Dora Maar, a photographer remembered as Picasso's tortured muse. Fraser and I walk the other way, toward Picasso's *The Three Dancers* (1925), in which the central pink-fleshed naked woman has her arms outstretched above her head. We sit on a wooden bench and the artist pulls out her silver thermos of green tea.

"Tate is a great populist institution," says Fraser, who is astonished by the mobs roaming the museum. "It is really difficult to negotiate the presentation of art in this context, to create intimacy in the midst of these crowds, to expect some depth of experience between spectacles."

Fraser tells me that the particular kind of psychotherapy that formed the raw material of *Projection* is always videotaped so that the therapist can present, with the patient's consent, clips in professional contexts. "The therapist is supposed to occupy the position of a toxic superego, to provoke a kind of cathartic anger. That never happened in my therapy, although I certainly ended up being annoyed about the whole process," says the artist. "It is me—a highly edited me," explains Fraser of the

patient-character. "We are different versions of ourselves in different situations, and therapy intensifies certain versions of ourselves."

The formal structure of the face-off is similar to that used by Marina Abramović in *The Artist Is Present* and also recalls Francesco Bonami's display of Hirst's sharks and diamond skulls in Doha. What does Fraser think about these other instances of confrontation and mirroring? "My basic feeling is that there are no wrong interpretations," she replies. "Marina Abramović is not somebody that I've ever felt particularly connected to." She doesn't like the way Abramović's focus on transcendence sweeps away social, economic, and political issues. With regard to Hirst, Fraser declares, "I wouldn't say that he's not an artist, but he belongs to a different art world than I do." She views Hirst and those once described as "Young British Artists" in relation to the British class system. "They represent strategies for navigating class conflicts that are extremely cynical and have some dire artistic and political consequences," she says, adding that they make her think about "how artists perform their complex relationship to wealth—that umbilical cord of gold."

Fraser's work is unusual in its stringent criticism of her profession. "Artists are not part of the solution," she says firmly. "We are part of the problem."

What is the problem? I ask. "Give me a minute," she says, looking dramatically off to one side, giving me her profile while she summons the right words. "Whether we are talking about cultural capital or economic capital," she says with an intake of breath, "art benefits from inequality and the increasingly unequal distribution of social power and privilege. The avant-garde has been trying to escape its own privilege for the last hundred years, but the art world is increasingly a winner-take-all market." She stops and shakes her head. She feels that we are at "the beginning of a new epoch," citing the enormous expansion of the art market as well as art schools and museums that cater to the public's demand for spectacle as much as scholarship. "These things make all the contradictions of being an artist much more intense," she explains. "When I'm not feeling totally pessimistic, I think this is a very exciting time to be an artist."

A guard approaches us and asks us very politely to leave the museum

as it is closing time. I turn to Fraser and start framing a question about the "Remember me" speech in her work *Official Welcome*. The artist interrupts me and performs the whole passage. "'Remember me' is what all artists whisper in their work," she recites. "It's a mark you want to leave in the world. It is still you even when you're not you anymore. If my work really has brought me love, that's what it means. If not, it has failed me at the deepest level. So remember me." She pauses. "That's a partial quote from Ross Bleckner, the painter, something he said in the eighties."

How do you want to be remembered? I ask.

Fraser's eyes flood. "I don't know," she says, then covers her mouth with one hand, looking truly mortified. "Hopefully in a positive way, but not too positive. I don't want to be sainted." She peels her hand away from her face, then flicks it theatrically. "I'm not unique. I'm just a particular instance of the possible."

William Powhida
Artist Assistant Checklist
2005

ACKNOWLEDGMENTS

My heartfelt thanks to the many artists who gave me interviews. I could not include everyone in the "group show" of the main text, but I nevertheless learned something from all the encounters. Suffice it to say that I hope to write about many of them in future.

Thirty-three is symbolic of a lot. In the interests of economy, the final book features fewer than that.* Those artists who became full-blown characters deserve extra thanks. They had to put up with intrusions that took many of them outside their comfort zones. Artists generally like to control their own projects, so it wasn't easy for them to subject themselves to mine. I appreciate their indulgence.

During the four years that I researched *33 Artists in 3 Acts*, I was writing regularly for the *Economist*, and some sentences in these pages appeared first in one of sixty-five articles published under their banner. I believe in the rigorous standards of the *Economist* and am honored that the institution chose to embrace my work (even if I don't love sacrificing my byline!). I have come to see my main *Economist* editor, Fiammetta Rocco, as a big sister. I've learned much from her intelligent advice, exacting editorial eye, grounded ethics, and love of books. I also

* Gertrude Stein's *Four Saints in Three Acts* (1934) features some twenty saints and more than three acts.

had the pleasure of working with Emily Bobrow, another exceedingly generous editor. My huge thanks to them both.

I combined my research for the book with journalism for a few other publications, writing more than once for David Velasco at *Artforum .com* and Richard Rhodes at *Canadian Art*. Both editors helped me clarify my thoughts. I was also happy to write for Cathy Galvin at the *Sunday Times Magazine*, Nick Compton at *Wallpaper*, and Melissa Denes at the *Guardian*.

Seven Days in the Art World led to many opportunities to speak in far-flung parts of the world. I am grateful to all my hosts but mention only two whose invitations influenced the content of *33 Artists in 3 Acts*. My thanks to Rita Aoun Abdo and her team in Abu Dhabi, particularly Tairone Bastien, who set up my onstage interview with Jeff Koons and Larry Gagosian (an encounter described in Act I). Thanks also to Yana Peel, Amelie von Wedel, and Alexandra Seno of Intelligence Squared, who invited me to Hong Kong to debate the topic "You don't need great skill to be a great artist." Hans Ulrich Obrist and I teamed up to argue against the absurd motion, losing by a landslide to Antony Gormley and Tim Marlow. Call me a sore loser, but I do hope that this book finally proves them wrong.

For their superlative professionalism and consistently thoughtful backing, I am thankful to Sarah Chalfant, Andrew Wylie, and their diligent staff. Indeed, it is a joy to be represented by the Wylie Agency. For their deep and wise counsel, I am obligated to the intrepid team of Daniel Taylor, James Heath, Justin Rushbrooke, and Ronald Thwaites. For help with design, I am grateful to Kyle Morrison.

I am delighted to be published for a second time by W. W. Norton and Granta, two independent publishers, full of talented, committed people. I adore my clever editors at both houses. At Norton, Tom Mayer has the patience of a saint combined with the big-picture judgment of Noah loading the ark. At Granta, Max Porter has the quick wit and deft editorial touch of a Shakespearean sprite. I am deeply grateful that their divergent perspectives somehow converged in a belief in me.

I am thankful to the friends—old and new—who gave me valuable feedback on all or part of the manuscript: Carroll Dunham, Andrea

Fraser, Charles Guarino, Sara Holloway, Andy Lambert, Angela McRobbie, Gabriel Orozco, and especially Reesa Greenberg and Alix Browne. I also appreciate the unfailing support of friends and family who acted as sounding boards: Leslie Camhi, Amy Cappellazzo, Louise Thornton Keating, Tina Mendelsohn, Jeremy Silver, Monte Thornton, and my kids, Cora and Otto Thornton-Silver.

Three people were essential to seeing this book through to completion. They read every scene as it was being written, giving me constructive criticism every step of the way. They are: my wonderful mother, Glenda Thornton; my best friend since the age of thirteen, Helge Dascher; and my other half, Jessica Silverman.

Now for some longer lists...

For research assistance, which mostly took the form of transcribing hours and hours of interviews, I am extremely grateful to Jessica Tedd, Cait Kelly, Victoria Genzani, Lindsay Russell, Charlène Bourliout, Charlotte Bellamy, Megan McCall, Nina De Paula Hannika, Keiko Takano, and the many students interested in ethnography at Sotheby's Institute and Christie's Education. I'm also grateful to Ingrid Bachmann, Emily Jan, Karin Zuppiger, and Dana Dal Bo of Concordia University, Montreal, for setting up complicated, confidential workshops related to the book's three acts. Thanks to Micky Meng at the California College of the Arts for help of all kinds, and to Emma Cheung, Akemi Ishii, and especially Lee Ambrozy for translating and interpreting in China and Japan. Thank you to the following writers and filmmakers for being collegiate on location: Myrna Ayad, Robert Bound, Jack Cocker, Silke Hohmann, Mark James, Takako Matsumoto, and Arsalan Mohammed.

I interviewed curators and museum people as expert witnesses and/ or observed them on occasions such as installation. In addition to the three curators who have billing in the table of contents, many thanks to the following people for sharing their thoughts: Iwona Blazwick, Ellen Blumenstein, Vinzenz Brinkmann, Carolyn Christov-Bakargiev, Jacopo Crivelli Visconte, Yilmaz Dziewior, Martin Engler, Laurie Farrell, Soledad Garcia, Mark Godfrey, RoseLee Goldberg, Matthew Higgs, Heike Höcherl, Jens Hoffman, Max Hollein, Laura Hoptman,

Samuel Keller, Udo Kittelman, Courtney Martin, Cuauhtémoc Medina, Jessica Morgan, Frances Morris, Mark Nash, Hans Ulrich Obrist, Erin O'Toole, Adriano Pedrosa, Jack Persekian, Julia Peyton-Jones, Valentina Ravaglia, Scott Rothkopf, Karen Smith, Nancy Spector, Robert Storr, Philip Tinari, Matthias Ulrich, and Qiu Zhijie.

I also picked the brains of a number of dealers, collectors, studio managers, and other art-world affiliates whose knowhow was helpful. My thanks to: Christopher D'Amelio, Martine d'Anglejan-Chatillon, Shelly Bancroft, Ludovica Barbieri, Massimo de Carlo, Valentina Castellani, Johnson Chang, Belinda Chen, Margaret Liu Clinton, Caroline Cohen, Jeffrey Deitch, Edward Dolman, Stefan Edlis, Jean-Paul Engelen, Molly Epstein, Mara and Marcio Fainziliber, Jens Faurschou, Ronald Feldman, Simon Finch, Marcia Fortes, Sara Friedlander, Stephen Friedman, Barbara Gladstone, Marian Goodman, Jerry Gorovoy, Isabella Graw, Jeanne Greenberg, Lorenz Heibling, Greg Hilty, Antonio Hommen, Jin Hua, Jane Irwin, Dakis Joannou, Nina Kellgren, José Kuri, Diane Henry Lepart, Dominique Lévy, Nicholas Logsdail, Daniella Luxembourg, Erin Manns, Monica Manzutto, Tim Marlow, Jacqueline Matisse Monnier, Gary McCraw, Victoria Miro, Lucy Mitchell-Innes, Flavio del Monte, Juan Pablo Moro, Christian Nagel, Francis M. Naumann, Peter Nesbett, Richard Noble, Francis Outred, Marc Payot, Friedrich Petzel, Jeffrey Poe, Andrew Renton, Janelle Reiring, Don and Mera Rubell, Colin Salmon, Patrizia Sandretto Re Rebaudengo, Arturo Schwarz, Allan Schwartzman, Glenn Scott Wright, Uli Sigg, Isao Takakura, Yoriko Tsurata, Larry Warsh, John Waters, Cheyenne Westphal, Amanda Wilkinson, Helene Winer, and Edward Winkleman.

I have been a fan of Calvin Tomkins's writing since I was an art history undergraduate. The epigraph that opens this book comes from one of his afternoon interviews with Marcel Duchamp, published in 2013.

SELECTED BIBLIOGRAPHY

Acocella, Joan. *Twenty-Eight Artists and Two Saints*. New York: Vintage, 2007.

Adams, Henry. *Tom and Jack: The Intertwined Lives of Thomas Hart Benton and Jackson Pollock*. New York: Bloomsbury, 2009.

Adamson, Glenn. *Thinking Through Craft*. London: Berg, 2007.

Adler, Judith. *Artists in Offices: An Ethnography of an Academic Art Scene*. London: Transaction, 2003.

Ai Weiwei. *Ai Weiwei's Blog: Writings, Interviews, and Digital Rants, 2006–2009*. Edited and translated by Lee Ambrozy. Cambridge, MA: MIT Press, 2011.

——. *Weiwei-isms*. Edited by Larry Warsh. Princeton, NJ: Princeton University Press, 2013.

——, and Mark Siemons. *Ai Weiwei*. London: Prestel, 2009.

Anastas, Rhea. "Scene of Production." *Artforum*, November 2013.

Bankowsky, Jack. "The Exhibition Formerly Known as *Sold Out*." *Exhibitionist*, no. 2 (2010).

——, et al., eds. *Pop Life: Art in a Material World*. London: Tate, 2009.

Baudelaire, Charles. *The Painter of Modern Life and Other Essays*. London: Phaidon, 1964.

Becker, Carol, ed. *The Subversive Imagination: Artists, Society and Social Responsibility*. London: Routledge, 1994.

Bickers, Patricia, and Andrew Wilson. *Talking Art: Interviews with Artists since 1976*. London: Art Monthly/Riding House, 2007.

Biesenbach, Klaus, ed. *Marina Abramović: The Artist Is Present*. New York: Museum of Modern Art, 2010.

Bois, Yve-Alain, ed. *Gabriel Orozco (October Files 9)*. Cambridge, MA: MIT Press, 2009.

Boltanski, Luc, and Eve Chiapello. *The New Spirit of Capitalism*. Translated by Gregory Elliott. London: Verso, 2007.

Bonami, Francesco. *Maurizio Cattelan: The Unauthorized Autobiography*. Translated by Steve Piccolo. Milan: Arnoldo Mondadori Editore, 2013.

———, ed. *Jeff Koons*. Milan: Mondadori Electa, 2006.

———, et al. *Maurizio Cattelan*. London: Phaidon, 2003.

Bonus, Holger, and Dieter Ronte. "Credibility and Economic Value in the Visual Arts." *Journal of Cultural Economics* 21 (1997).

Brougher, Kerry, et al. *Ai Weiwei: According to What?* New York: Prestel, 2013.

Buchloh, Benjamin H. D. "The Entropic Encyclopedia." *Artforum*, September 2013.

———. "Farewell to an Identity." *Artforum*, December 2012.

———. *Neo-Avantgarde and Culture Industry*. Cambridge, MA: MIT Press, 2000.

Bui, Quoctrung. "Who Had Richer Parents, Doctors Or Artists?" *Planet Money*, NPR, March 18, 2014.

Burton, Johanna, ed. *Cindy Sherman (October Files 6)*. Cambridge, MA: MIT Press, 2006.

Buskirk, Martha. *Creative Enterprise: Contemporary Art between Museum and Marketplace*. New York: Continuum, 2012.

———. "Marc Jancou, Cady Noland, and the Case of the Authorless Artwork." *Hyperallergic*, December 9, 2013.

Butler, Nola, ed. *Carroll Dunham: A Drawing Survey*. Los Angeles: Blum and Poe, 2012.

Cabanne, Pierre. *Dialogues with Marcel Duchamp*. Translated by Ron Padgett. London: Da Capo, 1987.

Chadwick, Whitney, and Isabelle de Courtivron, eds. *Significant Others: Creativity and Intimate Partnership*. London: Thames and Hudson, 1993.

Cicelyn, Eduardo. *Damien Hirst: The Agony and the Ecstasy*. Naples: Electa Napoli, 2004.

Coles, Alex. *The Transdisciplinary Studio*. Berlin: Sternberg, 2012.

Cone, Michèle. "Cady Noland." *Journal of Contemporary Art*, Fall 1990.

Corbetta, Caroline. "Cattelan." *Klat* #02, Spring 2010.

Cumming, Laura. *A Face to the World: On Self-Portraits*. London: HarperPress, 2010.

Dailey, Meghan. *Jeff Koons: Made in Heaven Paintings*. New York: Luxembourg and Dayan, 2010.

De Duve, Thierry. "The Invention of Non-Art: A History." *Artforum*, February 2014.

_____. *Sewn in the Sweatshops of Marx.* Translated by Rosalind E. Krauss. London: University of Chicago Press, 2012.

Demos, T. J. *The Exiles of Marcel Duchamp.* London: MIT Press, 2007.

Dunham, Carroll. "Late Renoir." *Artforum*, October 2010.

Dziewior, Yilmaz. *Andrea Fraser. Works: 1984–2003.* Hamburg: Kunstverein in Hamburg, 2003.

Ferguson, Russell. *Christian Marclay.* Los Angeles: Hammer Museum, 2003.

FitzGerald, Michael C. *Making Modernism: Picasso and the Creation of the Market for Twentieth-Century Art.* New York: Farrar, Straus, and Giroux, 1995.

Foster, Elena Ochoa, and Hans Ulrich Obrist. *Ways Beyond Art: Ai Weiwei.* London: Ivory, 2009.

Foster, Hal. "The Artist as Ethnographer?" In *The Return of the Real: The Avant-Garde at the End of the Century.* Cambridge, MA: MIT Press, 1996.

_____. *The First Pop Age.* Princeton, NJ: Princeton University Press, 2011.

Fraser, Andrea. "L'1%, C'est Moi." *Texte zur Kunst.* September 2011.

_____. "Speaking of the Social World." *Texte zur Kunst,* March 2011.

_____. "Why Fred Sandback makes me cry." *Grey Room* 22 (Winter 2006).

Frith, Simon. *Performing Rites: On the Value of Popular Music.* Cambridge, MA: Harvard University Press, 1998.

_____. *Sound Effects: Youth, Leisure, and the Politics of Rock 'n' Roll.* New York: Pantheon, 1981.

Galenson, David W. *Old Masters and Young Geniuses: The Two Life Cycles of Artistic Creativity.* Princeton, NJ: Princeton University Press, 2006.

Gallagher, Ann, ed. *Damien Hirst.* London: Tate, 2012.

Gayford, Martin. *Man with a Blue Scarf: On Sitting for a Portrait by Lucian Freud.* London: Thames and Hudson, 2010.

Geertz, Clifford. *The Interpretation of Cultures.* New York: Perseus, 1973.

Gether, Christian, and Marie Laurberg, eds. *Damien Hirst.* Skovvej, Denmark: ARKEN Museum of Modern Art, 2009.

Gilot, Françoise. *Life with Picasso.* London: Virago, 1990.

Gingeras, Alison. "Lives of the Artists." *Tate Etc.* 1 (Summer 2004).

Gioni, Massimiliano. "No man is an island." In Maurizio Cattelan, ed., *Maurizio Cattelan: The Taste of Others.* Paris: Three Star Books, 2011.

Gladwell, Malcolm. *Outliers: The Story of Success.* New York: Little, Brown, 2008.

Godelier, Maurice. *The Metamorphoses of Kinship.* Translated by Nora Scott. London: Verso, 2011.

Goffman, Erving. *The Presentation of Self in Everyday Life.* London: Penguin, 1969.

Goldberg, RoseLee. *Performance Art: From Futurism to the Present.* London: Thames and Hudson, 2011.

Graham-Dixon, Andrew. *Caravaggio: A Life Sacred and Profane.* New York: Norton, 2010.

Gregory, Jarrett, and Sarah Valdez. *Skin Fruit: Selections from the Dakis Joannou Collection.* New York: New Museum, 2010.

Grenier, Catherine. *Le saut dans le vide.* Paris: Editions du Seuil, 2011.

Haynes, Deborah J. *The Vocation of the Artist.* Cambridge, UK: Cambridge University Press, 1997.

Heinich, Nathalie. "Artists as an elite—a solution or a problem for democracy? The aristocratism of artists." In Sabine Fastert et al., eds., *Die Wiederkehr des Künstlers.* Cologne: Böhlau Verlag, 2011.

———. *Le Paradigme de l'Art Contemporain: Structures d'une révolution artistique.* Paris: Gallimard, 2014.

Heller, Margot. *Shelter.* London: South London Gallery, 2012.

Herkenhoff, Paulo. *Beatriz Milhazes: Color and Volupté.* Rio de Janeiro: Francisco Alves, 2007.

Hirst, Damien. *Beautiful Inside My Head Forever.* Vols.1–3. London: Sotheby's, 2008.

———, and Jason Beard. *The Death of God: Towards a Better Understanding of a Life Without God Aboard the Ship of Fools.* London: Other Criteria, 2006.

———, and Takashi Murakami. "A Conversation." In Victor Pinchuk et al., *Requiem.* London: Other Criteria/Pinchuk Art Centre, 2009.

Hoff, James. *Toilet Paper.* Bologna: Freedman/Damiani, 2012.

Holzwarth, Hans Werner. *Jeff Koons.* New York: Taschen, 2009.

Hoptman, Laura, et al. *Yayoi Kusama.* London: Phaidon, 2000.

Jacob, Mary Jane, and Michelle Grabner. *The Studio Reader: On the Space of Artists.* Chicago: University of Chicago Press, 2010.

Jelinek, Alana. *This is Not Art: Activism and Other "Non-Art."* London: Tauris, 2013.

Jones, Amelia. "Survey." In Tracey Warr, ed., *The Artist's Body.* London: Phaidon, 2012.

Jones, Caroline A. *The Machine in the Studio: Constructing the Post-War American Artist.* Chicago: University of Chicago Press, 1996.

Julien, Isaac, with Cynthia Rose, et al. *Riot.* New York: Museum of Modern Art, 2013.

Kaprow, Allan. "The Artist as a Man of the World." In Jeff Kelley, ed. *Essays*

on the Blurring of Art and Life. Los Angeles: University of California Press, 1993.

Kippenberger, Susanne. *Kippenberger: The Artist and His Families.* Translated by Damion Searls. New York: J & L Books, 2011.

Klein, Jacky. *Grayson Perry.* London: Thames and Hudson, 2009.

Kosuth, Joseph. "The Artist as Anthropologist." *Art After Philosophy and After: Collected Writings, 1966–1990.* Edited by Gabriele Guercio. Cambridge, MA: MIT Press, 1991.

Kusama, Yayoi. *Infinity Net: The Autobiography of Yayoi Kusama.* Translated by Ralph McCarthy. London: Tate, 2011.

Lange, Christy. "Bringin' it All Back Home: Interview with Martha Rosler." *Frieze* 14 (November 2005).

Linker, Kate. *Carroll Dunham: Painting and Sculpture 2004–2008.* Zurich: JRP-Ringier, 2008.

_____. *Laurie Simmons: Walking, Talking, Lying.* New York: Aperture Foundation, 2005.

Liu, Jenny. "Trouble in Paradise." *Frieze* 51 (March–April 2000).

MacCabe, Colin, with Mark Francis and Peter Wollen, eds. *Who is Andy Warhol?* London: British Film Institute and Andy Warhol Museum, 1997.

McRobbie, Angela. "The Artist as Human Capital." *Be Creative: Making a Living in the New Cultural Industries.* London: Polity, 2014.

Mercer, Kobena, and Chris Darke. *Isaac Julien.* London: Ellipsis, 2001.

Michelson, Annette, ed. *Andy Warhol (October Files 2).* London: MIT Press, 2001.

Morris, Frances. *Yayoi Kusama.* London: Tate, 2012.

Nicholl, Charles. *Leonardo da Vinci: Flights of the Mind.* London: Penguin, 2004.

Noland, Cady. *Towards a Metalanguage of Evil.* New York: Balcon, 1989.

Panamericano: Beatriz Milhazes Pinturas 1999–2012. Buenos Aires: Malba, 2012.

Parrino, Steven. "Americans: The New Work of Cady Noland." *Afterall,* Spring/Summer 2005.

Peppiatt, Michael. *Interviews with Artists 1966–2012.* New Haven: Yale University Press, 2012.

Perlman, Hirsch. "A Wastrel's Progress and the Worm's Retreat." *Art Journal* 64, no. 4 (2005).

Perry, Grayson. *The Tomb of the Unknown Craftsman.* London: British Museum, 2011.

Phillips, Lisa, and Dan Cameron. *Carroll Dunham Paintings.* New York: New Museum of Contemporary Art/Hatje Cantz, 2002.

Pratt, Alan R., ed. *The Critical Response to Andy Warhol*. London: Green-wood, 1997.

Prose, Francine. *The Lives of the Muses: Nine Women and the Artists They Inspired*. London: Aurum, 2004.

Rattee, Kathryn, and Melissa Larner. *Jeff Koons: Popeye Series*. London: Serpentine Gallery/Koenig Books, 2009.

Ray, Man. *Self Portrait*. London: Penguin, 2012.

Relyea, Lane. *Your Everyday Art World*. Cambridge, MA: MIT Press, 2013.

Rosler, Martha. *Decoys and Disruptions: Selected Writings 1975–2001*. London: MIT Press, 2004.

———. "Money, Power, Contemporary Art—Money, Power and the History of Art." *Art Bulletin*, March 1997.

———. *3 Works*. Halifax: Nova Scotia College of Art and Design, 2006.

Sanouillet, Michel, and Elmer Peterson, eds. *The Writings of Marcel Duchamp*. New York: Da Capo, 1973.

Schorr, Collier. *Laurie Simmons: Photographs 1978/79: Interiors and The Big Figures*. New York: Skarstedt Fine Art, 2002.

Schwarz, Arturo. *The Complete Works of Marcel Duchamp*. New York: Delano Greenidge, 2000.

Sennett, Richard. *The Craftsman*. London: Penguin, 2008.

Sherman, Cindy. *A Play of Selves*. London: Hatje Cantz, 2007.

Sholis, Brian. "Why we should talk about Cady Noland?" Blog post. www. briansholis.com, January 20, 2004.

Silverman, Debora. "Marketing Thanatos: Damien Hirst's Heart of Darkness." *American Imago* 68, no. 3 (2011).

Simmons, Laurie. "Guys and Dolls: The Art of Morton Bartlett." *Artforum*, September 2003.

———. *The Love Doll*. 2011.

———, and Peter Jensen. *Laurie: Spring Summer 2010*.

Smith, Karen, et al. *Ai Weiwei*. London: Phaidon, 2009.

———. *Nine Lives: The Birth of Avant-Garde Art in New China*. Beijing: Time-zone 8 Limited, 2011.

Smith, Zadie. "Killing Orson Welles at Midnight." *New York Review of Books*, April 28, 2011.

Spector, Nancy. *Maurizio Cattelan: All*. New York: Solomon R. Guggenheim Foundation, 2012.

Squiers, Carol, and Laurie Simmons. *Laurie Simmons—In and Around the House: Photographs 1976–78*. New York: Hatje Cantz, 2003.

Stevens, Mark, and Annalyn Swan. *De Kooning: An American Master*. New York: Knopf, 2004.

Stiglitz, Joseph E. "Of the 1%, by the 1%, for the 1%." *Vanity Fair*, May 2011.

Stüler, Ann, ed. *Elmgreen & Dragset: This is the First Day of My Life*. Berlin: Hatje Cantz, 2008.

Sylvester, David. *Looking Back at Francis Bacon*. London: Thames and Hudson, 2000.

Taschen, Angelika, ed. *Kippenberger*. Cologne: Taschen, 2003.

Temkin, Ann. *Gabriel Orozco*. New York: Museum of Modern Art, 2009.

ten-Doesschate Chu, Petra. *The Most Arrogant Man in France: Gustave Courbet and the Nineteenth-Century Media Culture*. Princeton, NJ: Princeton University Press, 2007.

Tomkins, Calvin. *The Bride and The Bachelors: The Heretical Courtship in Modern Art*. London: Weidenfeld and Nicolson, 1965.

———. *Duchamp: A Biography*. London: Random House, 1997.

———. *Lives of the Artists*. New York: Henry Holt, 2008.

———. *Marcel Duchamp: The Afternoon Interviews*. Brooklyn: Badlands, 2013.

———. *The Scene: Reports on Post-Modern Art*. New York: Viking, 1970.

Triple Candie, ed. *Maurizio Cattelan is Dead: Life and Work, 1960–2009*. New York: Triple Candie, 2012.

Ulrich, Matthias, et al., eds. *Jeff Koons: The Painter*. Frankfurt: Hatje Cantz, 2012.

———. *Jeff Koons: The Sculptor*. Frankfurt: Hatje Cantz, 2012.

Vasari, Giorgio. *Lives of the Artists*. Vol. 1. London: Penguin, 1987.

Vischer, Theodora, and Sam Keller. *Jeff Koons*. Basel: Fondation Beyeler, 2012.

Warhol, Andy. *The Philosophy of Andy Warhol: From A to B and Back Again*. London: Verso, 1977.

Watson, Scott. *Exhibition: Andrea Fraser*. Vancouver: Morris and Helen Belkin Art Gallery, 2002.

Weibel, Peter, and Andreas F. Beitin. *Elmgreen & Dragset: Trilogy*. Karlsruhe, Germany: ZMK/ Walther König, 2011.

Westcott, James. *When Marina Abramović Dies: A Biography*. London: MIT Press, 2010.

Widholm, Julie Rodrigues. *Rashid Johnson: Messages to Our Folks*. Chicago: Museum of Contemporary Art, 2012.

CREDITS

Almost all the artists featured in these pages waived their copyright fees. I am grateful for their generosity. Damien Hirst's illustrations were kindly donated by Sotheby's Department of Contemporary Art.

Introduction
Gabriel Orozco, *Horses Running Endlessly* (detail), 1995, wood, each knight: 3 × 3 × 9 cm, chessboard: 8.7 × 87.5 × 87.5 cm. Courtesy of the artist and Marian Goodman Gallery.

Act I, Scene 1
Jeff Koons, *Made in Heaven*, 1989, lithograph billboard, 125 × 272 inches. © Jeff Koons.

Act I, Scene 2
Ai Weiwei, *Dropping a Han Dynasty Urn*, 1995, three black-and-white photographic prints, 148 × 121 cm each. Courtesy of the artist.

Act I, Scene 3
Jeff Koons, *Landscape (Cherry Tree)*, 2009, oil on canvas, 108 × 84 inches. © Jeff Koons.

Act I, Scene 4
Ai Weiwei, *Sunflower Seeds*, 2010, 100 million seed-sized painted porcelain sculptures. Photo: Ai Weiwei. Courtesy of the artist.

Act I, Scene 5
Gabriel Orozco, *Black Kites*, 1997, graphite on skull, 8-1/2 × 5 × 6-1/4 inches. Courtesy of the artist, Marian Goodman Gallery, and Philadelphia Museum of Art.

Act I, Scene 6
Eugenio Dittborn, *To Hang (Airmail Painting No. 05)*, 1984, paint, monotype, wool, and photo-silkscreen on wrapping paper, 69 × 57 inches. Courtesy of the artist and Alexander and Bonin Gallery.

Act I, Scene 7
Ai Weiwei, *June 1994*, 1994, black-and-white photographic print, dimensions variable. Courtesy of the artist.

Act I, Scene 8
Zeng Fanzhi, *Self Portrait*, 2009, oil on canvas, 1200 × 200 cm. Courtesy of the artist.

Act I, Scene 9
Wangechi Mutu, *Me.I*, 2012, mixed media on Mylar, 42-1/4 × 69 × 3/4 inches. Courtesy of the artist and Gladstone Gallery.

Act I, Scene 10
Kutluğ Ataman, *JARSE* (detail), 2011, two sheets of A4 paper, each 21 × 29.7 cm. Courtesy of the artist.

Act I, Scene 11
Tammy Rae Carland, *I'm Dying Up Here (Strawberry Shortcake)*, 2010, C-print, 30 × 40 inches. Courtesy of the artist and Jessica Silverman Gallery.

Lyrics to Bikini Kill's "For Tammy Rae" used with permission of Kathleen Hanna.

Act I, Scene 12
Jeff Koons, *Rabbit*, 1986, stainless steel, 41 × 19 × 12 inches. © Jeff Koons.

Act I, Scene 13
Ai Weiwei, *Study of Perspective—The White House*, 1995, color print, dimensions variable. Courtesy of the artist.

Act I, Scene 14
Jeff Koons, *The New Jeff Koons*, 1980, Duratran, fluorescent light box, 42 × 32 × 8 inches. © Jeff Koons.

Act I, Scene 15
Martha Rosler, still from *Semiotics of the Kitchen*, 1975, running time: 6'09",
black-and-white, sound. Courtesy of the artist and Mitchell-Innes
& Nash.

Act I, Scene 16
Jeff Koons. *Metallic Venus*, 2010–12, mirror-polished stainless steel with trans-
parent color coating and live flowering plants, 100 × 52 × 40 inches. ©
Jeff Koons.

Act I, Scene 17
Ai Weiwei, *Hanging Man: Homage to Duchamp*, 1983, clothes hanger, sun-
flower seeds, 39 × 28 cm. Photo: Ai Weiwei. Courtesy of the artist.

Act II, Scene 1
Elmgreen & Dragset, *Marriage*, 2004, two mirrors, two porcelain sinks, taps,
stainless steel tubing, soap, 178 × 168 × 81 cm. Installation shot from "The
Collectors," Danish and Nordic Pavilions, Venice Biennale 2009. Photo:
Anders Sune Berg. Courtesy of VERDEC Collection, Belgium, and Gal-
lerie Nicolai Wallner, Copenhagen.

Act II, Scene 2
Maurizio Cattelan, *Super Us*, 1996, acetate sheets, 29.8 cm × 21 cm each. Cour-
tesy of Maurizio Cattelan Archive.

Act II, Scene 3
Laurie Simmons, *Talking Glove*, 1988, Cibachrome print, 64 × 46 inches. Cour-
tesy of the artist.

Act II, Scene 4
Carroll Dunham, *Study for Bathers*, 2010, graphite on paper, 12-5/8 × 8-7/8
inches. Courtesy of the artist and Gladstone Gallery.

Act II, Scene 5
Maurizio Cattelan, *Bidibidobidiboo*, 1996, taxidermied squirrel, ceramic, For-
mica, wood, paint, and steel, 45 × 60 × 58 cm. Photo: Zeno Zotti. Courtesy
of Maurizio Cattelan Archive.

Act II, Scene 6
Carroll Dunham, *Shoot the Messenger*, 1998–99, mixed media on linen, 57 ×
73 inches. Courtesy of the artist and Gladstone Gallery.

Act II, Scene 7

Francis Alÿs, *Paradox of the Praxis I (Sometimes Doing Something Leads to Nothing)*, 1997, Mexico City, video documentation of an action, running time: 5 minutes. Photo: Enrique Huerta. Courtesy of the artist.

Act II, Scene 8

Cindy Sherman, *Untitled #413*, 2003, chromogenic color print, 46 × 311.8 inches. Courtesy of the artist and Metro Pictures, New York.

Act II, Scene 9

Jennifer Dalton, *How Do Artists Live? (Will Having Children Hurt My Art Career?)*, 2006, pastel on chalkboard paint on paper, 18 × 24 inches. Courtesy of the artist and Winkleman Gallery.

Act II, Scene 10

Maurizio Cattelan, *L.O.V.E.*, 2010, hand: white "P" Carrara marble, base: bright Roman travertine, hand: 470 × 220 × 72 cm; base: 470 × 470 × 630 cm, full installation height: 1100 cm. Installation view: Piazza degli Affari, Milan, 2010. Photo, Zeno Zotti. Courtesy of Maurizio Cattelan Archive.

Act II, Scene 11

Laurie Simmons, *Love Doll: Day 27/Day 1 (New in Box)*, 2010, flex print, 70 × 52.5 inches. Courtesy of the artist.

Act II, Scene 12

Maurizio Cattelan, *ALL*, 2011. Installation view: Solomon R. Guggenheim Museum, New York, November 4, 2011–January 22, 2012. Photo: Zeno Zotti, © The Solomon R. Guggenheim Foundation, New York. Courtesy of Maurizio Cattelan Archive.

Act II, Scene 13

Lena Dunham, still from *Tiny Furniture*, 2010, running time: 98 minutes. Courtesy of Lena Dunham and Dark Arts Film.

Act II, Scene 14

Cindy Sherman, *Untitled* (detail), 2010, pigment print on PhotoTex adhesive fabric, dimensions variable. Courtesy of the artist and Metro Pictures, New York.

Act II, Scene 15

Rashid Johnson, *Self Portrait as the Professor of Astronomy, Miscegenation and Critical Theory at the New Negro Escapist Social and Athletic Club Center for Graduate Studies*, 2008. Courtesy of the artist.

Act II, Scene 16
Carroll Dunham, *Late Trees #5*, 2012, mixed media on linen, 80-1/4 × 75-1/4 inches. © Carroll Dunham. Courtesy of the artist and Gladstone Gallery.

Act II, Scene 17
Jason Nocito. *Maurizio Cattelan, Massimiliano Gioni and Ali Subotnick*, curatorial team of 4th Berlin Biennial for Contemporary Art, 2006.

Act II, Scene 18
Laurie Simmons, still from *MY ART*, narrative feature film written, directed by, and starring Laurie Simmons, in progress. Courtesy of the artist.

Act II, Scene 19
Maurizio Cattelan, *Mother*, 1999, silver dye bleach print, 156.5 × 125.1 cm. Photo: Attilio Maranzano. Courtesy of Maurizio Cattelan Archive.

Act III, Scene 1
Damien Hirst, *Mother and Child (Divided), Exhibition Copy*, 2007 (original 1993), glass, painted stainless steel, silicone, acrylic, monofilament, stainless steel, cow, calf, and formaldehyde solution, tank 1: 190 x 322.5 x 109 cm; tank 2: 102.9 x 168.9 x 62.3 cm. © Damien Hirst and Science Ltd. All rights reserved, DACS 2014. Image © Tate, London 2013. Funds for illustration donated by Sotheby's.

Act III, Scene 2
Andrea Fraser. *Official Welcome*, performance, 27 October 2009, "Number Three: Here and Now," Julia Stoschek Collection, Düsseldorf. Photo: Yun Lee, Düsseldorf. Courtesy of the artist and the Julia Stoschek Collection.

Act III, Scene 3
Andrea Fraser, *Untitled*, 2003, project and video installation. Courtesy of the artist.

Act III, Scene 4
Christian Marclay, still from *The Clock*, 2010, single channel video, running time: 24 hours. Courtesy of White Cube, London, and Paula Cooper Gallery, New York.

Act III, Scene 5
Marina Abramović, *The Artist Is Present*, performance, 2010, duration: 3 months, Museum of Modern Art, New York. Courtesy of the Marina Abramović Archives.

Act III, Scene 6
The V-Girls performing *Daughters of the ReVolution*, 1996, left to right: Andrea Fraser, Jessica Chalmers, Marianne Weems, Erin Cramer, Martha Baer, EA–Generali Foundation, Vienna. Photo: Werner Kaligofsky. Courtesy of Andrea Fraser.

Act III, Scene 7
Grayson Perry, *The Rosetta Vase*, 2011, glazed ceramic, height: 30-7/8 inches, diameter: 16-1/8 inches. Courtesy of the artist.

Act III, Scene 8
Yayoi Kusama, *Obliteration of My Life*, 2011, acrylic on canvas, 130.3 × 162.0 cm. Courtesy of Yayoi Kusama Studio Inc., Ota Fine Arts, Tokyo/Singapore, and Victoria Miro Gallery, London.

Act III, Scene 9
Damien Hirst, installation shot of room 13 of the retrospective at Tate Modern, including: *The Kingdom*, 2008, shark, glass, stainless steel, and formaldehyde solution, 2140 x 3836 x 1418 mm. And *Judgement Day*, 2009, gold-plated cabinet, glass, and manufactured diamonds, 240.3 x 874.3 x 10.2 cm. © Damien Hirst and Science Ltd. All rights reserved, DACS 2014. Image: Prudence Cuming Associates Ltd. Funds for illustration donated by Sotheby's.

Act III, Scene 11
Gabriel Orozco, *River Stones* in progress at the artist's home in Mexico City, 2013. Courtesy of the artist.

Act III, Scene 12
Beatriz Milhazes, *Flores e árvores (Flowers and Trees)*, 2012–13, acrylic on canvas, 180 × 250 cm. Photo: Manuel Águas & Pepe Schettino. Courtesy of Beatriz Milhazes Studio.

Act III, Scene 13
Andrea Fraser, *Art Must Hang*, 2001, video installation (335 × 244 cm) with paintings (oil, graphite on canvas, approx. 65 × 65 cm) and aluminum disks, running time 30 minutes. Collection Museum Ludwig, Cologne. Photo: Rheinisches Bildarchiv / Museum Ludwig / Britta Schlier. Courtesy of the artist and Galerie Nagel–Draxler.

Act III, Scene 14
Isaac Julien, photograph from the set of *PLAYTIME*, 2013, double projection on single-screen high-definition video installation, 7.1 surround sound,

running time: 66'57". Courtesy of the artist, Metro Pictures, New York, Victoria Miro Gallery, London, Galería Helga de Alvear, Madrid, and Roslyn Oxley9, Sydney.

Act III, Scene 15
Damien Hirst, installation shot of rotunda in Hirst retrospective overseen by Qatar Museum Authority in Doha. *For the Love of God*, 2007, platinum, diamonds, and human teeth, 6.75 x 5 x 7.5 inches. *For Heaven's Sake*, 2008, platinum, pink and white diamonds, 3.35 x 3.35 x 3.94 inches. *Leviathan* 2006–2013, glass, painted stainless steel, fiberglass, silicone, stainless steel, plastic, monofilament, shark, and formaldehyde solution, 115.3 x 409.2 x 102.1 inches. © Damien Hirst and Science Ltd. All rights reserved, DACS 2014. Image: Prudence Cuming Associates Ltd. Funds for illustration donated by Sotheby's.

Act III, Scene 16
Andrea Fraser, *Projection,* 2008, two-channel video installation. Courtesy of the artist and Galerie Nagel–Draxler.

Acknowledgements
William Powhida, *Artist Assistant Checklist,* 2005, graphite and gouache on paper, 16 x 12 inches, collection of Jane Irwin and Ross Hill, GreyChurch.

INDEX

Page numbers in *italics* refer to photos and illustrations.